Individuality

in Clothing Selection and Personal Appearance

Individuality
in Clothing Selection and Personal Appearance

SIXTH EDITION

Suzanne G. Marshall, Ph.D.
California State University
Long Beach

Hazel O. Jackson, Ph.D.
California State University
Long Beach

M. Sue Stanley, Ph.D.
California State University
Long Beach

Mary Kefgen
Professor Emerita, California State University
Long Beach

Phyllis Touchie-Specht
Professor
Mt. San Antonio College (retired)

PEARSON

Prentice
Hall

Upper Saddle River, New Jersey 07458

Library of Congress Cataloging-in-Publication Data

Individuality in clothing selection and personal appearance / Suzanne G. Marshall ... [et al.].—6th ed.
 p. cm.
 Includes index.
 ISBN 0-13-035865-7
 1. Clothing and dress—Psychological aspects. 2. Fashion—Psychological aspects. 3. Costume design. I. Marshall, Suzanne Greene.

TT507.I454 2004
646'.3—dc21 2003043351

Editor-in-Chief: Stephen Helba
Executive Editor: Vernon R. Anthony
Executive Assistant: Nancy Kesterson
Editorial Assistant: Ann Brunner
Director of Manufacturing and Production: Bruce Johnson
Managing Editor: Mary Carnis
Production Editor: Linda Zuk, WordCrafters Editorial Services, Inc.
Creative Director: Cheryl Asherman
Manufacturing Manager: Ilene Sanford
Manufacturing Buyer: Cathleen Petersen
Production Liaison: Adele Kupchik
Senior Design Coordinator: Miguel Ortiz
Interior Design and Formatting: Carlisle Communications, Inc.
Cover Designer: Cheryl Asherman
Cover Image: © Getty Images
Marketing Manager: Ryan DeGrote
Marketing Assistant: Elizabeth Farrell
Senior MArketing Coordinator: Adam Kloza
Printer/Binder: R.R. Donnelley & Sons, Crawfordsville
Cover Printer: Phoenix Color Corp.

Pearson Education LTD.
Pearson Education Singapore Pte. Ltd.
Pearson Education Canada Ltd.
Pearson Education—Japan

Pearson Education Australia PTY, Limited
Pearson Education North Asia Ltd.
Pearson Educación de Mexico, S.A. de C.V.
Pearson Education Malaysia, Pte. Ltd.

PEARSON
Prentice
Hall

10 9 8 7 6 5 4 3 2 1
ISBN 0-13-035865-7

For my husband, Jay,
and our sons, Christopher, Jonathan, and Zachary,
and my daughters-in-law, Katie and Kimi,
your devotion to a higher calling inspire my life and work.
(S.G.M.)

For Yasmine Jackson,
who gave her mother space,
and in memory of my mother, Elmira Webster,
for her unending love,

(H.O.J.)

For Ernie Tyler,
the wind beneath my wings,
and Sara and Mark Stanley,
my children and best friends

(M.S.S.)

Brief Contents

Contents

Message
to Our Readers

When *Individuality* was first published, it was one of the premier texts to address clothing choice as not merely a "right" or "wrong" choice but rather a way of producing a desired effect with which the wearer would be comfortable psychologically, physically, and socially. This now-classic text has continued to provide general guidelines for individual and family clothing choices through its five previous editions. It has been a major text for four decades by providing a broad base of knowledge at an introductory level for the general education of students—a task ignored by most clothing texts, which typically have either a more narrow, in-depth focus or target the more advanced student. *Individuality* is unique in that it meets the needs of the student who is interested in taking a single course in fashion as well as the student who aspires to become a fashion professional.

Focus

In this sixth edition, *Individuality* continues its tradition of providing a concise overview of fashion as it relates to the individual consumer. The primary aim of the authors is to offer students a basic overview of the various influences on individual thought processes regarding clothing preferences, how clothing is uniquely designed for specific target groups, and how clothing purchase choices are made.

Conceptualization and Update

In order to accomplish the challenge of providing students with the latest information in an organized and compelling format, the authors have divided the text into three sections. The basic organization of the text has remained essentially the same with the exception of Part I, in which the chapters were rearranged to begin with a macro view of consumers. Chapter 1, retitled Target Market Influences, is a discussion of the demographic breakdown of U.S. consumer groups and their responsiveness to fashion. It also discusses the impact of Generation Y (tweens and teens) on the fashion industry. Chapter 2 gives a brief overview of the fashion industry, specifically focusing on basic terminology, past and current influential designers, and theories of fashion movement. Chapter 3 covers the influences of an individual's culture on clothing and shows how diaspora has created an international fashion concept. Chapter 4, the sociopsychological influences on fashion, has few changes. Chapter 5 shows the physical influences of fashion with emphasis on the continuation of two conflicting trends: the idealization of the overly thin body and the dominance of processed foods in the U.S. diet.

Part II examines the design elements and principles as applied to clothing. The reader is given definitions of line, shape, color, and texture and then shown how each is applied to fashion items. This explanation of design elements is followed by a discussion of how these elements are organized by emphasis, rhythm, unity, proportion, and balance by designers who create fabrics and fashion.

Part III focuses on clothing selection issues facing consumers. Chapter 11 discusses the fit requirements of individuals in various age groups. This is followed by a discussion of clothing quality and its impact on price in Chapter 12. Chapter 13 updates previous editions' discussion of consumer clothing care including new methods of dry cleaning and care for new fibers. Chapter 14 specifically relates to wardrobe selection, emphasizing industry trends for careerwear such as the beginning of a movement in some companies back to a more traditional look for business apparel. Chapter 15 ends the book with a discussion of the retail environment of traditional bricks and mortar stores compared to the trend toward e-tailing—bricks & clicks.

In general, the content of each chapter has been updated with new data and photographs. Activities have been updated to reflect fashion in the twenty-first century. An emphasis on fashion and the web has been added with a large number of web addresses provided for student usage.

New Features

Several features were added in the fifth edition and updated in the sixth edition to reinforce important concepts to the reader:

- *A model* introduces each of the three parts and illustrates the topics of that part's five chapters. The model is also featured on the first page of each new chapter to remind the reader of interrelationship of this chapter to the whole part.
- *Objectives* open each chapter.
- *Definitions* are boxed to increase visibility.

- *Activities* that involve students in applying their new knowledge appear throughout the text rather than at the chapter's end.
- *Case studies* appear in several chapters.
- *Charts,* figures, and tables consolidate large portions of information.
- *A summary* of key information ends each chapter.
- *Key words and concepts* are given for the student to review at the end of each chapter.

The authors hope that we have been able to convey the excitement and fun of the dynamic world of fashion. Whether a student is entertaining the idea of a career in fashion or is interested personally in fashion, we hope that *Individuality* has introduced the concepts, theories, and pragmatic application of this challenging, ever changing, and never dull field.

Acknowledgments

We are indebted to many people who have contributed in many ways to the content of this book. Our families have provided moral support and understanding. Our students have inspired us and contributed their talents to our collaborative effort. Our colleagues have provided their expertise. We want to give special acknowledgment to several individuals who gave generously of their time and talents:

Our students:
Kristi Janczak and Tatum Schubert, who conducted research for several chapter topics.

Our colleagues:
Peter Shen, a former student who has developed into a valued colleague, for his generous contributions of sketches, often at a moment's notice.
Bob Freleigh, who reproduced endless photographs.
Kim Howard, for her creative artwork, generous gift of time, and calm spirit.
Gayla Totaro, a former student, whose Color Me Beautiful expertise significantly enriched the chapter on color.
Carol Jean Jensen, of Brigham Young University, for her careful and helpful review of the manuscript.
Kit Sui, for his illustrations.

Our families:
Jay, Christopher (Katie and Kieran), Jonathan (and Kimi), and Zachary Marshall; Yasmine Jackson; Ernie Tyler, and Sara and Mark Stanley for the sacrifices they made while the birthing of this book assumed a priority position.

Suzanne Marshall
Hazel Jackson
Sue Stanley

About the Authors

Suzanne G. Marshall is an Associate Professor and Area Coordinator of the Fashion Merchandising and Design area of the Family and Consumer Sciences Department at California State University, Long Beach , California. She received the B.S. from the University of Georgia in Clothing and Textiles, the M.S. from Oklahoma State University in Fashion Merchandising, and the M.A. and the Ph.D. from the University of California, Los Angeles, in Higher Education/Organizational Change. She has worked in the fashion industry as a manufacturer's educational representative and in retail management, and has taught at Bauder College and Saddleback College. She is one of the authors of *Merchandising Mathematics for Retailing* and has also published in the areas of women's leadership, organizational culture, assessment, creative teaching, and retail training. She was selected as a faculty intern for the J.C. Penney Company. Dr. Marshall has done research in various apparel manufacturing companies in the Los Angeles area studying the design and manufacturing process, management, leadership, and product development. She is a member of the International Textiles and Apparel Association, the American Association of Family and Consumer Sciences, the Costume Society of America, Gamma Sigma Delta Honor Society, and Pi Lambda Theta Honor Society.

Hazel O. Jackson received the B.S. degree in Home Economics Education from Tennessee State, the M.A. in Social Psychological Aspects of Textiles and Clothing from Michigan State University, and the Ph.D. in Home Economics from the University of Tennessee, Knoxville. She studied at the University of California, Los Angeles, and has taught at Morris Brown College, Pepperdine University, Tennessee State

University, and The Ohio State University. Currently Dr. Jackson is a Full Professor at California State University, Long Beach. She has published in a variety of areas including aging and apparel consumption; textile legislation, care, and recycling; and advertising and store choice. Her current research includes cultural perspectives of dress and assessment of student learning outcomes. She has served on the ASTM Institute for Standards Research on the Development of Body Measurements, as a peer reviewer for the Family Economics Review, and as a peer review panelist for the USDA's Office of Higher Education Programs. She received the Sphinx and Mortar Board Award for excellence in teaching at The Ohio State University. She is a certified Home Economist. She is a member of the American Association of Family and Consumer Sciences; the International Federation of Home Economics; the International Textiles and Apparel Association; and Phi Delta Gamma, Graduate, Kappa Omicron Phi, Omicron Nu, and Alpha Kappa Mu Honor Societies.

M. Sue Stanley has the B.A. in Home Economics from California State University, Chico, the M.S. in Clothing and Management from the University of Arizona, and the Ph.D. in Clothing, Textiles, and Merchandising from Oklahoma State University. She has taught at Pima College, Bakersfield College, and California State University, Long Beach. She currently serves as Chair of the Department of Family and Consumer Sciences at California State University, Long Beach. She has published in the areas of school uniforms, textiles, the role of Home Economists, and children and apparel perception. She has received an Outstanding Service Award at CSULB and the John Skinner Fellowship. She is a member of the American Association of Family and Consumer Sciences; the American Association for Higher Education; the Costume Society of America; the International Textile and Apparel Association; and Phi Omicron Upsilon, Kappa Omicron Nu, Epsilon Epsilon Epsilon, and Phi Beta Kappa Honor Societies.

Mary F. Kefgen is a Professor Emeritus at California State University, Long Beach. She received the B.S. from Iowa State University in Home Economics and the M.A. from New York University in Home Economics. She also studied at Oregon State University, Traphagen School of Fashion, and the Fashion Institute of Technology. She has done textile research in India and Southeast Asia. She was the recipient of a Ford Foundation Grant to participate in the Oklahoma State University project in Bangladesh. She has taught in Germany and France and was selected to teach in Ethiopa with the Agency for International Development Teacher Corps. Ms. Kefgen is a member of the Costume Council of the Los Angeles County Art Museum, the Textile Group of Los Angeles, and Omicron Nu Honor Society.

Phyllis Touchie-Specht received her B.S. in Home Economics from Oregon State University and her M.A. in Home Economics from California State University, Long Beach. She modeled professionally and had a daily fashion/food/talk show for KIEM-TV, Eureka California. Retired from the faculty of Mt. San Antonio College, Walnut, California, she has served twice as Academic Senate President and was named Outstanding Faculty Member in 1998. She is Fellow of the International Textiles and Apparel Association and the Costume Society of America. She is a member of Fashion group International, the Costume Council, and the Los Angeles County Museum of Art.

Influences on Consumer Clothing Selection

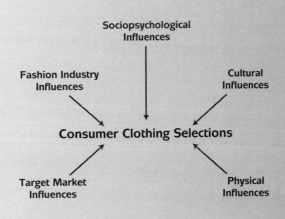

Sociopsychological
Influences

Fashion Industry
Influences

Cultural
Influences

Consumer Clothing Selections

Target Market
Influences

Physical
Influences

Chapter | **1**

Target Market Influences

Objectives

- Identify the most significant demographic statistics pertaining to fashion consumers.
- Demonstrate the blend of demographic and psychographic data and its use by fashion professionals.
- Characterize niche markets using demographic and psychographic descriptors.
- Explain the importance of generational marketing.

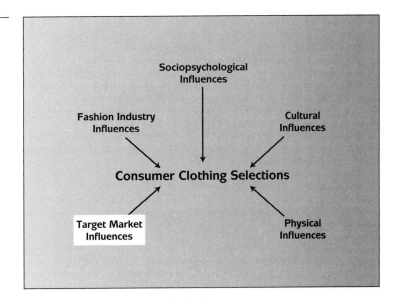

Sociopsychological
Influences

Fashion Industry
Influences

Cultural
Influences

Consumer Clothing Selections

Target Market
Influences

Physical
Influences

Before looking at the individual consumer and his or her clothing selection, the entire market of U.S. consumers will be addressed. By seeing the vast numbers of unique attributes of consumers as a whole, one can begin to understand the complexity of the fashion business, which seeks to satisfy specific target groups that can be identified from the larger group. This chapter will show consumers' quantitative or demographic characteristics that influence their clothing selection. Retailers value as much knowledge as possible about their consumers, believing that it is the key to success. As Bill Blass once commented, "You have to understand people to make clothes for them" (Walz, 1978, p. 47). Analyses of these characteristics enable retailers to segment populations (an important marketing strategy for the past thirty years), profile consumers, and thus provide products pinpointed to their specific needs. Demographics (p. 4) and psychographics (p. 9) can also be used to profile the fashion innovators in a group (Figure 1.1). Retailers use this information to answer such questions as:

- Who are the prospects for shopping in this store?
- Are they male or female?
- Do significant numbers identify with a particular ethnic or age group? Will this group be increasing or decreasing in the coming years?

Demographics	Innovator Characteristics
Gender	Equal numbers of men and women
Age	35–43
Marital status	Married
Family status	Have children
Income level	58% more likely to earn $50,000+
Education	37% more likely to have college education than the average American

Figure 1.1 Demographic characteristics of a sample group of innovators. *(J. Russell and W. R. Lane. 2002.* Kleppner's Advertising Procedure. *Upper Saddle River, NJ: Prentice Hall)*

- Where do these potential consumers live?
- What is their income level?
- Are there enough of these people to make a profit?
- How do they spend their time?
- Does this target group have similar or different characteristics from the overall fashion market?

Demographic information can also be important to fashion consumers themselves. Consumers can benefit from understanding the characteristics they share with others and, thus, the consumer groups within which they find themselves. A consumer might use demographics to answer questions such as:

- Are there significant numbers of people in my ethnic group, my size, or my age group to warrant a target segment for a specific retailer?
- What are the clothing trends for consumers in my occupational group and at my income level?
- Are consumers with similar demographics to mine increasing or decreasing in my geographic area?

The answers to these questions will guide consumers on the availability or absence of clothing at local retailers. If a consumer is in a minor demographic group—having characteristics far different from the majority of consumers—he or she may find limited choices at local stores and need to seek alternative purchasing venues such as catalogs or the Internet (see Chapter 15).

This chapter describes important demographic trends and predictable changes in these trends. It also explains the opportunities and challenges for the apparel industry as a result of these trends and changes.

Demographics

Demographics are statistical studies of measurable population characteristics such as birth rate, age distribution, and income (Frings, 2002).

What merchandise assortments will consumers see in the market? What kind of choices will be available? Much depends on the response of fashion professionals to the analysis of demographic trends. This section delineates briefly the most significant consumer demographics for the fashion industry. Examples of industry responses to these trends are given.

Population Changes

The U.S. population numbers 281.5 million, a figure that is predicted to remain fairly stable largely as a result of stable population growth—a trend since the 1970s. In addition, even though the numbers of families with children has risen, the size of the average family has declined (U.S. Department of Commerce, 2000).

The impact on the apparel industry of stable U.S. population growth and more but smaller families is that the total U.S. fashion industry will remain stable, mirroring the stable population growth. Many companies, not content with steady growth, are choosing to expand abroad (Seckler, 1998). In addition, the childrenswear industry is growing in order to supply clothing for the larger number of children. Since the trend toward smaller families is coupled with the trend of two-income families, many parents have more money to spend on their children, which has created a market for upscale children's apparel.

Income

Income change is another important demographic of consumers. In September 2000, the Census Bureau reported that the median income of a typical U.S. household was $40,816, of which 6 percent was spent on apparel. Throughout the 1990s income levels continued to rise. For example, 22 percent of households were earning $75,000 or more, and this percentage continues to rise (Profile of selected economic characteristics, 2000). On the other end of the income spectrum are households known as the downscale market.

> The **downscale market** is comprised of households with lower incomes, such as the 29.6 percent with annual incomes of $25,000 or less a year (Profile of selected economic characteristics, 2000).

The importance of income levels varies with product category. Although this information is not of great importance to sellers of basic fashion products such as socks or men's briefs, for example, it is quite important to sellers of higher priced apparel. The demographic trends regarding income implies that although a demand for exclusive merchandise exists, the demand for moderate and lower priced merchandise is much greater. In addition, the sheer numbers of downscale consumer households warrant the need for retailers to stock budget clothing.

Ethnicity

The Immigration and Naturalization Service estimates immigration to the United States at approximately 700,000 per year. The minority ethnic groups are the major growth segments in the United States, increasing much faster than whites. In the late

1990s, minorities were growing most rapidly in the suburbs rather than in the central cities. Thus, suburban neighborhoods in the future will be predominantly segregated by income level rather than race (Russell and Lane, 2002).

The main racial groups percentages by 2025 in the United States are projected to be:

62.5 percent White, Non-Hispanic
17.6 percent Hispanic
13 percent African American
7.1 percent Other (Pride and Ferrell, 2000)

Fashion producers and retailers are slowly realizing that they need to make products that appeal to these groups. For example, an increase in petite-sized clothing would meet the needs of the Asian population.

Education

Each year the average amount of education an American receives increases. Young workers are more educated now than at any time in the past: 81.6 percent of those 25 and older have completed high school and 25.1 percent have bachelor's degrees or better (Profile of selected economic characteristics, 2000). More educated consumers are more global minded, receptive to imports, discerning, and demanding (Daneshvary and Schwer, 2001) which stimulates fashion producers to provide high-quality products. To meet this demand, fashion manufacturers have hired special quality control workers to ensure a low percentage of manufacturing errors. In addition, there is a significant correlation between education and high salaries. The Commerce Department's Census Bureau reports that adults 18 and over with a bachelor's degree earn an average of $40,478 a year, while those with a high school diploma earn $22,895; those without a high school diploma earn $16,124, and those with advanced degrees earned $63,229 (Day, 1998).

Work Status

Sixty-three percent of the population 16 years of age and older is employed (56.8 percent of the women in the age bracket and 70.3 percent of the men) (Current population survey, 2001). There have been two major trends in employment: (1) a shift from blue-collar to white-collar jobs, and (2) increasing numbers of women in the workplace. These two trends have several implications for the apparel industry. First is the demand for career apparel for men and women. Up until the mid-1990s, this meant an increase in tailored garments. The trend toward more casual career apparel shifted the demand to more casual work apparel into the late 1990s, but began shifting back toward tailored garments in 2001.

Clothing expenditures typically represent between 6 and 8 percent of a consumer's disposable income; thus, a consumer with higher pay will have more money for clothing. Currently 33.8 percent of the U.S. workforce is employed in management, professional, and related occupations, which pay higher salaries, thus they have increased purchasing power. The percentage of that purchasing power used on apparel has increased (Profile of selected economic characteristics, 2000).

Geographic Location

Half of the U.S. population lives in ten states. The census data as stated in Russell and Lane (2002) projects that by 2026, California, Texas, and Florida will account for 45 percent of the U.S. net population as people choose to move to warmer climates. The majority of immigrants will settle in these states as well. In addition, rural areas and central cities have long been losing population as individuals move to suburban areas.

Individual fashion needs to change as people change locale. Obviously those living in southern and southwestern states need more lightweight clothing than those living in the Northeast. Retailers track population shifts not only to guide their assortment selection but also to guide new store locations when considering expansion.

Niche Markets

A **niche market** is a small group of customers with characteristics and wants that differ from the mass market (Donnellan, 2002).

Retailers combine demographic data with psychographic data to profile consumers, thus creating smaller submarkets, called niches.

Heterogeneous characteristics are dissimilar traits.

Homogeneous characteristics are similar traits.

Apparel manufacturers and retailers constantly look for areas in which they can be strong where their competitors are weak. They divide the larger heterogeneous market (Figure 1.2) into smaller subgroups, which are defined by homogeneous

Figure 1.2 *Heterogeneous markets have dissimilar characteristics. (Courtesy [left] Axis Clothing Corporation; [right] Skechers U.S.A.)*

Figure 1.3 *Homogeneous markets have similar characteristics.* *(Courtesy Axis Clothing Corporation)*

(Figure 1.3) characteristics such as fashion preferences, shopping habits, and purchasing behavior. Finding a small, untapped portion of the market—a niche or a submarket—becomes the goal (Activity 1.1). Fashion professionals combine the demographic data just discussed with the psychographic data discussed in Chapter 4 to divide these groups (Figure 1.4).

> **Psychographics** describe a market based on factors such as attitudes, opinions, interests, perceptions, and lifestyles of the consumers comprising that market (Russell and Lane, 2002).

The following are several key niche markets retailers are identifying as they move into the next century.

Ethnic Niches

Fashion companies have started to respond to the increase in minorities by producing products specially geared toward them. To meet the needs of African Americans

	Demographics	Psychographics
Consumer A	Age 21; female; African American; $35,000 income; single	Republican; Olympic volunteer; active in church; marathon runner; avid reader; travels frequently
Consumer B	Age 21; female; African American; $35,000 income; single	Democrat; volunteers in a homeless shelter; dates frequently; enjoys clubs; shops often

Figure 1.4 Demographic/psychographic profiles show demographic similarities & psychographic dissimilarities.

who "love to shop" more than any other demographic group, Sears introduced a line specifically designed for them called Mosaic. J. C. Penney also has a line targeted toward African Americans designed by Mark Hankins.

Even some shopping centers have taken on an ethnic flavor, such as Little Saigon in Garden Grove, California, or Milpitas, an Asian-inspired center in San Jose, California (Donnellan, 2002).

Understanding the needs of ethnic groups is of considerable economic importance to the fashion industry. Ethnic spending power hit $600 billion in 2000 (Pride and Ferrell, 2000). The biggest spenders on apparel are African American women. Nearly a third of this group spends more than $200 per month on clothing, yielding $7.6 billion in sales of apparel and accessories in 2000 alone ("Color My World," 2001).

In addition, as a result of researchers finding that generic advertising falls short because some minority groups prefer ads in their own language (Russell and Lane, 2002), fashion companies have made advertising language changes. For example, to reach Latino customers, Sears created a Spanish language advertising campaign (Donnellan, 2002).

Retailers realize that one of the main distinguishing elements of the ethnic market is brand loyalty. Once loyal, ethnic groups tend to maintain this loyalty over a lifetime; therefore, fashion companies seek to develop their loyalty early (Nicifora, 1998).

Large Sizes

Sixty-eight percent of Americans are overweight. This trend coincides with the aging of the consumer base. Manufacturers have responded by adjusting their sizing upward (see Case Study 1.1). For example, Haggar changed its pant core sizes for men's pant waists from 32–40 to 32–44 (Frings, 2002).

Currently, 50 percent of U.S. women wear a size 14 or larger (Nellis, 2001). Consequently many major department and specialty stores have added departments catering to women sized 14–26 (James, 2001), many of whom are professional businesswomen. Liz Claiborne responded to the large-size professional woman by introducing the Elizabeth line. Understanding consumer reluctance to admit a weight gain and purchase larger-sized clothing, makers of higher-priced women's garments

ACTIVITY 1.1 Target Markets

Consider the following potential consumer markets:

- Mothers with young children
- Newly marrieds
- Weight watchers
- Tourists
- Retirees
- Single parents
- Sports fans
- Singles
- College students
- Physically fit minded

Suppose you are opening a fashion retail store. Pick three of these potential consumer markets as your target group. For each group, identify the demographic and psychographic data that would be of interest to you as a fashion retailer. How would each best be reached for promotions? What would be the characteristics of the merchandise your store would carry and the services you would offer?

ACTIVITY 1.2 Using Demographics and Psychographics

Place yourself in the role of a fashion designer for BAM women's moderately priced careerwear. Answer the following questions:

- What kinds of demographic and psychographic information might you need about your potential customers in order to design for and market to them?
- What kinds of designs will you produce based on this information?
- How will you market to these consumers?

often size their garments a size smaller—called **psycho-sizing.** This gives a consumer the illusion of still wearing a size 6 when she actually has grown into a size 8.

Working Women

Today, of the females aged 20 to 54, more than 70 percent work outside the home. These women spend 35 percent more on apparel than nonworking women, so they are of great interest to retailers and manufacturers ("Career Smart," undated). Time is an important commodity for these women, who often juggle family and career responsibilities. Over the years, this consumer has found less pleasure in shopping, spent less time on each trip, and made fewer trips. This trend has resulted in the growth of catalog shopping and gives hope to Internet retailers (Activity 1.2.)

CASE STUDY 1.1
Niche Marketing

At the end of the nineteenth century, Lane Bryant entered the plus-size market. This was a time when large women had few options in clothing. Today, the 65 million American women who wear size 12 or above create a $30 billion dollar apparel market. Most department stores now carry plus sizes. Many manufacturers now produce fashions specifically designed for larger sizes rather than simply resizing versions of their missy line. Consider the following examples of those getting aboard the plus-size niche:

- Talbot's has opened stores catering only to the plus-size market.
- Hot Topic, one of the fastest growing trendy junior specialty stores, responded to their number one customer request—to offer plus sizes—by opening a new retail concept store called Torrid, which carries junior plus-size apparel.
- Ann Taylor is testing larger sizes on its website.
- Tommy Hilfiger jumped into the plus size market in the fall of 2001.
- Liz Claiborne and Lands' End jointly created Plussize.com, a virtual shopping mall for plus sizes that features apparel choices for various national retailers.
- Television star Delta Burke launched her own clothing line called RealSize and features her online catalog (www.realsize.com).

Observe advertisements on television and in magazines. Do you see many advertisements that feature large-sized apparel? What do you think would be the best way to reach this consumer? What would be your predictions of whether this trend will continue?

Adapted from Darryl James. (2001, June 22–28). Plus sizes: Upsized or fashion forward? *California Apparel News,* p. 10.

Age

Age is one of the most important demographic characteristics, as people who fall within similar age groups tend to have similar buying characteristics. The median age of the U.S. population has increased from 28.1 in 1970 to 35.3 in 2000 (U.S. Department of Commerce, 2001). This trend has been called the **Graying of America.** All age groups under 55 are expected to decrease, and all groups 55 and older are predicted to increase, with the average age being 38 by 2005. Currently people age 50 and older control $2 trillion in income, account for 80 percent of leisure travel, and spend more on jewelry and cosmetics than other age groups (Russell and Lane, 2002). By 2010 those over 50 will represent 32 percent of the population and 36 percent of the population by 2025 (Pride and Ferrell, 2000). See Figure 1.5 for a breakdown of consumer age groups in the year 2000.

Generational Marketing

Generational marketing appeals to segmented age groups of customers (Johnson and Moore, 1998).

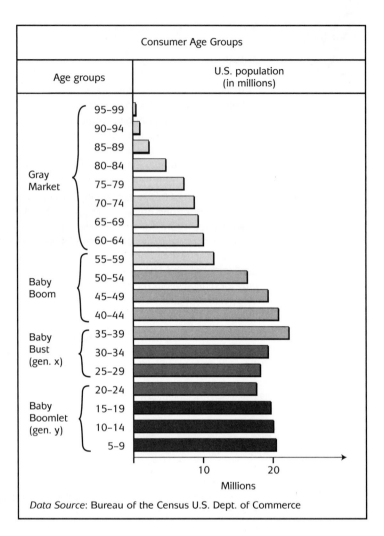

Figure 1.5 U.S. consumer age groups.

A specific category of niche marketing based on age segmentation is called generational marketing. Using birth year as a starting point, pertinent demographic characteristics have been combined to describe each major generation since 1912 (Figure 1.6). The following section describes each generation and cites several fashion industry implications.

Gray Market

The **gray market** includes consumers born between 1912 and 1945.

Up until the mid-1990s the gray market had been largely ignored by designers, retailers, and the media; however, this group is the second fastest growing age segment and has the most money to spend. Consumers born before 1945 control a large

Generation	Characteristics	Impact on Clothing
Gray market (born before 1946) 21.3%	• Traditional American values • Puritan work ethic • Self-sacrifice • Teamwork • Conformity for the common good	• Value and quality oriented • Functionality important • Seek national brands and American made products; forgo designer labels
Baby boomers 1946–1964 28.2%	• Self-assured • Self-sacrifice • Better educated than any generation • Think they're more sophisticated • Think they know more • Self-conscious about fixing things and changing the world	• Demand products geared toward their lifestyle; manufacturers respond because of the size of this segment (e.g., Dockers) • Brand names important • Youngest tend toward more trendy styles
Generation X 1965–1979 16.4%	• Overeducated slackers • Self-reliant • Entrepreneurial • Techno-focused • Socially tolerant • Cautious about marriage • Media-savvy	• Demand their own look • Reject designer label and brand names • Antifashion • Low consumer confidence
Generation Y 1980–1994 25.8%	• Outspend all previous generations • Techno-savvy • Coddled • Optimistic • Prone to abrupt shifts in taste	• Enormous impact on fashion • Demand challenging clothing (e.g., No Fear) • Brand conscious
Generation Z/ Millennials 1995– 8.3%	• Defy easy classification • Wide mix of backgrounds	Too early to predict

Figure 1.6 Characteristics of generations and the impact on clothing choice.

portion of both financial assets and discretionary income in the United States. Ken Dychtwald, president of Age Wave Research Company, reported, in the mid-1990s, "They tend to feel 10–15 years younger than their actual age, but they've been marketed to as if they were 10–15 years older" (Dychtwald, 1994, p. 18). Advertisers have begun to change as they have seen that women over 55 alone spent more than $21 billion on clothing in 2001 (Russell and Lane, 2002).

Baby Boomers

The **baby boomers** are the segment of the U.S. market who were born between 1946 and 1964. This group comprises 30 percent of the U.S. population and spends heavily.

The primary demographic spending group in America is the baby boomers, numbering 76 million. Baby boomers account for 50 percent of discretionary spending power, which is approximately $13,286 per household or 2.5 times the average per capita ("Boomer Facts & Figures," 2000). Baby boomers report that they are satisfied with their lives, have traditional social values, and have money to spend, as income generally peaks between ages 45 and 54.

Characterized as better educated, marrying less and later, divorcing more, having fewer children (Russell and Lane, 2002), and working hard to surpass their parents, this generation's attitude is "spend, borrow, and spend some more." Also, this group tends to identify more with younger people than with older people. They are mature but tend to hide their age (Brookman, 1998).

The baby boom generation is of extreme importance to retailers. Women ages 37–55 are the most powerful of all consumer markets ("The Clout," 1998). The fashion industry has created specific lines for them. Because baby boomers have had a major influence on the apparel market in every decade they have passed through, they are used to having the apparel industry adjust to them. In the 1960s, the vast number of youth-aged boomers gave impetus to the origin of the junior market. In the 1970s, this generation caused the creation of the upscale contemporary look. In the 1980s, manufacturers created bridge lines of sportswear (priced between designer and moderate lines) for these individuals (Harnett, 1998).

Specifically aimed toward baby boomer men, Levi's introduced Dockers in 1986 to accommodate expanding boomer waistlines. Dockers were so instantly successful that when Levi's re-engineering efforts restructured the company, only two divisions were created: jeans and Dockers. In addition, Ellen Tracey created a line of bridge careerwear for female, career baby boomers. Also, Revlon created Eterna 27 cosmetics specifically targeted to the woman over 50.

Now that the oldest boomers are in their 50s, fashion industry executives say they must market to them in a way that transcends age by "portraying products as fitting a certain lifestyle or state of mind. Fifty once was regarded as over the hill but now is . . . regarded . . . as the peak age of professional and personal lives" (Monget, 1998, p. 4).

The younger portion of this generation (born between 1955 and 1964) is more hip and chooses brands such as Tommy Hilfiger and BCBG (Johnson and Moore, 1998). A quarter of this younger group is single, which tends to make a steady market for clothing for social events. Many in this group have postponed parenthood

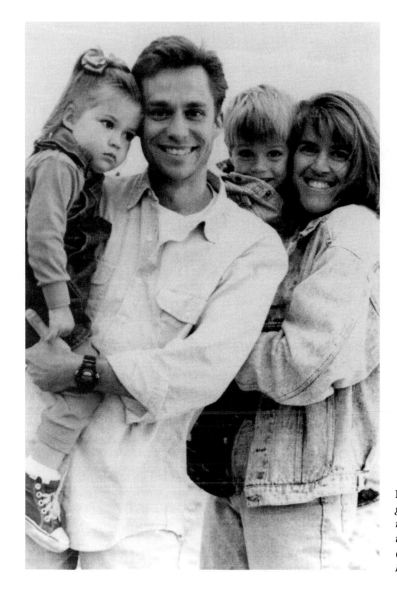

Figure 1.7 *The older group of Generation X is married and has moved into parenthood. (Courtesy Jane Nicklas Photography)*

until a later age and higher earning status, which creates a lucrative market for both childrenswear and children's products.

Generation X or Baby Busters

Generation X consumers, also known as baby busters, are a relatively smaller portion of the market (2.2 million or 9 percent) born between 1965 and 1979.

Many of the older portion of Generation X have married and are parents (Figure 1.7). The younger portion of this group is often characterized as individualists, yet

Figure 1.8 *This retailer targets Generation X with its logo.*

they have attracted much media attention with fashion antistatement looks such as retro, grunge, and punk.

Turned off by brand names and having low consumer confidence, this group is influenced by rock stars and fashion models. Retailers seek to attract Generation X (Figure 1.8) because of their willingness to spend a large portion of their money on clothing. Wet Seal, a West Coast junior specialty store that targets females from Generation Y, saw an opportunity to target Gen X and opened a new chain of specialty stores named Arden B (Hardesty, 1998). Bob Caplan, director of sales and retail marketing at Levi's, states, "At Levi Strauss & Co., we believe that if you sell and cater to the young you will own the future" (Johnson and Moore, 1998, p. 53).

For a comparison of the shopping habits of females in Generation X and Generation Y, see Figure 1.9.

Generation Y or Baby Boomlet

The **Generation Y** group, or baby boomlet, includes the 30 million consumers born since 1980.

Generation Y has caused great excitement among fashion professionals, especially among producers of junior fashions (Silverman, 1998) (Figure 1.10). Within

Attitudes toward Shopping	Gen X	Gen Y
Positive attitude toward shopping	22%	31%
Time spent when clothing shopping	107 min.	128 min.
Interested in fashion more than comfort	45%	52%
Number of shopping trips per month	2.6	3
Sense of quality	Yes	No
Fashion forward	33%	46%
Spend $1,000–$1,500/year in clothing	15%	15%
Clothing is first priority in spending choices	58%	71%

Figure 1.9 Comparison of female Gen X and Gen Y shopping attitudes. *(Sky's the Limit. 1998, April 16.* Women's Wear Daily, *p. 2; Teens versus twentysomethings. 1998, April 23.* Women's Wear Daily, *p. 2)*

Figure 1.10 *Generation Y has caused great excitement in the fashion industry, especially among manufacturers of junior apparel and accessories. (Courtesy Skechers U.S.A.)*

Figure 1.11 *The youngest members of Generation Y, called tweens, are often children of dual-income families who spend liberally to dress their children. (Courtesy IMP Originals)*

this larger group there are disparate groups: young children (Figure 1.11), pre-teens or **tweens** (Figure 1.12), midteens, and older teens. Companies often try to target a brand to each of these groups. For example, Renaissance Cosmetics starts girls as young as 3 on Tinkerbell cosmetics to satisfy their desire to look like their older sisters ("Stores Sculpt Sections," 1998).

 This group is the most technically advanced of the generations, which is predicted to impact their buying patterns as they grow older. Many consumers in this group have grown up in either a time-stressed dual-career family or a single-parent home. This has resulted in very independent consumers. Not only do they make inde-

Figure 1.12 *"Tweens" enjoy imitating the clothing of older members of Generation Y. (Courtesy Nicole Miller)*

pendent clothing purchase decisions, but 68 percent of the money they spend is their own. Over 2 million of these teens and young adults have full-time jobs; another 4.5 million have part-time jobs (Silverman, 1998). Because of the entertainment orientation of this group, retailers have introduced retail-tainment.

Retail-tainment combines retail and entertainment, specifically to appeal to younger shoppers.

Figure 1.13 *Generation Y likes challenging labels including Quiksilver. (Courtesy Quiksilver)*

ACTIVITY 1.3 Target Customers

Identify the store in which you most frequently shop. Characterize the target market to whom this store is aiming its appeal. Describe the techniques the store is using. How successful are they? What changes would you make?

Gen Y's number one choice for spending their money is on clothing. This group spent $103 billion in 1997 (Silverman, 1998), the majority of it on challenging clothing labels such as No Fear, Bad Boy, Quiksilver, and Stussy (Figure 1.13). This generation is brand-name conscious and has parents who respond positively to their demands (Johnson and Moore, 1998).

Fashion companies have responded to this generation by catering to their needs. Levi Strauss has begun to use some of the members of this generation (often as young as 11 years old) as consultants on trends. JNCO jeans also saw the importance of knowing this customer better and developed a website that surveys this group. As a result they market a super wide legged jeans that is "the antithesis of Levi's," says Bob Sayre, General Merchandise Manager for Men's and Accessories at Pacific Sunwear. "This is the generation that must have their own look" (Sayre, 1998). Gadzooks, a Dallas store chain of 183 stores targeting Generation Y, features trendy items such as nose rings and irreverent T-shirts (Johnson and Moore, 1998) (Activity 1.3).

Tweens is one of the fastest growing demographic groups. They are the younger ages of Generation Y—between ages 4 and 12—and are the new fashion leaders of the youth market. There are currently 2.7 million tweens who spend more than $14 million annually on clothing (Neidler and Figueroa, 2001). For example, the average 10-year-old has $7–14 in weekly discretionary income. Tweens have demanded their own style and resist being called "juniors" (Generation Y, 1999–2001). The Limited responded by opening Limited Too, and Wet Seal opened a new tween store called Zootopia (Neidler and Figueroa, 2001).

The study of generations will continue to pique the interest of fashion professionals who seek to understand consumers more fully. This knowledge will be a key to success in this new millennium.

❧ Summary

Marketers have known the importance of studying consumer demographics since the 1950s. Combined with other segmenting methods such as psychographics, demographic data provide key consumer information enabling retailers to micromarket to various consumer segments. Fashion professionals use demographic and psychographic information to develop, select, and promote apparel products and to understand their customer. In addition, when consumers better understand trends in consumer groups, they can better understand the presence or absence of product offerings.

◥ Key Terms and Concepts

Baby boomers
Demographics
Downscale market
Generation X
Generation Y
Generational marketing
Gray market
Graying of America

Heterogeneous characteristics
Homogeneous characteristics
Niche marketing
Psychographics
Psycho-sizing
Retail-tainment
Tweens

◥ References

Boomer facts & figures. (2000, January 7). *Houston Business Journal.*

Brookman, F. (1998, June). Aging boomers, booming sales. *Women's Wear Daily,* p. 8.

Career Smart. (Undated). NPD Special Industry Services: Dupont brochure, p. 3.

The clout of baby boomers. (1998, August 6). *Women's Wear Daily,* p. 39.

Color my world. (2001, May 31). *Women's Wear Daily,* p. 2.

Current population survey. (2001). *Bureau of Labor Statistics,* Washington, DC: U.S. Department of Labor.

Daneshvary, R., and Schwer, R. (2001). The influence of socioeconomic factors on the perceived importance of buying a garment made in the USA. *Journal of Fashion Marketing and Management,* 5, 10–27.

Day, J. (1998, December 10). Higher education means more money. Washington, DC: U.S. Census Bureau Public Information Office.

Donnellan, J. (2002). *Merchandise buying and management.* New York: Fairchild.

Dychtwald, K. (1994, June 15). Senior market ripe for action. *Women's Wear Daily,* p. 18.

Frings, G. S. (2002). *Fashion: From concept to consumer.* Upper Saddle River, NJ: Prentice Hall.

Generation Y. (1999–2001). The Consumer Trends Institute, LLC. http://www.trendinstitute.com/ geny.htm.

Hardesty, G. (1998, June 10). Wet Seal makes a splash. *Orange County Register,* p. B1.

Harnett, M. (1998, February 23). The "gold" in oldies is yet to come. *Discount Store News,* p. 17.

James, D. (2001, June 22–28). Plus sizes: Upsized or fashion forward. *California Apparel News,* p. 10.

Johnson, M. J., and Moore, E. C. (1998). *So you want to work in the fashion business?* Upper Saddle River, NJ: Prentice Hall.

Monget, K. (1998, June 3). Tapping the middle-aged mood. *Women's Wear Daily,* p. 4.

Neidler, A., and Figueroas. (2001, May 4–10). Tweens take off. *California Apparel News,* pp. 1, 8.

Nellis, C. (2001). All about sizes. http://fashion. about.com/library/weekly/aa1221oob.htm.

Nicifora, A. (1998, August 7). Marketing on a shoestring. *Small Business Highlights.* America City Business Journals, Inc.

Pride, W., and Ferrell, O. (2000). *Marketing concepts and strategies.* New York: Houghton Mifflin.

Profile of selected economic characteristics: 2000. *Census 2000: Supplementary Survey Summary Tables.* Washington, DC: U.S. Bureau of Census.

Russell, J., and Lane, W. R. (2002). *Kleppner's advertising procedure.* Upper Saddle River, NJ: Prentice Hall.

Sayre, B. (1998, June 6). *General Merchandise Manager for Pacific*. Interview.

Seckler, V. (1998, June 15). IRMA study: Hunt for new profits. *Women's Wear Daily,* p. 18.

Silverman, D. (1998, May 11). Malls have that teen spirit again. *Daily News Record,* pp. 8, 9.

Stores sculpt sections. (1998, April). *Women's Wear Daily,* p. 10.

U.S. Department of Commerce, Economics and Statistics Division, Bureau of Census. (2000, December). *Statistical abstracts of the U.S.* Washington, DC.

Walz, B. (1978). *The fashion makers.* New York: Random House, p. 47.

Chapter 2

Fashion Industry Influences

Objectives

- Trace the historical development of fashion.
- Define basic fashion terminology.
- Highlight the contributions of selected international designers to the fashion industry.
- Discuss the main components of the contemporary fashion industry and its influence on consumers' clothing purchase decisions.

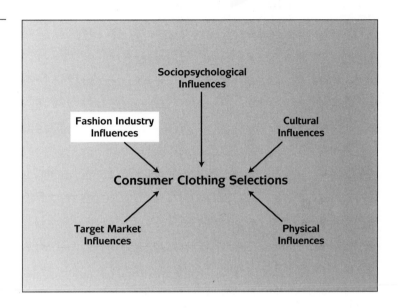

Sociopsychological Influences

Fashion Industry Influences

Cultural Influences

Consumer Clothing Selections

Target Market Influences

Physical Influences

Fashion, in its broadest definition, is a general social phenomenon that affects and shapes society as a whole.

The concept of fashion has a strange fascination: It can be habit forming. Basic to comprehending the idea of fashion is an academic understanding of all that it encompasses and the impact that fashion has exerted on the world. The study of fashion is an outstanding example of interdisciplinary collaboration. Economics, psychology, sociology, social psychology, anthropology, and ethnology (animal and human) converge in the study of fashion.

Fashion is a universal, formative principle in civilization and is not limited to clothing or personal adornment. Clothing can be considered an active expression of the fashion of a particular period, but clothing is only a small part of the entire fashion concept.

Each period of civilization has exhibited the force of fashion. Each group of people developed a lifestyle that was suitable to their particular needs. They established patterns of family, housing, eating, speaking, working, playing, governing, and

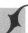

ACTIVITY 2.1 Fashion Trends

Examples of fashion trends can be observed by watching television, films, or people. Select several observation activities and give examples of fashion in:

- Speech
- Music
- Dance
- Manners
- Morals
- Body movement
- Architecture
- Cars
- Furniture
- Clothing

Contrast these findings with the trends from another historical period.

dressing. These patterns were interrelational and, combined, depicted the fashion of that period.

For example, historical drama (theater, movies, television) gives insight into the fashion of the period portrayed. Historical novels, music, dance, concerts, and museum exhibits can help recreate the flavor of past fashion eras. Study of popular design (form, shape, space, line, color, and texture) of any fashion period reveals fascinating relationships between clothing and other characteristics of the period (Activity 2.1).

For instance, the Greeks of the Archaic and later periods wore complicated draped garments that played an important role in Greek art and are found duplicated in Greek architecture. Gothic clothing and decoration were based on doting attention to delicate detail as revealed in the period's tapestries and jewelry. The length of Gothic clothing corresponds in form and spirit to the heights of Gothic architecture (Figure 2.1). The spire of the steeple suggested the hemline; the pointed arches of doors and windows were echoed in the pointed toes of shoes and pointed sleeves; the slim, soaring rib of the Gothic cathedral found a counterpart in the narrow, tightly covered human body; and the magnificent beauty of stained-glass windows compared to the finely set Gothic jewelry.

Likewise, in the Renaissance period clothing was designed to broaden the body. The wide, rectangular necklines, padded shoulders with detachable sleeves, and bulky shapes of short cloaks echoed the massive forms of Renaissance architecture (Konig, 1973) (Figure 2.2).

Similar interrelationships also can be found in contemporary fashion. The efficiency of modern buildings, transportation, communication, entertainment, and language is repeated in many of the sleek body-revealing garments that are fashionable. Most modern clothing is easy to get into, easy to care for, and permits comfortable, natural body movement.

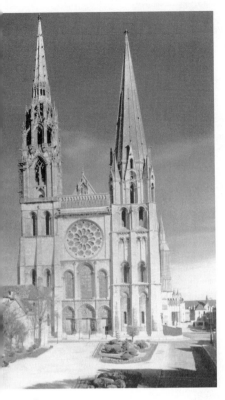

a.

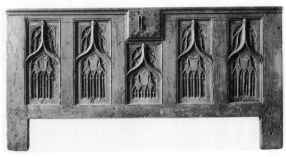

c.

Figure 2.1 *Each period of history has exhibited a trend in fashion. Interesting relationships can be found among the fashionable patterns of clothing, architecture, and furniture, and also among patterns found in its literature, work, play, and dance. (a) Chartres Cathedral is a good illustration of fifteenth-century architecture. Note the long, narrow, vertical shapes and the lines that form the doors, windows, and spires (Religious News Service Photo). (b) A fifteenth-century manuscript illustration vividly portrays the clothing of the men and women of this period. The overall silhouette was made up of elongated vertical lines (Courtesy Bibliotheque Nationale, Paris). (c) This fifteenth-century chest has space divisions that respond to the configuration of the spires and the pointed arches of the doors and windows of the cathedral (Courtesy The Metropolitan Museum of Art, Rogers Fund, 1905). (d) The vertical lines in this fifteenth-century chair form the pointed arch, a distinctive decorative feature characteristic of this period (Courtesy The Metropolitan Museum of Art, Rogers Fund, 1907). (e) Portrait of a knight and his lady, early fifteenth-century, as depicted on their tomb, giving us a picture of the clothing fashions of the period. Note characteristics that relate to the furnishings and architecture illustrated (Courtesy Victoria and Albert Museum. Copyright of The Crown).*

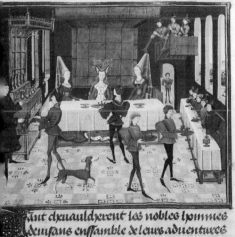

b.

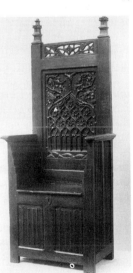

d.

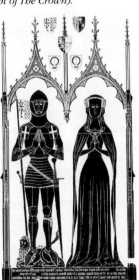

e.

a.

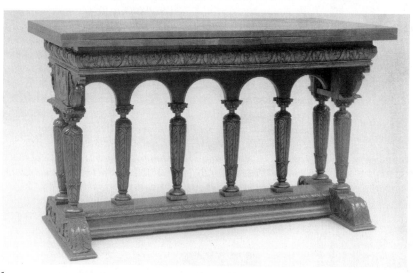

b.

Figure 2.2 *In the sixteenth century, the Renaissance brought many fashion modifications. Lines and shapes changed from predominantly vertical to horizontal. (a) The interior of a sixteenth-century Dutch room shows the use of predominantly horizontal lines. (Courtesy the New York Public Library). Note the flattened arch at the main entrances. (Courtesy the New York Public Library). (b) This sixteenth-century French table has a sturdy appearing base, producing an overall broad horizontal appearance (Courtesy The Metropolitan Museum of Art, Bequest of Michael Friedsarn, 1931. The Friedsarn Collection). (c) In this early sixteenth-century Flemish building, the windows are nearly square in shape. (d) This Renaissance chair has thick, solid-looking structural shapes. The decorative features at the chair back reflect the flattened, rounded arch (Courtesy The Metropolitan Museum of Art, Gift of George Blumenthal, 1941). (e, f) These portraits illustrate the extreme use of horizontal lines popular during the sixteenth century. (e, Courtesy the New York Public Library. f, Courtesy The Metropolitan Museum of Art, Gift of J. P. Morgan, 1911).*

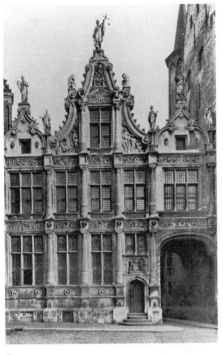

c.

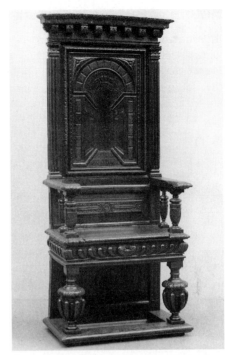

d.

e.

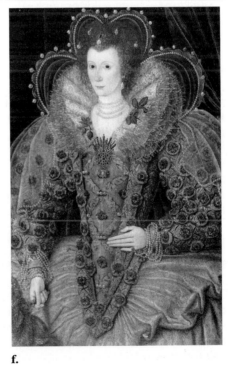

f.

History of Fashion in Clothing

Although the term *fashion* has broader societal meaning, to most consumers fashion is most frequently associated with clothing. A specific fashion is a defined style that is accepted by a large group of people at a particular time (Figure 2.3). To illustrate this definition, consider the following:

- The elaborately trimmed military uniforms worn over corsets by the Western European men during the reign of Napoleon.
- The ante-bellum fashion of bouffant, crinoline-supported hoop skirts popular with American women in the South prior to the Civil War.
- The unisex "flower children" jeans/T-shirt look of the late 1960s.
- The grunge and retro looks of the late 1990s.
- Body piercings and tatoos of the 2000s.

Although these periods are often described by clothing, each of these garment style periods is accompanied by the style prescribed by fashion for the total spectrum of human activity, including all social activities, manners, and morals. In other words, the manner of living, eating, talking, walking, dancing, and behavior of the ante-bellum period was appropriate to that period, as was the style of dress.

The same is true for every other period of human existence. The style of clothing is only one aspect of fashion but a most important one. For fashion historians, it is easier to recall the mode of dress than the code of etiquette of the same period. Clothing styles are easier to preserve and to evaluate.

Fashion is change. For example, the Australian aborigines exhibited how fashion changes. When the group was first found, they were completely naked. Later they began to wear a waist bracelet, or string. Next, cloth was draped from the waist in front and back in the form of a small apron. Sometime later, the apron was drawn between the legs to form a loincloth.

Occasionally a fashion seems to stand still and be a present reminder of a previous historical period (Figure 2.4). Among the North American Indians, for instance, the women of the Navajo and Apache adopted the colorful velvet blouse of the Spaniards and have retained it ever since. Other examples of "fossilized fashions" include many peasant costumes, monks' habits, academic regalia (Figure 2.5), and Spanish bullfighters' dress.

Fashion is said to be the code language of status within a group. Those within the group fully understand the meaning; those outside can only guess. Each stratum of status may have its own variations of fashion, causing subdivisions. For example, on a college campus, striations of status can be found among the students living in fraternities, dormitories, apartments, or with parents. Campus activities, scholastic standing, economic position, employment, ethnic background, and educational major may be other status subdivisions.

Fashion cannot exist in seclusion. It must be displayed on a broad stage, and it needs time to be adapted. Demonstration and acceptance are two essential features of fashion. Only with exposure can fashion stimulate change in dominant consumer behavior patterns and customs and replace them with new ones. Only when a large number of people have been affected by the change will a new fashion be created.

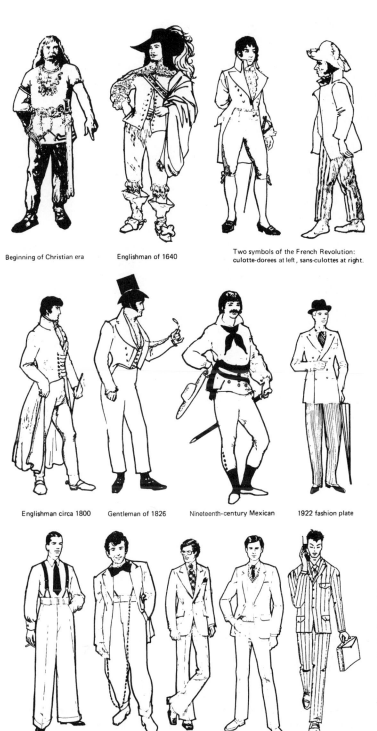

Beginning of Christian era Englishman of 1640

Two symbols of the French Revolution:
culotte-dorees at left, sans-culottes at right.

Englishman circa 1800 Gentleman of 1826 Nineteenth-century Mexican 1922 fashion plate

1930 "bags" 1940's zoot suit 1970 1980 2000

Figure 2.3 *Fashion represents the total style of human activity that is accepted by a large group of people at a specific time. The style of clothing is only one aspect of fashion. These sketches of men's clothing are examples of fashions of different periods.*

Figure 2.4 *This relief, probably of Hermes, was taken from an Athenian temple of c. 520 B.C. The shirt resembles the modern tanktop or undershirt in cut and texture. This is an example of fossilized fashion. (Photo Karl G. Kessler, permission Acropolis Museum, Athens)*

Fashion also must be novel. The desire for change is responsible for continued acceptance of the movement of fashion. At certain periods fashion becomes nostalgic, but it never returns exactly to the earlier periods. Current fashion may have characteristics reminiscent of another time, but closer examination will reveal that the current fashion is new and different.

In short, to many, fashion is responsible for introducing beauty into the lives of the masses. However, within the confines of the regulatory forces of fashion, there is a great freedom for self-expression.

Fashion Terminology

In order to be able to communicate effectively about fashion, the vocabulary and the connotation of the terms applied must be understood. Some definitions and expla-

Figure 2.5 *Some fashions change very little and may seem to be fossilized, such as academic regalia.*

nations help clarify the terms used in this text and should serve as a point of reference when reading the various chapters.

Silhouette is the physical shape or outline of a style.

An example of silhouette is a wedge silhouette, created by a garment with shoulders wider than the waist such as most suit jackets. Alternatively, natural silhouettes reveal a person's body, such as women's swimwear or exercise wear.

Design is the individual interpretation of a garment of the same style (Figure 2.6).

An example of design is the unique characteristics of Calvin Klein jeans as opposed to Levi's jeans.

Style is the distinctive characteristics of a product that distinguish it from other products of the same type.

A style remains a style whether it is currently fashionable or not. Style in dress describes the lines that distinguish one form or shape from another. For example pleated, A-line, and straight are styles of skirts.

The term *style* is often used erroneously to describe an individual's sense of fashion. For example, we often hear comments like, "Hayley has style" or "Zac dresses in a stylish manner." The term is misused because style describes the distinguishing characteristics of a garment.

Classics are styles that endure (Figure 2.7).

Figure 2.6 *Both photos show a button-down Henley shirt, but the design—individual interpretation—is different. Can you identify the design detail differences? (Courtesy Bryan Wisley)*

Classics continue to be accepted by a large segment of the buying public because of their timeless quality and because they continue to meet the lifestyle needs of many (Figure 2.8). Classic clothes are designed with clean, uncluttered, body-conforming lines. Cowboy shirts and boots, pearls, boxer shorts, trench coats, and tuxedos are each considered classics.

Designers often develop classic designs that are the backbone of their collections. Chanel did this with her suits, Balenciaga with the little black dress, Ralph Lauren with his traditional sportswear, and Donna Karan with her interchangeable separates.

Trend is the direction fashion is moving.

Figure 2.7 *Jeans are a style of pants that are considered classics. (Courtesy Peter Shen)*

ACTIVITY 2.2 Fashion Count

1. Determine whether styles are trending forward or backward by doing a fashion count.
2. Decide:
 - What you are going to count, e.g., jean styles, accessories, jacket styles.
 - Where you will count.
 - When you will count.
3. Do at least fifty samples.
4. Repeat at different times and places.
5. Analyze the data and discuss it with the class.

A fashion may be trending forward toward being accepted by a larger group of people (Figure 2.9) or trending backward, which means fewer consumers are wearing the fashion and have moved on to other fashions (Activity 2.2).

Fads are fashions that are short-lived.

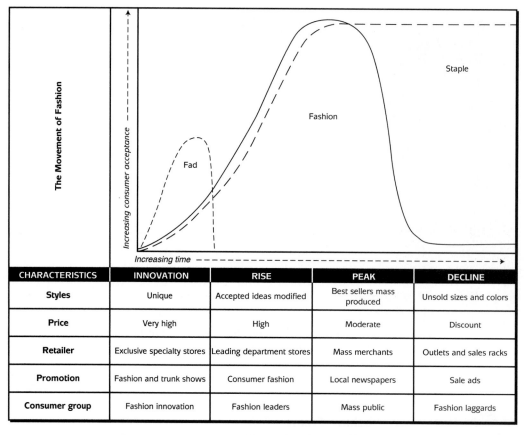

CHARACTERISTICS	INNOVATION	RISE	PEAK	DECLINE
Styles	Unique	Accepted ideas modified	Best sellers mass produced	Unsold sizes and colors
Price	Very high	High	Moderate	Discount
Retailer	Exclusive specialty stores	Leading department stores	Mass merchants	Outlets and sales racks
Promotion	Fashion and trunk shows	Consumer fashion	Local newspapers	Sale ads
Consumer group	Fashion innovation	Fashion leaders	Mass public	Fashion laggards

Figure 2.8 Fashion movement.

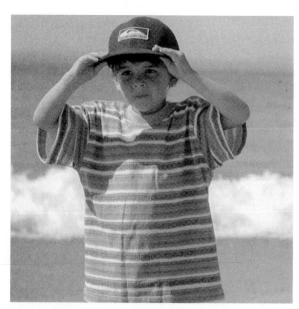

Figure 2.9 *Trends of the twenty-first century include baseball caps and oversized shirts. (Courtesy Quiksilver)*

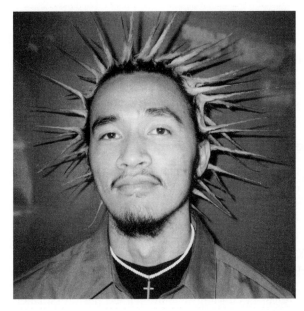

Figure 2.10 *Hair styles give unlimited opportunities to try the latest fad, such as spiked hair.*

Fads usually are quickly accepted by a relatively small group of people (Figure 2.10), and they leave the scene almost as quickly. Fads of recent years include plastic shoes, tattooing, or dying one's hair blue.

Fads may be confined to a particular locale or they may sweep the country, such as nail polish in nontraditional colors like green and black (Activity 2.3).

Taste is a subjective judgment of what we think is appropriate or beautiful. Thus, standards of taste are not universal.

ACTIVITY 2.3 Fashion Examples

Using fashion magazines, newspapers, and the popular press, collect men's, women's, and children's pictures to illustrate each of the following:

- Design
- Style
- Trend
- Fad
- Silhouette
- Classics
- Taste

Taste is a result of individual interpretations of aesthetics, educational and cultural experience, and values and attitudes.

French Fashion Design History

For centuries, clothing was made by hand. Women sewed for their families, and the wealthy class hired others to sew for them. The beginning of a clothing industry occurred in France among the wealthy ruling class.

Origin of French Fashion Design

Since the middle of the seventeenth century, when members of the court of Louis XIV were the tastemakers, France has held a position of fashion leadership. The emphasis placed on clothing by French women has had an important impact on the fashion industry. Madame de Pompadour and Madame du Barry, both mistresses of Louis XV, are credited with setting the pace for court attire by dressing in magnificent clothes. Marie Antoinette symbolized the epitome of fashion impact in her day: She spent most of her time and the fortunes of the king on her personal adornment and introduced many innovations that became fashion. So powerful was Marie Antoinette and so strong was her interest in clothing that she named her dressmaker, Madame Bertin, the Minister of Fashion.

Custom-made luxurious clothing came to symbolize France, eventually leading to the origin of the haute couture fashion business.

Haute Couture

Haute couture garments are unique, custom-made, one-of-a-kind garments fashioned of the most expensive fabrics and trims.

The first haute couture salon was opened in Paris in 1864 by an Englishman, Charles Worth. He designed show pieces for his wife and then escorted her to the most important social functions. In this manner he attracted the attention of Empress Eugenie, wife of Napoleon III, and became her dressmaker. This relationship with the empress secured his position as the "father of the couture."

A **couturier** is a designer who creates his or her own fashion designs in a couture house.

Soon, other couture houses were established, and royalty both supported and encouraged them. A couture house is an establishment devoted to the creation of fashion where the couturier develops his ideas. The couture sells one-of-a-kind clothing to an exclusive clientele.

Most memorable of the early couturieres were Madame Cheruit and Madame Redfern in 1881, Jeanne Lanvin in 1890, and the House of Callot Soeurs in 1895. As the status of royalty changed with political events, the clientele of the couturier expanded to include the very wealthy, the international set, stage and film actresses, and finally society women and wives of political and business leaders. Magazine and

newspaper coverage given to these famous women in their various activities helped to spread the favored styles. Fashion magazines were created with the specific purpose of presenting fashion news to an even wider public. Fashions were copied by home seamstresses, which led to the development of the pattern industry.

Chambre Syndicale

Chambre Syndicale de la Couture Parisienne is a trade association, founded in 1868, to protect French designers.

The general function of the Chambre Syndicale is to serve its membership in all branches of fashion. It acts as adviser and counselor in such matters as interpretation of laws and taxes, employment relationships, and business management. It coordinates the dates for showing each designer's collection and offers protection from knockoff companies. A series of identifying photographs of each design is registered with the Chambre Syndicale so that any design pirating can be prosecuted. The Chambre Syndicale also conducts a school to train personnel for the needle trades, thus assuring a continued supply of these vital workers.

French National Support

France, and particularly Paris, continues to play a major role in the fashion world. Often called the Fashion Capital of the World, France continues to foster a climate and an atmosphere that encourages creativity and inspiration. Paris still serves as a meeting ground for all of the arts. The architecture, parks, monuments, and the very layout of the city present unequaled expressions of beauty along the winding river Seine.

Fashion is regarded as a national industry in France, and as such it is fostered, protected, and financed by its government. The artists of fashion design find inspiration in the priceless collections of art found in the hundreds of museums. In 1986 the Musee des Arts de la Mode became the national French museum of fashion. It combines two separate costume collections: the Musee des Arts Decoratifs, which consists mostly of accessories, textiles, and historical costumes dating back to the eighteenth century, and Union Centrale des Arts Decoratifs, which is strongest in the nineteenth and twentieth centuries and has a rich collection of fashion magazines, photographs, and designer drawings. The museum occupies a nine-floor building in the Louvre complex, at 109 Rue de Rivoli, Paris.

Exhibits present all of the fashion arts including clothes, accessories, jewelry, combs, hair curlers, shoes, mirrors, buttons, canes, handkerchiefs, ribbons, hats, umbrellas, underwear, wigs, handbags, and fans. Also showcased are the people who produced these items and the production process from sketch to completed garment, including sewing, pressing, and photographing.

The French fashion industry is supported by devoted and skilled dressmakers. Dressmaking is a most honorable profession in France; legions of well-trained seamstresses are available to execute a designer's work. A great spirit of cooperation exists among the allied trades; for example, buttonmakers will provide the exact fastener that the designer requests or needs. Entire cities such as Alencon, Chantilly, Valenciennes, and Calais exist to support the fashion industry with their exquisite laces and trims.

The various French textile manufacturers cooperate by providing fabrics to the designer free of charge for the first model. The silk and textiles industry has received financial assistance from the French government since the fifteenth century. Because of this subsidy, production continues, and the beautiful cottons, lovely silks, and fine wools of France are known and treasured throughout the world. For example, Toile de Jouy, the printed fabric made in the town of Jouy, was developed by an engraver-designer named Oberkampf during the time of Napoleon. Oberkampf was awarded the French Legion of Honor for his contribution to the French textile industry.

Twentieth-Century French Couturiers

The couture industry in Paris has long been a vital part of the French economy. "Fashion is a very important economic sector for our country, and couture is the flagship of French fashion and the radiance of France," said Dominique Straus-Kahn, the former French minister of industry ("Couture Rule," 1992, p. 33). The following are profiles of a few of the French designers who have made this true.

Poiret

Designs by Paul Poiret (1879–1943) released women from the confines of corsets and allowed them to breath freely (Figure 2.11a). He went on to introduce culottes and a riding skirt, which were revolutionary styles for women. He was the first couturier to create a perfume.

Vionnet

In 1914, Madeleine Vionnet opened her couture house, which was soon closed by World War I. She reopened in 1919 and made tremendous contributions to fashion. Vionnet was art nouveau before there was such a period. Her sketches and designs are collectors' items of this intriguing art form. She was the first to design asymmetrical necklines, skirts with handkerchief points, dresses to be worn without underwear, and costumes with the coat lining and dress fabric the same. Her greatest innovation was the use of bias: No one had used the bias cut before Vionnet.

Chanel

In 1918, Gabrielle "Coco" Chanel established her house, and her designs and innovations have been dynamic forces in fashion ever since. "I used my talent as one uses explosives," said Chanel. (Benaim, 2001). Her designs have since become classics.

In 1919, Chanel was the first to use wool knits in suits and coats; until that time this fabric had been used only for underwear. The popularity of wool knits today illustrates Chanel's farsighted approach to fashion. The chemise dress, featured in her 1924 collection, became fashionable at all social levels—so much so that it could be regarded as the "uniform of the day." Chanel always showed a great understanding of fabric and fit.

Her garments seem so simple in design, yet they use fabric to its best advantage. A Chanel design is reputed to be the most comfortable of all clothes to wear. The Chanel Suit is a common fashion term used to describe any suit with a collarless

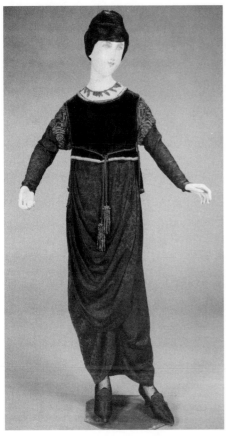
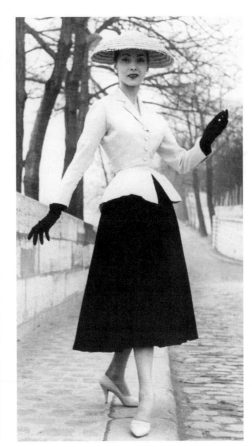

a. b.

Figure 2.11 *Paul Poiret was a French designer who was first responsible for the change in women's dress in the twentieth century. He did away with the corset, relaxed the waistline, and freed the body from clothing constrictions of almost a hundred years. The dress (a) shows oriental influence. (Courtesy Los Angeles County Museum of Art) (b) Christian Dior's New Look. Presented immediately after World War II, it is rated the fashion coup of all time. (Courtesy Christian Dior)*

cardigan jacket. Her perfume, Chanel No. 5 (named for her favorite number), is one of the best known fragrances throughout the world.

Because of Chanel's love of jewelry, a whole new concept of jewelry evolved: costume jewelry. Chanel loved extravagant ropes of pearls; large, bright pins and bracelets; and colorful earrings, but until she featured these pieces in her 1920 collection, costume jewelry was not accepted socially. Before 1920, the only kind of jewelry regarded as proper was made of precious metals and stones. Chanel's penchant for jewelry gave consumers the wide variety of costume jewelry enjoyed today.

Chanel died in 1971. Since 1983 her name has been carried on by Karl Lagerfeld (Frings, 2002).

Schiaparelli

Elsa Schiaparelli (1890–1973) entered the fashion world out of economic necessity. She had many wealthy, socialite friends to whom she sold her latest designs. Her first effort was a trimmed cardigan sweater that now is regarded as a classic. Her feeling for design in some ways is comparable to Chanel's, because she stressed comfort and movement in her clothing.

Among her contributions to fashion were shoulder emphasis, use of scarves as accessories, use of synthetic fabrics, chic tailored evening dresses, and a fashion color called "shocking pink." Schiaparelli is also credited with removing class distinction from clothing through simplicity of designs that were suitable for mass production.

Dior

After World War II, Christian Dior created the fashion coup to date by introducing the New Look. Skirts plunged toward the ankles, and the natural shoulder and the nipped-in waist displayed feminine curves in a manner that delighted both sexes (Figure 2.11b). The lifting of rationing and wartime restrictions plus the mood of the times made this phenomenon of fashion possible. Within four years the New Look had swept the fashion world. Every woman with the ability and means to do so had completely replaced her wardrobe—if not with Paris originals then with mass-produced copies or home-crafted creations.

The New Look was instrumental in revitalizing French couture. The houses of Balenciaga, Givenchy, La Roche, and Chanel flourished. New couturiers arrived, including Fath, Cardin, Balmain, St. Laurent, Courreges, Bohan, Valentino, and Ungaro.

Saint Laurent

Yves Saint Laurent won his first prize in fashion at the age of 17. He was hired at 19 to work for Dior and became top designer at the House of Dior following Dior's death. Saint Laurent opened his own couture house in 1962 and by the age of 37 was considered the king of fashion. He understood women, designing simple, slightly masculine, wearable clothing in luxurious fabrics. He was the only couturier to be honored with a 25-year retrospective of his work at the Metropolitan Museum of Art (Stegemeyer, 1996).

Courreges

A strong statement was made by Andres Courreges in the early 1960s. His engineered garments—miniskirts and short A-line dresses—picked up the mod look of London kids.

Gaultier

This French designer popularized androgynous clothing (Figure 2.12), which has the characteristics of both male and female. Jean Paul Gaultier dresses men in sarongs or trouser skirts and women in layered vests and jackets. Popular with a younger crowd, his designs often mock traditional apparel.

Some of the new novice couturiers to watch are Adelene Andre, Dominque Sirop, Franck Sorbire, and Pascal Humbert.

Figure 2.12 *In 1994, Gaultier introduced an important fashion concept called androgyny. By combining male and female characteristics into one fashion concept, he gives new meaning to the term* cross-dressing.

Emergence of American Fashion Designers

During World War II, France was occupied by Nazi Germany. Hitler understood the economic strength of the French fashion industry and felt it should be a part of post-war Germany. Many of the great houses closed rather than serve Hitler. Fashion designers became national heroes and went underground. Thus, from 1940 to 1945 the French fashion industry ceased to function.

Until this time, American designers were unknowns who designed under a manufacturer's label. However, during World War II American designers moved into prominence in the fashion world. Among these early designers were Claire McCardell (mother of American sportswear), Mainbocher, Howard Greer, and Charles James.

Gilbert Adrian, the designer who probably had the most influence at this time, designed for the film industry when Hollywood was at its zenith. Believed to be one of the world's greatest designers, Adrian did things that had never been done before: For example, he created a new triangular silhouette (Figure 2.13). Because much of his work was done during the fabric rationing of World War II, he often worked with such fabrics as cotton gingham and rayon crepe, yet he created masterpieces for both the screen and his private couture clientele. His influence was felt in every showroom and store in this country; his trim suits and slinky dresses were reproduced in every price bracket. To judge by his imitators, he was the most influential designer in their copybooks. For them he took the place of Paris during the war years. His untimely death in 1959 robbed the world of a great creative talent that was changing the face

Figure 2.13 *Gilbert Adrian established a couture house in Los Angeles in 1939. He designed for many famous Hollywood film stars including Marlene Dietrich (shown here), Joan Crawford, and Katherine Hepburn. The Los Angeles County Museum of Art has featured his work in several exhibits. (Courtesy John Engstead)*

of fashion (Ewing, 1979). Adrian's work was "rediscovered" in the early 1980s when it was very compatible with the wide shoulders and narrow-skirted styles of that time.

Other important pioneer American designers were independent and patterned their business operations after those in Paris. Among the best known are James Galanos, Pauline Trigere, Norman Norell, Bonnie Cashin, Ben Zuckerman, Sidney Wragge, Rudi Gernreich, Halston, Anne Fogarty, Bill Blass, Geoffrey Beene, and Anne Klein.

Probably the greatest American contributions have been in sportswear, particularly swimwear. Standardization of size and the design engineering of American foundation garments have no equals in the world. American textile research and production have made possible whole new concepts for the designer. American mass production has made fashion a commodity available to all, and its innovation of planned obsolescence helps to keep fashion vital, alive, and on the move.

Contemporary Fashion Designers

High fashion refers to unique new garment styles with several identifiable characteristics (Figure 2.14).

The role of high fashion in contemporary times is to inspire fashion change. Thierry Mugler likens couture to a laboratory where a designer's imagination is permitted

Characteristic	Examples
Very expensive	Highest quality and more costly fabric Daytime suit: $9,000–$20,000 Blouse: $2,000–$10,000 Evening gown: $100,000 and up
Special design	250,000 handsewn beads on an evening jacket Handpainted fabric Valentino wedding dress: 40 feet of fabric
Excellent workmanship	Wedding gown: 500 hours Jacket: 130 hours Gown: 300 hours
Custom fitted to the customer	Lacroix jacket: 10 fittings

Figure 2.14 Characteristics of couture garments. (*Adapted from E. Dick. 1998, April. Why $30,000?* Instyle *p. 208; F. Rubenstein. 1998, April. Why does this dress cost $30,000?* Instyle *pp. 195–200.*)

the most freedom (Rubenstein, 1998). When high fashion is introduced, it is extreme sometimes to the point of being startling. This piques interest in the design and the designer but limits the appeal of the garment to those who can and will wear it. High fashion remains high fashion only until the newness wears off. If a high fashion gains acceptance and is mass produced, it then becomes fashion.

To most consumers in the twenty-first century, French couture prices seem out of reach. For the couturier, the costs are high as well. A typical couture collection costs between $500,000 and $4,000,000 to produce and show.

Other changes—lifestyle changes, the rise of a large influential middle class, the mass of youth—have affected French couture. The number of customers has eroded from a high in the 1950s of 15,000 to 2,000 today of whom 60 percent are Americans. Only 200 are regular customers ("What Is Haute Couture?" 2001).

Prêt-à-porter is French for "ready to wear."

Few designers expect to make their fortunes from selling couture gowns. Many of the famous old-name houses have closed. Twenty couture houses remain in Paris (Frings, 2002). To survive, these establishments have had to diversify and change their methods of operation. Most have entered the high-profit market of cosmetics, accessories, perfumes, and **prêt-à-porter** for both men and women. In Paris, the exclusive couture salon upstairs is most often supported by the street-level boutique catering to walk-in customers. Couturier boutiques have been franchised and are found in cities throughout the world.

Many couturiers are in the licensing business. That means that they lend or license their names on a royalty basis to producers who manufacture and market merchandise sold under the designer's name or logo. Pierre Cardin licenses 840 products—everything from packaging for candy to furniture and electronic items. Yves Saint

Figure 2.15 *St. John caters to the successful women's market and specializes in knits and evening wear. (Courtesy St. John)*

Laurent has 200 licenses. The income from these business transactions helps subsidize their couture (Frings, 2002).

In the late part of the twentieth century, increasing numbers of international designers (more than thirty in 1995) began to show in Paris, making the fashion industry there less "French." Although France boasts of relative newcomers Lacroix and Gaultier, many of the French couture houses now employ couturiers who were born in other countries. Oscar de la Renta, from the Dominican Republic, designs for Balmain, Tom Ford designs for St. Laurent (Socha, 2001), and Italian Gianfranco Ferré designs for Dior. Thus, Paris has become more important as an international city that brings together global fashion in a way that is convenient for store buyers.

There has been a significant change in the makeup of influential contemporary designers. The list of influential designers of the twenty-first century will be a more global group. Designers from all over the world already contribute inspiration to the fashion picture. For example, in the late 1990s, well-known American designers with an international following included Bill Blass, Marie Gray for St. John (Figure 2.15), Nicole Miller, Tom Ford, Michael Kors, Donna Karan, Calvin Klein, Ralph Lauren, and Richard Tyler (Activity 2.4).

In addition, many governments have encouraged and subsidized designers because of the important economic benefits for their country. In England, Vivienne

STELLA MCCARTNEY
Designer to watch at Gucci

"I know what makes a chick tick," said Stella McCartney shortly after taking over the job of designer for Chloe at age 25. She increased sales fivefold in her tenure at Chloe before departing in April 2001 to begin her own label at the Gucci empire.

Born to ex-Beatle Paul McCartney and his wife Linda, she had a "real-world" upbringing unlike most children of celebrities. Brought up without nannies and bodyguards, she attended local public schools and even washed dishes in a restaurant to earn money for school clothes. At 15 she began her career by working for Christian Lacroix. While studying fashion at St. Martin's College of Art, she was often bullied for being a famous child, yet her designs were soon worn by the rich and famous such as Madonna, Cameron Diaz, Kate Moss, and Naomi Campbell.

Figure 2.16 Stella McCartney brief. *(Davis, B. 2001, October 8. Stella McCartney. http://www.fashionwindows.com/fashion)*

Westwood, Katherine Hamnett, Bruce Oldfield, Zandra Rhodes, and newcomer Stella McCartney (Figure 2.16) have all been recognized for their contribution to the fashion industry and its monetary benefits to the country. Sybil Connolly of Ireland revived a fashion interest in Irish tweeds and linens through her designs. For this, she has been granted official recognition and financial support by her government.

Italy now enjoys a reputation for technical leadership in knits and woven fabrics, creative couture, and quality prêt-à-porter. Milan has become the main center for ready-to-wear in Italy. Couturiers of the early twenty-first century in Italy include Valentino, Romeo Gigli, the partners Domenico Dolce and Stefano Gabbana, and Donetello Versace. Missoni is known for superb knits. Gucci and Ferragamo are longtime leaders in leather handbags and shoes. Fendi creates innovative furs and clothing, and Giorgio Armani has been credited with worldwide impact in menswear, particularly the unstructured look.

Designers from other countries are becoming widely known. Germany, home of designers Hugo Boss, Escada, Wolfgang Joop, Helmut Lang, Mondi, and Jil Sander, is the biggest European exporter of wearing apparel. Japan's international design reputation has been brightened by Hanae Mori, Issey Miyake, and Yohi Yamamoto.

The list of international fashion designers and contributions goes on and on. American department stores reveal how international consumers' tastes have become. As each designer makes his or her unique contribution from one corner of the world, inspiration is excited in another land. Thus, a design may feature Tyrolean-inspired embroidery gracing a Japanese fabric, a mandarin neckline on a Mexican peasant shirt, or Japanese batik print. The desire of women and men for something different, unique, and exciting creates the impetus for the international fashion market.

The Fashion Industry

A complex, multibillion-dollar, worldwide industry has been created to produce and distribute the vast number of apparel and accessory designs for men, women, and children. The fashion industry is the largest manufacturing employer in the world.

ACTIVITY 2.4 Fashion Designers

Select a contemporary fashion designer:
- Trace his/her career with educational background.
- Find pictures to illustrate his/her work.
- Analyze the pictures and determine the unique characteristics that identify his/her designs.

Millions of people are employed in the production of textiles, clothing, and accessories and in the staffing of stores that sell this merchandise. Consumer consumption sends this figure ever higher. In the United States, apparel manufacturing alone employs 600,000—more people than the entire printing and publishing field and the automobile manufacturing industry combined (Frings, 2002).

Role of Fashion Designers

As already discussed, fashion designers initiate the styles that the buying public accepts or rejects. Designers often show similar trends each season, and it is commonly thought that they work together to form a conspiracy to direct the public acceptance of their work. This is not true. Designers work independently, and actually they are most jealous of their collections and work in utmost secrecy. Seamstresses, models, custodians, and other personnel who have access to workrooms and designs are carefully policed so that they will not pass on trade secrets.

Designers are affected by the same influences, which leads to similar themes or trends in their designs. Successful designers must be in constant touch with the times. They must fully understand the consumers for whom they design: their interests, attitudes, values of dress, modes of living, and occupations. Designers must also be aware of political affairs.

Popular newspapers and magazines, museums, books, plays, television, motion pictures, sports, and music all are important sources of information for designers (Figure 2.17). When the current events focus on a particular person or place, designers translate these happenings into clothing styles.

Small changes in fashion seem to occur very quickly as compared to basic changes in the silhouette that take place over a period of years. Small changes in fashion appear to be affected by fashion leadership, whereas the major changes are affected by political, economic, and cultural factors.

Role of Retail Buyers

Retail buyers, representing exclusive specialty stores, attend couture fashion shows twice a year. In every collection, buyers look for the one or two pieces that may become trendsetters. Originals may often vary only slightly from last year's styles, but a subtle change in sleeve fullness, jacket lapel, pocket placement, or hem length may be just what consumers desire.

Decade	Social Events	Fashion Trends
1960s	• Kennedy years • Social upheaval • Youth became king • Vietnam	• A-line silhouette • Girls wore short skirts; women followed • Capri pants • Hatless
1970s	• Hippie movement • Cambodian war • Diane Keaton dressed masculine in Annie Hall • John Travolta in Saturday Night Fever	• Antifashion • Retro, ethnic • Hot pants, platform shoes, maxi-coats • Thrift shops • Disco clothes
1980s	• Excess, greed • Leveraged buyouts • Economic extremes • Resist rules	• Shoulder pads • Design flair, applied design • Yuppie status symbols • Androgynous
1990s	• Fusion of cultures • Buying for home important	• Minimalism • Deconstruction • Retro, ethnic, techno, grunge • Mix of styles
2000s	• Vigorous economy • Information age • Globalization • September 11, 2001, bombing	• Renewed enthusiasm for fashion • Body-conscious, sexy focus • Made in America

Figure 2.17 Social events and fashion trends. *(Adapted from C. Huard. 1998, May 1. Then and Now.* Daily Breeze, *p. 23).*

Toiles are less expensive versions of an original design. They are made of muslin, and full directions for making them are included.

Buyers can purchase couture models for copy purposes only. The originals may not be resold, and they must be returned by a specified date. Limited replicas of the original are sold, and less expensive models, called toiles, may also be purchased. These become the designs for ready-to-wear.

Often adaptations must be made so that the garment may be manufactured in lower price ranges. At rapid speed less sophisticated copies are **knocked off.** Mass-produced fashions are produced in volume for a large portion of the public. If widely accepted, these popular styles, called bodies, may be used in following seasons produced in a different fabrication until consumers demand a change.

A **knock-off** is a lower-priced copy of an original design.

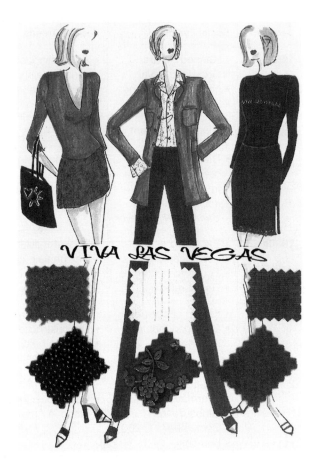

Figure 2.18 *Designers name their lines like the one here called "Viva Las Vegas." The names communicate the feeling the designer wants to present to retail buyers. (Courtesy Heart & Soul)*

Mass production is the high volume version of an original design for widespread distribution.

Bodies are widely accepted versions of a basic design, used year after year.

Role of Fashion Promotion

Before a new style becomes fashion, a feeling of familiarity must be established. The first of a long line of publicity begins when a new collection is presented by the designer. As each model is presented at the showing, it is labeled with a name such as "Slinky," "Macho," or "Techno," which helps to establish the mood for this line (Figure 2.18).

As retail buyers and prestige individual consumers make their selections, fashion writers and editors appraise the collection and send stories and sketches to their newspapers and magazines. Often the fashion reporter selects the most extreme and bizarre models, as these make good copy. Magazine writers select the models of the collection that they feel will appeal to their particular reading audience.

January 20, 1997	Silk gown with mink trim shown at Dior. Price: $27,000.
March 24	Nicole Kidman wore to Oscars.
March 26	ABS knocks off acetate/rayon version without mink.
May 26	Available at Macy's for $250; 800 sell.
January 28, 1998	Altered version worn on *Drew Carey Show*.

Figure 2.19 Couture to knock-off timeline. *(Adapted from A. Kim. 1998, April. Runway to Main Street.* Instyle, *p. 208)*

Women's Wear Daily (WWD), the main news publication of the garment industry, is closely read by those interested and involved in fashion, both in and out of the trade. *WWD* maintains a resident staff in all the major cities in the United States and abroad to continually gather fashion information. *W,* a fashion magazine highlighting important fashion trends, is edited by *Women's Wear Daily.*

Women's fashion magazines carry the collection news about two months after the opening presentations and do much to promote trends. Influential editors in this medium have the power to make or break either a design or a designer, often promoting their own advertisers through their editorial sections. This type of cooperative promotion is highly desirable and thus very profitable to the magazine.

Competing with magazines, couture shows began to be shown on television in the late 1990s. With the increased popularity of the Internet, high-fashion garments can often be seen by consumers even before they reach the press (Figure 2.19).

Popular high-fashion magazines for women include America's *Vogue, Harper's Bazaar,* and *Elle;* France's *Marie Claire* and *L'Officiel;* and Italy's *Linea Italiana.* Fashion magazines directed toward college or career girls are *Instyle, Allure, Lucky,* and *Glamour.* These publications present youthful, avant-garde fashions. *Seventeen* presents styles for the Generation Y consumer. *Details, Gentlemen's Quarterly, M,* and *Esquire* are men's fashion magazines. Combined, these publications exert tremendous influence on fashion and fashion trends.

> The **fashion figure** typified by models, generally half a head taller than the average consumer, shows clothing to best advantage.

Fashion magazines use fashion photography, an art form that has become a multimillion-dollar business. Every geographical location from the outposts of the Sahara to the deltas of the Ganges are used to publicize high fashion. Models used in fashion photography are more representative of the fashion figure (Figure 2.20) than the average male or female. That is, they have long, drawn-out, slender bodies, often with very few womanly curves or manly muscles. The poses used in fashion illustrations are often unrealistic, yet they set an image and show a mood.

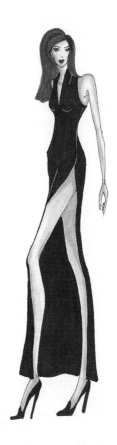

Figure 2.20 *Clothing on a tall figure, such as this model, shows differently than on a shorter person. (Courtesy Kit Sui)*

Cooperative advertising maximizes promotional budgets by sharing the cost of advertising.

Some retailers, hoping to increase their promotional budgets and thus the visibility of their clothing, negotiate cooperative advertising deals with textile mills and clothing manufacturers. This advertising is directed to the ultimate consumer by national media—newspapers, magazines, and television. The high cost of this advertising is shared. The participating companies may cooperate to extend this type of advertising further to tie in local merchants throughout the country.

At the community level, stores feature new designs in their advertising and special events such as fashion shows. In addition, mail-order catalogs and flyers, enclosed with monthly credit card statements, reach customers directly.

The focus of much fashion advertising is on the designer himself/herself. Today, with increased publicity, the names and faces of many designers, and often their models, are easily recognized by consumers at all economic levels. With their names in public view, these designers have taken their places alongside Hollywood film stars in the public mind, often finding their pictures on the front pages of newspapers and magazines.

The fashion industry has been quick to use the celebrity status of designers to promote increased sales. An appearance today by Todd Oldham or Tom Ford (Gucci) is sure to draw a crowd into a store. Designers such as Calvin Klein, Bill Blass, and Ralph Lauren are so well known and embraced by consumers that the new products they produce often are "presold." For example, Calvin Klein jeans were overwhelmingly accepted when they were introduced into an already crowded jean market.

Role of Licensing

> **Licensing** is paying a royalty for the use of an established name such as a famous athlete, designer, or cartoon character.

While fashion designers have become celebrities, celebrities have become "designers" by means of licensing. The fashion industry began to negotiate with people who were already well known and popular with consumers to use their names on clothing. One of the earliest examples is the contract that Sears Roebuck negotiated with top model Cheryl Tiegs to license her name for a line of clothing exclusive to Sears. In the fall of 1984, 12 million Americans received the Sears catalog with its cover picture of Cheryl Tiegs wearing her designer-wear sweater, skirt, and blouse. The success of early licensing deals have propelled the licensing trend forward using popular names from television, films, and athletics. In 1995, Wal-Mart licensed a line of Kathie Lee Gifford apparel, and Kmart licensed Kathy Ireland swimwear. Some of today's most popular licensed names are Ralph Lauren, Liz Claiborne, and Nike.

Role of the Consumer

The production and sale of garments is dependent on the idea of fashion—that which is accepted by a group of people at a particular time and place. In other words, the clothing industry, upon closer inspection, is actually the fashion industry.

The more one understands the dynamics of fashion, the more obvious it becomes that fashion is not imposed on the public by a controlling industry. Of the many thousands of clothing styles that are promoted, only a few actually become fashion. A style is never a fashion if it is worn by only a few people, no matter who they may be. Fashion is not a matter of opinion but of actual count (Jarnow and Dickerson, 1996). As Jarnow and Dickerson (1996) admit, "Many factors influence fashion trends but it is the customer who has the final word on whether a fashion lives or dies" (p. 53).

Consumer acceptance is fickle. Consider the change in consumer acceptance for such brands as Gloria Vanderbilt, Caroline Roehm, Esprit, Mossimo, Levi's, and Nike. Designers often find they need to reposition themselves in consumers' minds to regain their lost following.

As new designs become available, who are the first to pick them up? Traditionally, a group comprised of the wealthy, the socially prominent, actresses or actors, political and business leaders or their spouses, and other persons who are widely recognized and publicized have been the first to adopt new styles. Fashion leaders must have money, opportunities to display their wardrobes, and the self-confidence and courage to dress differently from the masses.

- Venturesomeness: Willing to be the first to try something new.
- Social integration: Frequent and extensive contact with others.
- Cosmopolitan: Point of view extends beyond one's immediate community.
- Social mobility: Upward social scale movement.
- Privilegedness: Attitude; possession of money, so that trying new things is less risky.

Figure 2.21 *Characteristics of innovators. (Marketing—Target market, innovators, early adopters, influencers. 2001. http://www.determan.net/Michele/mtarget.htm)*

However, fashion leadership can be found at all social strata. Each social group seems to have a member or two who leads the way in new styles of dress. After the fashion leaders introduce the new style, the followers take it up. Followers are basically imitative and need to become familiar with the new style to feel confident in it. Followers also need the assurance that the new style has gained the approval of a number of fashion leaders (Fig. 2.21).

Fashion Position

Each person takes a fashion position. Those who reject the current fashion are labeled either old-fashioned, antifashion, or innovators. Those who are extremely far ahead of fashion are called the avant-garde. In each community, and in each subgroup of the community, there are fashion leaders, who quickly adopt new styles, and fashion followers, who wait for fashions to be completely established before embracing them. Fashion leaders are sometimes considered liberals, whereas fashion followers are often labeled conservatives. One's fashion position is often defined by association. Moving through daily activities and social groups, one can move from the position of fashion leader to fashion follower or from fashion follower to fashion leader.

Fashion Adoption Theories

Fashion theories help explain the phenomenon of fashion. These theories may be operating separately or concurrently. Each is easier to identify after the style has become fashion than to predict. Fashion merchandisers must develop some sense of fashion movement but admit that no theory of predicting the general acceptance of a style is foolproof (Figure 2.22).

Trickle-down theory (or upper-class leadership theory). Centuries ago the setters of fashion were royalty. The nobility copied the royalty, and they in turn were copied by the middle class. At this time the lower class was prohibited by sumptuary laws from copying anyone.

In time, royalty was replaced by the fashion leadership of the families of businessmen who had climbed to the top of the economic and social ladder and wanted to display their wealth and power. It became important for others in business to adopt the dress, activities, and appearances of the fashion leaders. Those scattered along the socioeconomic scale found it safe to copy what royalty wore rather than to lead in fashion experimentation. Thus, fashion trickled down from higher to lower echelons. As fashions were adopted by the masses, new styles were introduced at the top. During this period the couture was in its most prestigious position.

Social Class	Direction of Fashion Adaption		
Upper class	Origin	Origin	
Middle class		Origin	
Lower class		Origin	Origin
Theories:	Trickle down	Trickle across	Bottom up

Figure 2.22 Fashion adoption theories.

This trickle-down theory of fashion evolution was identified and accepted by the nineteenth-century economists John Roe, Caroline R. Foley, and Thorstein Veblen and by the sociologist George Simmel, who published a step-by-step description of the theory in 1904. Kaiser (1996) applied this theory to the classic fashions of the early 1980s. Businesswear for women imitated the classic blazer and classic blouse worn by the upper classes long before women entered the business world en masse. The polo-style pullover shirt follows a classic style worn by the upper classes for leisure-time wear for over two decades. Kaiser reminds us that generally the upper-upper classes do not set fashions. The classes immediately below them—that is, the lower-upper and upper-middle—set the fashions because the upper-upper classes are generally not as concerned with fashion.

The trickle-down theory of fashion is applicable in the contemporary scene. Examples of trickle-down fashion are designer clothes, customized ski boots, foreign sports cars, and Perrier mineral water.

Trickle-across theory (or mass market theory). As the twentieth century progressed, fashion no longer was created by imitating any specific social or economic class. Heroes and heroines from all walks of life became fashion leaders. Film stars, television personalities, campus celebrities, folk heroes, sports stars, and other figures captured the public's fancy and gave impetus to fashion. The trickle-across theory of fashion was proposed by Charles W. King in 1963. He acknowledged that each group or segment of society has its own leader or leaders of fashion. The

approval of these local leaders is required before a fashion can be adopted by the group.

Recent examples of the trickle-across theory include the Casual Friday movement among office workers nationwide, multiple pierced earrings, and the Jennifer Aniston haircut.

Bottom-up theory (or subcultural). The bottom-up theory explains that fashions filter up from youth to age and from lower to upper socioeconomic groups. The idea behind this theory is that lower-income youths have little social position and thus fewer inhibitions. They are freer to create new dress patterns. Those from upper socioeconomic groups are secure in their positions and feel free to adopt novel dress patterns. Those in the middle socioeconomic groups are often more conservative but can accept clothing styles emerging from lower and upper socioeconomic groups. *from both*

Some examples of the bottom-up theory are the mod look of the 1960s that came from the poor boys and girls of London; the T-shirt/jeans uniform originating with hippies; and tattoos, once worn predominantly by gang members. The 1990s found teens, influenced in part from watching reruns of television sitcoms from the past, demanding retro clothing. Each of these looks eventually found itself worn by members of each social group.

The 1990s also found teenagers taking a traditional clothing item and combining it with a clothing item that seems to be the direct opposite—jean jackets with fur collars or tennis shoes with lacy dresses—or changing a traditional part of fashion to a trendy new look such as green, black, or blue nail polish. These moves make a new statement that shocks the older generation. The trend toward combining thrift store clothing, accessories, and distressed hair styles creates a cross-polarization of fashion time zones, which gives a new generation its very own look. This look moves up to influence the whole fashion world.

The duration of popularity of any fashion varies. Classics remain fashionable over a long time period. Fads flit in and out of fashion quickly. When people tire of a fashion, they discard it. As soon as the fashion has been accepted by the masses, the fashion leaders tire of it and experiment to find the next trend. This pattern appears to be followed by all but the very highest and the very lowest socioeconomic groups.

Understanding this movement of fashion is important to the expenditure of the clothing budget. Buying clothing on the outgoing phase of popularity is more expensive than buying new fashion as it comes in, because the old will be discarded more quickly. This caution should be particularly applied to sale merchandise, as sometimes it is already obsolete or soon will be (Activity 2.5).

ACTIVITY 2.5 Fashion Movement

Find illustrations of clothing trends resulting from each of the fashion adoption theories:

- Trickle down (upper classes to lower)
- Trickle across (peer groups)
- Trickle up (lower classes to upper)

Summary

This chapter lays the foundation for understanding the history of the fashion industry and its influence on consumers. From its beginnings in France in the mid-nineteenth century, the fashion industry has evolved into a multibillion-dollar worldwide business. The key players are the fashion designers, who create clothing and accessory styles; the retail buyers, who select items for their store inventories; the fashion promoters such as fashion magazines and newspapers that spread fashion news to the public; the manufacturers, who produce merchandise, often bearing the licensed names of the famous; and the consumers upon whose buying decisions the entire industry rises or falls.

Key Terms and Concepts

Bodies	High fashion
Chambre Syndicale de la Couture Parisienne	Knock-off
Classics	License
Cooperative advertising	Mass production
Couturier	Prêt-à-porter
Design	Silhouette
Fad	Style
Fashion	Taste
Fashion figure	Toile
Haute couture	Trend

References

Benaim, L. (2001). Haute couture—behind the scenes. http://www.france.diplomatie.fr/label, p. 2.

Couture rule changes lead. (1992, October 21). *Women's Wear Daily,* p. 33.

Davis, B. (2001, October 8). Stella McCartney. http://www.fashionwindows.com/fashion.

Dick, E. (1998, April). Why $30,000? *Instyle,* p. 68.

Dickerson, K. (2003). *Inside the fashion business.* Columbus, OH: Merrill.

Ewing, N. (1979, January 7). Preparator, field trip presentation, Textiles and Costume Department, Los Angeles County Museum of Art.

Frings, G. (2002). *Fashion: From concept to consumer.* Upper Saddle River, NJ: Prentice Hall.

Kaiser, S. (2003). *Social psychology of clothing and personal adornment.* New York: Macmillan.

Kim, A. (1998, April). Runway to Main Street. *Instyle,* p. 69.

Konig, R. (1973). *A la mode, on the social psychology of fashion.* New York: Seabury.

Marketing—target market, innovators, early adopters, influencers. (2001). http://www.determan.net/Michele/mtarget.htm.

Rubenstein, F. (1998, April). Why does this dress cost $30,000? *Instyle.*

Socha, M. (2001, April). Fab Ford. *Women's Wear Daily,* p. 130.

Stegemeyer, A. (1996). *Who's who in fashion.* New York: Fairchild.

What Is Haute Couture? (2001). The Columbia Electronic Encyclopedia. New York: Columbia University Press.

Chapter | 3

Cultural Influences

 Objectives

- Present historical evidence regarding primary motivations behind clothing choices.

- Examine forms of historical and contemporary clothing and adornment as directly influenced by the culture.

- Discuss the diffusion of cultural ideas and symbols in clothing and adornment.

- Identify influences of diffusion of cultural ideas about clothing and adornment on individuals' contemporary clothing and adornment choices.

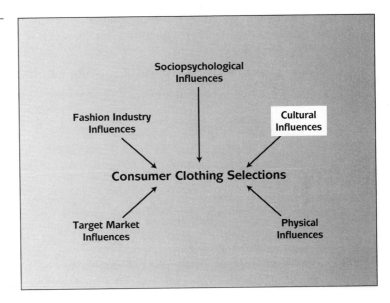

Sociopsychological
Influences

Fashion Industry
Influences

Cultural
Influences

Consumer Clothing Selections

Target Market
Influences

Physical
Influences

"Culture consists of the abstract values, beliefs, and perceptions of the world that lie behind people's behavior, and which are reflected in their behavior." (Haviland, 1993, p. 60)

An understanding of the influences of culture on choices in clothing and items of adornment is important for both individuals and fashion professionals. The types of clothing and adornment worn and the meanings associated with them within a society are determined by the cultural environment of contributory members. Firmly established in this environment are knowledge and beliefs from the past that are remodeled in the present.

> **"Culture** refers to the learned, socially acquired traditions of thought and behavior in human societies" (Harris and Johnson, 2000, p. 9).

Further, culture is passed down from one generation to another. Though there are reinterpretations of certain aspects of culture by different generations of people, culture tends to be similar in many respects from one generation to another (Harris and Johnson, 2000).

Each individual has a cultural history. Groups and individuals within groups differ in their ideas of what is appropriate, attractive, or fashionable because each individual is uniquely influenced by the cultural environment.

The study of clothing and culture has a long and rich history. Even though one may find few examples of the wearing of national dress on a daily basis, the study

of clothing and adornment practices in earlier times, varying geographic locations, and differing cultures reveals how humans have solved the problem of the special need to be clothed. An infinite variety of forms of clothing and items of adornment has evolved and is continually being expanded. The fashion professional uses an understanding of cultural diversity among consumers, the influence of culture on choices in clothing and adornment, and global diffusion of symbols of clothing and adornment to better design, produce, and select products to meet the needs of consumers.

Primary Motivations Behind Clothing Choices

According to Ryder:

> Our ancestors left Africa in two waves. The first of these occurred about 1.5 million years ago and involved Homo erectus. . . . The second wave occurred about 100,000 years ago and involved our own species, Homo sapiens. . . . Archeologists are convinced that only by the later development of clothing were human beings able to colonize the cooler, northern temperature, and colder polar regions of the Earth. . . . During the last Ice Age, which ended as recently as 10,000 years ago, northern Europe was covered with ice. . . . Even at the edge of the ice the climate was extremely cold, and as the ice retreated north with the melting of the polar ice cap, man, ever short of hunting grounds, followed" (Ryder, 2000, pp. 13–14).

From the moment humans acknowledged the existence of each other, the characteristics of culture were established (Figure 3.1). Culture consists of adapting the environment to meet the basic needs of food, clothing, and shelter.

From the earliest recorded forms of clothing it is known that individuals adapted materials from within the environment to clothe themselves. Many theories have attempted to explain the motivations for individuals to cover and decorate all or parts of the body. The basic reasons behind the motivation appear to be the *physical, psychological,* and *sociocultural* needs of all individuals.

Component	Definition
Infrastructure	"The technology and the practices employed for expanding basic subsistence production . . . food, and other forms of energy. . . . The technology and practices employed for expanding, limiting, and maintaining population size" (Harris and Johnson, 2000, p. 20).
Structure	"The organization of reproduction and basic production, exchange and consumption within camps, houses, apartments, or other domestic settings, family structure, domestic division of labor . . . age and gender roles . . . political organization. . . . (Harris and Johnson, 2000, p. 20).
Superstructure	The arts, values, meanings, symbols, rituals, myths and beliefs, sports and games, and science (Harris and Johnson, 2000).

Figure 3.1 Components of culture.

Historical Evidence of Clothing Forms and Structures

Prehistoric cave paintings have preserved the images of the clothing and adornment of early people. One of the oldest depictions is in the caverns in the French Pyrenees known as Trois Freres, dated as being created twenty to thirty thousand years ago. The cave paintings show a man wearing animal skins and a headpiece. It appears that he was a hunter disguised as an animal.

> It has long been assumed that the first clothing was the skin of an animal killed for food. Archaeological evidence for this comes from the Paleolithic period (the Old Stone Age). . . . In northern Eurasia, fox and wolf skeletons were found without their feet. . . . Prepared skins could be cut and shaped. Pieces of skin are likely to have been stitched together by looping and knotting lengths of sinew (or plant fibre) through holes in the skin, even before the invention of the eyed needle. . . . A recent excavation of a Paleolithic site at Qeqertasussuk in Greenland yielded many fine bone needles and the earliest remains of stitched-skin clothing preserved in permafrost. . . . The use of plant fibres before wool confirms findings from excavations of Swiss Neolithic Lake Dwellings. . . . His clothing was in layers: under the cape he had a skin jerkin or tunic and under this was a loin-cloth held from the same belt, from which 'suspenders' held up his leggings."(Ryder, 2000, pp. 14–15)

Parfit (2000) provided evidence of early footwear and adornment in the American west. He observed that "Details of early lives revealed woven sandals up to 13,000 years old and a tattooing tool" (p. 62). For Parfit these artifacts, along with others, reveal a complex lifestyle built on many resources.

Coulson (1999) studied snapshots of daily life as revealed through paintings on rocks at least four thousand years old in Northern Africa. These included female figures "with tulip-shaped heads and hourglass bodies" (p. 109) approximately 2,500 years old, "drawings of body painting" (p. 115), and a "seven inch photograph named 'the Hairdresser' showing one man leaning over a bowl while another carefully washes his long hair" (p. 115).

Barber (1999) described the well-preserved mummies found in the Tarim Basin of China. One of these was a 1,000-year-old man who was about "6'6" tall, with light brown hair; he wore white deerskin boots and brightly colored woolen pants, shirt and felt leggings" (Plate 1). She further observed that two long woven rectangles formed the body of the shirt. Reinhard (1999) found other examples such as a woven-type fabric on a 500-year-old Incan mummy.

Clothing and Adornment for Protection

Protection is efforts to shield the body from harm.

Two types of protection are suggested here: physical and psychological. Physical protection involves making body coverings and items of adornment to facilitate individuals' survival in an unfriendly environment. Psychological protection, on the other hand, involves adapting body coverings and items of adornment that would ward off "human and unseen evil spirits."

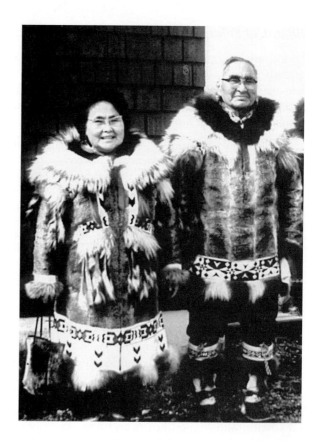

Figure 3.2 *The Inuit made clothing from fur and skins, which offered warmth and protection. (Courtesy Josephine Schultz)*

Physical Protection

The climates where early civilizations flourished were tropical or semitropical. The temperatures were warm or hot and the air was very dry. (This was a vital factor in the preservation of their artifacts.) Clothing for warmth was rarely necessary. Clothing for protection from the hot sun would seem more important, but from what is known of the styles, this was not often a consideration. Knowledge of the clothing practices of the Sumerians and their neighbors, the Egyptians, reveals that dress was used to show rank, wealth, and status and for ritual and individual ornamentation, more than for protection.

Gall (1998) and Ryder (2000) asserted that in many parts of the world, clothing has been worn to keep the body warm. Both observed that the Inuit (Eskimo) assembled and layered items of clothing, which ensured their survival in the harsh environment of the Arctic (Figure 3.2).

Today's skiwear follows somewhat the characteristics of types of clothing worn for maximum protection from the cold. Capitalizing on the quality and high performance of fabric made from synthetic fibers and many fiber variants, companies have developed high-fashion and high-quality skiwear that is durable, waterproof, and breathable (Wallace 1999).

Figure 3.3 *New fibers and fabrics make it easy to stay comfortable in most weather conditions. Wearers pull outer layers off when indoors.* *(Courtesy Jane Nicklas Photography)*

Today, when astronauts leave the earth's atmosphere for space, their lives depend on the technological expertise of a host of individuals. A part of this incredible feat is the design of the spacesuit. The garment is carefully constructed to make the earth's atmosphere portable. The spacesuit was developed to protect the wearer and to support life. The spacesuit is truly a triumph of modern scientific ingenuity.

The term used to describe and measure the clothing insulating factor is **clo value.** "*Clo* describes the comfort of clothing used to keep the body warm under adverse weather conditions" (Kadolph, 1998, p. 337) or clothing's resistance to dry heat transfer.

Clothing and accessories, such as "cooling" head bands, have also been designed to control body heat when at work or play in hot environments. For everyday wear most individuals choose clothing that is related to the geographical location and climatic conditions in which they live. Many individual wardrobes have clothing suitable to meet a range of temperatures and weather conditions (Figure 3.3). People tend to layer clothing for warmth and peel it off for cooling.

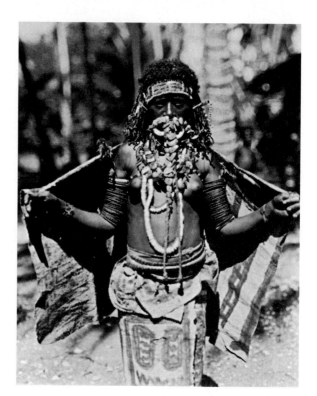

Figure 3.4 *Cowrie shells are important adornments in many Pacific cultures. (Courtesy Department Library Services American Museum of Natural History)*

Psychological Protection

From the most ancient times through today, psychological protection has been an important function of clothing. Some scholars theorize that the origin and primary function of adorning the bodies of early individuals was the need to defend themselves from harmful spiritual powers. Belief in the power of supernatural forces to cause floods, earth tremors, drought, illness, and death prompts individuals to adorn the body for protection. Superstitions, fear of the unseen, belief in evil spirits and demons, and luck have all been responsible for the use of certain garments, jewelry, and other body adornment. Examples include:

- Cowrie shells protect women from sterility in many Pacific cultures (Figure 3.4).
- Bridal veils protect the bride from evil spirits (Figure 3.5).
- Evil-eye beads protect children and animals from unseen powers in Southeast Asia (Figure 3.6 or 3.7).
- Eagle feathers are highly valued by some Native Americans. They are believed to possess magical power (Gall, 1998). During the dances performed in a contemporary pow wow, one sees many examples of the use of feathers.

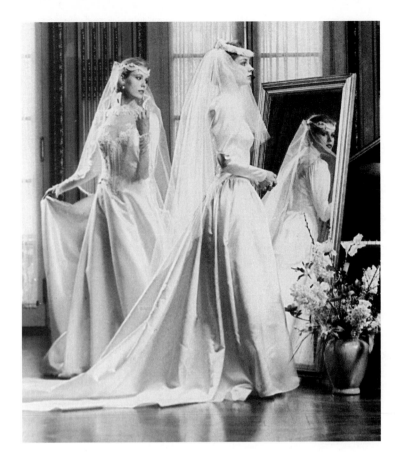

Figure 3.5 *Modern bridal veils evolved from a belief that they protect the bride from evil spirits.* (Courtesy Priscilla of Boston)

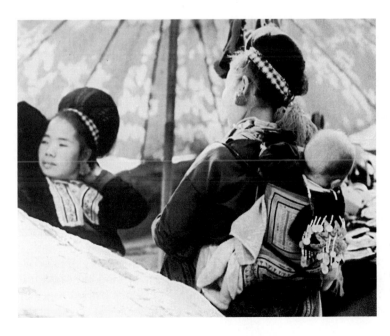

Figure 3.6 *The Hmong (Miao), a northern Thai hill people, embellish their clothing with fine appliqué and embroidery for magic purposes. Baby carriers are decorated to prevent evil spirits from attacking the baby from the back. (Courtesy Heidi Kessler)*

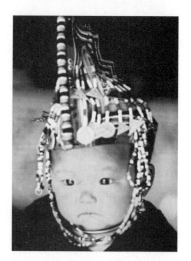

Figure 3.7 *An ornate headdress is decorated with metal spangles and colorful beads. Around the child's arms, neck, and other joints are bracelets to prevent the child's soul from leaving the body. This jewelry serves to attach the child's soul to the child. (Courtesy Heidi Kessler)*

Clothing and Adornment to Meet Psychological Needs

Psychological needs are the basic forces that impel people to act.

Modesty is the standard regarding the area of the anatomy to be concealed.

Adornment is the act of decorating the body.

Two basic psychological needs have been suggested to explain the primary motives that led individuals to develop clothing and items of adornment for the body: modesty and adornment.

Clothing for Modesty

Most individuals would probably agree that the psychological need for modesty is present in some form in most societies. Yet it is the area of the anatomy to be concealed that creates the wide range of different customs.

In order to answer the question of modesty as the primary motive behind clothing choices, one needs to examine ideas and practices showing the relationship between clothing and modesty. Expressions of modesty are found among all cultures. There is, however, a lack of agreement as to what constitutes modesty, even among individuals of the same cultural group.

Different concepts of modesty are found in different cultures. Covering or not covering certain parts of the body may be considered improper or immodest because of cultural interpretation. In the Japanese public bath, both sexes bathed together and their nudity was not considered immodest, but for any other social situation, the

 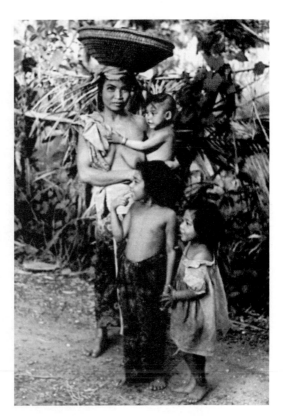

Figure 3.8 *Cultures differ about what constitutes modesty. Left: A bikini at the beach is not considered immodest in the United States. Right: This Balinese mother would consider it highly immodest to show her legs.*

conventional Japanese apparel for both men and women was body enveloping. A brief bikini worn on an American beach is not usually considered immodest, but the same garment would not be acceptable if worn on a business street (Figure 3.8).

Conventions of modesty change over time in the same culture. In the nineteenth century, concealing the leg was a manifestation of modesty; even the word *leg* was taboo. If one had to refer to "that" part of the body, it was called a limb. (Even the legs of furniture were covered by dust ruffles.) However, by the early 1980s the French-cut bathing suit revealed all of the female leg.

From these examples it is clear that each culture determines what is modest and that immodesty is breaking a cultural custom (Figure 3.9). Body shame is not instinctual: Young children do not have an innate sense of modesty; rather, feelings about immodesty are learned. The intention of clothing the body for purposes of modesty is in direct opposition to the intention of clothing the body for adornment.

Fashion calls attention to one part of the body until that gets wearisome or boring and then covers that part and exposes another part. This exposure and concealment have covered and uncovered almost the entire body at one time or another.

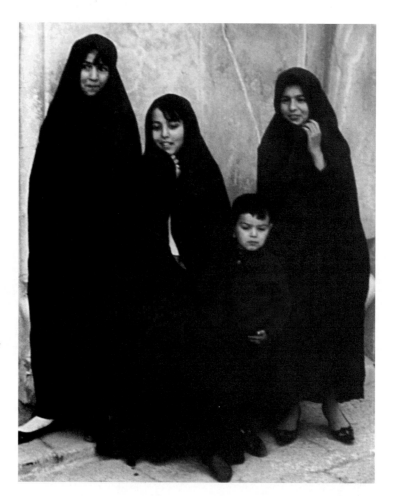

Figure 3.9 *Isfahan, Iran. Three teenage Muslim girls wear a body-enveloping shawl, the chador; they would consider themselves immodestly dressed if they appeared on the street without the wrap. Short Western-style skirts and white cotton blouses are worn under the shawl.*

It is generally believed by scholars of clothing and human behavior that modesty was not the primary motive in the development of clothing. How can modesty in dress exist if clothes are not the custom of the culture?

Clothing for Adornment

Adornment has several dimensions. To mention just a few, adornment is used:

- As nonverbal communication and indicates many characteristics of the individual such as age, gender, and status/role.
- For psychological protection such as to ward off evil spirits or to frighten the enemy.
- For sexual attraction.

A statuette known as the Venus of Willendorf, over twenty thousand years old, was made in the Aurignacian epoch (Figure 3.10). This prehistoric fertility figure, whose face

Figure 3.10 *Cast of the statuette Venus of Willendorf wears an elaborate and detailed hairstyle. (Original in Natural History Museum, Vienna, Austria. Courtesy American Museum of Natural History)*

Figure 3.11 *A statuette from Grotte de Pape at Brassempouy of the Aurignacian-Perigordian period (c. 20,000–30,000 B.C.) shows that hair styles have been a preoccupation of individuals from early times to the present. (Courtesy Betty Kessler)*

has been ignored by her creator, wears an elaborate and detailed hairstyle. Other stat-uettes from prehistory, such as the woman's head from Grotte de Pape at Brassempouy, France (Figure 3.11), also show care in the styling of the hair (Figures 3.12 and 3.13)

Consider the popularity of brand-name clothing in the United States. The identi-fying name, insignia, or logo makes the item "status" clothing within a small clique, a large group, nationally, or internationally. The symbols make a statement for all to read and interpret.

Some people use permanent forms of adornment. Their styles of ornamentation form lasting cultural practices. If, in their society, little or no clothing is worn, they frequently adorn their skin. If the skin is of a light enough tone, tattooing may be used. If tattoo-

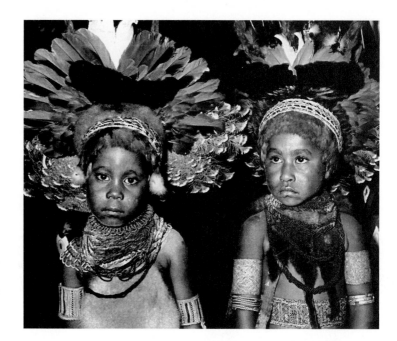

Figure 3.12 *Clothing is worn to win admiration and assure an individual that he or she belongs.* (Courtesy Qantas)

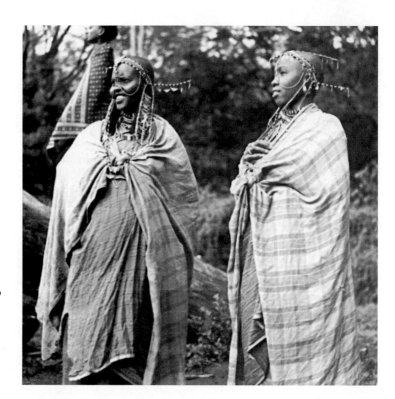

Figure 3.13 *A shaven head is a sign of beauty to the Masai women of Kenya. It sets off to advantage the beaded ornaments that adorn their heads and necks.* (Courtesy Gloria Le Baron)

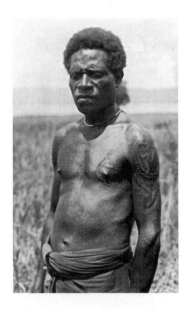

Figure 3.14 *Scarification, Mandang, New Guinea. Intricate curvilinear designs adorn the arm and chest of this young man. (Courtesy Department Library Services American Museum of Natural History)*

Figure 3.15 *An African pygmy with his teeth filed to points. This practice has religious meaning. (Courtesy Department Library Services American Museum of Natural History)*

ing is not visible, scarification may be used (Figure 3.14). Other forms of permanent adornment are foot binding (China), and filing or removal of teeth (Figure 3.15).

The earliest evidence of cosmetics for adornment was found on bones in mid-Paleolithic Neanderthal burial sites where ochre clays were used. On the cave floors in Europe, Paleolithic peoples left bone and antler containers with stoppers that contained cosmetic pigments mixed with fats, yellow and red iron oxides, and black manganese oxides.

Among the most outstanding examples of use of pastes are for artistic expression. For example, during the Eunoto ceremony, the Masai warriors draw designs on their bodies. Some disguise themselves as zebras; others use symbolic patterns to indicate their bravery in having killed a lion or man (Beckwith and Fisher, 1999).

ACTIVITY 3.1 The Popular Media

Watch a television program or a movie. Determine which of the theories of clothing choices studied seem to be exemplified. Select one actress or actor and discuss her or his dress specifically. If possible, tape this individual in a scene or two and bring the tape to class to illustrate your findings.

Individuals' pursuit of personal adornment is universal. People of all societies have adorned themselves in some form. It is interesting to consider that, except for pierced body parts, permanent tattooing, and cosmetic surgery, most modern individuals' forms of adornment are temporary. Clothes are added or removed and cosmetics or hairstyles changed, creating temporary alterations in appearance. Fashion dictates changes in adornment, as the nature of fashion is change.

Protection, Modesty, or Adornment?

Of the three basic reasons for covering the body—protection, modesty, and adornment—there is some disagreement as to the primary motive. Anthropologists Ember and Ember (1999) noted that in "all societies, people decorate or adorn their bodies. . . . Much of this decoration seems to be motivated by aesthetic considerations. . . . Body decoration or adornment may be used to delineate social position, rank, sex, occupation, local, and ethnic identity or religion within a society" (pp. 286–287). (See Activity 3.1.)

Clothing and Adornment to Meet Sociocultural Needs

> **Sociocultural needs** refer to an individual's need to be recognized as a member of a social group, to occupy a position within the group, and to experience social acceptance.

An infinite number of diverse cultures exist around the world; yet, certain universals exist in all cultures (Figure 3.16). Clothing and adornment practices communicate the culture's components and the interactive nature of these components as well as the uniqueness of each culture.

The following discussion is designed to demonstrate what clothing and adornment communicate about the culture. These topics guide the discussion:

- Economic position
- Social status/identification and rank
- Ethnic identification
- Gender differentiation
- Rites of passage

- A natural environment

- A primary means of subsistence

- Some form of and expectations for a primary family

- A system of kinship

- A set of rules of conduct

- Raw materials, tools, and technology

- Social organization

- A shared aesthetic system

Figure 3.16 Cultural universals.

- Marital status
- Political beliefs
- Religious ideas
- Technical changes and industrialization
- Aesthetic ideals

Because of the overlapping and interweaving of the meanings and use of dress, certain items may fit under several categories. For example, the ancient practice of Chinese foot binding is an example of economic position, social status, attitudes toward women, and aesthetic ideal.

Economic Position

Both quality and quantity of possessions are indicators of economic position (see Figures 3.17–3.20). For example, in ancient times, the wealthy Chinese grew their fingernails to inordinate lengths, thus affirming to all that they did not perform lowly manual tasks. To further enforce the inactivity of their hands, they wore robes with very long sleeves that completely covered the fingernails. Any work involving the hands was impossible.

Likewise, at the end of the nineteenth century, rich and powerful English businessmen wore a high, tight, white collar with their heavy, stiff Edwardian suits. Physical exertion of any kind was inhibited and probably would have caused difficulty in breathing. Thus the term *white-collar worker* came into use. This term, as well as the clothing practice, denoted both economic success and status above that of the manual laborer, who usually wore a soft-collared, blue shirt.

In Cuba, economic conditions under the Castro government in the early 1970s restricted the amount of clothing a person was allowed to twenty-seven yards of fabric per individual per year. To stretch this amount to cover all clothing needs, designs were created using patchwork and very short, tight skirts. Nylon stockings were worn until they no longer resembled the original stockings, but took on designs of

Location	Wearer	Example
South Cotabato, Mindanao, Philippines	Young woman	Wears layers of clothing and several items of expensive jewelry.
New Delhi, India	Woman	A wealthy *begum* wears saris of rich brocaded silk. Her neck and wrists are adorned with heavy lustrous silver (Figure 3.18).
Northwest India	Farmer's wife	The *Gujarat* is garbed in brightly embroidered cotton skirts and blouses with veils of tie and dye. Heavy bracelets of silver circle her wrists and ankles.
Northern Nigeria	Hausa chief	Wears a "layered look," with as many as twelve embroidered robes, one on top of the other.
Bangladesh	Bengali bride	Wears a richly brocaded silk sari and heavy, gold neck and wrist jewelry (Figure 3.19).

Figure 3.17 Examples of clothing as expressions of high economic position.

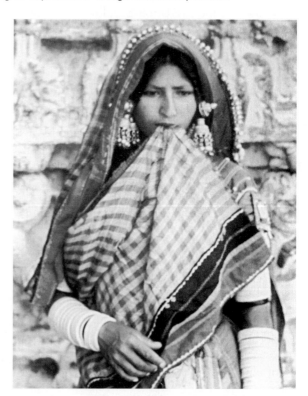

Figure 3.18 *Heavy silver earrings and ivory bracelets on this woman proclaim that she is from a wealthy Indian family.*
(Courtesy John J. Shaak)

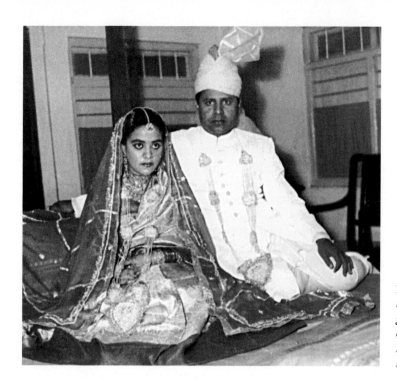

Figure 3.19 *A richly brocaded sari and heavy gold jewelry express the economic wealth of this Bengali bride in Bangladesh.*

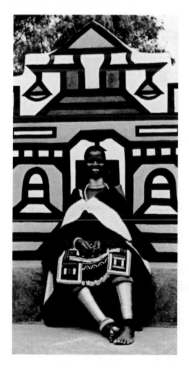

Figure 3.20 *This Ndebele woman with her neck, arms, and legs encircled in brass rings makes it plain to all that she is not engaged in physical labor. (Courtesy South African Tourist Corporation)*

darns and mends. Because only one color of hair coloring was usually available, many women had the same hair color.

In the United States, economic position is often displayed by dress. Among some social groups, conspicuous display of rare furs, precious jewels, and expensive fabrics has been practiced, while other groups have rejected this form of ostentation. For example, the 1960s' rebellion against such values as material success, work, status, and grooming was epitomized by the "hippie" lifestyle and symbolized by the "jeans look." At that time the more faded, worn, ragged, patched, and body-conforming the jeans, the greater was the status.

During the early 1970s many high school and college students' wardrobes of jeans represented reverse snobbism. They paid high prices for recycled, faded, patched, and embellished jeans. The faded, used, worn look was achieved by laundering the indigo-dyed fabric a minimum of four times. Hangtags noted that any defects in the garments were intentional. Accessories for these jeans were carefully selected. The wealthy teamed them with Gucci shoes, Hermes scarves, Cardin shirts, Vuitton handbags, and fragile suede jackets, which left no doubt about the economic position of the wearer.

Sportswear, as an immense industry in the United States, was the result of economic conditions. Until the early part of the twentieth century, participation in active sports was a privilege of the wealthy upper class exclusively. Others had neither the leisure time nor the money for such pursuits. As working conditions improved, shorter working hours, education, and economic security became available to a large part of the American population. More and more people had the time, learned the skills, and could afford to participate in sports. As most sports involve special dress, the sportswear industry was born.

Parallel to the development of participant sports apparel was the creation of spectator sports clothing—"athleisure"—that evolved into the wardrobe of the post–World War II suburban families' casual lifestyle. Recently the more casual look has also entered the workplace (Chapter 14).

Social Status: Identification and Rank

Very often social status is the basis for clothing selections. Individuals generalize that the wealthy have money and, therefore, have the resources to buy any wardrobe they choose, whereas less income means less status and less money for clothing. Both of these ideas are faulty. Financial success or social status is not always an accurate indicator of wealth. Sometimes wealthy people limit their clothing expenditures, and their wardrobes appear small, even old and eccentric. Lower-income people who desire to appear prosperous may spend the majority of their income on apparel. In addition, mass production of clothing has increased the volume of clothing in the marketplace, yielding a wider selection of fashionable clothing available to all.

Clothing variety can show social rank by cut, texture, trim, color, symbols, and surface enrichment (Figure 3.21). Clothing can be quickly changed or replaced, mass produced inexpensively, or designed as exclusive one-of-a-kind garments of the most expensive, rare materials.

social Rank

Quantity or volume	Layers of garments; numbers of beads and necklaces; rows of bracelets, both leg and arm.
Size or scale	Length of sleeve, pants, or trains; large and small headgear; reduction/extension of shoe.
Quality	Metals, jewels, fabrics, and furs, "off the rack" or "custom."
Workmanship	Construction techniques of garments; quality of tattooing or scarification.
Color	The rarest dyes are the most exclusive; laws may limit use to population groups.

Figure 3.21 Clothing and adornment used to show social rank.

Sumptuary Laws and Clothing

Sumptuary laws are restrictions that regulate style of and personal expenditures on dress.

A study of historical and cultural dress reveals an aspect of clothing that is related to legal code. By regulating style and personal expenditure of dress, sumptuary laws in many societies have perpetuated distinctions in social class.

Many examples of sumptuary laws were found in Western Europe before the European unification. As the business classes gained wealth, they were able to challenge the status of royalty by purchasing the opulent apparel of the royal courts. Sumptuary laws were enacted to restrict individual clothing choices in color, motif, and style that designated rank, class, and position within the society. These laws maintained class distinctions. Sumptuary laws have often promoted extreme excesses and exaggerations before the style dies. During the 1300s, French court dress was rich and opulent. Footwear was used to show social status. Shoes, known as _poulaines,_ had long pointed toes.

Commoners found ways to circumvent sumptuary laws. Magnificent creative stitchery appeared on many regional peasant costumes. The cut and cloth of these garments were decreed by law, but the surface enrichment did not break the law and yet expressed individuality. Other examples can be found in the paintings of the Dutch masters showing wealthy businessmen and their families. The clothing is austere, but elegant petticoats peep out from under skirts, and beautiful ermine and mink pelts adorn capes and tunics.

Sumptuary laws were also part of the dress history of many other cultures (Figure 3.22). During the Cultural Revolution in China, the clothing commonly worn was known as the Mao suit (Figure 3.23). Other more recent limitations have been observed around the world. Gall (1998), in the _Worldmark Encyclopedia of Cultures and Daily Life,_ provided brief and clear examples of the interrelatedness of all aspects of culture. One of his most significant findings revealed prohibitions on dress (Figure 3.24).

Location	Date	Individuals Affected	Sumptuary Law
China	1759	The emperor, empress, princes, concubines, nobles, military, and civil servants	Regulated costumes and accessories to be used at ceremonies. Each member of the hierarchy had similar robes with color and decorative details indicating rank.
China	mid-1960s	All men and women not of the gentry or scholar officials	A strict utilitaritan dress code was imposed, the Mao suit.
Japan	circa 1661	All citizens	Controlled wearing apparel as to fabric, color, and decorative designs.

Figure 3.22 Sumptuary laws regulating dress and adornment.

Figure 3.23 *This is the typical Mao suit worn during the Chinese Cultural Revolution.*

Most of the recorded history of Japan includes the use of sumptuary laws such as that affecting the development of the Japanese *kimono*. Two devastating fires, in Edo (1657) and in Kyoto (1661), destroyed the possessions of most Japanese. To replace the kimonos lost in these fires, the weavers and dyers were forced to develop quicker and simpler methods. In this period of recovery, the merchants became extremely affluent. Dress became very elaborate as merchants' wives vied with each

Where/Whom	When	Form of the Ban	Rationale
Philippines, Filipinos	The Colonial Period	• traditional dress such as the G-string • traditional European clothing	immodest
Laos, Laotians	1975	• blue jeans and traditional sarong	
Iran, women	1979	• Western clothing	must cover the hair and wear the *chador*
Other Examples from the Popular Press			
United States, high school girls	1960s	• Twiggy's miniskirt	
United States, young girls	1970s	• Farrah's clogs	
Cambodia young girls	1990s	• shorts and short skirts • few clothes	too sexy
Malawi Young girls	1990s	• pants, shorts and above the knee skirts	too exposed
British Columbia, Female teachers	1990s	• short skirts, midriff-baring and low-cut tops	
Saudi Arabia, females, past puberty	1990s	• must be covered, from head to toe	too much skin showing
Sudan, women	1990s	• must cover hair and body	too much skin showing
Afghanistan women	1990s and 2000s	• must be covered from head to toe	immodest

Figure 3.24 Banned items of dress and adornment.

other for fashion leadership. Kimono designs became bold, flowing, and abstract. Thus, the merchant class outshone the local leaders. As a result, a series of sumptuary laws were passed that prescribed dress for the various classes. The penalty for violation of these laws was usually death. These sumptuary laws brought sweeping change in the decoration of the kimono.

Although sumptuary laws were not passed in the United States, General Limitation Order #L-85 did limit styles of dress during World War I, and certain measures have been taken to restrict dress (Activity 3.2). For example, the style of clothing was modified in order to reduce the amount of fabric needed.

ACTIVITY 3.2 In the Public Eye

Collect news articles and pictures illustrating how a person's dress became worthy of a news item.

School dress codes might also be considered a form of sumptuary law. For example, in 1994, California's Long Beach Unified School District implemented a school dress code that began with elementary grade students, and other districts have followed.

Ethnic Identification by Dress

Ethnic identity refers to a set of self-ideas and the presentation of self as a member of a particular ethnic group.

According to Eicher, Evenson, and Lutz (2000) ethnicity refers to the identification of a unique cultural construct with which people identify. The construct involves shared values, beliefs, customs, and norms. Items of dress and adornment are necessary components of the "identity kit" one uses to define one's ethnic identity.

In the United States, the Mayans have reproduced major cultural dress symbols of Maya identity such as *huipil* and *corte* for women (Figure 3.25).

Like the Maya, the Hmong also take great pride in maintaining knowledge about their past traditions and transferring this knowledge between generations. The Hmong reenact some of the most important events from their past including the years of military action, wartime migration and settlement in Laos, and camp life in Thailand. Embroidered, narrative story cloths capture the migration.

Clothing and items of adornment also manifest the collective, cultural consciousness of some African American men and women. O'Neal (1998) observed and interviewed African American professional women who had integrated cultural dress (traditionally styled garments and accessories imported from various African countries) into their professional wardrobes. These interviews revealed not only a collective, cultural consciousness about their Africanness, but also about their African Americanness. To illustrate Africanness, O'Neal noted that "the shift toward wearing cultural dress . . . evolved as appreciation for Africa and African heritage developed. . . . Informants frequently established the link between wearing cultural dress and an understanding of one's cultural heritage" (p. 32).

Dress was also used "as tangible evidence of the link to the geographic place of their cultural heritage . . . and was stated by one participant as follows: 'I think that inside of each African American who has been told the stories of Western enslavement . . . there is this piece that always wanted to go back and embrace that African piece' " (p. 31).

Figure 3.25 *The* huipil *usually lacks set-in sleeves. It is made of one to three rectangular panels of fabric. Most are woven on a backstrap loom. They may reach from anywhere between just below the bust to the ankle in length.*

Figure 3.26 *The embroidered and appliqued story cloth traces the journey of the Hmong.*

To illustrate African Americanness, O'Neal discovered that the women also used dress to "define the self" (a personal statement on their present condition) and to "educate others about African and African American culture" (p. 31). She concluded:

> Since learning about their heritage, the women do not wish to live as if they are simply American. They share common . . . physical characteristics, language patterns, history, and ways of relating to the supernatural that can be linked to their geographic area of origin. Dress serves as the visual expression of that ethnicity. (p. 32)

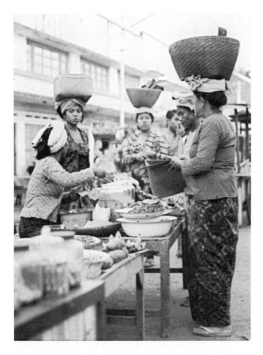

Figure 3.27 *The batik sarong of Java, Indonesia, is worn by both men and women. Left: An Indonesian woman wears a batik sarong in the marketplace. Right: The decorative panel, called a* kapala, *running from the waist to the hem of the sarong indicates masculinity or femininity.*

Gender Differentiation with Clothing

Dress is used to identify gender in most societies. True, in some societies male and female attire appears identical, but close observation will show differences. For example, the *sarong,* or wrapped skirt, of Indonesia is worn by both males and females. The *kapala* or decorative panel that runs from the waist to the hem of the skirt is the feature that indicates masculinity or femininity. The kapala is worn in the front or back of the body, depending on local custom (Figure 3.27).

Today, many in the United States feel strongly about the sexuality of clothing and items of adornment. Consider hair. At the turn of the twentieth century both men and women wore long hair. Men usually had facial hair such as beards, moustaches, and sideburns. World War I brought in the Prussian military influence, and men cut their hair quite short and shaved their faces. In the period of the 1920s and women's suffrage, women bobbed their hair to show their emancipation. The World War II era saw men with crew cuts and whiskerless faces. Post–World War II women's hair was shortened and named the Italian Cut, the Poodle Cut, and the Ducktail. When high school boys picked up the same hairstyles, one could not tell the men from the women.

During the 1960s hairstyles were influenced by rock and roll stars led by Elvis Presley and the Beatles. Hippies and flower children grew hair to set themselves apart and display their protest. Parents were horrified to have sons with hair longer than their daughters'.

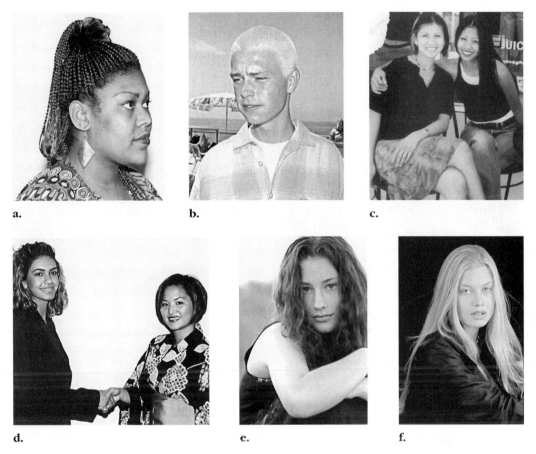

a. b. c.

d. e. f.

Figure 3.28 *A variety of hairstyles can be seen on men and women. Notice the subtle uses of ethnic symbols, corn-rows, Filipino with braids, the surfer look, Armenian and Japanese American with frosted hair; long, curly; long, blonde, straight. (Courtesy: b. Quicksilver; e. and f. Jane Nicklas Photography)*

Young women grew their hair as long as possible. Waist-length hair parted in the center and hanging was the fashion. Hand movements and body language involving pushing hair from the face became habits.

Only straight hair could accommodate this style, so straightening or pressing hair (literally with an iron and ironing board) became popular.

The 1960s civil rights movement, lead by Dr. Martin Luther King, Jr. and others, inspired the motto "black is beautiful." Taking pride in their racial heritage, black men and women styled their hair in Afros. The first to wear the Afro were viewed with apprehension and labeled agitators or revolutionists, but by the late 1970s the Afro was commonplace. The frizzy permanent that approximates the Afro had been adopted by others, and blacks had moved on to corn-rowing (a series of French braids done in elaborate geometric patterns over the entire scalp, often enhanced with beads and feathers).

Beginning in the 1980s, sales of hair-care products and services became big business and sales remained high. As illustrated in Figure 3.28, many styles are popular

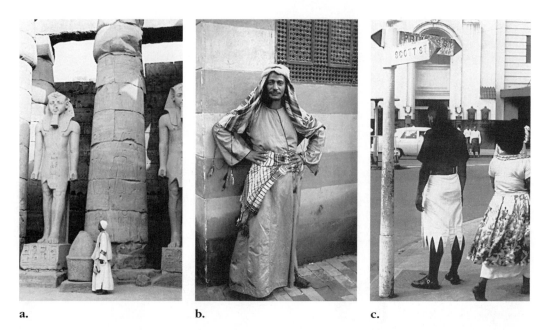

a. b. c.

Figure 3.29 *Custom or tradition establishes the sex of a garment. For centuries men have worn skirts in many parts of the world. (a) An Egyptian male stands before the temples of Karnak near Luxor. (Courtesy Qantas) (b) An Arabian man wears a body-enveloping garment that protects him from the blowing desert sands. (Courtesy Department Library Services American Museum of Natural History) (c) Policemen in Fiji direct traffic in skirts serrated at the hem. (Courtesy James W. Peters)*

for men and women: short and long, straight and curly, braided and corn-rowed, moussed and colored.

Gender Coding of Garments

> **Gender** refers to the social construction of a set of behaviors expected of males and females (Eicher, Evenson, and Lutz, 2000).

Garments have been gender coded historically. This means that certain elements within the garment have been designated as exclusively male or exclusively female symbols. Cultural customs or traditions established the gender of a garment (Figure 3.29). In the Western world people have learned to think of pants as masculine and skirts as feminine because distinct dress differences for males and females were based on role differences.

In the nineteenth century women organized several movements to reform dress. They were striking out against dress that made them look dependent on men, adorned as a sex object, and subject to health hazards. In 1851 a short dress and trouser costume was introduced by Elizabeth Smith Miller. Amelia Bloomer (Figure 3.30), among others, adopted the costume. In the late nineteenth century, sports involving physical activity demanded unencumbering dress. Popularity of the bicycle made bloomers "respectable."

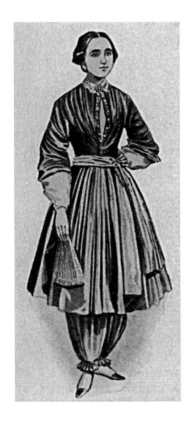

Figure 3.30 *Amelia Bloomer, among the first women to join the movement to reform dress, wore a trouser costume in the mid-1800s in spite of the ridicule that she had to endure. (Courtesy The Bettmann Archive)*

By the 1920s women's dress and women's suffrage had undergone revolutionary changes. During World War I, as women filled the wartime needs of industry, they wore trousers like the workmen they replaced. Pants were then considered appropriate work and play garments for women, although they were not considered appropriate for street wear, most social functions, or in most schools and colleges. Women's pants suits were introduced into European high fashion in the middle of the 1960s. The wearing of pants by women of all walks of life for all kinds of occasions, from marriages to funerals, was interpreted as a push for women's freedom among certain groups of the U.S. population.

During this same time a change in attire developed for men. The male fashion leaders were the rock and roll stars of the 1960s, who dressed flamboyantly. Their young fans adopted these styles, and soon men of all ages and socioeconomic levels were caught up in the fashion-forward style.

First came color. The standard businessmen's white dress shirt became colored and patterned, worn first by those in artistic fields.

Bell-bottomed trousers came next. As the popularity of jeans for everyone spread, new designs developed. Hip huggers and bell bottoms were called *low rise* and *flares* and were adapted to the business suit pant. The universal use of body-conforming jeans made tight pants fashionable for all men. Because the close fit of these trousers eliminated pockets, some men began to carry an attaché case or purse.

African Americans, Latinos, and Asians demonstrated pride in their cultural heritages by wearing the costumes of the countries of their ancestry. The *caftan* or *jalapa* has even put some men into skirts.

Androgynous Dressing

Androgynous means having the characteristics of both male and female.

While men's clothing was moving from a very narrow conservative choice to a much wider freedom in color, design, and informality, another bastion of nineteenth- and twentieth-century masculinity, the natural face, was quietly being changed. Rock and roll celebrities, led by Elvis Presley, in the late 1950s began to use eyeliner, mascara, cheek blusher, and lip gloss. David Bowie and Alice Cooper, followed by the thousands of music groups that later created rock videos, continued this practice. During this time period, the "punkers" appeared in England, and their fashion influence moved in many directions to affect dress and adornment.

In the early 1980s two male superstars brought male makeup to an abrupt climax. England's Boy George and America's Michael Jackson both wore full makeup on and off stage. Young people who were devoted to MTV, its music, and these superstars developed a new look and easily adapted the makeup practices to their own faces. By 1984 many young men were wearing facial makeup and feminine-appearing garments.

Unisex dressing is as old as the oldest civilization, but the unisex look has most often taken on the appearance of male attire: for example, jeans and T-shirts. By 1984, there was something new in the culture: the androgynous look, designed by Jean-Paul Gaultier. He wore a skirt and used male, female, and transsexual models dressed in bandeaus and sarongs, earrings, and skirted suits. Foremost among Gaultier's beliefs was that men and women can dress alike and still look different.

Rites of Passage

Rites of passage celebrate the social movement of individuals into and out of groups (Harris and Johnson, 2000).

Certain customs that change the human form are observed for the sake of fashion, beauty, status, religion, or lifestyle. These changes involve, at the minimum, inconvenience and discomfort, and at the maximum, mutilation and continuing pain (Figure 3.31).

Many of these changes begin with ceremonies to mark the transition from childhood into adulthood. The ceremony is usually a focal point of the social and/or religious life of the community. Commonly known as puberty rites, these traditions often involve body alteration such as tooth removal, tooth-filing, scarification, or tattooing. Included also is revealing or draping the body with clothing and changing the appearance of the head and face with ornamentation or hair arrangement. Role expectations for both sexes have been involved with coming-of-age rites.

Cultural Group	Social Movement	Uses of Dress and Adornment
Balinese, teenager	Prerequisite to adulthood	Tooth-filing (Gall, 1998, p. 81)
Karens, Southeast Asian, female	Wedding	Bride changes from her unmarried Asian woman's long dress to a married woman's two-part outfit (Gall, 1998, p. 379)
Latino, female, 15 years of age	Quinceanera, presents the debutante	Best white formal dress and items of adornment
Massia, warrior	Eunoto, elevates warriors to the status of elders	Elaborate body painting headdress, and jewelry (Beckwith and Fisher, 1999, p. 52)
Maasi, female at puberty	Circumcised	Shroud of circumcision featuring headband made of cowrie shell
Minangkabau infant	A formal visit to his father's family	First haircut (Gall, 1998, p. 520)

Figure 3.31 Examples of clothing and adornment as expressions of rites of passage.

Usually the male was expected to demonstrate extreme physical strength and endure suffering to prove his manhood. Women, too, have had their share of pain during these rites.

In the United States, these practices have been abandoned by fashion. At present, the clothing of young and old is very much alike (Figure 3.32). Currently such events as high school proms, graduations, fraternity and sorority installations, military inductions, bar mitzvahs, and religious confirmations require a change of dress. Although such ceremonies are often of short duration, they do mark growing up.

Chinese Foot Binding

Foot binding in China began centuries ago and was practiced into the early years of the twentieth century (Figure 3.33). It usually occurred at a very young age: as early as three years old so that by adulthood the tiny feet would be a sign of beauty.

Marital Status

Visible means of recognizing marital status is a common practice among many different cultures (Figure 3.34). Hair arrangements have often been used for this purpose. Among the Hopi Indians the young unmarried girls wore their hair in large spirals on either side of their head as a symbol of the immature squash blossom (Figure 3.35).

Figure 3.32 *Three generations dress in bib overalls. They say each has worn them at various times throughout their lives.*

Figure 3.33 *Social status can be expressed by size or scale. Shoes worn by an American woman contrast with the shoes once worn on the bound foot of a Chinese woman. (Courtesy JoAnn Crist)*

Figure 3.34 *When a young Zulu woman is ready for marriage, the sign is a decorated hairstyle. Headbands are worn to show respect for the father-in-law. Beadworked rectangles, which hang from the neck, are ornaments indicating an engagement. The color and pattern of the beads have meaning and express the girls' wishes. These ornamented pieces are similar to love letters. (Courtesy South African Tourist Corporation)*

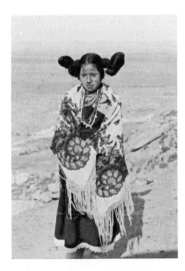

Figure 3.35 *This Hopi hairstyle represents the immature squash blossom. (Courtesy Department Library Services American Museum of Natural History)*

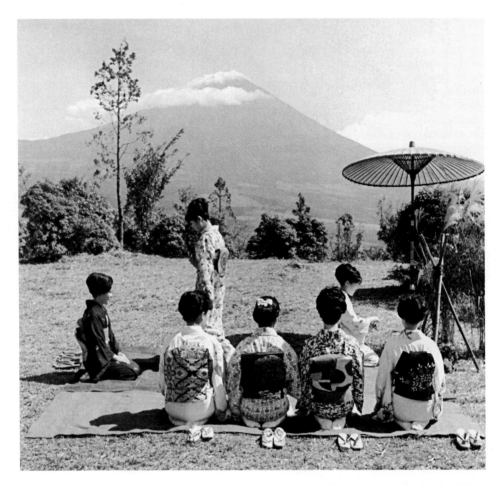

Figure 3.36 *In Japan the young women wear bright, colorful, patterned kimonos while the mature and married women wear solid colors in dark shades. The manner in which the obi is tied also indicates marital status. (Courtesy Japan National Tourist Organization)*

In Japan, the color of the kimono was used to show age. Young children and marriageable young women wore brightly colored and gaily patterned kimonos. Dark kimonos of a solid color were for the mature, including married women (Figure 3.36).

Traditional Japanese hairstyling was stiffened into sculptured shapes with camellia oil. Unmarried girls wore one large puff in front and a smaller one behind, whereas married women wore just one puff placed on top of the head (Figure 3.37).

In Japan, the kimono is held together with an obi, a band of decorated cloth about 5 yards long and a foot wide. The way the obi is tied indicates the wearer's marital state. On her wedding day the bride wears the obi tied in a butterfly bow straight across the back or at an angle as young girls do. As a married woman, she ties her obi in a flat knot across the back. The sleeve of the kimono is also used to show marital state. Young girls wear kimonos with long swinging sleeves. The married woman's kimono is called the *kosode* and has a small, short sleeve.

Figure 3.37 *Traditional Japanese hairstyling stiffened into sculptured shapes with camellia oil. A Japanese beauty salon (right) creates traditional hairstyles that indicate marital status. (Courtesy Japan National Tourist Organization)*

To mark a change of status, widows in Cambodia have traditionally worn white garments and shaved their heads. Similarly, in the past, women who entered Catholic convents had their hair cut very short or shaved as a symbol of shedding the vanities of this world to become brides of Christ.

Rings are popular in many cultures as symbols of marriage. The placement of the ring varies. Some wear the rings on the right hand and some on the left. Various fingers are also used. Sometimes the ring is placed in the nose or on the toes. In some cultures bracelets worn on the arms and ankles also take on this symbolism.

Political Beliefs

Political movements have been supported and suppressed by dress. During the Roman Empire the Phrygian-style cap was worn by slaves who were given their freedom. This same cap was worn by the French revolutionists and the American revolutionists as a symbol of freedom. In the American Revolution it was known as the liberty cap. Perhaps the most famous political garment was the *sans-culotte,* which became the battle cry of the French Revolution of 1789.

Religious Ideas

Clothing and religion have been intertwined throughout history. Many examples of clothing rules and regulations are available in the wide range of religious practices from ancient to current times. The special qualities of clothing, such as identification, simplicity, propriety, reserve, and adornment, contribute to the enduring relationship between clothing and religions.

Tenets of the Islamic faith prohibit the wearing of garments of pure silk. However, weaving silk with cotton creates an acceptable fabric. Followers can accept this compromise with reality while still adhering to the letter of the law.

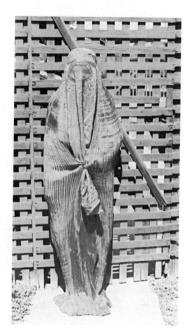

Figure 3.38 *In some Muslim countries women wear a garment that shields them from the eyes of others. The bright red-orange silk garment of Afghanistan has tiny knife pleats. A fine mesh grille permits the wearer to see her way.*

The East Indian woman is adorned with a red or saffron *tika* mark on her fore-head to show that she has made her offering at the temple. The tika symbol is of Hindu origin. It has now become fashionable for the non-Hindu East Indian also to wear a tika. The ultramodern East Indian girl has replaced the traditional tika with a sequin to match the color of her sari.

In some Islamic countries, women wear a veil that covers them from head to toe when they leave their homes. The wearing of this veil, or *burka,* as it is known in Pakistan, is a condition known as being in *purdah* (Figures 3.38 and 3.39). In Chad, Muslim women are covered even more completely; they may expose only one hand and one eye. Saudi Arabian women follow rigid practices in covering their bodies. The Muslim women of Indonesia, Malaysia, and Egypt do not wear such a garment. The holy book of the Muslims, the Koran, does not spell out rigid rules pertaining to body covering. It does not instruct women to veil their faces; rather, the Koran provides guidance (Koran, sura [Chapter] 24, aya [verse] 30).

Each country interprets this guidance according to its tradition. Societies with a tradition of rigid male domination interpret the Koran in a strict sense, while others are more tolerant.

Holy men of many faiths are distinguished by their dress. The *sadhus* of India are wandering holy men who devote their entire lives to meditation. They wear a min-imum of clothing to show their ascetic condition. On their foreheads, lines of col-ored ashes form the signs of the Hindu deities.

The saffron-robed monks of the Buddhist faith do not blend in with the dress of the Buddhist followers. Their specially draped garment of an intense yellow-orange color sets them apart from the masses (Figure 3.40).

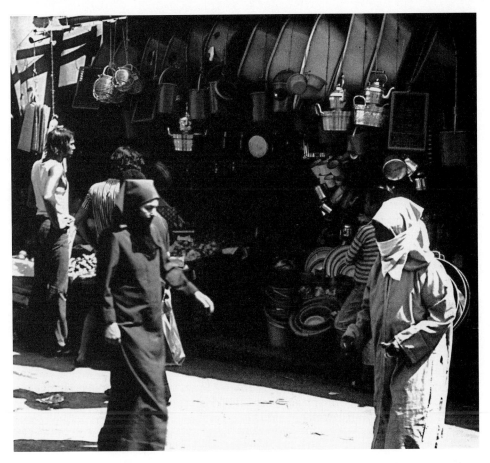

Figure 3.39 *Tangier, Morocco. Muslim women wear a veil around the head and another below the eyes as a shield from the sight of others. (Courtesy James W. Peters)*

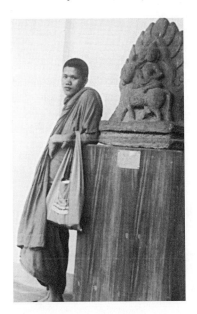

Figure 3.40 *This saffron-robed monk of Thailand wears a garment that sets him apart from his fellow man.*

In the United States many religions are identified by dress. The *Rama Krishna* groups have adopted a yellow robe similar to that of the Buddhist monk. Their heads are shaved except for the crown hair that is braided into a long queue. The Amish cling to a farm dress where the men wear work clothes or black suits, black felt hats, and bearded faces. The women wear somber-colored, body-concealing dresses that cover arms and legs; bonnets cover their heads. Their children are dressed similarly. The people of this faith avoid such modern devices as buttons and zippers.

The clothing of Catholic nuns has gone through a period of change and transition. Some nuns are identified by the traditional medieval habit; another member of the same order may be dressed very fashionably. A third member of the order may be dressed in a combination of traditional and modern, with the head veiled, a somber-colored midcalf-length skirt, and a large visible crucifix.

Technical Changes and Industrialization

In a technical and highly industrial society, clothing styles change rapidly. This has been true in the United States. The earliest settlers were farmers who often were able to produce a surplus of crops that could be marketed, such as cotton. To process the cotton, textile mills were built. Mills produced great amounts of fabric, and factories to mass produce clothing followed. The United States has been in the clothing business since this early period.

A study of the history of dress in the United States reveals continued changes in styles. Technical advancement and vast industrialization and merchandising have created the tremendous clothing industry in this country. To support this giant, changing styles and planned obsolescence are necessary.

Aesthetic Ideals

Aesthetics refers to the understanding and appreciation of art.

Ideals of beauty are part of each culture. Individuals learn what is considered beautiful in their society. The standards for judging what is beautiful vary as widely as the geographic locations of the different societies. The customs of body covering and adornment reflect what is considered aesthetically pleasing. There is no right way for all people to be beautiful.

Diaspora and International Style in Clothing and Adornment

Diaspora (dy-as'-puh-ruh) is defined as members of a cultural group who have migrated to other places (Eicher, Evenson, and Lutz, 2000, p. 36).

Diffusion is the spread of customs and practices from one culture to another.

Over the years the rate of migration of people from one geographical area to another has increased dramatically. Today the term *diaspora* refers to various ethnic-group communities living outside of their land of origin.

Anthias (1998) described diaspora as "the processes of and adaptation relating to a large range of transnational migration movements. . . . " (p. 557). In 1990, immigration to the United States reached a record level. At that time over 10 percent of all Americans were born in other countries. Swerdlow (2001) further asserted that "migration patterns world wide show a flow of people from poor countries to those with stronger economies. . . . " (p. 46).

These ethnic, cultural, and subcultural groups bring with them symbols of community and culture. Migrants may have multiple and complex relationships with both their homelands and their new places of settlement (Huang, Teo, and Yeoh, 2000). Within the context of a particular geographical location these ideas and symbols are borrowed, shared, mixed, blended, and reinterpreted.

People are creative about borrowing. Consumers pick and choose from multiple possibilities and sources. Usually individuals' selections are limited to those elements from the other culture that seem compatible with their existing culture. Furthermore, the borrowed symbols undergo modification. Participants reconstruct and reconstitute their new identities (Kaiser, 1990).

Nowhere are the borrowing, mixing, and blending of symbols more evident than in the symbols of dress and adornment. Indeed, blending the national with the international in dress and adornment has become the predominant form of fashion in postmodern cultures.

Goldstein-Gidoni (2001) "examined the processes of cultural making and marking of the 'indigenous' and the 'foreign' in contemporary Japan" (p. 68). He observed the foreign and the local interacting in a unique way. For example, most Japanese wear the *yofuku* (Western wear) most of the time and the kimono on special occasions when they want to express their Japaneseness. It is argued that "dressing up in kimono means much more than wrapping the body with kimono itself, it includes not only the proper hair, setting accessories, and shoes (tabi and zori) but also the appropriate demeanor" (p. 79).

In almost every society one can observe ethnic influences from other cultures. In modern Moscow, for example, the Italian presence is noted through Benetton's new 21,000-square-foot megastore, which replaced the state-run Nataska. Benetton also replaced Soviet fashions with Italian fashions (Montaigne, 2001). The United States is well on its way to becoming the first country in history that is literally made up of every part of the world, wrote Swerdlow (2001). Japanese have become westernized on one hand but have maintained their Japanessness on the other. London thrives as a society of multiethnic groups; global finance; and international food, culture, and fashion (Worrall, 2000).

While these multicultural urban centers paint a picture of homogeneity, in fact, this may be an illusion. Beneath the look of sameness may be "a current of ethnic soul—a diversity" (Swerdlow, 2001, pp. 48–49) or symbolic ethnicity that people cling to as they conform. (Examples of "ethnic soul" are shown in Figure 3.41 and 3.42; examples of borrowing and blending are shown in Figures 3.43, 3.44, and 3.45

Figure 3.41 *(a) A* Quinceanera *usually includes the waltz led by the father and the debutante. (b) Former UCLA professor wears his tartan clan as often as possible. (c) The* barong tagalog *remains the national attire of the Philippines and is the proper clothing for any Filipino formal occasion. This beautiful garment is made of pineapple fiber and is embellished with the finest hand embroidery.*

Figure 3.42 *Students from Nigeria frequently wear traditional dress on campus. Sometimes they wear the headwrap only, always in African-inspired fabric, with a pair of blue jeans and a T-shirt.*

Figure 3.43 *Some people celebrate difference. This woman has an almost full-body tattoo. The symbols all have important meanings for her.*

Figure 3.44 *Which body part will he pierce next?*

Figure 3.45 *The 1998 California State University-Long Beach design competition featured Asian Indian-inspired designs. For the two longer skirts, the traditional sari was used as the fabric.*
(Courtesy Edit Keshishan)

and in Case Study 3.1). International symbols in dress and adornment filter through the cultural milieu while national symbols remain as well.

Although twelve of the European member nations have come together around the principle of cooperation, they hold true to their cultural diversity—a culture like a *bouquet de fleurs,* as remarked by Herr Eisenhauer, a German native (Reid, 2002). Therefore, on special occasions Portuguese women will continue to wear a vertically striped woven skirt, in red, with a heavily embroidered border. Spanish males will continue to wear, for special occasions, a well-fitted short jacket and trousers and a wide-brimmed sombrero. French older women may continue to wear the working dress of the fisherman's wife. And so from Germany to Belgium, the Netherlands, Luxembourg, the U.K., Sweden, Finland, Denmark, Austria, and Italy the practice of wearing traditional dress for special occasions will continue.

ACTIVITY 3.3 World Dress

Search the Internet to locate the types of clothing worn in one of the following locations:

Tokyo, Japan	Mexico City, Mexico
Seoul, Korea	Dakar, Senegal
San Juan, Puerto Rico	Johannesburg, South Africa
London, England	Anchorage, Alaska

Take notes. Compare your findings with those of your classmates.

▶ Summary

This chapter demonstrates the influence of culture on individuals' and groups' selections of items of clothing and personal adornment. Cultural categories such as age, gender, ethnicity, and economic position are communicated through choices in clothing and items of personal adornment. Each individual has a cultural history that, more or less, influences the way they construct their identity. The fashion professional uses this information to better design, produce, and select products to meet the needs of a culturally diverse consuming population.

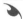

▶ Key Terms and Concepts

Adornment	Gender
Aesthetic	Modesty
Androgynous	Protection
Clo value	Psychological need
Culture	Rites of passage
Diaspora	Sociocultural need
Diffusion	Sumptuary laws
Ethnic identity	

▶ References

Anthias, F. (1998). Evaluating "diaspora": Beyond ethnicity? *Sociology, 32*(3), 557–580.

Barber, E. W. (1999). *The mummies of Urumchi*. New York: Norton.

Beckwith, C., and Fisher, A. (1999). Masai passage to manhood. *National Geographic, 196*(3), 52–56.

Coulson, D. (1999). Ancient art of the Sallara. *National Geographic, 195*(8), 98–119.

Ember, C. R., and Ember, M. (1999). *Cultural anthropology*. Upper Saddle River, NJ: Prentice Hall.

Eicher, J. B., Evenson. S. L., and Lutz, H. A. (2000). *The visible self: Global perspectives on dress, culture, and society*. New York: Fairchild Publications.

Gall, T. L. (Ed.). (1998). *Worldmark encyclopedia of cultures and daily life*. Detroit: Gale Research.

Goldstein-Gidoni, O. (2001). The making and marking of the 'Japanese' and the 'western' on Japanese contemporary material culture. *Journal of Material Culture, 6*(1), 67–90.

CASE STUDY 3.1

Beatrice Wood: A Case Study *by Marcia Forsberg*

American ceramist Beatrice Wood was as dazzling as the iridescent, luster-glazed pottery she became famous for. She dressed up for life, simultaneously embellishing her luminous bowls, chalices, vases, goblets, pots, and vessels with equivalent sparkle.

Beatrice was notoriously flirtatious and witty, quite like her "naughty" clay folk-art figurative sculptures that humorously explore social mores and the duality of the sexes.

Her colorful personality was reflected in her art as well as in her style of dress. Distinctive clothing and jewelry were not simply props; they were an expression of the woman herself.

Beatrice had a fun-loving but rebellious streak, and, ever the coquette, she enjoyed attention. What better way to get it than to defy convention through her appearance? The stunning image she presented to the world was as carefully assembled as one of her beautiful ceramic pieces.

In the early 1960s, an official invitation to show her work and to lecture on American crafts prompted Beatrice to go to India three times. She fell in love with the culture, and after her second visit, she chose to wear Indian saris as her everyday dress

Beatrice Wood challenged the cultural category of ethnicity and the traditional assumptions about who should wear the sari. (Courtesy Richard A. Nightingale, Trustee, Beatrice Wood Personal Property Trust)

continues

CASE STUDY 3.1

until her death at age 105 in March 1998. Depending on her mood, she was wrapped shoulder to ankle in a gauzy, pale pastel sari or a bright, vibrantly colored one.

And she piled on a good pound or two of chunky, jingling jewelry—various beaded, silver, or antique necklaces, multiple rings on fingers and toes, wide bracelets, and dangling earrings.

"I love jewelry, although my mother said so much jewelry was vulgar," Beatrice declared. "If I were younger I would put a diamond in my nose," she said at age 68.

She wore her beloved Indian garb even when mixing luster glazes and while working at the potter's wheel and kiln in her Ojai, California, home-studio. She found saris "comfortable, economic and lovely. I don't know why women would want to wear anything else."

Born to wealth and privilege in San Francisco in 1893, Beatrice was raised on New York's fashionable Upper East Side. Her aristocratic and domineering mother "dressed me in lace, taught me to curtsy and to remain silent unless spoken to," wrote Beatrice in her autobiography, *I Shock Myself.*

Beatrice broke away from her family's comfortable but stifling lifestyle and took off for Paris to study drawing and acting. Finally returning to New York at the beginning of World War I, she entered the Dada art circle and modern art scene through two great loves of her life—artist Marcel Duchamp and French diplomat and writer Henri-Pierre Roche.

Beatrice was a nonconformist in how she lived and how she dressed. But she followed her instincts and always landed on her feet despite an unhappy childhood, lost loves, and financial setbacks.

Beatrice's ceramic pieces and drawings are found in the collections of the Metropolitan Museum of Art, the Museum of Modern Art, the Smithsonian Institution, the Victoria and Albert Museum, the Los Angeles County Museum of Art, and numerous others.

———

Forsberg, M. (1998). Portrait of the artist as an ageless woman. *Modern Maturity, 41*(2), 34. Naumann, F. M., (Ed.). (1997). *Beatrice Wood: A centennial tribute.* New York: American Craft Museum.

Harris, M., and Johnson, O. (2000). *Cultural anthropology.* Boston, MA: Allyn & Bacon.

Huang, S., Teo, P., and Yeoh, S. A. (2000). Diasporic subjects and identity negotiations: Women in and from Asia. *Women's Studies International Forum, 23*(4), 391–398.

Kadolph, S. J. (1998). *Quality assurance for textiles and apparel.* New York: Fairchild Publications.

Kaiser, S. B. (1990). *The social psychology of clothing: Symbolic appearances in context.* New York: Macmillan.

Montaigne, F. (2001). Russia rising. *National Geographic, 200*(5), 2–31.

O'Neal, G. (1998). African American women's professional dress as expression of ethnicity. *Journal of Family and Consumer Sciences, 90*(1), 28–33.

Parfit, M. (2000). Dawn of humans. *National Geographic, 198*(6), 40–46.

Reid, T. J. (2002). The new Europe. *National Geographic, 201*(1), 32–47.

Reinhard, J. (1999). Frozen in time. *National Geographic, 196*(5), 36–55.

Ryder, M. (2000). The functional history of clothing. *The Textile Institute, 29*(3), 13–19.

Swerdlow, J. L. (2001). Changing America. *National Geographic, 201*(3), 42–61.

Wallace, B. (1999). Dress the part. *Time Mirror Magazine, 52*(4), 100–107.

Worrall, S. (2000). London on a roll. *National Geographic, 197*(6), 2–21.

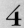

Chapter | 4

Sociopsychological Influences

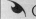 Objectives

- Explain the significance of apparel as a form of nonverbal communication.
- Apply the theory of impression formation to clothing and human behavior.
- Apply individuality to clothing and human behavior.
- Recognize the role of physical and nonphysical qualities in individuality, such as physical appearance, self-image, personality, and lifestyle.

mage! Impression! In the same length of time that it takes to read those two words an individual can come in contact with a stranger and make an impression. The reflex of a first impression is automatic and instantaneous. As W. Jacobson said, "Our clothes are our calling cards." People observe strangers and decide if they are friendly or threatening, and whether they are worthy of more attention. This speedy observation is categorized and the ensuing behavior is determined based on the combinations of these first assessments. If a stranger appears nonthreatening and not very interesting, the impression will probably not even register. If the stranger is threatening, more attention will be given and various physical actions will follow to alleviate the fear. If the stranger is friendly and interesting, attention is piqued and the first impression is recorded and remembered.

Individuals in a highly competitive society are repeatedly judged in the course of their daily lives. These assessments come in the form of first impressions, and the images created by these first impressions can change a person's life. They can mean the difference between success and failure, not only in interpersonal relationships but also in educational pursuits and professional careers.

The marketplace is jammed with items that are packaged to make a calculated first impression. If the package design does not transmit a visual message that attracts

and sells the consumer, then the packaging is manipulated until a satisfactory visual image is achieved or the product is withdrawn from the market. Unimpressive product packaging has been responsible for the bankruptcy of many business ventures. The packaged product has to "look good" to the consumer or it will not be purchased. The product that does not have the "right look" often fails.

The composition of society puts people into the same kind of supermarket competition. They must be "packaged" to make the right visual image. People packaging includes clothing and decorative accessories, grooming, and scents as well as physical appearance, facial expressions, and body movements (Case Study 4.1).

This chapter discusses the use of nonverbal communication and impression formation as they relate to sending and receiving clothing messages. Then, psychological and sociological influences such as self-image, personality, and lifestyle are explored to enhance the understanding of complex, contemporary people and the images they present.

Nonverbal Communication

Nonverbal communication is the use of symbols for expressing an idea, thought, or opinion.

Clothing has been called a **silent language.** As such, it has a silent vocabulary that takes the form of symbols (signs, cues, or icons) used by individuals as tools for social interaction. This form of nonverbal communication is very informative. Through dress, individuals tell others:

- What kind of person they are.
- What kind of person they think they are.

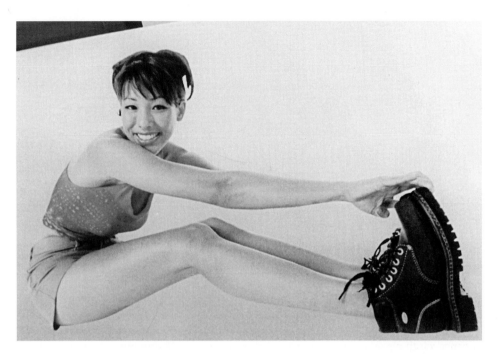

Figure 4.1 *Clothing has been called a silent language. What messages do the clothing symbols in this photograph send? (Courtesy Skechers U.S.A.)*

- What kind of person they would like to be.
- What they think about the person they represent (Figure 4.1).

When speaking a language and saying something that is misunderstood or not intended, individuals can usually retract their words immediately and attempt to clarify their intent. The silent language of clothing, however, cannot be as easily retracted. Clarifying a clothing message requires a change of clothes and another opportunity to say something. Thus, close attention should be paid to clothing messages.

Reading Clothing Messages

Clothing symbols express meaning and provide information to others. Observers understand clothing messages if the meaning that the wearer attaches to the clothing is the same message that the observer reads. For example, wearing a letter jacket may have special meaning only for alumni of the same institution (Figure 4.2). Any person will have difficulty interpreting cultural clothing symbols when they differ from those that are familiar. When sending and receiving clothing messages, it is important for the wearer and observer to have the same clothing symbol vocabulary.

Clothing symbols are not static. They assume different meanings depending on where, when, and how the clothing is worn and who wears the clothing. For

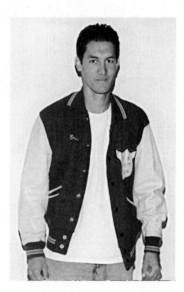

Figure 4.2 *A letter jacket may have special meaning only for alumni of the same institution.*

example, a body draped in a white sheet sends one message on Halloween night and another message at a college fraternity/sorority Roman theme party.

Some clothing symbols do not lend themselves to all situations. For example, a business suit carries a different connotation when worn on a city street than it does when worn at the club pool. A low-cut satin dress may be appropriate at a nightclub but out of order in the office. It is the association of clothing symbols with the context that enables clothing to communicate information nonverbally (Eicher, Evenson, and Lutz, 2000).

Some clothing symbols can lead to false assumptions about the wearer. Surgery greens, the gowns worn by doctors, nurses, and technicians in a hospital surgical suite, have been adopted by some people for leisure wear. Wearing these apparel items could lead to false assumptions about the wearer's medical skills.

Clothing messages are everywhere, representing a wide range of messages such as product advertising, political beliefs, school and work loyalties, geographic travels, and humor. T-shirt illustrations and slogans are visual symbols for all to see and interpret (Figure 4.3).

All types of uniforms present clothing symbols. They are worn by millions of students and employees every day (Figure 4.4). Uniforms can represent:

- Power and authority
- A social or cultural role
- Rank and privilege
- Identification and membership
- Loyalty
- Professionalism and credibility
- Competence

Clothing messages communicated through uniforms vary with the observer and the circumstances under which the uniform is being observed. For example, parts of

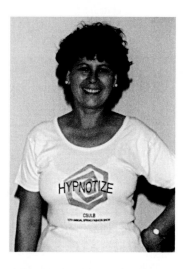

Figure 4.3 *T-shirts provide clothing messages for people to see and interpret.*

Examples of people who wear uniforms:	
Astronaut	Medical technician
Automobile mechanic	Military officer
Band member	Police officer
Discount store sales associate	Real estate sales associate
Fast-food server	Sports team member
Flight attendant	Student

Figure 4.4 Clothing messages and uniforms.

military uniforms may be worn as accessories by civilians, but when worn by a member of the active military, they represent an entirely different message.

People have preconceived ideas of what various clothing symbols represent. Each individual holds an infinite number of ideas that can be used to interpret a particular cue or set of cues. Impressions and the behavior that follows them are based on these individual responses to clothing symbols, which are based on past experiences and personal values.

Activity 4.1 supports the concept that each person speaks a silent clothing language through the way he or she dresses. As in verbal communication, sometimes the wearer's clothing message is clearly understood and sometimes it is not. If wearers and observers have a broad clothing symbol vocabulary, then their chances of sharing the meaning of the message is high. But message sending and receiving can be influenced by personalities and circumstances that may cause misunderstandings. Developing clothing communication skills is an important part of literacy.

ACTIVITY 4.1 Clothing Symbols and Their Messages

List the messages each of these clothing symbols would have for a teenager, a professor, a gang member, or an elderly person.

Designer clothing	Ethnic clothing
Jogging shorts	Sweat suits
Reading glasses	Sunglasses
Briefcase	Backpack
Spike heels	Platform sandals
Nose ring	Pierced ears

Sending and Receiving Clothing Messages

To more fully understand how clothing messages are developed and interpreted, a **person perception communication model** can be used to give a pictorial view of the process (Stanley, 1986). The model consists of four components: (1) the environment, (2) the sender, (3) the receiver, and (4) the social context (Figure 4.5).

The *environment* refers to the physical, technological, aesthetic, and cultural domains that influence the individual. For example, the colors in one's surroundings, the resources available in the geographic area, and the culture's level of technological advancement affect people's communication development.

The *sender,* the person who develops the message (Case study 4.2), and the *receiver,* the person who reads and interprets the message (Case study 4.3), are key players in the model. Each person involved in the communication has three aspects of the self that influence how messages are sent and received: their intrapersonal development, their interpersonal development, and the socialization processes they have experienced.

A person's *intrapersonal development* includes:

- *Cognitive* development: the ability to think critically and analytically.
- *Perceptual* development: the ability to adapt to one's environment.
- *Sex-role* development: learned gender behavioral expectations set by one's culture.

Interpersonal development is best represented by Sontag and Schlater's (1982) five perspectives of Proximity to Self.

- *Picture of self* consists of a profile of the individual's physical, mental, and material characteristics. Clothing cues are used to communicate a person's character.
- *Presentation of self to others* includes ongoing behavior used to reflect identity, values, and attitudes. Clothing cues project the desired image.
- *Self-worth* is the comparison of the self to a cultural standard. Clothing is chosen to reflect one's self-esteem.

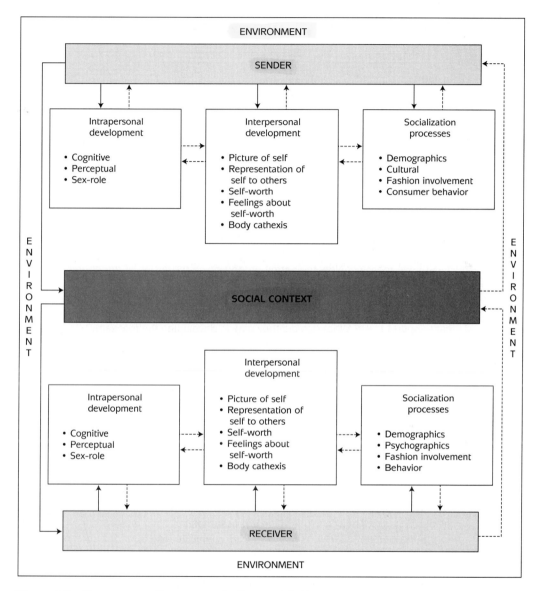

Figure 4.5 Person perception communication model. *(Courtesy of M. Sue Stanley)*

- *Feelings about self-worth* consist of the emotional and behavioral response to self-evaluation and affect the behavior and projected image of the self. People who feel good about themselves act like they feel good about themselves.
- *Body cathexis* is the level of satisfaction one feels toward one's physical self. Clothing is used to camouflage or emphasize real or imagined physical attributes.

CASE STUDY 4.2

 The Sender

In the foreword to Cunningham and Marberry's book, *Crowns: Portraits of Black Women in Church Hats* (2000), Maya Angelou wrote:

> Sundays are a precious gift to hardworking women. . . . If the woman is African American, she has some fancy hat boxes on a shelf. . . . She would have laid out the clothes she plans to wear to church, the stockings and the shoes, but the choosing of the hat is saved for Sunday morning itself. The woman may, depending on how many she has, lay them out. . . . She may try on each hat two or three times before she dresses. . . . She dresses in the finest Sunday church clothes she owns, layers her face with Fashion Fair cosmetics and sprays herself with a wonderful perfume, and then puts on THE HAT. . . . She looks at her reflection from every possible angle. And then, she leaves home and joins the company of her mothers and aunts. . . . They, too, had waited longingly for the gift of Sunday morning. Now they stroll up and down the aisles of the church, stars of splendor. (pp. 2–3)

Describe an event or celebration that focuses on a sender. What were the significant apparel cues? What role did they play in developing the message?

CASE STUDY 4.3

 The Power of the Receiver

In their article on the role of clothing as evidence in rape or sexual harassment court cases, Lennon, Johnson, and Schulz (1999) discussed the impact of inferences drawn from apparel cues. Their review of court cases revealed that (1) women perceived as dressing like prostitutes were identified as soliciting sex; (2) men infer more sexuality in apparel items than do women; and (3) there is a gender misinterpretation of fashion looks. They concluded "the law assumes that the perceiver's view of the information communicated by dress is both accurate and intended by the wearer" (p. 150). Clothing was seen as an indicator of showing consent and welcoming, encouraging, and accepting sexual involvement.

Have you ever assigned characteristics to someone only to find out later that they were inaccurate? What are some of the ways people can check the accuracy of their perceptions?

Socialization processes are the demographic and lifestyle aspects of a person that influence their fashion involvement and consumer behavior. Examples include age, occupation, education, income, group membership, values, and attitudes.

The *social context* component brings situations and motives involved in nonverbal communication together with the sending and receiving of clothing messages.

Examples of the social context include the physical setting, emotional climate, purpose of the communication, interpersonal relationships among the participants, social status, and power.

How does the model work? Using a stage play as an analogy, the sender uses props (clothing) on stage (social context) with a script (message) to perform the play (communicate with the receiver). In response, the audience claps in praise or boos in rejection of the performance (the message is or is not understood).

Example of the model

So far, the discussion has centered on the concepts involved in nonverbal communication through clothing such as the silent language of clothes, reading clothing messages, and sending and receiving messages in a social context. The next section focuses on impression formation and the relationship between what a person wears and the judgments that result from clothing choices.

Impression Formation

Impression formation is when an observer makes attribute and behavioral judgments of wearers based on observable characteristics.

Impressions are an important form of nonverbal communication. During brief encounters a limited number of cues are used by message receivers to assess the message sender. Researchers have found that clothing affects impressions (Behling and Williams, 1991; Bell, 1991; Nisbett and Johnson, 1992; Pradheepram and Littrell, 1993). Clothing gives cues to others about age, sex, race, social status, roles, intelligence, popularity, potential success, and competence.

The First Four Minutes

Initial human contact is established or reaffirmed in a very short period of time. Observations of hundreds of people over time in a wide variety of social, professional, and personal settings found that the length of time during which strangers in a social situation interact before they decide to part or continue their encounter ranges from a few seconds to four minutes. This brief period of time is considered to be the breakaway point—the length of contact that is considered socially acceptable before a shift of conversational partners can occur.

few sec. to 4 min.

First Impression

Many times a person has only one chance to make a first impression (Figure 4.6). Approval or rejection results. This happens in social situations, in school competitions, and in job interviews. If a person wins approval, there will be other opportunities to reinforce the first impression, alter the initial judgment, or perhaps change it completely. If the person is rejected, there may never be a second chance to make an impression.

Today, most people have many opportunities for first impressions. They frequently move from one job to another, sometimes across the country or to another country. Parties, tours, clubs, schools, and other kinds of group contact throw people together quickly and randomly. The need for understanding effective first impressions is a very real one.

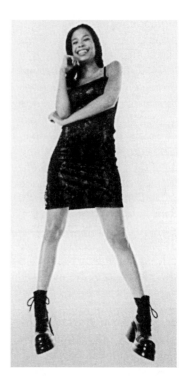

Figure 4.6 *First impressions are an important form of nonverbal communication. During the initial contact many clothing cues are received and judgments are made. What is the first impression of the person pictured here? (Courtesy Skechers U.S.A.)*

The Halo Effect

A **halo effect** results when a few observable characteristics act as a gateway to the assignment of other positive or negative characteristics.

The halo effect results from a static first impression. It may become a lasting and unchanging impression regardless of any future encounters with that person. People who are positively impressed with a person at the first meeting often credit that person with talents and traits that may not have any relationship to the first encounter or to the individual.

Here is a scenario to illustrate how the halo effect works. A teacher who likes the way a student looks and acts in the first class meeting may assume the student is very intelligent. Subsequent class work this student produces may be subjected to the halo effect; thus, the student may receive a good grade that is not earned.

The reverse may be true also. When a poor first impression is made, the halo effect can influence opinions negatively. When this happens, the future conduct or performance of the individual does not alter the original negative impression. For example, no matter how successful or talented a student proves to be, the teacher's evaluation remains critical, and, when grading is subjective, this student may receive lower marks than earned.

ACTIVITY 4.2 Identifying Stereotypes

Give an example of assigning a stereotype to someone based on his or her appearance.

Emotional reactions + Intellectual judgments and experiences = Stereotyping
Sound
Sight
Smell
Physical characteristics

Stereotyping

A **stereotype** is a standardized mental picture that is held in common about members of a group.

Stereotypes represent an overgeneralized opinion that can influence the understanding of others. They are simplistic in nature and often convey special meanings. In impression formation they are used as instant mental shorthand to categorize and sort information. Criteria used to form stereotypes can include age, sex, ethnicity, politics, religion, or physical appearance (Activity 4.2).

Assumptions are opinions or ideas that are taken for granted as true or factual.

Stereotypes are based on assumptions. What and how a person assumes can be critically important in the development of stereotypes. At the time of initial contact, instant assumptions are developed and become a part of an impression. Some assumptions are valid; others may not be. Since everyone operates at one time or another on assumption, it is important to recognize assumptions' influence in stereotyping (Figure 4.7). Some stereotypes that illustrate the influence of assumptions are:

Examples:

- Blondes are dumb.
- Homosexuals have AIDS.
- African Americans are good dancers.
- Whites are racists.
- Latinos and Latinas are passionate lovers.
- Obese people are lazy.
- Asians get good grades.
- Irish like green.

If individuals receive further information regarding a person that conflicts with the stereotype and do not revise their assumptions but rather hold to their stereotyping, then prejudice results (Kaiser, 1996).

Figure 4.7 *Stereotyped societal uniforms such as these grass skirts are often associated with people of the South Seas. Here Tahitian dancers greet tourists at an air terminal, thus promoting such typing. (Courtesy Qantas)*

Role	Example
Communicate a role	Actress
Motivate a person to act	Athlete in sports uniform
Attract attention	T-shirt slogan
Separate groups	Gang membership
Show discipline	Follow dress codes
Show rebellion	Wear socially unacceptable clothing

Figure 4.8 Role of clothing in impression formation.

Perceptions

How clothing is perceived depends entirely on the frame of reference of the person making the judgment (Figure 4.8). Different people, because of their own unique background, will evaluate clothing cues in their own manner. People who dress in a similar manner generally approve of each other and criticize those who dress differently. The wider the variation in dress, the more divergent the impression.

CASE STUDY 4.4

 Impression Formation

In his *Wall Street Journal* article "Survival Strategies for the Casual Office," Scott Omelianuk (2000) discussed the role of casual dress in corporate offices. Some career professionals are "worried that their bright green cable-knit sweater makes them look like a $5-an-hour intern" (p. A-18). Others see "the shapely city clerk in Newark who thought it was okay one particularly hot day to wear a tube top" (p. A-18).

Omelianuk suggests that casual dress is simply "dressing up in a less traditionally formal way" (p. A-18). Becoming knowledgeable about casual dress is the first step to becoming comfortable about the use of casual dress at work. Professionals should blend their psychological and physical comfort with their desired professional image when selecting career apparel.

Observe the following people on your campus:

- Receptionist in the dean's office
- Campus president
- Bookstore manager
- Professor of engineering vs. professor of art

Are they wearing casual clothes? What impression have they created by their clothing choices? What impression have you created today with your clothing choices?

Up to now the discussion has focused on nonverbal communication and impression formation as they relate to the sending and receiving of clothing messages. Nonverbal communication is a message-sending and -receiving process used every day to transmit information. Clothing symbols form a vocabulary by which a wearer can tell observers who they are. Observers form impressions of wearers based on clothing symbols. Communication occurs when wearers and observers share the meaning of clothing symbols (Case Study 4.4).

Clothing is also important as a means of transmitting self-identity to others. The next section explores the components of individuality and its expression through clothing choices.

Individuality

Individuality is the personification of characteristics that make each person distinctive.

"Each individual is distinguished by a specific configuration of physical and personal characteristics along with an idiosyncratic personal history" (Eicher, Evenson, and Lutz, 2000, p. 339) (Figure 4.9). The term *individuality* is often used but seldom

Figure 4.9 *Individuality means identifying your talents and developing them to the utmost. (Courtesy Danskin, Inc.)*

ACTIVITY 4.3 Understanding Individuality

1. Write a description of your best friend. What makes this person different or distinctive?
2. Describe yourself to someone you do not know well. What distinctive adjectives would you use to explain your uniqueness?
3. Analyze both descriptions. What part did physical attributes play in your descriptions?

understood (Activity 4.3). Individuality consists of characteristics such as uniqueness, originality, risk-taking, independence, and assertiveness.

Signs of a person's individuality may be expressed through clothing choices. For example:

- Rejecting popular fashion styles that are unflattering.
- Refraining from wearing the same style garments, hair style, and jewelry just because everyone else is wearing them.
- Choosing to wear a favorite color often.
- Having a signature "look."
- Being known as the first to try new styles.

Individuality also means having an exclusive or distinctive characteristic or quality that not everyone else has, such as a dimple, freckles, a crooked tooth or a personalized physical feature such as a hairstyle or tattoo. Individuality can be expressed through apparel and accessories such as distinctive jewelry, unusual eyeglass frames, or unusual color combinations.

Each individual is composed of physical and nonphysical qualities. The physical appearance of an individual—body and face conformation, skin, nails, and hair (Chapter 5)—are observable and can be measured and described. The nonphysical properties of the individual—self-image, personality, and lifestyle—are more difficult to assess because each individual interprets these nonphysical qualities differently.

Physical Qualities

Beauty is a greater recommendation than any letter of introduction.
Aristotle, fourth century B.C.

Researchers have studied physical attractiveness extensively. They have found that physical attractiveness is measurable and, although hard to define, a consensus of what is attractive can be obtained (Figure 4.10). For example, thinness in women has

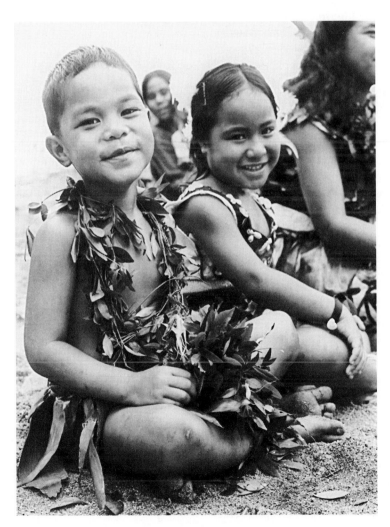

Figure 4.10 *Physical attractiveness is hard to define. When photographs are used, a consensus can be obtained. Do you consider these children physically attractive? (Courtesy Qantas, Warrem Clarke photograph)*

been found to be a culturally desirable attribute in contemporary American culture (Lennon, 1997).

The effects of physical attractiveness begin at birth. Attribute assignment and behavior reinforcement is influenced by an infant's appearance. Toys, books, movies, and television enhance the power of physical attractiveness judgments. Peers, teachers, and parents continue attribute assignment and behavior reinforcement during later socialization of the child, teen, and young adult.

In her study on the social construction of femininity in two sororities, Arthur (1999) discussed conformity to a stereotype as a means of acceptance. Through enculturation into a sorority, pledges begin to adopt the idealized images associated with the sorority look. Attractiveness is defined as fashionable, classy, thin, tanned, feminine, well-dressed, and blonde. Clothing symbolizes belongingness to the sorority and separateness from other campus females. Pledges embrace the role of a sorority member by conforming in appearance to the sorority look and wearing sorority symbols on their clothing. In return, sorority members are given the security of acceptance. Thus, the conformity needed to maintain good standing can also affect the individuality needed to be an independent young adult.

Another physical quality of appearance is body image.

> **Body image** is how the physical self is perceived (Rudd and Lennon, 2000).

Body image is a culturally defined construct that is part of a person's interpersonal development. This cultural standard can affect self-esteem, body satisfaction, and appearance satisfaction (Jung, Lennon, and Rudd, 2001; Lennon, Rudd, Sloan, and Kim, 1999; Rudd and Lennon, 2000). Culture and fashion influence the development of and changes in body image. In Western European cultures, female body satisfaction focuses on attractiveness, fitness, and thinness. By comparing themselves with members of their own group and those of other groups, these females establish an image of self-worth that in turn influences their body cathexis. Body image is seen as something that can be controlled through diet, exercise, cosmetic surgery, and clothing that camouflages less-than-desirable features.

Nonphysical Qualities

Self-Image

> **Self-image** is the physical and psychological perception that one has of oneself.

Self-image is the mental concept of how someone looks and acts. It evolves from a person's intrapersonal and interpersonal development. Self-image is dynamic. Continuous feedback such as verbal comments about clothing, physique, behavior, and nonverbal responses to one's appearance affects its development. Mirrors and photographs also provide self-image assessment of physical and nonphysical qualities. Some people also use comparative assessments, basing their judgments on cultural ideals, peer group preferences, and aspirations.

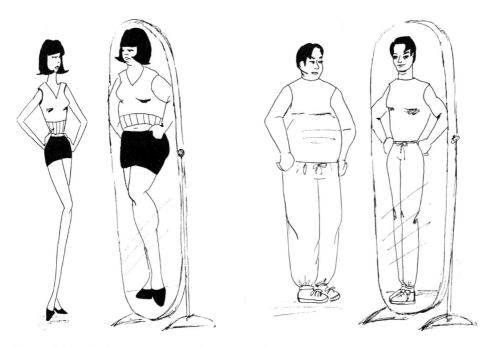

Figure 4.11 *One's self-concept might not be realistic. (Courtesy of Billy Green)*

Clothing choices express a person's self-image. For example, a chubby person may select tight pants that outline every bulge. The person may not perceive himself to be overweight; instead, his self-image allows him to believe that he appears slim, trim, and attractive in pants (Figure 4.11). When individuals have a true assessment of their self-image, they can more accurately select clothing that reflects their individuality.

Everyone has favorite clothing. These garments often offer physical as well as psychological comfort, expressing the wearer's self-image. At age 5, Mark's favorite apparel item is his tractor pants, a pair of brushed denim jeans with a tractor appliquéd on the back pocket. Life is great when Mark wears these pants. He is warm, his knees are protected during play, the pants are soft, they fit, and they are like his friends' pants. They reinforce a 5-year-old boy's self-image.

Everyone has clothing items that are out of fashion, poorly fitted, the wrong color, hard to clean, or that no longer reflect a chosen lifestyle. Some garments are continually pushed to the back of the closet for no apparent reason. The choice not to wear these garments may reflect an incompatibility with a preferred self-image: Perhaps they are not psychologically comfortable.

A person's wardrobe sends messages about who that person is. Some people have a variety of clothing that represents various images. Their closets contain a potpourri of diverse themes, with no strong underlying feeling linking them to a particular personality. Other people have a consistent sense of identity that focuses on a fixed, predictable behavior. They look the same all the time. Still other people match their wardrobes to the various roles they play. Each ensemble has an important function in identifying the role they are playing at the moment.

Personality

> **Personality** is the distinctive individual qualities of a person.

Each person is a composite of many qualities. One's personality is influenced by abilities, temperament, talents, physical structure, emotional tendencies, ideas, ideals, skills, motives, memories, goals, values, moods, attitudes, feelings, beliefs, habits, and behavior. These highly individualized qualities make up a personality. The influences of heredity, social and cultural contacts, education, and experience also contribute significantly to one's personality.

Many attempts have been made to classify personalities into types. Even one's clothing preferences have been classified into *fashion* personalities, such as dramatic or sporty (see Chapter 14). Personality typing assumes that individuals will fit into rigid groupings. It is possible to categorize people in some respects, but the many facets that make up individuality cannot be made to fit into a simple classification that covers large, diverse groups.

> **Trait** is a consistent manner of behavior.

When a person is defined as aggressive, friendly, artistic, or austere, traits are being used to describe his or her personality. Individuals possess a composite of many varied and unique traits. A personality is multifaceted, continually changing as it matures and evolves and as it is understood by others. Traits are a way of describing one's individuality.

Apparel is one tool used by individuals to express personality (Figure 4.12). For example, natural personalities are more comfortable in relaxed-style clothing with a roomy fit and layered look. Classic personalities focus on elegant, well-fitted, tailored clothing styles. Creative personalities tend to use a variety of clothing items in different combinations to reflect their mood and to show off their fitness (Spillane and Sherlock, 1995). Chapter 14 contains a more complete discussion of fashion personality.

> **Cognitive dissonance** occurs when wearers select apparel items that do not correspond with their personality or behavior, causing observers to experience discomfort and/or uncertainty.

It is important that clothing be selected to harmonize with the wearer's personality. If clothing represents certain expectations but actions are not compatible with the clothing cues, cognitive dissonance occurs. For example, if an individual dresses like an hourly employee but is actually the boss, he may incur the hostility or disrespect of those who mistake his identity.

> In **impression management,** clothing cues are used as a tool to influence the assignment of characteristics to the wearer.

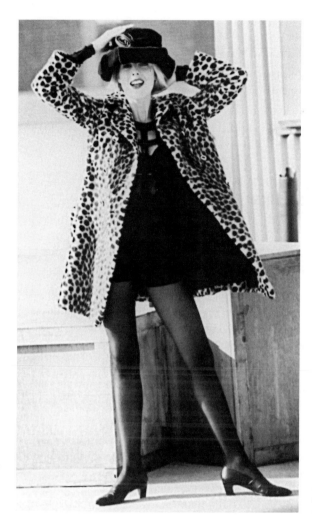

Figure 4.12 *Garments present visible cues to the characteristics of the wearer. What adjectives would describe this person's personality? (Courtesy of Jennifer Forbes)*

Because each individual is a complex personality and engages in many activities, clothing for differing moods and occasions is almost a necessity. Most wardrobes consist of a variety of garments that can be used to impress people, fulfill roles, and represent lifestyles as well as reflect one's personality. College clothing choices may reflect local customs, campus traditions, or one's major. Clothing worn at work is influenced by employer dress codes and corporate philosophy. Through impression management employees use clothing to send a nonverbal message about their desire to work for a firm or move to a higher level of employment.

Lifestyle

Lifestyle is the pattern by which we live.

ACTIVITY 4.4 Lifestyle Choices

Write a brief statement characterizing your lifestyle. Which of the following choices have shaped your lifestyle the most?

Family unit	Transportation
Financial status	Hobbies
Housing	Travel
Education	Recreation
Occupation	Leisure
Employer	Values
Geographical location	Attitudes
Food patterns	Interests
Friends	Colleagues

Lifestyles, whether or not they are consciously chosen, establish a kind of order in patterns of consumption. They are part of the socialization process that influences fashion involvement and consumer behavior. Lifestyles help people make choices from the numerous alternatives facing them each day. Once a lifestyle has been chosen, the decisions are narrowed or automatic. A way of life, friendships, food preferences, clothing choices, careers, personal philosophies, book selections, time management, speech patterns, the value placed on people and objects, and the joy of living are some of the facets of life that are determined by an individual's lifestyle (Activity 4.4).

The style of living in which one finds oneself is shaped by the things that are of primary importance to the individual at that particular time. College students generally have a lifestyle that is centered around education. Couples who choose to become parents discover that their lifestyle changes with each stage of development of their children. Empty-nest parents often make dramatic changes in their lifestyle that may include changing housing, occupation, and geographical locations along with devoting more time to education, hobbies, recreation, and travel.

Today's lifestyle may not be permanent. A child lives a lifestyle selected by family; as the child moves into adulthood, lifestyle changes correspond to the person's pattern of life. Changes of lifestyle commonly evolve as one experiences life.

Completion of education and acquiring a professional job often marks a change in lifestyle. Some people choose abrupt lifestyle changes such as changing employment or residence. For example, a business executive living in the middle of a large cosmopolitan city who moves to the wilderness to write a book has made such a change.

People identify others by their lifestyle. Outward signs such as clothes, homes, cars, and jobs help people to link with others who share similar interests and values. Popcorn and Marigold (1997) identified some late-twentieth-century lifestyle trends that have a direct impact on apparel choices (Figure 4.13).

Trend	Description	Implications for Clothing
Environment	Concern for plant and animal life and the earth's environment	Select clothing produced with environmentally friendly processes; recycling; green customers
Family life	Increased focus on family values	Wardrobes meet needs of family activities
Cocooning	Retreat into safe, home-like environment	TV and catalog shopping; use media for fashion sense
Time	Multiple roles expected of today's consumers increases the value of time	Convenience shopping; multifunctional stores; type of clothing care important
Decreased materialism	Reducing emphasis on more, bigger, better, faster	Small, more utilitarian wardrobe; reduction in shopping
Value	Increased interest in value for dollars spent	Growth of discount stores
Clanning	Finding belongingness through clubs, talk radio, support groups, cohousing, cyberclans	Social group membership
Fantasy adventure	Escape boredom; risk-free adventures	On the edge cosmetics; obsession with celebrities
Egonomics	Customization of life; service on demand	Mail order; online shopping; customized apparel
Aging	Quest for quality of life	Physical fitness; cosmetic surgery; youthful clothing and accessories; break senior citizen stereotype

Figure 4.13 Lifestyle trends. *(F. Popcorn and L. Marigold. 1997.* Clicking. *New York: HarperCollins)*

Lifestyle is determined by the values, attitudes, and interests of each individual. Changes in lifestyle can be responsible for shaping some values. It can also reshuffle the priority of one's value system.

Values are directive or motivating forces in behavior and decision making.

Values. Values are derived from one's culture, environment, family, associates, and individual experiences. They are influenced by peer groups, families, and the media, especially television, as well as the Internet and advertising. Some values are

ACTIVITY 4.5 Individual Values

Identify your top five values.
Now, prioritize them.

Beauty	Physical attractiveness
Being challenged	Financial security
Close personal relationships	Receiving love
Recognition	Nature
Professional commitment	Health
Personal integrity	Spirituality
Social skills	Family
Individuality	Solitude
New experiences	Independence
Emotional maturity	Freedom
Being masculine	People
Openness	Knowing
Being successful	Helping others be happy
Influencing others	Harmony with others
Doing things that are important	Close friendships
Giving love	Achievement
Being protective	Wisdom
Emotional security	Equality
Time	Sexual attractiveness
Comfort	Money
Happiness	Perfection
Helping others to succeed	Being respected

commonly held by all members of a specific culture but may vary in application. For example, in the United States we value free education for the young. Yet, the amount of education deemed necessary by different segments of the population may vary from basic reading and writing skills to advanced degrees. Individual experience influences the wide range in application of this value (Activity 4.5).

Understanding the influences of values on clothing choices is not always easy. Values often conflict, leading to a compromise on the part of the wearer. For example, a teen in a family with a modest income may value conformity with her peer group, but if the family budget will not allow this, some kind of value compromise must be made. Often a conflict of values leads to tension between parents and children. Length of hair, closeness of fit, color of hair dye, tattoos, and number of earrings: all have been debated in many families.

Over a period of time values may change. Group value change becomes a cultural change. This is particularly true in a technological society, as the individual must change with the times. An economic value that has changed is the method most used to pay for consumer goods such as clothing: from cash to check to credit card to debit card to e-cash. Several social values have changed as science has made dis-

Value	Description	Relationship to Clothing
Theoretical	Discovery	Focus on product information
Economic	Practical	Dress for comfort, bargain
Aesthetic	Beauty	Dress attractively
Social	Other directed	Conformity in apparel
Political	Power	Dress to impress
Religious	Spiritual	Modesty in dress

Figure 4.14 Spranger's value orientations. *(E. Spranger. 1928.* Types of Men. *P. J. W. Pigors, Trans. Halle [Saale]: Max Neimeyer Verlag)*

coveries concerning nutrition and physiology as well as diet and exercise. The clothing requirements demanded by active sports have resulted in value changes of how much body exposure is socially acceptable.

Traditionally, values have been measured using Spranger's (1928) six dominant value orientations. These six basic traits representing an individual's character were used by Allport, Vernon, and Lindzey (1960) to develop a measure to rank values. Lapitsky (1966) and Creekmore (1963) used them to develop clothing value measures (Figure 4.14).

Another system for measuring values is VALS-2 (Values and Life-Styles 2) (Russell, Lane, and Pearce, 1993). This lifestyle segmentation system clusters customers to facilitate predicting consumer behavior. There are two components to the VALS-2 system, two key dimensions that help classify consumers, and eight interconnected segments that group consumers for marketing purposes. The two key dimensions are self-orientation and resources.

Self-orientation refers to a person's need to identify his or her social image and to exist in a nurturing environment. The three components of self-orientation include principle, status, and action. Principle-orientation consumers make choices based on their inner feelings. Status-oriented consumers make choices based on the real or imagined reactions of others. Action-oriented consumers make choices based on accompanying actions.

Resources is the second key dimension. It refers to the consumer's material and acquired items such as money, position, and education and to a consumer's psychological qualities such as a person's interpersonal skills, creativity, enthusiasm, and intelligence. Figure 4.15 lists the eight interconnected segments and their implications for clothing selection.

Attitudes are expressions of feelings, thoughts, and behaviors.

VALS-2 Segment	Description	Clothing Selection
Actualizers	Successful; active; flexible; leaders; social consciousness; abundant resources	Image important; like nice things; clothing used to express individuality
Fulfilleds	Mature; secure; content; well educated; professional occupations; open to new ideas; reinforce status quo	Conservative; practical; durable; functional; value for dollars; based decisions on principles
Believers	Conservative; traditional beliefs; strong moral codes; modest education and income; focus on home, family, and faith	Predictable; buy American brands
Achievers	Successful; career oriented; self-recognition and self-identification important; like stability and to be in control; work represents duty, money, and success; family important; respect authority; conservative	Image important; want services and products that reflect their success; like luxury items
Strivers	Actions guided by others; approval of others important; limited economic, social, and resources; easily bored; impulsive	Being stylish important; copy what people have that they cannot afford
Experiencers	Young; impulsive; rebellious; seek variety and excitement; energetic; uninterested in politics; distain for authority/awed by power	Avid consumers; spend large portion of income on clothing, fast food, music, movies, videos
Makers	Practical; self-sufficient; have constructive skills; focus on family, work, and recreation; conservative; suspicious of new ideas; unimpressed by material possessions; respect authority/resent invasion of privacy	Practical; functional
Strugglers	Older; poor education; passive; concerned with health, security, and safety; very poor; focus on current needs; feel powerless; conservative; moral direction from religion	Cautious consumers; very strong brand loyalties

Figure 4.15 VALS-2 typology of American consumers. *(J. T. Russell, W. R., Lane, and C. Pearce. 1993.* Kleppner's Advertising Procedure, *(12th ed.) Upper Saddle River, NJ: Prentice Hall, 1993)*

Figure 4.16 *Attitudes are often thought of as a person's mood, opinion, or disposition. What attitudes would you assign to this person? (Courtesy of Jennifer Forbes)*

Attitudes. Attitudes are most often thought of as a person's mood, opinion, or disposition. Attitudes are individualistic. They are often learned from family and peer groups. With maturity, attitudes are molded over time by societal, familial, and educational experiences. Attitudes about clothing tend to focus on comfort, utility, conformity, economy, fashion, self-expression, and status. People reflect their attitudes about specific garment styles through apparel choices (Figure 4.16).

The concept of attitude has been divided into three components: affective, cognitive, and behavioral. The *affective component* refers to the feelings or emotions associated with a given object or entity. Clothing choices can create a wide variety of feelings or emotions (Figure 4.17).

The *cognitive aspect* of attitude focuses on the beliefs held about clothing. A person may believe that clothing is unimportant but must be tolerated because of the dictates of society. Someone else may feel that clothing is the key to social status and that by acquiring an impressive, designer wardrobe they will gain status and recognition.

The *behavioral component* of attitude is inferred from what the person actually does. A teen may stay home from a party because she does not have the right dress.

Feeling/Emotion	Clothing Choices
Sexuality	Body-revealing
Happiness	Fun-fashion, bright color
Sadness	Somber hue, body-concealing
Youthfulness	Current teen fads
Sophistication	Understated, severe, cosmopolitan
Superiority	Expensive, high-fashion, use of expensive symbols, jewelry, club insignia
Inferiority	Seductive, worn, inappropriate, or too perfect
Self-confidence	Appropriate style for the function

Figure 4.17 Attitudes and clothing choices.

A man may hide behind a voluminous coat because he is overweight. A student may be an exhibitionist, defying socially accepted attitudes with nudity.

Attitudes are expressed by the clothing selected and the behavior exhibited while wearing that clothing. For example, in the late twentieth century many male teens wore athletic shoes with their tuxedos to formal dances. This expressed their attitude that the ability to dance easily was more important than following the tradition of apparel. Their behavior allowed them to dance with ease.

Interest is a feeling of having one's attention or curiosity engaged by something.

Interests. Interest is the opposite of indifference or dislike. One may be interested in classes of things such as rocks, animals, or fashion or in fields of study such as biology, economics, or industrial technology. Usually, the stronger the interest in the subject, the more effort is put into studying the subject (Figure 4.18).

Another type of interest in clothing is shown by people who are interested in clothes in an impersonal manner. Designers, fashion buyers, clothing manufacturers, and sales representatives are among those who have an awareness of clothing from a merchandising point of view.

Throughout a lifetime, interest in clothing varies. Clothing is used to meet certain social and cultural needs of the individual (Chapter 3). Clothing also is related to the development of the personality and the satisfaction of emotional needs.

In summary, the individuality section of this chapter has focused on the development of the self and its influence on clothing messages. Each person has a unique appearance, self-image, personality, and lifestyle. Personal judgments are based on

Expressions of Clothing Interest

Attending fashion shows

Attention to personal appearance

Attention to wardrobe care and maintenance

Awareness of clothing practices of others

Concern with the selection of the wardrobe

Experimenting with different "looks"

Frequent shopping for clothing

Reading fashion magazines

Figure 4.18 Interest and clothing choices.

CASE STUDY 4.5

 Closet Comments

What clothing messages does your closet send? Using your closet as a resource, answer the following questions.

- What impressions can be made with your clothes?
- Can you put together an ensemble that would represent a stereotype?
- What is the unique theme or characteristic of your wardrobe?
- What would you choose to wear to emphasize your physical attractiveness?
- Describe your favorite ensemble.
- Is there a consistent sense of identity in your wardrobe?
- Can you describe your personality using the clothes in your closet?
- Can you select an ensemble that would represent your lifestyle?

appearance, physique, attractiveness, and gestures—and clothing has a strong influence on these judgments. The manner in which people present themselves reflects how they feel about themselves and their values, attitudes, and interests.

Today individuals are not bound by narrow standards of dress. An enormous variety of styles allows people the opportunity for self-expression and individuality in dress. Clothing characteristics can be a portrait of self-concept, telling others who a person is or what he or she would like to be (Case Study 4.5).

✒ Summary

This chapter focuses on apparel as a form of nonverbal communication and how it is used to send and receive an impression. It also shows clothing as an expression of individuality. Both the physical and nonphysical qualities of individuality are used by people to create an impression on others that will influence social, family, and business relationships.

✒ Key Terms and Concepts

Assumptions
Attitudes
Body image
Clothing symbols
Cognitive dissonance
Halo effect
Impression formation
Impression management
Individuality
Interests

Lifestyle
Nonverbal communication
Person perception communication model
Personality
Self-image
Silent language
Stereotype
Trait
Values

✒ References

Allport, G. W., Vernon, P. E., and Lindzey, G. (1960). *Study of values.* Boston: Houghton Mifflin.

Arthur, L. (1999). Dress and the social construction of gender in two sororities. *Clothing and Textiles Research Journal, 17*(2), 84–93.

Behling, D., and Williams, E. A. (1991). Influences of dress on perception of intelligence and expectations of scholastic achievement. *Clothing and Textiles Research Journal, 9*(4), 1–7.

Bell, E. L. (1991). Adult's perception of male garment styles. *Clothing and Textiles Research Journal, 10*(1), 8–12.

Creekmore, A. M. (1963). *Clothing behaviors and their relationship to general values and to the striving for basic needs.* Unpublished doctoral dissertation, Pennsylvania State University, University Park.

Cunningham, M., and Marberry, C. (2000). *Crowns: Portraits of black women in church hats.* New York: Doubleday.

Eicher, J. B., Evenson, J. S., and Lutz, H. A. (2000). *The visible self* (2nd ed.). New York: Fairchild.

Jung, J., Lennon, S. J., and Rudd, N. A. (2001). Self-schema or self-discrepancy? Which best explains body image? *Clothing and Textiles Research Journal, 19*(4), 171–184.

Kaiser, S. B. (1996). *The social psychology of clothing: Symbolic appearances in context* (revised 2nd ed.). New York: Fairchild.

Lapitsky, M. (1966). Clothing values. In A. M. Creekmore (Ed.), *Methods of measuring clothing variables* (pp. 59–64). Michigan Experiment Station Project Number 785.

Lennon, S. J. (1997). Physical attractiveness, age and body type: Further evidence. *Clothing and Textiles Research Journal, 15*(1), 60–64.

Lennon, S. J., Johnson, K. K. P., and Schulz, T. L. (1999). Forged linkages between dress and law in the U.S., Part I: Rape and sexual harassment. *Clothing and Textiles Research Journal, 17*(3), 144–156.

Lennon, S. J., Rudd, N. A., Sloan, B., and Kim, J. S. (1999). Attitudes toward gender roles, self-esteem, and body image: Application of a model. *Clothing and Textiles Research Journal, 17*(4), 191–202.

Nisbett, D. J., and Johnson, K. K. P. (1992). Clothing fashionability and students with a disability: Impressions of social and mental competencies. *Clothing and Textiles Research Journal, 11*(1), 39–44.

Omelianuk, S. (2000, June 23). Survival strategies for the casual office. *Wall Street Journal,* p. A-18.

Popcorn, F., and Marigold, L. (1997). *Clicking.* New York: Harper Collins.

Pradheepram, L, and Littrell, M. A. (1993). Intercultural communication: Appearance as a factor in attributional confidence. *Clothing and Textiles Research Journal, 11*(2), 53–58.

Rudd, N. A., and Lennon, S. J. (2000). Body image and appearance-management behaviors in college women. *Clothing and Textiles Research Journal, 18*(3), 152–162.

Russell, J. T., Lane, W. R., and Pearce, C. (1993). *Kleppner's advertising procedure* (12th ed.). Upper Saddle River, NJ: Prentice Hall.

Sarkisian-Miller, N. (2001, November 2–8). Los Angeles firm dresses men for online success. *California Apparel News,* p. 7.

Sontag, M. S., and Schlater, J. D. (1982). Proximity of clothing to self: Evolution of a concept. *Clothing and Textiles Research Journal, 1,* 1–8.

Spillane, M., and Sherlock, C. (1995). *Color me beautiful's looking your best.* New York: Madison Books.

Spranger, E. (1928). *Types of men* (P. J. W. Pigors, Trans.) Halle (Saale): Max Neimeyer Verlag.

Stanley, M. S. (1986). *Children's appearance as a facilitator in person perception typology.* Unpublished doctoral dissertation, Oklahoma State University, Stillwater.

Chapter **5**

Physical Influences

 Objectives

- Identify the current body standards in proportion, shape, and height/weight distribution.
- Explain the components of physical fitness.
- Differentiate the benefits of the various exercise forms.
- Explain the anatomy of skin, nails, and hair.
- Explain the environmental concerns regarding skin.
- Discuss skincare, skin surgery, and cosmetics.
- Identify the sources and functions of the six essential nutrients.
- Discuss major topics of nutritional concern.
- Explain malnutrition and its results.

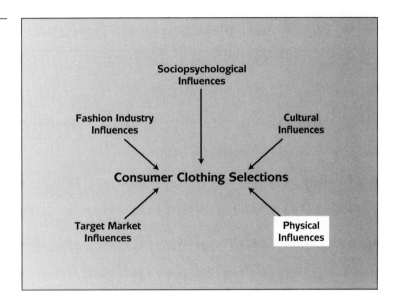

An understanding of the physical body is important for both individual consumers and fashion professionals. Understanding the assets and liabilities of a consumer's own physique will enable the consumer to select complementary apparel. The fashion professional uses an understanding of the physical differences among consumers to better design and select apparel to meet the needs of customer groups. This chapter discusses the various physical influences on clothing selection including body build, skin, hair, and nails and the importance of diet toward maintaining the health of these body components.

Body Build

The ideals of body build are cultural and change with fashion (Activity 5.1). Although the anatomy remains the same, it is often forced into a variety of positions and shapes by the prevailing "fashion body" ideals of a culture.

The Western world has, at times through history, admired women with ample hips, slender hips, large breasts, flat chests, tiny waists, small hands and feet, short legs, long legs, and various combinations of these physical parts. When a style of body becomes fashionable, many try to attain it. For example, consider the efforts made to be thin. At the turn of the century women had ribs removed to achieve an

ACTIVITY 5.1 Body Shape Changes

Collect pictures that show how fashion has decreed changes in body shapes over the years. Use catalogs of great paintings, historic fashion books, and old magazines.
 Use current fashion magazines to discuss what body shape, such as extreme thinness, is promoted by fashion and advertising only.

hourglass figure. Similarly, in the 1960s, when Twiggy was the top fashion model, many coeds dieted and starved to attain her adolescent-boyish figure of 5 feet, 7 inches and less than 100 pounds. Currently the children of the Twiggy generation are often bulimic or anorexic in that same drive toward extreme thinness.

Similarly today, model Kate Moss is 5 feet 7 inches tall and weights 95 pounds, and again teens are often bulimic or anorexic in a drive toward the same extreme thinness ("The Media and Eating Disorders," 2001).

Consider the following statistics:

- The average age when a girl starts dieting is 8.
- Fifty-one percent of 9- and 10-year-old girls admitted feeling better about themselves when sticking to their diet.
- Fifty percent of fourth-grade girls are on a diet.
- Eighty-one percent of 10-year-old girls are afraid of being fat.
- Forty percent of women and 20 percent of men would trade three to five years of their lives to achieve their weight goals (The Bodywise Handbook, 2000).

Historically, the conformation of the male body has also evolved through many fashion changes. Areas of the male anatomy that have been admired (Figure 5.1) at differing times include the well-developed calf, the small waist, the large abdomen, the barrel chest, and overdeveloped muscles.

Why are body ideals of interest to consumers? Because body ideals are the prototypes used in both designing and promoting clothing (Figure 5.2). If consumers understand how their bodies vary from these ideals, it will be easier to select clothing. Figure 5.3 summarizes some of the general body build ideals for men and women today.

The human body comes in an infinite variety of forms. For instance, people vary in body and head proportion, muscle and fat percentages, body types, and body shape. The following sections will more specifically delineate these ideals.

Body and Head Proportion

Proportion is the relationship of all parts to each other and of the parts to the whole.

Body proportion includes the size relationship of the head to the torso, arms, hands, legs, and feet, and the relationship of each mentioned part of the anatomy to the entire body conformation (Figure 5.4).

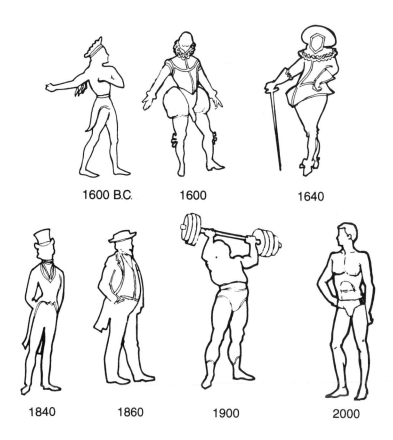

Figure 5.1 *Areas of male anatomy that have been admired during various fashion periods.*

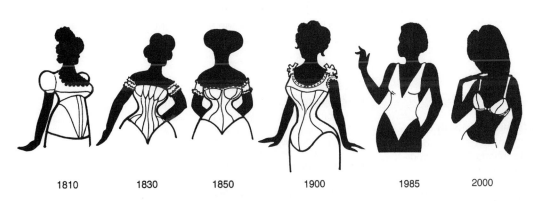

Figure 5.2 *Female body distortion dictated by fashion.*

Male Body Ideals	Female Body Ideals
• Youthful, athlete build (swimmer, runner) • Tall and slender • Shoulder muscles broad and well-developed • Torso tapers to slender waist • Flat abdomen • Hip narrower than width of shoulders • Slender, well-muscled arms and legs • Head, hands, and feet proportionate	• Tall, slender • Shoulder and hip width (front face) are equal • Hip and bust circumferences are equal • Waist: 9–11 inches smaller than hips/bust • Flat abdomen • Calf: 4–6 inches larger than ankle • Thigh: 6–7 inches larger than calf

Figure 5.3 Current male/female body build ideals.

Figure 5.4 Body proportion standards and deviations. How do your body measurements compare to these standards?

Height divided by head length = 8

• Short: 1:6.8 or less
• Average: 1:7
• Tall: 1:7.2 or more

Shoulder slopes 2″ from neck base

• Square: Slope > 2.5″
• Sloped: Slope 1.5″ or less

Shoulder width

• Balanced: Shoulder width/2 = head length
• Wedge/broad: Shoulder width > 2 head lengths
• Narrow: Shoulder width < 2 head lengths

Waist compared to hips

• Small: Waist 10″+ smaller than chest
• Average: Waist 9–10″ smaller than waist
• Large: Waist 8″ or less smaller than the chest

Waist is 1/2 distance between underarm and hip

• Short-waisted: Waist > 1″ above ideal
• Long-waisted: Waist is > 1″ below ideal

Legs are half the body height

• Long legs: Legs > half the body height
• Short legs: Legs < half the body height

Body shape

• Ectomorph: Long lines in limbs and torso
• Endomorph: Soft, rounded body contour
• Mesomorph: Bulky/athletic muscles

Hips: 1″ narrower than shoulders

Elbows: fall at waist level

Fingertips: fall at mid-thigh

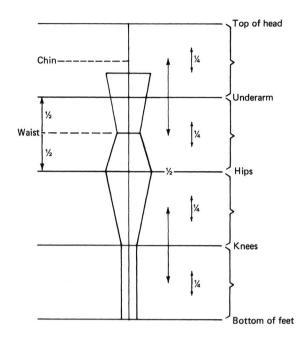

Figure 5.5 A well-proportioned body may be divided into four equals parts.

A vertically well-proportioned human body may be divided into four quarters (Figure 5.5):

- The top of the head to the underarm.
- The underarm to the hip (the waist divides the underarm to hip section in half).
- The hip to the knee.
- The knee to the bottom of the foot.

Another area of proportional interest is head length compared to the body. The head must appear to be in proportion with the body to give a pleasing relationship. A person with a small head appears out of proportion and unbalanced. A large head distorts the proportional relationship of the body and may make one appear shorter or top heavy.

To determine head-length height, divide height by head length. The average man or woman will measure seven to seven and one-half head lengths tall, whereas fashion models are eight head-lengths tall. Looking back to the four body proportions above, in the perfectly proportioned body, each of the four divisions would equal two head lengths (Activity 5.2).

Muscles versus Fat

Muscles are the underlying tissues in the body that alternate contracting and extending, yielding movement.

Another area of difference in body build is the muscle-versus-fat proportion. An individual's muscular contractions contour and tone the muscles. Contoured muscles

ACTIVITY 5.2 Body Proportion

1. Find several advertisements that use sketches rather than photos. Measure the total body length of the model using head lengths.
 - How many heads tall is the model sketched?
 - Why do clothes look different on the human body than on the model sketched?
2. Repeat the exercise using store mannequins and fashion photographs.
3. What can be learned about body proportion?

give the body shape and an attractive appearance. The condition and density of the muscle, not the size, is determined by its use. Muscles that are not used will atrophy. An atrophied muscle appears loose and flabby.

Male muscle contains more fibers than the female muscle, which means that the female has different physiological responses in strength development. A man and woman of the same size, height, and physical conditioning would never have equal muscular strength. This higher percentage of muscle mass also accounts for a faster metabolic rate in males.

This proportion varies sharply between males and females. Some women worry that exercised muscles will create a masculine appearance. However, female and male hormones are responsible for the variation between male and female muscle appearance. The predominantly male hormone, testosterone, is responsible for the mass and bulkiness of muscles. This hormone is present in women but in very small amounts; therefore, women's muscles will be smaller in mass and bulk than men's muscles.

A woman has a thicker layer of fat deposited around her muscles, which is related to the higher percentage of body fat required in females for reproductive purposes. This gives her a softer appearance and feel than a male, whereas men's muscles are better defined under the skin and appear firmer.

Body Types

Understanding muscle and fat distribution gives insight into the basic **body types.** The human body has been categorized according to similarities in body composition— the percentage of an individual's total body weight that comes from fat tissue versus lean body mass (muscle, bones, fluid, and internal organs)— into three basic **somatotypes** (body types). They are the **endomorph,** the **mesomorph,** and the **ectomorph** (Figure 5.6). For characteristics of these three types, refer to Figure 5.7.

The somatotype theory does not presuppose that all people can be definitively typed because of the variety of genetic combinations. Some people are combinations of the three types. The hypothesis is that men and women come in all shapes and sizes with many variations. However, all human forms can be analyzed against the three prototypes. This theory helps people understand why no matter how hard they try, there are some body types that are impossible for a particular individual to achieve.

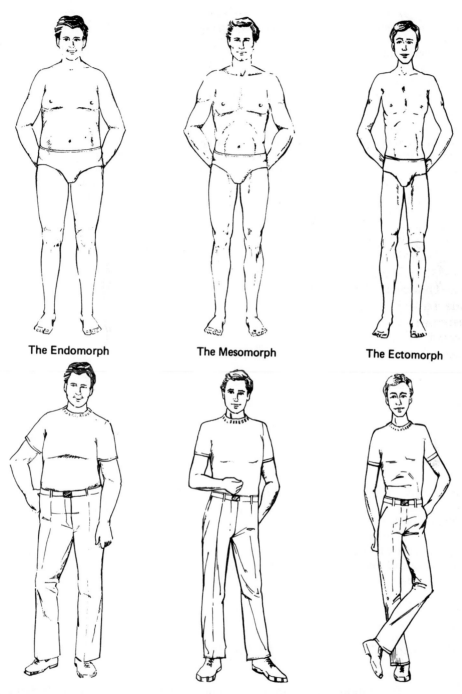

The Endomorph The Mesomorph The Ectomorph

Figure 5.6 The human body has been categorized according to similarities into three basic somatotypes: the endomorph, the mesomorph, and the ectomorph.

Endomorph Characteristics	Mesomorph Characteristics	Ectomorph Characteristics
• Soft/round body parts: fleshy upper arms and thighs, prominent abdomen • Muscular development not prominent • Extreme endomorphs have sizable round bodies and a higher percentage of body fat • Neck and limbs are short • Larger amount of overall body fat • Underweight endomorphs have a low ratio of muscle mass to body fat	• Frame: sturdy, muscled • Often called an "athletic build" • Musculature is the body's most visibly pronounced feature • Large shoulders and chest • Well-developed arm and leg muscles • Minimum body fat	• Muscular development is lineal • Body is tall and narrow • Limbs are long and thin • Very little body fat • Appears underfed • Overweight ectomorphs appear puffy or blown-up • Extra fat would make the skeletal frame virtually disappear

Figure 5.7 Characteristics of somatotypes.

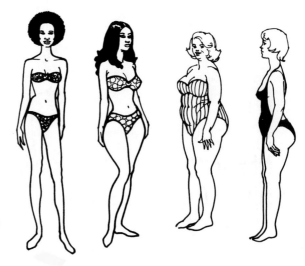

Figure 5.8 In body analysis it is important to consider the distribution of weight on the body frame. The actual weight is not as important as the way it is arranged to create the shape of the body.

Body Shape: Height/Weight Distribution

Because clothing is often designed to hang as a cylinder from the shoulders or from the waist, it is important to analyze the distribution of weight on the body frame. It is not the actual weight but rather the way the body fat is arranged on the frame that creates the shape or silhouette of the body. Distribution of weight explains where the body tends to store body fat (Figure 5.8).

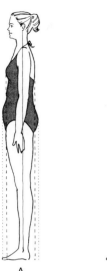

A. B. C.

Figure 5.9 Some clothing is designed to hang as cylinders from the shoulders or from the waist. These plumb lines work for both men and women. Posture plays an important part in how clothing hangs on the body (Body C), as does weight distribution (Body A).

Body mass is distributed on the skeletal frame (Figure 5.9). The ideal body mass is distributed evenly from the center core of the body or the spine as the body is viewed from the front, back, and side. The bust/chest mass should balance the buttocks mass as the body is viewed in profile. However, females tend to store body fat in their hips and thighs, whereas males tend to store it in the abdominal area.

Height/weight distribution yields various body silhouettes. The most common ones are:

- **Wedge:** Shoulder width exceeds hip width.
- **Triangle:** Hip width exceeds shoulder width.
- **Balanced:** Hip and shoulder measurements are equal; waist measurement is 9–11 inches smaller.
- **Rectangle:** Little or no waist indentation.

When an individual gains weight, it tends to be in the area in which he is already the heaviest, exaggerating the silhouette. For example, a triangular-shaped person gains additional weight in the hip area; a balanced-shaped person gains weight evenly in hips and chest; a wedge-shaped individual gains weight in the chest area. When an extreme amount of weight is gained, as seen in some older men in the stomach area, for example, proper clothing fit is impaired.

Body Weight

A body weight that is considered healthy should be achieved at age 25 and maintained for life (Case study 5.1). For healthy weight standards, consult Figure 5.10. For a range of weight, add and subtract five pounds from the ideal. (Note: A Harvard Medical School study found the lowest mortality rates in those 15 percent below average weight ["Study: Data on Women's Weight," 1995].)

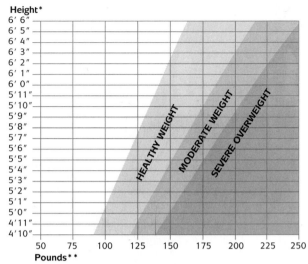

Figure 5.10 Are you overweight?
*Without shoes.
**Without clothes. The higher weights apply to people with more muscle and bone, such as many men. (*Report of the Dietary Guidelines Advisory Committee on the Dietary Guidelines for Americans. 1995,* pp. 23–24)

* Without shoes.

** Without clothes. The higher weights apply to people with more muscle and bone, such as many men.

CASE STUDY 5.1

 Ideal Body Weight

To determine healthy body weight:

Men: 5 feet = 110 pounds
Women: 5 feet = 100 pounds
For each extra inch add 5 pounds. For each year under 25 (down to 18) subtract 1 pound.
Range: Add and subtract 5 pounds.

Male example: What would be a healthy weight for a 6-foot male age 35?
Solution: 110 pounds + 5 (12″) = 170 pounds. Range: 165–175

Female example: What would be a healthy weight for a 5-foot, 2-inch woman age 21?
Solution: 100 + 5 (2″) − 4 = 106 pounds. Range: 101–111

Women can pinpoint their weight ideal more accurately by first determining their frame size. (This measurement has not been developed for men.) Measure the circumference just below the wrist bone on the arm that is used least:

Small frame 4.5 inches to 5.13 inches
Medium frame 5.25 inches to 6.13 inches
Large frame 6.25 inches to 6.75 inches

Activity 5.3 offers several methods of overall body analysis.

ACTIVITY 5.3 Body Analysis

Method 1. Body Pictures

1. One of the most effective tools to employ to see yourself as you really are is a series of full-length photographs taken in a body-revealing outfit, such as a bathing suit or leotard. Do not wear shoes. These pictures should be taken so that the body level is not distorted. The weight should be equally distributed on each foot; the hands and arms should not interfere with the body silhouette. The "benchmarks" of the body can be indicated by tying contrasting string or tape around under arm, waist, hip, the knee and ankle, as well as the shoulder width (place around arm socket). Hair should be pulled to the back of the head so that ear lobe and neck-shoulder conformation are revealed.

 Take at least three pictures: body front, body back, and body profile. Be certain that your photographer does not take an artistic pose. Head and feet must be in the photo.

2. Study your body pictures carefully. Decide what you like about your body.

3. On *front* and *back full-view photos.* Draw a vertical line that bisects the body. Compare right side with left side (remember, the photo is your body reversed). Determine any difference between the two sides.

 • Draw a horizontal line across shoulders, waist, hip, and knee. Study each of these areas. Are the horizontal lines level?

 • Draw straight lines on each side from shoulder to hip (along silhouette). *For women,* these lines should be parallel; that is, the silhouette measurement should be the same for shoulder and hip. *For men,* these lines should taper from shoulder to hip (the shoulders should be wider than the hip).

4. On the *profile-view photo* draw a vertical line from ear lobe to ankle. Determine the distribution of your body mass on both sides of this line (Figure 5.11). Rate your posture. Is your body in good alignment? Study shoulder and stomach areas carefully. Compare profile posture with full-view, front, and back posture. Examine your full-length weight distribution.

 • *On the face side,* draw a vertical full-length line that just touches the widest of bust/chest silhouette. *On the back side,* draw a vertical full-length line that just touches the widest part of the shoulder blade. Study these lines carefully. Remember, any garment designed to hang from the shoulders will follow these lines (coats, jacket, shirts). How does your body conformation correspond to this clothing design requirement?

 • *On the face side,* draw a vertical line from fullest point of stomach silhouette to the floor. *On the back side,* draw a vertical line from the fullest part of the buttocks to the floor. Study these lines carefully. Remember, any garment designed to hang from the waist (skirts, pants) will follow these lines. How does your body conformation correspond to this clothing design requirement?

5. Complete the checklist Body Picture Analysis:

Body Picture Analysis

Front full-view photo reveals:

Shoulders	parallel _____	right high _____	left high _____
Waist	parallel _____	right high _____	left high _____
Hips	parallel _____	right high _____	left high _____
Knees	parallel _____	right high _____	left high _____
Feet	parallel _____	toes out _____	toes in _____

continues

ACTIVITY 5.3 *continued*

continued

Back full-view photo reveals:

Shoulders	parallel _____	right high _____	left high _____
Shoulder blades	balanced _____	protruding _____	too flat _____
Spine	vertical _____	moves right _____	moves left _____
Waist	parallel _____	right high _____	left high _____
Hips	parallel _____	right high _____	left high _____
Knees	parallel _____	right high _____	left high _____
Feet	parallel _____	toes out _____	toes in _____

Profile-view photo reveals:

Head	balanced _____	forward _____	back _____
Body line	balanced _____	forward _____	backward _____
Knees	flexed _____	hyperextended _____	too fixed _____
Abdomen	contracted _____	protruding _____	too flat _____
Back curve	balanced _____	hollow _____	flat _____
Chest	balanced _____	high _____	flat _____
Shoulders	balanced _____	round/forward _____	back _____

Proportion Study

Width Proportions

Shoulder width compared to hip width

wider _____ the same _____ narrower _____

If you did not check "the same," it is because your

_____ shoulders are wide

_____ shoulders are narrow

_____ hips are wide

_____ hips are narrow

Thigh compared to hip/abdomen

balanced _____ protrudes to front _____ protrudes to back _____

Calf compared to hip/abdomen

balanced _____ protrudes to back _____

Length Proportions

Top-of-head to chin compared to chin to tip-of-bust (chest) length

longer _____ the same _____ shorter _____

If you did not check "the same," it is because you

_____ have an elongated head

_____ have a shorter head

_____ are high-busted (chest)

_____ are low-busted (chest)

Elbows compared to waist

longer _____ the same location _____ shorter _____

If you did not check "the same," it is because your

_____ upper arm is long

_____ upper arm is short

continues

ACTIVITY 5.3 *continued*

continued

_____ waist is high
_____ waist is low
Wrist compared to crotch
 higher _____ the same location _____ lower _____
 If you did not check "the same," it is because your
 _____ forearm is long
 _____ forearm is short
 _____ crotch is high
 _____ crotch is low
Waist/knee length compared to knee/heel length
 longer _____ the same _____ shorter _____
 If you did not check "the same," it is because your
 _____ thighs are long _____ buttocks are long
 _____ thighs are short _____ buttocks are short
 _____ calves are long _____ calves are short
Head/wrist length compared to wrist/foot length
 longer _____ the same _____ shorter _____
 If you did not check "the same," it is because your
 _____ arms are long
 _____ arms are short
 _____ legs are long
 _____ legs are short

Method 2. Body Proportion Drawing

1. Equipment needed:
 Shelf paper (longer and wider than you are), pencils, felt pen, 12-inch ruler, 36-inch ruler, string, body-contour-revealing clothing.
2. Directions:
 a. Crease paper in half lengthwise to establish a center line. Mark center line with felt pen. Fasten paper to a flat wall or door. Crease paper at floor level and tape to floor. (Paper must extend onto floor.)
 b. Secure string around waistline, full hip, and other body benchmarks.
 c. Center your body along the vertical centerfold line of the paper. Stand so your body is relaxed but straight. Shoeless feet should be together. Do not move while someone else marks the following measurements on your paper.
 d. Using a straightedge, mark these points on paper:
 • top of head, not top of hair
 • tip of chin
 • base of neck (height, width)
 • tip of shoulder (height, width)
 • underarm (height, width)
 • crown of bust, woman (height, width)
 • widest part of chest, man (height, width)
 • waistline (height, width)
 • hip line (height, width)

continues

ACTIVITY 5.3 *continued*

continued
- knee line (sides and centers) (height, width)
- ankles (sides and centers) (height, width)
- feet at floor line (width)

e. After all marking is completed, fold paper in half across the width, matching the floor line with the top-of-the-head line. Fold each half in half dividing your body length into four equal sections. Open paper out and match underarm crease (top 1/4 line) to hip-line crease (3/4 line) and press in a new crease, which will indicate waistline level. Mark dotted line at all fold lines with felt pen.

f. Draw your body. To do this draw horizontal lines connecting width points at the levels indicating:

top of the head	waistline
chin	knee line
shoulder line	ankle line
underarm	floor line

3. Comparison of body proportions based on head-length measurement. Fill in your measurements in blanks.

Length	Female Fashion Model	Self	Male Fashion Model
Top of Head to	(Head Lengths)	(Head Lengths)	(Head Lengths)
Chin	1	1	1
Base of neck	1 1/3	_____	1 1/4
Shoulder	1 1/2	_____	1 1/2
Bust/chest	2	_____	2 1/8
Waist	2 5/6	_____	3
Full hip	4	_____	4
Knee	6	_____	6 1/4
Ankle	7 1/2	_____	8 1/4
Floor	8	_____	8 1/2
Width			
Shoulder	1 1/2	_____	2
Waist	3/4	_____	1 1/8
Full hip	1 1/4	_____	1 1/2
Knee	2/3	_____	3/4
Ankle	1/3	_____	5/8

4. Connect with diagonal lines:
 - base of neck to shoulder
 - shoulder to waist
 - waist to hip
 - hip to knee
 - knee to ankle (inside and outside)
 - ankle to floor (inside and outside)

5. Measure your body in head lengths. To establish a head-length unit for measuring, take a separate piece of paper and measure the length of your head on your paper body drawing. Be exact. Trim off excess paper. Fold the exact head-length measure into fractions and mark carefully each fraction with the actual number.

continues

ACTIVITY 5.3 *continued*

continued

Measure body drawing lengths and widths with your own head-length unit measure, using paper exactly as you would use a ruler. Record head lengths on chart on this page. Using a scale of 1 head length = 1 inch, draw your body in the indicated area (Figure 5.11).

6. Compare your body proportions to the fashion model body and body-proportion body shown in Figure 5.12.

Method 3. Silhouette Drawing

A third method for measuring body proportions is to have your body silhouette drawn on a large sheet of paper fixed to the wall. The outline of both the front and side view should be drawn. Be careful to make exact size. Comparisons to the fashion figure can then be made.

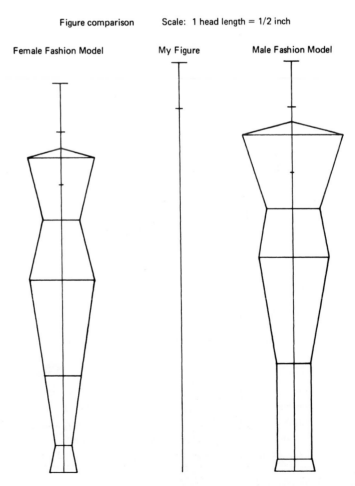

Figure comparison Scale: 1 head length = 1/2 inch

Female Fashion Model My Figure Male Fashion Model

Figure 5.11 The scale shown here is one head length = 1/2 inch, but when you reproduce this exercise for body comparison, you should use a larger scale of one head length = 1 inch.

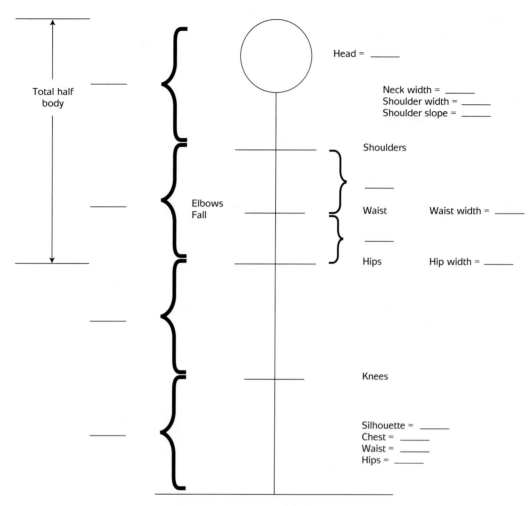

Figure 5.12 Body proportion personal summary. How do your measurements compare?

Physical Fitness

Physical fitness means having both cardiovascular (heart and lung) strength and muscular strength, as well as the flexibility to perform daily activities without injury.

A fitness craze began in the United States in the 1980s and continues today. Great numbers of people of all ages make fitness part of their lifestyle by participating in exercise classes, weight training, sports, marathons, and cycling. Individuals can be seen at all times of the day and night walking or jogging along country roads or busy city streets.

Memberships in health clubs and spas are at an all-time high. The 1990s popularized gyms not just for men but for women and families as well. Many Americans seem

Figure 5.13 *Exercise has become a way of life for many Americans. It is common to see people walking or jogging in neighborhoods nationwide or participating in sporting events for schools and amateur and professional organizations.*

obsessed with healthy bodies (Figure 5.13). In addition, big businesses throughout the world are reacting to the high cost of medical care by encouraging physical fitness and providing exercise facilities. Similarly, some insurance companies' group policies feature a wellness provision as part of their effort toward medical management. This feature covers monthly gym membership fees for their senior citizens.

Fitness today is fashionable, and most people are knowledgeable about its benefits however, a recent survey by the Surgeon General ("Physical Activity and Health," 1996) reported that:

- Activity levels of Americans have changed little if at all since the 1970s (Nestle and Jacobson, 2000).
- Twenty-five percent of adults are *not active at all*.
- More than 60 percent of adult Americans are not *regularly* physically active.
- Approximately 15 percent of U.S. adults exercise regularly three times a week for at least twenty minutes.
- Twenty-two percent engage regularly five times a week for at least thirty minutes ("The Real Skinny," 2002).
- Those who do begin an exercise program often abandon it during the first twenty-one days.

Physical Fitness Components	Definition
Muscular strength	Maximum amount of force a muscle group can develop during a single contraction.
Muscular endurance	Maximum number of repeated contractions a muscle group can perform against a resistance without fatiguing.
Cardiorespiratory endurance	Ability of the heart, lungs, and blood vessels to deliver an adequate supply of oxygen to exercising muscles.
Flexibility	Amount of movement that can be accomplished at a joint such as the knee, referred to as *range of motion*.
Body composition	Maintaining an ideal percent of body fat: 17–25 percent for women and 10–16 percent for men.

(U.S. Department of Health and Human Services. Physical Activities & Health: A Report to the Surgeon General. Atlanta: Author, 1996).

Figure 5.14 Components of physical fitness.

The Surgeon General suggests the following guidelines for developing and maintaining physical fitness:

- Frequency of activity: 3 to 5 days per week.
- Intensity of activity: 55 to 90 percent of maximum heart rate.
- Duration of activity: 20 to 60 minutes of continuous activity.
- Mode of activity: Any activity that uses large-muscle groups.
- Resistance activity: Strength training of moderate intensity at least two times per week.
- Flexibility activity: Stretching of the major muscle groups two to three times per week (Sizer and Whitney, 2000).

The fitness industry uses five components (Figure 5.14) to define the term *fitness* (Sudy, 1991). A common approach to developing and maintaining a fit body is through participation in a sport. In analyzing over seventy sports, researchers have identified six basic ways of moving: jumping, throwing, kicking, running, walking, and stance. It is recommended that these basic movements be incorporated in any physical fitness regime.

Physical fitness is imperative to good health and attractive appearance. The body needs vigorous exercise to:

- Maintain tone and strength.
- Burn off caloric intake.
- Help in the functioning of the vital organs such as the heart, lungs, and circulatory system.
- Slow down the aging process.
- Add grace to your movements.
- Improve the quality of life in the later years.

Figure 5.15 *Isotonic exercises contract muscles and produce movement. A popular isotonic exercise for both men and women is weight lifting for firming and toning the body.*

Exercise Types

There are various kinds of exercise. Each kind of exercise produces a certain type of result or benefit. To firm and reshape the body, a program combining the four main types of exercises—**isometrics, isotonics** (Figure 5.15), **isokinetics,** and **cardiovascular** (Figure 5.16)—should consistently be used to maintain and ensure a high quality of life. For a lifetime of physical fitness, one of the cardiovascular exercises should be undertaken for at least thirty minutes or more every day.

Fashions for Fitness

An incredible number of apparel businesses have spun off from the fitness trend (Figure 5.17). Retailers have targeted consumer groups with special apparel for such fitness activities as cycling, weight lifting, and aerobics. Fitness apparel is worn not only in the gym but also in casual social situations. For example, athletic shoes are now worn by many for work and for play. In 2000, U.S. sales in athletic footwear were $9.05 billion (Carini, 2001).

Headbands, leotards, and tights are examples of clothing that originated for athletic pursuits. The fashion industry labels this new division of clothes *activewear*.

Exercise Type	Description	Examples	Benefits	Liabilities
Isometrics (literally, "equal measures")	Contract one set of muscles against another or an object without producing movement.	Pushing against opposite sides of a door jamb; pushing toes hard against floor.	Increase size and strength of muscles. Firm and tone muscles.	Little significant effect on cardiovascular systems.
Isotonics (dynamic resistance such as strength training)	Exercise muscles over a range of motion.	Calisthenics; weight lifting; workouts on stationary weight-training equipment.	Develop skeletal muscles. Firm and tone body.	Little effect on pulmonary/ cardiovascular systems.
Isokinetic (literally, "equal speed")	Muscles generate maximum force throughout entire range of motion by keeping the speed of movement constant.	Computerized machines that change resistance and control speed of movement.	Muscle experiences both a concentric phase (shortening of the muscle fiber) and an eccentric phase (lengthening of the muscle fiber).	Insufficient cardiovascular benefits. Machinery is highly expensive and requires a technician to run. Used mostly for rehabilitation and testing.
Aerobic (literally, "with oxygen")	Demands oxygen and can be continued over a long period of time.	Running, jogging, dancing, swimming, cycling, walking, and exercise routines.	Lungs process more air with less effort; heart grows stronger, pumping more blood with fewer strokes; blood supply to the muscles improves; blood volume increases.	Health problems prevent some from participating in this strenuous exercise.

Figure 5.16 Overview of exercise types. *(J. Zumerchik,* Encyclopedia of Sports. *New York: Macmillan Library Reference, 1997)*

Figure 5.17 *The fashion industry has developed a new category called athleisure to merchandise clothing that was developed for active sports but is now being worn during leisure time. The board short, used first as a swimsuit, has filtered into daily wear and is considered athleisure gear. (Courtesy Quiksilver)*

Frequently even those who do not participate in sports still want to look as if they are part of the physical fitness scene. In many women's closets Nike labels hang right beside Prada, Gucci, and Chanel.

Fitness is also a constant influence in apparel design for the teen market. Companies such as Nike and Adidas have developed their trademarked logos into multimillion-dollar vehicles. These logos have become highly fashionable for teens nationwide.

Skin

Healthy skin has long been associated with beauty. The skin reflects the individual's nutritional habits and serves as a container for the body (Figure 5.18).

Functions of the Skin

The skin is one of the largest organs of the human body. The skin of an average adult contains nerves, blood vessels, and glands packaged in an average skin thickness of 2 millimeters and a total skin area of approximately 12 to 20 square feet (1.8 square meters). The average adult skin weighs about 8.5 pounds (3.82 kg) or 6 percent of one's body weight (Visscher, 2001).

Figure 5.18 *Healthy skin, hair, and nails are an important part of individuality and reflect personal care.*

The skin is the most versatile of all organs, for it serves many functions:

- It acts as a container for the body, protecting it from injury and invasion by bacteria through manufacturing T-cells.
- Its temperature-regulating function can cool the body, conserve body heat, or, with the help of the sweat glands and blood vessels, raise body temperature to fever height.
- With the help of sunlight, the skin manufactures vitamin D for the body.
- The skin allows one to feel the world outside, to know warmth and cold, and to recognize texture.
- Pain and itch are also understood through the skin (Visscher, 2001).

Anatomy of the Skin

The skin can be divided into three layers: the epidermis, the dermis, (Figure 5.19), and the subcutis.

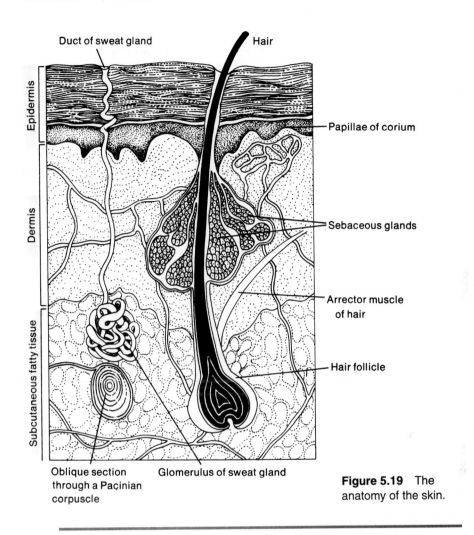

Figure 5.19 The anatomy of the skin.

The epidermis is the visible, outer layer of the skin.

The dermis or corium is the invisible, inner-supporting layer of the skin.

The subcutis is composed of collagen and fat cells

Epidermis

The primary function of the epidermis is to provide physical protection for the dermis. The epidermis is as thin as a sheet of paper, creates a barrier that seals in all the body fluids while keeping out things that are harmful to the body. The outer layer can absorb a limited number of chemicals or drugs, all of which will be taken into the general circulation system.

The epidermis consists of several rows of living cells covered by multiple sheets of densely compacted dead cells. This layer, called the **keratin** or horny layer, is constantly growing. The living cells are born at the base of the outer layer. They quickly die, and these dead cells are then pushed toward the outer surface of the skin by the arrival of the new cells. The top surface of dead cells is continually shed. If the outer skin is scraped or cut, it will regrow without a trace of scar tissue (Visscher, 2001).

Dermis

The dermis, fifteen to forty sheets of paper thick, supports the outer layer, nourishes it, and supplies it with moisture. In the dermal layer are found the blood supply, the lymphatic channels, the nerve supply, and a variety of nerve endings. Hair roots, sweat glands, and sebaceous glands are also located here and communicate with the outer layer by means of tubular ducts. (The surface ends of the sebaceous glands are commonly called **pores.**)

The dermis determines the skin's contour. This layer cannot replace itself and grows only until physical maturity is reached. Damage to the inner layer results in degeneration and the formation of scar tissue. Any damage to the inner layer, no matter how slight, will result in a permanent structural change. In addition to contour, this layer is also responsible for tone and resiliency; its condition determines whether the skin appears taut and unlined or wrinkled, loose, and sagging.

The tissue of the inner layer is all living. It consists of bundles of tough supporting tissue interlaced with elastic fibers. Blood vessels transport water and nutrients to the entire skin (Visscher, 2001).

Subcutis

This layer forms a network of collagen and fat cells and is responsible for conserving the body's heat. It also helps to protect the body's organs from injury by acting as a type of shock absorber (Visscher, 2001).

Skin Color

Skin color is determined in the inner and actively growing layer of the epidermis, technically called the stratum spinosum. The cells in this area contain varying amounts of the brown pigment **melanin.** African Americans and other dark-skinned people have a greater amount of melanin in all layers of the epidermis. Only albinos, found in all races, have no melanin in their skin.

Undertones in skin coloring are created by the presence of the orange pigment **carotene** found in the epidermis or by the cast of the circulating blood that shows through the skin. The hemoglobin of the blood is responsible for this reddish-blue or pink color. The intensity of this color depends on the state of contraction or dilation of the superficial blood vessels and upon the extent of oxygenation of the blood (Gray, 1985; Robins, 1991; Visscher, 2001).

The difference in color among individuals and ethnic groups depends on the concentration of the pigments melanin and carotene and the thickness of the skin. Thinner skins allow the hemoglobin color of the circulating blood to shadow through. Freckles are spots created by pigment concentrations (Robins, 1991).

The skin color of most of the world's population is brown. African Americans alone have thirty-five different skin tones (*Ethnic skin,* 1998). Only people of Northwestern European descent are very light-skinned as a group. Exceedingly dark or black skin is almost as rare as "white" skin, although brown is geographically distributed more widely.

Environmental Concerns

For the skin, the earth's environment can be considered hostile. Exposure to sunlight, extremes of weather, and substances in the air damage the skin.

Sunlight

The most harmful of the environmental factors is sunlight. A few months of intense sun exposure produces more damaging skin changes than a lifetime of normal wear. Sunlight is capable of penetrating the skin; it affects not only the surface but the living tissues of both epidermis and dermis. The structural changes caused by the sun are both immediate and delayed.

The immediate changes are a direct response to the irritating effects of the sun. The skin begins to produce more melanin to absorb the damaging rays. This is followed by cellular buildup in the outer layer. Both of these responses are designed to protect the dermis. If sun exposure is repeated, the pigmentation and cellular buildup will become more lasting—suntan (Visscher, 2000). "Tanning is the skin's attempt to protect itself from ultraviolet radiation" (*Sun,* 1998, p. 1), and melanin is the body's natural sunscreen.

Too much exposure to the sun results in sunburn—an inflammation of the skin occurring when ultraviolet rays destroy skin cells in the outer layer and damage tiny blood vessels under the skin. Several days later the skin may shed its dead cells by peeling (Visscher, 2000).

Delayed skin changes caused by sun exposure are both permanent and cumulative, appearing later in life, increasing in degree, and becoming irreversible. The final result of sun damage is skin with dark areas of accumulated pigment, rough red spots, and skin cancer. The Skin Cancer Foundation (Smith, 2001) reports 1 million new basal-cell carcinomas annually of which 7,300 all fatal. The delayed inner layer changes are caused by severe damage to the skin's supporting tissue—the **collagen** network, which is the springy web of fibers that supports the skin. Studies at the University of Michigan showed that sun-exposed skin produced 65 percent less collagen than normally covered skin (Turkington and Dover, 1996). Sun-damaged skin appears thick, tough, wrinkled, spotty, and aged. Since melanin provides some protection against damaging rays, darker-skinned people with more melanin in their skin may get fewer wrinkles (Smith, 2001).

The extent and severity of the permanent light-induced changes that appear in the skin are determined by three factors: skin type or complexion, intensity of exposure, and time or duration of the exposure. Fair skin that freckles easily is the most susceptible to light. Darker skins are generally thicker and have more protective pigment. Black skin is not completely immune to sun damage: The same changes seen in fair skin will also occur in dark skin with intense, prolonged exposure

The most serious and lasting sun damage occurs before age 18 (Smith, 2001).

Figure 5.20 *Because sunlight damage to the skin is cumulative, protection should begin at an early age. (Courtesy Quiksilver)*

Sun Protection. The suncare category has increased 40 percent since 1995. The largest growth has been in products in the sunless category, which is growing at a rate of 9 percent per year. The in-sun category has increased due to advanced technology, which has led to sprays, sticks, and gels to add to the traditional lotions and oil. Suncare and protection products were a $580 million business in the United States in 2001 (Isreltre, 2001).

Sunscreens protect against **ultraviolet-B** (UVB) rays. Sunscreens containing para-aminobenzoic acid (PABA) absorb ultraviolet-B rays, while sunblocks containing titanium or zinc dioxide reflect ultraviolet-B rays. Most sunscreen products are not designed to protect against **ultraviolet-A** rays because UVA rays were once considered "safe." However, recent researchers found that UVA contributes to both aging and skin cancer. The best protection against UVA rays are products with the ingredient Parsol 1789 (avobenzone).

Sunscreens differ according to their efficiency and degree of protection. Food and Drug Administration regulations require all sunscreen labels to bear a number that identifies the **sun protection factor (SPF)** of each product. For example, an SPF of 15 means a person can tolerate fifteen times more sun than it would normally take to burn. Experts suggest a minimum SPF of 15 for normal skin (Visscher, 2001) and 29 for fair skin. Even an SPF of 50 allows some UVB rays through, so one is never totally protected (Figure 5.20). However, the FDA and dermatologists say an SPF over 30 is overkill (Smith, 2001). For individuals who are sensitive to chemicals, sunscreen companies have recently developed a chemical-free sun blocker with SPF 4-25 (Shiro, 1993). Consult Figure 5.21 for examples of safe exposure times by protection factor.

SPFs are not cumulative. Thus when layering products with differing SPFs, the protection factor is no more than that of the product with the highest SPF (*Sun,* 1998). The Skin Cancer Foundation rates sunscreens and suggests that consumers

Skin Type	SPF Recommendation	Amount of Protection & Tanning
Fair complexion; freckled, always burns	15 or greater	Ultra Protection, No Tanning
Fair complexion; always burns, tans minimally	8–15	Maximum protection from burning; permits little or no tanning
Light to medium complexion; burns moderately, tans gradually	6–8	Extra protection from burning, permits limited tanning
Medium complexion; burns minimally, tans well	4–6	Moderate protection from burning; permits some tanning
Dark brown or black complexion; rarely burns, always tans easily and deeply	2–4	Minimal protection from burning, permits tanning

Figure 5.21 Guide to sun protection products. *(Smith, 2001)*

check for their seal on the label indicating that the product has met standards more stringent than those required by the FDA.

Clothing for Sun Protection

Generally, dark-colored clothing made of fabrics with a tighter, denser weave in a matte finish give the most sun protection. Knits such as T-shirts give poor protection since the UV rays pass through the knit loops. In recent years, several companies have begun to produce sunlight- or UV-resistant fabric woven from 100 percent Supplex nylon fiber, which reportedly blocks 50 percent of UV rays. Similarly, high perform-ance polyester that absorbs the UV radiation and reflects visible radiation can block up to 96 percent of UVA and UVB rays and has a SPF rating of 30 to 35 (Smith, 2001).

Alternate Tanning Methods

1. *Tanning booths/beds.* An estimated two million Americans secure their tans in tanning booths, which emit UVA rays. Because UVA rays are now considered unsafe, twenty-four states have laws governing indoor tan-ning. Before choosing this tanning method, remember that thirty minutes in a tanning bed are equal to six to eight hours in the sun. Retail giant Wal-Mart opened twelve tanning salons in their stores in 2001 (Gross-man, 2001).
2. *Tanning accelerators.* Typically in the form of lotions or pills, these products contain tyrosine (an amino acid) and claim to enhance tanning by stimulating

and increasing melanin formation. They are unapproved by the FDA as there is no scientific evidence that they work.

3. *Tanning pills.* These pills contain canthaxanthin, which the FDA has approved only as a color additive for food when used in small amounts. When ingested, these produce colors ranging from orange to brownish to various body parts. Side effects have included the formation of yellow deposits in the retina of the eye.

4. *Sunless tanners and bronzers.* Also referred to as self-tanners or tanning extenders, they are promoted as a suntan without the sun. These products interact with amino acids to make the epidermis of the skin appear brown, which fades when skin cells are shed. The only FDA-approved ingredient is dihydroxyacetone (DHA). These products can be difficult to apply, and they also react differently to different skin types, sometimes producing an uneven effect.

Bronzers stain the skin temporarily and can usually be removed with soap and water. They may streak and/or stain clothing. Tinted moisturizers and brush-on powders are also marketed as bronzers ("Sunscreens, Tanning Products, and Sun Safety," 2000).

Extremes of Weather

Extremes of weather, such as humidity and temperature variations, also damage skin through severe moisture depletion. Moisture depletion causes the skin to feel rough, dry, wrinkled, and easily irritated. Moisture depletion affects only the outer layer of skin.

Cold is aggravated by wind and the extreme dryness of heated rooms. Unprotected skin exposed to cold weather followed by a dry, overheated room atmosphere will be damaged by a critical loss of moisture. Extreme cold can cause frostbite.

Heat damage caused by exposing the skin to intense heat—such as facial saunas, hot towels, and steam generated from cooking—can produce skin damage very similar to that caused by sunlight.

Air Pollution

Air pollution in the environment also damages the skin. In many ways this irritant is more difficult to avoid than those already discussed. The exact damage caused to the skin by air pollution is not yet known. However, it is known that among the most common pollutants are sulfur-containing compounds, which are partially converted to sulfuric acid on the skin surface.

Aging

As the skin ages, the process involved in shedding of cells slows down, making the epidermis of the skin appear dull or rough. Often this is a result of large clumps of cells that are dry and flaky. At the same time, the elastic fibers in the dermis become coarse and disappear, which impedes the skin's return to its natural state after stretching. The blood vessels also decrease in size and number, thus decreasing the nutrient supply to the skin (Visscher, 2000).

ACTIVITY 5.4 Skincare/Cosmetic Advertisements

Collect skincare and cosmetic advertisements.

- Evaluate these advertisements to determine which part of the appeal is factual and which part is emotional.
- What percentage of the copy is honest information based on physiology?
- What percentage is a distortion of the facts?

Facial Skin Care

An area of special concern for men and women is the skin of the face with its unique care requirements. *Skincare* is the current buzzword in the personal care industry. The trend in skincare among Americans is toward preservation (Safire, 1993). Fueled by the 85 million Americans between the ages of 30 and 49 (Carini, 2001) who are obsessed with looking young, big businesses have been created to manufacture, promote, and sell both products and services for the care, maintenance, and embellishment of the skin. Total U.S. sales in the personal care market were $29 billion by the end of 2001 (Morrison, 2001). (Activity 5.4).

The skin type of the face is generally referred to as oily, dry, normal, or a combination of these. The areas of the forehead, nose, and chin are most often oily. The thin skin surrounding the eye area is generally dry because there are no oil glands there.

Large pores, which are often found on the cheeks or nose, are duct openings of oil glands that have become widened and permanently stretched. This damage is caused by plugging by fat and dirt and the force of material extruded from the gland, all of which causes a variation in the natural elasticity and vascularity of the skin. Blackheads and pimples are pores clogged with matter created by infection or improper cleansing of the skin.

Facial skin has three main problems: dirty surface film, thickening cellular buildup, and lack of moisture. To correct these problems, facial skin care involves:

- *Cleansing* to remove the dirty surface film using a cleansing agent that is non-irritating, easily removed, pure, and unadulterated with cream, fat, deodorant, medication, or fragrances.
- *Thinning* to remove dead surface cells, open pores blocked by cellular buildup, and prevent the formation of blemishes. (Men thin by shaving; women can thin by rubbing with a washcloth or using abrasive particles in a cleansing base.)
- *Moisturizing,* which replaces the natural moisturizers removed during the cleansing process and prevents premature wrinkling. Moisturizers cannot penetrate the skin; they work by spreading a protective film over the skin, slowing the evaporative water loss from the epidermis.

Skincare Surgery and Techniques

Increasing numbers of Americans, seeking a more dramatic improvement in their skin to combat signs of aging, opt for surgical procedures of two main types: chemabrasion and plastic surgery.

Chemical Face Peel/Chemabrasion

A chemical face peel, also referred to as **chemabrasion,** is a deep, second-degree burn using a chemical designed to repair damage done to the skin by acne or the sun. It regenerates elastin (collagen). At costs of up to $200 per peel, the surgery uses gly-colic, lactic, or trichloroacetic acid; phenol; or resorcinal, which dissolves the top layer of skin and erases irregular pigmentation, scars, and fine wrinkles. After the peel, a crust develops, which lasts a week. Severe redness may last for up to six months. The resulting younger-looking skin lasts long term with maintenance (Platt, 1999). Alpha-hydroxy acid, beta-hydroxy acid, glycolic acid, and other chemicals in strong strengths are used for milder face peels (Brody, 2001; "Beta Hydroxy Acids in Cosmetics," 2000).

Plastic Surgery

In 2000, 1.3 million Americans underwent some form of plastic surgery—a 227 per-cent rise since 1992 (Wilkinson, 2001). The top five procedures—abdominoplasty (tummy tuck), breast augmentation, eyelid surgery, face lift, and liposuction—are in-creasing at an average of 26 percent per year (Mayer, 2001). Plastic surgery is on the rise, according to Dr. Toby Mayer, mainly as the result of the demand by baby boomers (Mayer, 2001).

 Liposuction—removal of excess fat from any area of the body—is the most pop-ular cosmetic surgery and has doubled since 1997 (Bellafante, 2001). Men now ac-count for 33 percent of all cosmetic surgery, reports the American Academy of Cosmetic Surgery (Mayer, 2001).

 A less invasive form of plastic surgery is collagen injections, which are used to plump up wrinkles. Injectable collagen is made from the skin of cattle. Injected un-der the skin, the results are immediate; however, they last only three weeks to six months (Platt, 2002) At $300–$800 an injection, this procedure has increased 81 per-cent since 1992 (Wilkinson, 2001).

 Botox, which is derived from botulism toxin A, has become popular recently. When injected in microscopic doses, it temporarily freezes the muscle, thus pre-venting wrinkles. It is believed that over time this may cause atrophy of the muscle and slow down aging (Wilkinson, 2001).

Cosmetics

Prestige beauty sales (cosmetics, skincare, and fragrance) were $6.2 billion in 2001 ("Makeup Sales: It's Back to Basics," 2001) while mass market cosmetics added an-other $3.5 billion (Barnes, 2001). Cosmetic companies cite the 25- to 54-year-old fe-male as the biggest spender on cosmetics. However, the increased number of women in their 50s buying cosmetics has prompted companies to target them as well. In 2001, Revlon decided to create an ageless campaign, "It's fabulous to be a woman," using unknown women (Morrison, 2001). Cosmetics can be grouped as follows.

Medicated Cosmetics

Medicated cosmetics are big business, directed to all age groups but especially to teenagers. However, the human skin has a phenomenal built-in defense system against infectious bacteria. Constant degerming and chemical interfering with this natural restorative process of the skin can and often does lead to more, not less, trouble.

Hypoallergenic Cosmetics

Hypoallergenic cosmetics are designed to prevent allergic reactions in people who have allergies or extra-sensitive skin. Many cosmetics claim to be hypoallergenic, and consumers should read labels carefully (Activity 5.5).

Cosmetics for Men

In 1970, Aramis introduced the first men's beauty products and propelled the men's grooming industry forward. Sales of these men's products hit the billion-dollar mark in 1977 and have not stopped climbing. The male grooming market is worth over $9 billion per year ("Male Grooming," 2001).

Companies are producing a wide range of skincare and cosmetic lines especially for men such as Chanel's Techniques. The lines have a wide array of product offerings. For example, when it was introduced, Calvin Klein's Eternity collection included face moisture, face cleaner, shaving gel, hair spray, body scrub, soap, shower gel, and talc. Clinique's men's line included a "scruffing" lotion and a post-shave healer, while Estée Lauder offered a men's skin comfort lotion.

Men are now venturing into concealers, bronzers, tinted lip balms, and other products that lend a healthy glow (Torres, 2001). As a result men are spending nearly

ACTIVITY 5.5 Cosmetic Product Legislation

Collect news articles pertaining to legislation regulating cosmetic products. Write for additional information to:

The Skin Cancer Foundation
P.O. Box 561
New York, NY 10156
Phone: 1-800-SKIN490
E-mail: info@skincancer.org
Web: www.skincancer.org

American Academy of Dermatology
P. O. Box 4014
Schaumburg, IL 60168-4014
Phone: 1-888-462-3376
Web: www.aad.org

Cancer Information Center (CIS) 1-800-4-Cancer
http://cis.nci.nih.gov

Discuss trends that appear to be emerging in this area.

fifty-one minutes getting ready in the morning, which is nearly equal the fifty-four minutes spent by women ("Male Grooming," 2001).

Cosmetics for Children

Cosmetic brands such as Tinkerbell, Gear, and Bonnie Belle are targeting girls ages 3 to 12 who spend $161 million a year on such products. They include hair painting wands, body glossers, scented and sparkling nail polishes, and flavored lip gloss and lip balm. Selling for a fraction of adult versions, these products often come with a free makeup guide. Wal-Mart has begun to sell a seventy-item cosmetic product line under its own label for tweens and teens ("Wal-Mart to Sell Cosmetic Line," 2001). Some drugstores report that these "tween" products account for 15 to 20 percent of their entire cosmetic offerings ("Heavy Lifting," 1998).

Tattooing

Tattooing instills permanent colors onto the skin, generally in words and designs. Traditionally used as a means of identification or tribal marking, tattoos have resurged as a means of body decoration. In the United States, the number of tattoo studios has grown from three hundred to over four thousand nationally in the past twenty years (Saint Louis, 1999).

In the late 1990s, women began to use tattooing to apply permanent color to their faces. Some chose to have tiny black dots tattooed on their eyelids to simulate eyeliner; others chose to have pink tattooing applied to their cheekbones as a blush or to their lips for permanent lipstick. With no state or federal regulations on tattooing, caution should be observed. Tattoo removal takes about a year with one visit per month. Some report that the removal process is more painful than the application process (Dover, 1999).

Cosmetic Additives

Anti-aging ingredients like collagen, AHA, and Retin-A are all buzzwords of the cosmetics industry and are used in a wide variety of cosmetics, from foundations to foot care products. Industry insiders report that products that claim to slow the aging process are immediate hits. For example, L'Oreal SA—the world's largest cosmetic company—reported that its antiwrinkle product, Revitalift, became its best seller in only one year (Steele, 1996).

Collagen. Collagen is a tough, natural part of the body's connective tissue. Because it is insoluble, it gives the skin elasticity, helping to hold the cells and tissues together. The skin wrinkles as it ages partially because the epidermis becomes thinner and dryer. Locally applied creams containing collagen and hormones may counteract nature by thickening the skin somewhat and by holding water to the skin, but so will other simple emollient creams. However, the fatty layer below the dermis provides support for the skin. As a person ages, the fatty layer often diminishes, particularly in some areas of the face, resulting in wrinkling and changes in facial contour. No cream will restore fat to the subcutaneous layer.

Retinoic Acid. **Retin-A** (retinoic acid) is a synthetic form of vitamin A used to restore collagen. Research on skin treated with Retin-A shows up to an 80 percent increase in the protein that aids in forming collagen. Typically, solutions of 0.025 percent to 0.05 percent cream are used on alternate nights for three to six months before results are visible. Retin-A makes the skin more vulnerable to the sun, so strong sun blocks must be used during treatment (Turkington and Dover, 1996).

Alpha-Hydroxy Acid. **Alpha-hydroxy acid (AHA)** is a generic term for several organic chemicals that, when applied to the skin, result in a mild "peel." Derived from sugar cane or fruits, AHA strengths of 10 percent can be purchased over the counter, and strengths of up to 70 percent are available through dermatologists. Products containing AHA speed up the natural shedding of the skin and soften lines ("AHAs and UV Sensitivity 2000), although they may cause redness and irritation on some skin.

Men's cosmetic companies jumped on the AHA bandwagon in the mid-1990s. Department stores have expanded cosmetic counter space for products such as Polo Sport Face Fitness by Ralph Lauren, which contains AHA. Introduced in 1995, Face Fitness became the number one selling men's AHA product (Spindler, 1996). Aramis's biggest selling men's line was christened the Lab Series. Fragrance and oil free, the products contain both AHA and a sunscreen. Lab Series advertisements mention reducing dark circles and lines while adding moisture to the skin and repairing cells. Lab Series products include Eye Time, Lift Off (a day moisturizer), and Sharp Shooter (a night moisturizer). The Stop Shine product promises to reduce the shine from oily skin.

Beta-Hydroxy Acid. Consisting of salicylic acid, **beta-hydroxy acid (BHA)** is a gentle alternative to alpha-hydroxy acid. BHA produces similar peeling effects but is non-irritating, says Bowman Gray Medical School Professor Zoe Draelos, M.D., who suggests alternating AHA products with kinder BHA products ("Why Beta Is Better," 1997).

Trichloracetic Acid. Another peel is trichloracetic acid (TCA), which is applied in a lower strength of 10 percent. It is especially good for fine lines around the mouth. The purpose of all peels is to promote cell rejuvenation and to give the skin a glow (Wilkinson, 2001).

Vitamin Additives. Recent cosmetic additives are vitamins C and E. For example, MediCell Laboratories produces Hydrox-C, which combines three types of vitamin C with AHA. L'Oreal's Futur E is a similar vitamin-enriched product. These products promise to protect against environmental concerns. Facelift Vitamin C's Anti-Wrinkle was the first patch-type application of vitamins to the skin. It received overwhelmingly positive results after its introduction featuring five million samples given out in 1998 (Brookman, 1998).

Nails

Nails are flattened, elastic structures of a horny texture located on the ends of toes and fingers.

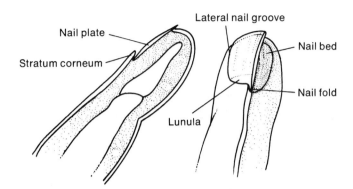

Figure 5.22 The anatomy of the nail.

Nails are made of keratin, the tough protein that is also the basis of skin and hair (Turkington and Dover, 1996). The **nail root** is implanted into a groove in the skin. The exposed portion of the nail is called the **body,** and the distal extremity is the **free edge** (Figure 5.22). The nail firmly adheres to the epidermis and is accurately molded to its surface. The part beneath the body and root of the nail is called the nail **matrix,** where the nail is produced. Near the root of the nail is an area that is whiter in color, called the **lunula.** The cuticle is attached to the surface of the nail a little in advance of the root (Gray, 1985).

The nails grow about 1 millimeter per week in length. This growth is caused by a proliferation of cells at the root of the nail. It takes up to six months to grow a fingernail from the base to the tip; toenails take twice as long to grow ("Nailcare," 2001). In addition, the nails on a person's dominant side grow faster than the nails on the nondominant side, and they grow faster in warm weather than in cold weather. The thickness of the nail is determined by the cell formation underlying the lunula (Gray, 1985).

The illusion of long healthy nails through artificial nails became a big business in the 1990s. In 1997, the nail care industry generated $6 billion in income, mainly as the result of acrylic nails (Fedor, 1998).

Hair

In addition to body build, skin, and nails, hair is an important part of individuality.

Anatomy of Hair

Like skin and nails, a hair is composed of keratin. It consists of a **hair root,** the part implanted in the skin, and a **shaft,** the portion projecting from the skin surface.

Root

The root of the hair ends in an enlargement, the hair **bulb,** which is whiter in color and softer than the shaft, and is lodged in a hair **follicle** in the dermis (Figure 5.23). The hair follicle extends from the skin's surface in a funnel-like shape to its deep extremity where it takes the shape of the hair bulb, which supplies keratin and melanin.

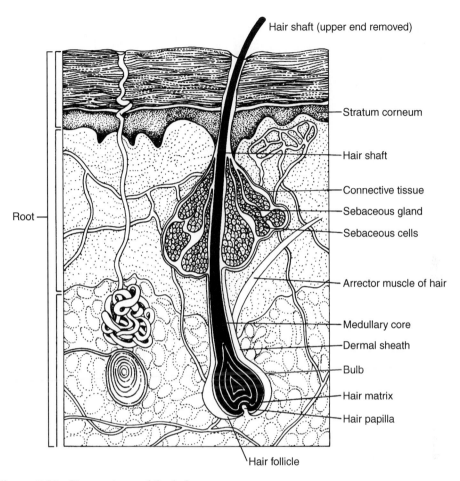

Hair shaft (upper end removed)

Stratum corneum

Hair shaft

Connective tissue

Sebaceous gland

Sebaceous cells

Arrector muscle of hair

Medullary core

Dermal sheath

Bulb

Hair matrix

Hair papilla

Root

Hair follicle

Figure 5.23 The anatomy of the hair.

Opening into the hair follicle are one or more sebaceous glands. (The oil secreted by these glands gives hair its sheen.)

At the bottom of each hair follicle is the **papilla.** This small peg of tissue pushes up through the center of the follicle into the bottom of the hair bulb. When a hair is plucked out, the papilla stays behind and manufactures a replacement. The papilla is rich in minute blood vessels; it supplies amino acids that are synthesized into protein to feed the continuous formation of cells on the outer surface of the papilla. These new cells are continuously being created from below and pushing the older cells up. As they rise, the cells undergo structural differentiation into the variously shaped cells that make up the hair shaft. After a hardening process, **keratinization,** the shaft emerges from the mouth of the hair follicle as a hardened shaft of hair (Gray, 1985).

|(100)|(500)|(1,500)|(5,000)|

Figure 5.24　The portion of the hair that extends beyond the skin is called the hair shaft. It is composed of united cells arranged in different layers. Sketches show microscope sections of a healthy hair magnified 100, 500, 1,500, and 5,000 times.

Hair Shaft

The portion of the hair that extends beyond the skin is called the hair shaft. It is composed of united cells arranged in different layers: the cuticle, the cortex, and the medulla (Figure 5.24).

The **cuticle,** or the outer hair membrane, is made up of delicate overlapping cells. In finer hairs, these cells resemble flat bands. In coarser hairs, they may be likened to shingles on a roof. The scales are derived from epithelial cells that have become hardened and are very closely related to fingernails. This is made of dead cells, not living tissue.

The **cortex,** or middle portion of the hair, which is the largest part of the shaft, is made up of elongated cells. The pigment of the hair is found here.

The **medulla,** which is the inner layer or central pith of the hair, is composed of rows of polyhedral cells. Short, fine body hair and some long, coarse hair do not have this layer (Cooper, 1971).

Forms of Hair

Straight, wavy, curly, or crinkly forms of hair are determined by the shape and cross-section of the hair follicle and the direction of the hair follicle in the skin. Straight hair grows from follicles that are perfectly straight throughout their length.

Wavy hair grows from curved follicles; the degree of waviness is dependent on the amount of curvature. Loosely waved hair is usually deceptive in appearance. Because of its shallow curvature it may appear straight. Sometimes the weight of the hair will pull the hair wave into a straight position.

Curly, woolly, or kinky hair is also caused by the curvature of the follicle. The more curvature, the more curl. In the most extreme curl, the follicles are almost coiled.

Hair is a physical sign of racial difference. Its texture, color, and distribution vary widely among races. Almost all Asians, including Chinese and Japanese, as well as American Indians and Eskimos, have straight, coarse, dark hair on their heads and only sparse facial and body hair. People of African descent have slightly more body hair and crinkly or woolly hair on the head. Caucasians have an in-between form of

wavy, curly, or straight, fine hair and more body hair than any other race except the Heinous of Northern Japan (Gray, 1985).

Hair Color

The geographical distribution of hair color tends to follow skin color. The darker the skin is, the blacker is the hair. The lighter the skin tones are, the lighter is the hair shading, ranging from brown to blond.

Hair contains both keratin and melanin. Hair color depends on the concentration of the pigment melanin, which is most often black. A heavy deposit of melanin in the hair cells results in black hair. Less melanin produces hair color ranging from dark brown to light brown to blond. The more dilute the melanin is, the weaker is the color. As it ages, the body produces less melanin and the hair appears to be yellowish gray—the color of keratin.

Red hair is the result of the presence of gene-related red melanin. If the red melanin content is low or deficient, the hair will be light red. If the red melanin is present with strong black melanin, the red will not show, will act as a highlight in black hair, or will produce reddish-brown or chestnut shades (Turkington and Dover, 1996). Hair-color genes can be slow in appearing. Often light-haired babies will have dark hair as adults.

Hair Growth

There are an average of 100,000 hairs on an individual head, each growing 1/72 of an inch per day—or an inch each seventy-five days. Hair grows in phases. An active growing period is followed by follicular regression that is then followed by a resting period. In adults hair grows from three to four years then rests for three months; therefore, approximately 85 percent of one's hair will be actively growing at a time while the remainder rests (Alaiti, 2001).

Hair grows at different rates on different parts of the body, and the rate of growth varies with sex, age, and health. Hair grows faster on people between the ages of 15 and 30. Women between the ages of 16 and 24 have the fastest rate. This may be as much as 18 centimeters, or 7 inches of hair growth per year. The rate of growth slows down as we age. Hair-growth patterns are slowed down during illness and, in females, during pregnancy. Often during convalescence after a severe illness, the growth pattern of hair is accelerated.

Shaving or cutting does not really promote hair growth, but it may make the growth appear coarse because of blunt ends. Hair often grows faster in hot weather. A single strand of hair may grow 22–28 inches (55–70 centimeters).

Hair Loss

Although hair is continually growing, it is also continually sloughing off. Some daily hair loss is natural: Between forty to sixty hairs fall out each day. As long as the hair's substance is continually being formed at the papilla, the individual hair grows longer and longer. When the follicle can no longer support the weight, the growth ceases. In an adult this takes from two to four years (Gray, 1985).

In children and young adults, the discarded hair is replaced and often will actually increase in the number of individual hairs produced. This is how the hair on a

baby's head thickens as the child grows. As long as the scalp is thick and pliable and moves freely over the skull, the hair growth will be healthy. If the hair follicle is damaged or the matrix cells lose their vitality for any reason, hair will not grow. In maturity or in illness, the scalp is sometimes drawn tightly over the skull. This causes constriction of the blood vessels and atrophy of the hair roots. Massage can help to loosen the scalp and improve circulation, which can promote hair growth.

The tendency to go bald is an inherited characteristic. Researchers believe that specific genes that cause baldness are carried by both males and females. Although baldness is more common in men, the right combinations of genes can produce balding and thinning in women. Although many conditions cause baldness, an overproduction of male hormones (androgens) is believed to be a factor.

There are two kinds of male baldness, alopecia premature (early baldness) and alopecia senilis (old-age baldness). It is estimated that one man in five starts to go bald soon after adolescence; 40 percent are bald by the age of 35. Another one in five retains a full head of hair past 60. The rest range in more gradual hair loss. The greatest amount of baldness in both men and women comes after 50. Sixty percent of women experience hair loss by the time of menopause.

As of this writing, minoxidil (tradename Rogaine Topical Solution) is the only proven product for hair regrowth. Clinical tests in twenty-seven medical centers on 2,300 men showed 48 percent of the men experienced hair regrowth, with an additional 36 percent of the men having minimal regrowth while using Rogaine. Two-thirds of the women experienced regrowth. Scientists are studying anti-androgen drugs in an effort to counter the effect of excessive testosterone, which alerts the hair to fall out ("Non-Surgical Treatments for Baldness," 2001). Meanwhile, many men prefer a more immediate solution to baldness; in 2000, 250,000 men had hair transplants ("Surgical Treatments for Baldness," 2001).

Hair Processing

Changing hair color, amount of curl, and style are quick ways of making a new fashion statement. Although some measures are temporary, such as adding gels, mousses, or sprays, others are more lasting.

Permanents

Permanents are used to curl or straighten hair. To curl, chemical solutions placed on the hair break down the sodium bonds and allow the hair to be molded in the shape of the rod on which it is wrapped. Permanents add body to fine, limp hair and give it the illusion of increased volume. To straighten curly hair, the same solution is used except the hair is combed out straight. Afterwards, a neutralizer that restores the sodium bond is applied. Thus, the newly created pattern is set in the hair, where it will remain.

Coloring

Hair changes color naturally throughout the different stages of life. The vivid colors of youth generally begin to lighten or dull by the mid-20s. Many individuals change the color of their hair throughout life to lighter or darker shades, often going back to the

colors of their youth. The Gen Y generation continues to push the trend of using non-traditional hair coloring (yellow, purple, green). Haircare companies are aware that a teen who desires yellow hair today may want purple hair tomorrow. One company responded with a product called Funky Stick, a roll-on semipermanent hair color stick that comes in seven colors and washes out after several washings (Costello, 2001).

Hair coloring has also become popular with men. Since 1995, the market for men's hair color has nearly tripled becoming a $113.5 million industry in 1999. Today men feel that using hair products such as gels and mousses gives them a competitive edge (Theissman, 2000).

Coloring the hair can be temporary or permanent. Temporary color change is accomplished by coating the hair shaft with color. This type of color change is usually called tinting. It will often last for several shampoos but must be renewed frequently. Permanent hair color change is a chemical process. Bleach is used to lighten the hair to a dark, medium, or light yellow. Chemicals force open the cells of the hair shaft and strip out the pigment. Toners are used to achieve the exact color. The paler the tone desired, the lighter the bleaching process must be.

This chemical alteration of the hair weakens the hair. If improperly done, the cellular arrangement of the hair shaft can be completely destroyed and the hair shaft will break off at scalp level. Overprocessed hair has been allowed to go beyond the point where the sodium bond can be restored. The result is damaged hair that is soft and spongy when wet, and dry and brittle when dry.

Diet

Body build and the health of skin, hair, and nails is closely related to eating habits, food intake, and nutritional status. Body shape is maintained, controlled, and contoured by diet and exercise. This section presents an overview of diet as it relates to body conformation and ultimately to clothing selection.

The subject of nutrition deals with dietary requirements that promote health and development. There are six **essential nutrients:** carbohydrates, proteins, fats, vitamins, minerals, and water (Figure 5.25). A knowledge of the six classes of essential nutrients will help form a better understanding of the importance of including each in the daily diet. Although there is some overlapping, the three main roles of the various nutrients are:

1. Body building, maintenance, and repair: proteins, minerals, vitamins, water.
2. Body fuel for energy and heat: carbohydrates, proteins, fats.
3. Regulation of body processes: vitamins, minerals, water.

USDA's Food Guide Pyramid

The Food Guide Pyramid was developed in 1992 by the U.S. Department of Agriculture to guide individuals' food choices to meet nutrient requirements as well as to make recommendations for health and disease prevention.

Nutrient	Function	Sources
Carbohydrates	Body heat and energy	• *Sugar:* honey, jellies, desserts • *Starch:* bread, pasta, cereal, vegetables
Protein	Build, maintain, and repair body tissues in the blood, bones, muscles, nerves, and connective tissues	Meat, eggs, legumes, cheese, milk, nuts, grains
Fats	Body heat and energy	• *Natural:* dairy products, nuts, seeds, chocolate • *Added:* fried foods, pastry, salad dressing
Vitamins	• Normal growth and development • Maintenance of health	• *Natural:* minute amounts in foods • *Synthetic:* vitamin supplements
Minerals	• Normal growth; body maintenance and regulation • Constituent of bones, teeth, and soft tissues • Elasticity to muscles and nerves	Milk, raw vegetables, nuts, grains
Water	• Body weight: 50–75% water • Cells: predominately water • Circulation, digestion, elimination • Dehydration: 5% loss; death 10% loss	Water and other fluids

Figure 5.25 Function and sources of essential nutrients. *(Adapted from USDA Guidelines)*

The average American eats 1,400 pounds of food a year. The Food Guide Pyramid (Figure 5.26) suggests that daily food selection be distributed among six groups: (1) breads, cereal, rice, and pasta; (2) vegetables; (3) fruits; (4) milk, yogurt, and cheese; (5) meat, poultry, fish, dry beans, eggs, and nuts; and (6) fats (Figure 5.27).

The shape of the pyramid is a visual illustration of the emphasis various food categories should have in the diet. The large base of the pyramid is the bread category, which should be the largest portion of the diet; the smallest point at the top is relegated to fats, which should be the smallest portion of the diet.

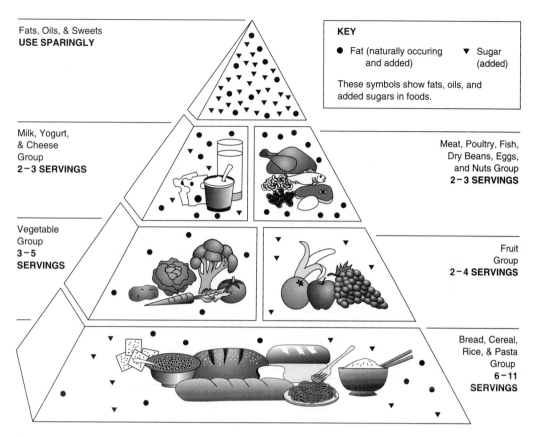

Figure 5.26 The USDA Food Guide Pyramid illustrates making daily good choices among the five food groups (plus a minimum of fat) that meet nutrient requirements as well as recommendations for health and disease prevention. *("USDA Food Guide Pyramid" prepared by Human Nutrition Information Service, August 1992,* Home and Garden Bulletin *No. 232, Washington, DC: USDA and DHHS)*

Common Topics of Nutritional Concern

Sugar

Dietary sugar consists of a group of sweeteners: sucrose (cane and beet sugar), corn or glucose syrups, and sugars that occur naturally in food such as lactose in milk and fructose in fruit. U.S. consumption of sugar is 158 pounds (50 teaspoons per day) per capita per year ("Sugar Intake," 2000). Sugar is said to promote obesity, dental cavities, and an increase in the risk of heart disease.

The desire for a sweetener without calories promoted the development of artificial sweeteners. A survey by the Calorie Control Council found that 144 million American adults regularly consume low-calorie, sugar-free products made with artificial sweeteners (Henkel, 1999). Of the three oldest types of artificial sweeteners—saccharin, cyclamate, and aspartame—only aspartame is considered "safe." Known as Nutrasweet, it is used in more than four thousand products (Henkel, 1999). A more

Servings per Food Group	Serving Examples	Benefits
Bread-Cereal Group: 6–11 servings daily	• 1 slice bread • 1/2 c. cooked cereal, rice, or pasta • 1 oz. ready-to-eat cereal • 1/2 bagel or English muffin • 1 small roll, biscuit, or muffin • 3 or 4 small crackers	• Sources of complex carbohydrates, B vitamins, and iron. • Protein for vegetarian diets. • Whole grains contribute magnesium, folacin, and fiber. • Breakfast cereals are fortified with vitamins A, B12, C, and D.
Vegetable Group: 3–5 servings daily	• 1/2 c. cooked or raw vegetable • 1 c. leafy raw vegetable • 1/2 c. cooked legumes • 3/4 c. vegetable juice	• Vitamins A and C, fiber. • Dark-green and deep-yellow vegetables: vitamin A, riboflavin, folacin, iron, and magnesium. • Collards, kale, mustard, turnip, and dandelion greens provide calcium.
Fruit Group: 2–4 servings daily	• 1 apple, banana, orange, melon wedge • 1/2 grapefruit • 3/4 c. juice • 1/2 c. berries • 1/5 c. dried fruit	• Contribute vitamins A and C, potassium, fiber.
Meat-Poultry-Fish-Alternatives Group: 2–3 servings daily	• 2–3 ounces of lean, cooked meat, poultry, or fish • 1 egg • 1/2 c. cooked dry beans, dry peas, soybeans, or lentils • 2 T. peanut butter	• Protein, phosphorus, vitamins B6 and B12, iron, zinc, magnesium, and niacin. • Red meats and oysters: zinc. • Liver and egg yolks: vitamin A. • Dry beans, dry peas, soybeans, and nuts: magnesium. • Seeds (sunflower, sesame): polyunsaturated fatty acids.
Milk-Cheese Group: • 2 servings daily • 3 servings daily for teens, pregnant or lactating women; postmenopausal women	• 1 c. milk or yogurt • 2 oz. processed cheese food • 1.5 oz. cheese	• Dairy products: calcium, riboflavin, protein, and vitamins A and B12. • Often fortified with vitamin D.
Fats-Sweets-Alcohol Group: Use sparingly	No serving sizes are suggested for this group	• Provide mainly calories. • Vegetable oils: vitamin E.

Figure 5.27 USDA's Food Guide pyramid serving recommendations.

recent no-calorie sweetener, Sucralose, trade name Splenda, is six hundred times sweeter than sugar. Created by reorganizing sugar molecules, it passes through the body unabsorbed with no side effects (Sizer and Whitney, 2000). The use of artificial sweeteners continues to be the subject of research in the United States, and although current research suggests that moderate intakes of artificial sweeteners pose no heart risks, moderation is the key (Position of the American Dietetic Association, 1998).

Consumers can check the ingredient label for sweeteners and sugars in products. Watch for such words as *xylitol, turbinado sugar, sorghum, soribuital, mannitol, maltose, levulose, lactose, sucrose, glucose, dextrose, fructose, corn syrups, corn sweeteners, natural sweeteners,* and *invert sugar* (Henkel, 1999). Ingredients are listed on the label in the order of predominance, with the ingredients used in largest amounts listed first.

Fat

Cholesterol is a fat-like substance found in the blood.

High-fat diets—especially high saturated-fat diets—promote higher levels of blood cholesterol. High levels of cholesterol are linked to the formation of fat deposits in the linings of arteries, a condition associated with heart disease. In contrast, diets with lower levels of saturated fat and relatively more **polyunsaturated fat** (most vegetable oils) are linked to lower levels of blood cholesterol and possibly less risk of heart disease. The current recommendation by the American Heart Association is to have no more than 30 percent of one's daily calories from fat. Of that fat, it should be approximately one-third or less saturated fat, one-third polyunsaturated, and one-third unsaturated (Size and Whitney, 2000). Cholesterol intake should be less than 300 milligrams daily (Mayfield, 1999).

Procter & Gamble spent $200 million and twenty-five years developing an artificial fat, Olestra (Olean), which is made from sugar and vegetable oil. Its molecules are too large to digest and therefore pass through the body. Called fat-free fat, Olean is used in chips, crackers, and other snack foods. It may cause side effects such as stomach cramps in some consumers (Sizer and Whitney, 2000).

Sodium

Excess sodium in the diet is believed to contribute to high blood pressure (hypertension), which increases the risk for heart disease and stroke in some people. To limit sodium intake, limit the use of table salt (sodium chloride) and salty foods. To determine the presence of salt, read product labels looking for the words indicating soda or sodium or the symbol "Na" such as *sodium bicarbonate* (baking soda), *monosodium glutamate* (most baking powders) *disodium phosphate, sodium alginate, sodium benzoate, sodium hydroxide, sodium propionate, sodium sulfite,* and *sodium saccharin.*

Fiber

Dietary **fiber** is plant material that is not digested in the gastrointestinal tract. Fiber is classified according to how readily it dissolves in water.

Insoluble fibers—found in brown rice, fruits, legumes, seeds, vegetables, wheat bran, and whole grains—consist of fibrous structures of fruits, vegetables, and grains.

Ethnic Food Preferences

- Horse meat is a favorite food in north-central *Asia.*
- Pork, popular in *North* and *South America,* is rigidly forbidden in Islamic countries.
- Bone-marrow soup and snails are favorites in *France,* while kidney pie is a traditional choice in the *Philippines.*
- In some countries people eat snails and insects but feed soybeans and corn to animals.
- Peanut butter is a staple of *West Africa.*
- *Mexicans* favor beans, rice, meat, and potatoes on tortillas with salsa.
- *Chinese* cook small portions of meats and vegetables together, centering meals around a starch dish and consider eyeballs a delicacy (Sizer and Whitney, 2000).
- *Japanese* diets (traditionally rice, vegetables, and small quantities of meat) have seen a tenfold increase in the consumption of meat since the 1940s (Mokoto, 1989).
- Beef is considered sacred and forbidden as food in *India.*

Figure 5.28 Examples of ethnic food preferences.

Health effects include softening of stools, regulating bowel movements, reduction of colon cancer, and reducing risks of appendicitis and diverticulosis.

Soluble fibers—found in barley, fruits, legumes, oats, rye, seeds, and vegetables—readily dissolve in water, often giving gummy or gel-like characteristics to food. For example, pectin from fruit is used to thicken jellies. Its health effects include lowering blood cholesterol, slowing glucose absorption, and slowing food transit through the upper digestive tract (Eure, 2001). The World Health Organization recommends a daily intake of 27–40 grams of fiber (Sizer and Whitney, 2000).

Eating Patterns

People learn from their society which foods to eat and which to avoid (Figure 5.28). Foods often have symbolic, emotional, and cultural meaning such as comfort foods, health foods, junk foods, fun foods, organic foods, soul foods, fattening foods, mood foods, and pig-out foods.

The American tradition is to have three meals a day—breakfast, lunch, and dinner, with some snacks in between. However, busy consumers are balancing school, sports, jobs, and social activities, which all take preference to eating with the family or living group. Americans have become grazers who grab food on the run from home, the vending machine, or a fast-food drive-through. Americans spend nearly half their food budgets on meals consumed outside the home (Nestle and Jacobson, 2000). Experts report that unhealthy eating practices begin as early as 8 years old ("Bodywise Eating Disorders," 2000). Twenty-five percent of the daily calorie intake for teens comes from snacks that are often fast food eaten away from home (Sizer and Whitney, 2000). A typical American eating pattern is:

- Presweetened cereal and milk or no breakfast.
- Mother skips lunch; dad eats in a restaurant; kids eat from the school vending machine or trade the contents from lunch boxes.
- Dinner consists of a heat-and-serve or a take-out meal.

This diet is high in fat, high in sugar, and high in calories. Nutritionists warn that this diet, when eaten exclusively, could give a consumer scurvy because of the lack of vitamin C. Emphasis is now on time savings; nutritional value does not seem to concern consumers.

Fad Diets

Fad diets are usually based on one food or a strange combination of foods. They promise to "crash" weight off in a limited time. The weight lost from such a regime is usually quickly regained. Fad diets can be dangerous to one's health, causing illness and, in some extreme cases, death.

Advertisers frequently promote bogus weight-loss products that may be scrutinized by the FDA. The FDA names diet scams as one of the nation's leading causes of fraud (Sizer and Whitney, 2000). The following are examples of bogus weight-reduction products that the FDA banned from the market:

- Cellasene supposedly worked from within to nutritionally help eliminate cellulite at its source.
- The Fat Trapper and Exercise in a Bottle made false weight-loss claims. Slim Again, Absorbit-All, and Absorbit-All Plus claimed they could rid consumers of up to 49 pounds in 29 days, take 5 inches off their waistlines, and 3 inches from their thighs ("Diet Fraud," 2002).
- "Fat magnet" pills supposedly contained thousands of fat-attracting magnetic particles. When swallowed, they attracted fat to themselves and were flushed out of one's system.
- Appetite patches were made of a few drops of herbal liquid on a bandage patch to be worn by the overweight. Supposedly the herbal liquid was absorbed into the appetite center of the brain and turned it off.
- "Dream away" pills were taken before bedtime; they allegedly burned off fat by morning (Brown, 1995).

Health Foods

Pushing from another direction are the **health food** promoters, who started in the 1970s touting food claims such as "organically grown," "all natural," "no preservatives," "no additives." "Nothing artificial" became the catchwords of the health-food movement. After steady growth, the vitamin and nutritional supplements businesses alone became a $6.5-billion annual business (Strauss, 1998) with 40 percent of the population taking them (Sizer and Whitney, 2000). In addition, the Organic Trade Association estimates a growth rate of 20 percent per year, with $6.4 billion worth of sales of organically grown food in 1999 (La Ferla, 2001).

Building on the fear of poor-quality foodstuffs, health-food promoters often twist basic nutritional information so it can be exploited for profit. Health food has grown in popularity because a number of people have become alarmed about the proliferation of low-nutrition food. Health-food stores generally specialize; some will sell special grain bakery products; some sell chemicals, vitamins, and minerals; others sell organically grown vegetables; and yet others sell raw milk. The merit of these foods can be debated. Often the prices in these stores are very high—two to three

ACTIVITY 5.6 Nutritional Analysis

Keep track of an individual's food intake for a three- to seven-day period of time.
- Compare food choices to the Food Guide Pyramid.
- Compare serving sizes to the suggested servings on the Food Guide Pyramid.
- Analyze the nutritional status of this person's diet.

Nutrient	Recommended Value	Actual Value
Protein	12%	17%
Simple sugars	10%	25%
Carbohydrates	58%	47%
Saturated fat	10%	13%
Total fat	30%	36%

Figure 5.29 Recommended and actual nutrient values. *(Adapted from U.S. Department of Agriculture & U.S. Department of Health and Human Services, Home and Garden Bulletin No. 232,* Nutrition and Your Health: Dietary Guidelines for Americans, *3rd ed. Washington, DC: U.S. Government Printing Office, 1990)*

times the price of comparable foods. Because of a low-volume turnover, the quality sometimes can be quite low. Research has shown that these "organically grown foods" often contain more harmful pesticides and fewer trace minerals than comparable foods lacking the "organic" claim.

Malnutrition

Malnutrition is the result of both overconsumption (overnourishment) or underconsumption (undernourishment) of proper nutrients.

Research studies have shown that many Americans' diets contain high quantities of fats and sugars. Only 25 percent of Americans consume five or more servings of fruits and vegetables per day (CDC, 2001) (Activity 5.6). The USDA compares the recommended values and actual values of food components based on a percentage of total calories (Figure 5.29).

Lack of proper nutrition, inadequate nutrition, and unbalanced nutrition are very serious problems worldwide. Various diseases can be either attributed to or accelerated by malnutrition. Statistics show alarming increases of deaths from diseases such as heart disease, arteriosclerosis, cerebrovascular disease (stroke), diabetes, arterial hypertension, and gout. These are called **degenerative diseases** because each involves the breakdown of individual body cells, which results in the degenerative

CASE 5.2

Calculating Fat Percentage in Foods

Kathy was concerned about her fat intake. She selected a cookie that contained 6 grams of fat and 120 calories. What is the percentage of fat in her cookie? Fat = 9 calories per gram.

1. 6 fat grams × 9 calories per gram = 54 fat calories
2. 54 fat calories/120 total calories = 45 percent

Thus, this snack would be a poor choice since it is more than 30 percent fat.

breakdown of the whole person as well. One degenerative disease can lead to another. For example, a diabetic can become a victim of hardening of the arteries, a heart attack, high blood pressure, and finally suffer a stroke. Degenerative diseases are striking down the young as well as the old. The incubation period for arteriosclerosis is estimated to be twenty years, so anyone older than 20 could be in the process of developing this disease.

Calories

Calorie is the unit of measurement used to describe the amount of heat generated when food is burned by the body.

When food is consumed, digested, and used in the body, energy is released. Heat is a by-product of energy. Food energy is measured in kilocalories (thousands of calories), abbreviated kilocalories or kcals or capitalized: Calories. A calorie is not a nutrient. It serves simply as a convenient measurement of the yield of energy from nutrients—proteins, fats, and carbohydrates.

The calorie chart is a tool to use in food planning. In studying the calorie values of various foods, it is easy to see that foods high in fat are high in calories. To measure calories, scientists compare the number of calories per gram of food. Fats are the most energy rich of nutrients, containing 9 calories per gram compared to both proteins and carbohydrates, which contain 4 calories per gram. Fat is often expressed as a percentage; for example "25 percent of calories from fat" (Case Study 5.2). A food with higher than 30 percent fat content is considered a poor choice.

Removal of fat lowers the caloric count of a food. Nonfat milk has about half the number of calories as whole milk. Lean steak with the fat trimmed away is dramatically lower in calories than untrimmed, well-marbled meat.

Calorie values of food vary greatly, and fat content is one of the prime reasons for this variation. But calories themselves do not vary in value; the unit of measurement always remains the same. Therefore, no food can be more "fattening" than any other food. Calories merely add up faster in foods that are high in fat.

CASE 5.3

 Weight Maintenance and Loss

A. Weight maintenance
1 pound of fat = 3,500 calories.
To gain 1 pound: increase food intake by 3,500 calories.
To lose 1 pound: reduce food intake by 3,500 calories.
To maintain current weight: also consider lifestyles:

- Inactive/sedentary: 6–8 kcals per pound
- Moderately active: 14–15 kcals per pound
- Extremely active: 20 kcals per pound

(Tapley, Morris, Rowland, and Weiss, 1989)

B. Weight Loss

1. **Male Example:** Joe is moderately active and weighs 210 pounds. He wants to lose 10 pounds in the next five weeks. How many calories should he eat per day?
Solution:

1. 10 lbs × 3,500 = 35,000 kcals/5 weeks = 7,000 kcals less/week
2. 7,000 kcals/7 days = 1,000 kcals less per day
3. 210 lbs × 15 kcals = 3,150 kcals to maintain weight
4. 3,150 − 1,000 = 2,150 kcals allowed per day to lose weight

Thus, Joe must limit his caloric intake to 2,150 kcals per day in order to lose 10 pounds in five weeks.

2. **Female Example:** Jill is a runner and extremely active. She just had a baby and weighs 140 pounds. She wants to lose 10 pounds in the next five weeks. How many calories should she eat per day?
Solution:

1. 10 lbs × 3,500 = 35,000 kcals/5 weeks = 7,000 kcals less/week
2. 7,000 kcals/7 days = 1,000 kcals less per day
3. 140 pounds × 20 kcals = 2,800 kcals to maintain weight
4. 2,800 − 1,000 = 1,800 kcals allowed per day

Thus, Jill must limit her caloric intake to 1,800 calories per day in order to lose 10 pounds in five weeks.

Weight Control

The use of calories in weight control can sometimes simplify the task (Case Study 5.3). Food intake becomes simple arithmetic. To gain, increase the intake of calories; to lose, decrease the intake of calories; to maintain, keep the same intake of calories. In this manner various favorite foods, even those with a high calorie count, may be enjoyed if the daily totals are observed. A combination of calorie reduction and added exercise will speed weight loss.

BMI	Obesity Class	Risks to Health
< 18.5	Underweight	The lower the BMI, the greater the risk
18.5 through 24.9	Normal	Very low risk
25.0 through 29.9	Overweight	Increased risk/high risk[a]
30.0 through 34.9	Class I obesity	High risk/very high risk[b]
35.0 through 39.9	Class II obesity	Very high risk
40.0 or above	Class III obesity	Extreme risk

[a]Risk for type 2 diabetes, hypertension, and cardiovascular disease.
[b]The lower risk applies to men with a waist circumference of 102 centimeters (40 inches) or less and women with a waist circumference of 88 centimeters (35 inches) or less. The higher risk applies to those with a waist circumference above these values.
(*Data from National Heart, Lung, and Blood Institute Expert Panel, Executive summary of the clinical guidelines on the identification, evaluation, and treatment of overweight and obesity in adults.* Journal of the American Dietetic Association 98 (1998): 1178–1191)

Figure 5.30 BMI values and health risks.[a]

The USDA's Food Guide Pyramid makes suggestions for choices based on nutrient density—a measure of nutrients relative to the energy the food provides. There are no "good calories" or "bad calories" nutritionally, but there are foods that supply little but calories (empty calories) and others that supply calories plus nutrients. For example both skim milk and ice cream are listed in the milk group. Which is more **nutrient dense** (assuming comparable serving sizes)?

- 1 cup of skim milk provides 300 mg of calcium and 85 calories.
- 1/2 cup of ice cream provides 168 mg of calcium and 265 calories.

Obviously, the skim milk is a better selection, being more nutrient dense while containing fewer calories (Sizer and Whitney, 2000).

The Food Guide Pyramid is flexible and can be used by people with different energy requirements. If you want to lose weight, cut down first on the portions from the sixth group (fats, sweets); then select the low end of the range of servings from the other groups. For example, select six servings of bread rather than eleven. Remember, cut down but do not cut out any of the first four food groups. Learn to select a variety of the nutrient-dense foods within each group. If you wish to gain weight, select the higher range of servings from all food groups. Nutritionists and other health authorities agree that a wide assortment of foods provides the best diet.

Body Mass Index

Body mass Index mathematically correlates height and weight with health risks (Sizer and Whitney, 2000).

Another way to determine if one's weight puts one at a health risk is body mass index (BMI) (Figure 5.30). Overweight adults are defined as having a BMI of 25–29.9;

Finding your BMI

$$BMI = \frac{weight\ (kg)}{height\ (m)^2}$$

or

$$BMI = \frac{weight\ (lb)}{height\ (in)^2} \times 705$$

Example: A 5'10" person weighing 150 pounds has a BMI of 21.6.

$$BMI = \frac{150}{70^2} \times 705$$

$$BMI = \frac{150}{4900} \times 705$$

BMI = .0306 × 705

BMI = 21.6 (rounded)

Figure 5.31 Finding your BMI.

- Fat cells increase during the growing years and level off in adulthood.
- Fat cells increase rapidly in obese children, with many entering their teen years with as many fat cells as adults. Thus they have a difficult time losing weight and regain it rapidly.
- Obesity runs in families. Children's chances of becoming overweight are:
 7% with two normal-weight parents
 60% with one overweight parent
 90% with two overweight parents
- The obese adult has three times as many fat cells as his normal-weight counterpart.

Figure 5.32 Facts about obesity (Sizer and Whitney, 2000).

obese adults have BMIs of 30 or more (Sizer and Whitney, 2000). For example, the average American woman is 5 feet 4 inches tall and 148 pounds and has a body mass index of 25.4 (Cicero, 2002). This would place her in the overweight rather than the obese category. See Figure 5.31 to determine your BMI.

Overnourishment

Individuals who are overnourished take in more calories than needed to perform daily activities. Calories over this amount will be stored as fat.

✂ *Obesity.* The obese are considered overnourished (Figure 5.32). **Obesity** is simply carrying too much body fat. This does not refer exclusively to the grossly overweight; obesity refers to individuals who are 20 percent higher in weight than the U.S. Department of Agriculture's Suggested Weights for Adults table (see Figure 5.10).

Obesity increased from 12 percent to 19.8 percent between 1991 and 2000 (CDC, 2001). Sixty percent of all adults (20 years or older) are overweight (Wallop, 2001). Fifty percent of U.S. women wear size 14 or above (Dam, 2001). Fifty-two million plus-size women live in the United States (37 percent of the nation's female population), generating 27 percent of all women's apparel sales (Carini, 2001). Obesity is also on the rise for children. According to the Center for Disease Control and Prevention, obesity rates for children and teens have doubled since the late 1970s (Wallop, 2001) (Activity 5.7).

Binge Eating Disorder. A pattern of overeating that leads to obesity is called **binge eating.** People with this disorder have histories of weight loss and regain. The condition is characterized by eating large quantities of food within a short period of time, feeling a lack of control over the habit, and becoming depressed afterwards. To qualify for the disorder, binges must occur twice weekly for a six-month period. Bingeing becomes bulimia when the binger induces vomiting or uses laxatives to purge the body of food after bingeing. Between 2 and 5 percent of Americans experience binge eating disorder in a six-month period ("Eating Disorders," 2001). Up to 40 percent of people who are obese may be binge eaters ("Binge Eating Disorder," 2001).

Diet Groups. On any given day in the United States, 30–40 percent of women and 20–25 percent of men are trying to lose weight. Dieters spend $30–40 billion annually (Media and Eating Disorders, 2001) (or $120 per person) (Tedeschi, 2001) on more than 29,000 weight-loss products and services including stomach-reduction surgery, which have doubled since 1998 ("The Real Skinny," 2002). The sales of diet pills and diet supplements have quadrupled since the mid-1990s (Wallop, 2001). Yet only 5–10 percent maintain the weight loss (Sanz, 1997).

Psychologists and physicians concerned with obesity generally agree that diet groups are among the more successful techniques known to date in treating overweight people. Each group has certain fees, rules, procedures, and diets. The basic diet is essentially the same for each group and is based on a variety of the six essential nutrients while lowering the intake of fats and sugars. The goal of each group is to help clients lose weight safely and to maintain the loss by establishing new, healthful patterns of eating.

Weight-loss programs are now offered on the Internet. Consumers spend an average of twenty-three minutes a month on the most popular Internet dieting sites (almost twice the time spent on other health-related sites). For an average fee of $10–$15 per month, users can track their weight, plan their diets, and chat with registered nutritionists, psychologists, and fellow dieters (Tedeschi, 2001).

ACTIVITY 5.7 Sizing in Fashion Ads

Review fashion advertisements from a variety of sources.
- How many large or "plus" sizes for either men or women were found?
- How does this relate to the nutritional/weight status of the United States population?

Undernourished

Lack of adequate nutrition leads to **underweight,** defined as those who weigh 10 percent less than the USDA Table of Suggested Weights for Adults (see Figure 5.10). Some individuals, particularly females, set a weight goal considered to be underweight. For example, research shows that women overestimate the size of their hips by 16 percent and their waists by 25 percent. When asked to select an "ideal body weight," they selected one that was 20 percent underweight ("The Media and Eating Disorders," 2001). Over the years the trend toward a desired weight has moved to even younger girls. Fifty percent of 9-year-old girls have dieted ("Facts about Figures," 1995).

People with eating disorders may suffer from low self-esteem, have a strong need for control, and be perfectionists and overachievers. They see eating as a way to cope with the stress and anxiety of their lives (Schimelpfening, 2001).

Anorexia Nervosa. One's body image may be a distortion of reality. Some overweight people see themselves as slender; some slender people see themselves as heavy. Distorted body image may result in what is known as an **eating disorder.** In addition, consumers often evaluate themselves by the standards of fashion models, who are thinner than 95 percent of the population, being 22–23 percent leaner than the average person. For example, the average U.S. woman is 5 feet 4 inches tall and weighs 140 pounds. However the average model is 5 feet 11 inches tall and weighs 117 pounds ("The Media and Eating Disorders," 2001).

> **Anorexia nervosa** is the practice of severely restricting caloric intake, or starving oneself.

Anorexics weigh less than 85 percent of the normal weight for their height ("Eating Disorders," 2001). Figure 5.33 describes the characteristics of anorexia. An estimated five million Americans have anorexia; most are women under 25 (Tresniowski and Nelson 2001). An estimated 0.5-3.7 percent of women will develop anorexia in their lifetime. Women make up 85 percent of the anorexia cases ("Eating Disorders," 2001). Victims report that 90–100 percent of their waking time is spent thinking about food ("Bodywise Eating Disorders," 2000).

In an effort to be thin, individuals go to the extreme. If anorexics stop eating, they may die of starvation if untreated. Cases of anorexia have been reported in children as young as 5 years of age through women in their 40s, with the mean age being 17 ("Eating Disorders," 2001).

The additional use of laxatives and diuretics may lead to changes in bowel habits and dehydration, which can result in muscle weakness and possible renal and cardiovascular failure. If untreated or ineffectively treated, 10 percent of the victims will die.

> **Bulimia nervosa** is the practice of bingeing on food and then purging the system to avoid weight gain.

Bulimia Nervosa. Bulimia has recently been recognized as a very common practice, particularly among college students. Case studies reveal that bulimics often consume over 10,000 calories on a binge and purge themselves five to ten times a day. An estimated 1.1

Anorexia	Bulimia	Binge Eating Disorder
• Loss of hair/growth of downy hair • Weighs 85% or less than expected weight for height • Intense fear of gaining weight • False view of body weight; sees body as fat when underweight • In women: Infrequent/absence of menstrual period • In men: sex hormone levels drop • Unusual eating habits • Compulsive exercise • Purging by various means • Heartbeat and blood pressure slows • Erosion of dental enamel	• Recurrent episodes of binge eating: excessive amounts of food eaten in a short time and with lack of control • Compensatory behavior in order to prevent weight gain: vomiting, laxatives, diuretics, etc. • Occurs twice weekly for three months • Weigh within normal range • Fear weight gain • Dissatisfied with body • Perform behaviors in secret • Diets when not bingeing	• Recurrent episodes of binge eating: eating excessive amounts of food in a short time and with lack of control • Episodes are associated with at least three of the following: eating rapidly; eating to uncomfortable fullness; eating when not feeling hungry; eating alone because of embarrassment; feeling disgusted with self, depressed, or guilty • Distress about binge eating • Occurs two days a week for six months • Do not purge; thus, often overweight

Figure 5.33 Characteristics of eating disorders. *(Schimelpfening, 2001. Troubled teens fact sheets for parents. http://depression.about.com/library and eating disorders, 2001.* Diagnostic & Statistical Manual of Mental Disorders, *(4th ed) Washington, DC: American Psychiatric Association).*

to 4.2 percent of women will have bulimia nervosa in their lifetime. Women make up 65 percent of the bulimia cases ("Eating Disorders," 2001). Bulimics may have underlying emotional disturbances or conflict that seem best conquered through therapy.

❧ Summary

Variations in the human body influence the selection of apparel. This chapter covers the body variances—body build; body, head, and muscle/fat proportion; body type; and weight—that give each individual a unique body. As a result, consumer body consciousness has led to an increased interest in physical fitness. Other physical components including the numerous combinations of skin color, hair color and type, and nails also contribute to individuality. The health and conformation of these components are each dependent on diet. An inadequate nutritional intake is reflected by the body and may lead to various forms of eating disorders, some of which lead to death. For individual consumers and fashion professionals, an increased understanding of these physical influences lead to more appropriate clothing selection.

❧ Key Terms and Concepts

Alpha-hydroxy acid (AHA)
Anorexia nervosa
Balanced silhouette
Beta-hydroxy acid (BHA)
Binge eating
Body
Body mass index (BMI)
Body proportion
Body types
Bulb
Bulimia nervosa
Calorie
Cardiovascular
Carotene
Chemabrasion
Cholesterol
Collagen
Cortex
Cuticle
Degenerative diseases
Dermis
Eating disorder
Ectomorph
Endomorph
Epidermis
Essential nutrients
Fiber
Follicle
Food Guide Pyramid
Free edge
Hair root
Health food
Isokinetics

Isometrics
Isotonics
Keratin
Keratinization
Liposuction
Lunula
Malnutrition
Matrix
Medulla
Melanin
Mesomorph
Muscles
Nail root
Nails
Nutrient dense
Obesity
Papilla
Physical fitness
Polyunsaturated fat
Pores
Proportion
Rectangle silhouette
Retin-A
Shaft
Somatotype
Subcutis
Sun protection factor (SPF)
Triangle silhouette
Ultraviolet-A
Ultraviolet-B
Underweight
Wedge silhouette

❧ References

AHAs and UV sensitivity: Results of new FDA-sponsored studies. (2000, March 7). *Office of Cosmetics and Colors Fact Sheet.* Washington, DC: U.S. Food and Drug Administration Center of Food Safety and Applied Nutrition.

Alaiti, S. (2001, August 24). Hair anatomy. *eMedicine Journal,* Vol. 2, Number 8, Sections 1–8.

Barnes, J. (2001, July 22). The making (or possible breaking) of a megabrand. *New York Times,* Section 3, p. 1.

Bellafante, G. (2001, June 5). In this bare-it-all age, bikinis are back. *New York Times,* Section A, p. 1.

Beta hydroxy acids in cosmetics. (2000, March 7). *Office of Cosmetics and Colors Fact Sheet.* Washington, DC: U.S. Food

and Drug Administration Center of Food Safety and Applied Nutrition.

Binge eating disorder, anorexia nervosa, bulimia. (2001). American Anorexia Bulimia Association, Inc.

The bodywise eating disorders information packet for middle school personnel. (2000, July). Office of Women's Health. Washington, DC: U.S. Department of Health and Human Services Program Support Center.

Brody, J. (2001, May 22). Time to review your cosmetics, under bright light. *New York Times,* Section F, p. 5.

Brookman, F. (1998, March 20). Skincare's bedside manner. *Women's Wear Daily,* p. 12.

Brown, J. E. (1995). *Nutrition now.* Los Angeles: West Publishing.

Carini, M. (2001, October 11). Apparel and footwear industry news. Standard & Poor's Industry Surveys. http://www.netadvantage. standardpoor.com.

CDC: Obesity, diabetes an epidemic in U.S. (2001, September 17). *Medical Industry Today.* Medical Industry International, Inc.

Cicero, K. (2002, March). What to eat today for a better body tomorrow. *Glamour,* pp. 94–96.

Cooper, W. (1971). *Hair.* New York: Stein & Day, pp. 16–17.

Costello, B. (2001, October). To dye for. *Women's Wear Daily,* Beautybiz, p. 16.

Dam, J. (2001, July 2). Making it big. *People,* 126–133.

Diet Fraud. (2002). Fat trapper breaks FTC sanctions (2002) retrieval: www.dietfraud.com.

Dover, J. (1999, October 27). *Tattoo removal made easier with new laser therapies.* New York: American Academy of Dermatology.

Eating disorders. (2001). *Diagnostic and statistical manual of mental disorders* (4th ed.). Washington, DC: American Psychiatric Association.

Ethnic Skin. (1998). New York: Clinique Laboratories, Inc.

Eure, M. (2001). Health benefits of fiber. *Senior Health.*

Facts about figures (1995, June 3). *People,* p. 71.

Fedor, M. (1998, April). Style guide: Nails. *In Style,* 247.

Gray, H. (1985). *Anatomy of the human body.* New York: Churchill Livingstone, pp. 376–411.

Grossman, A. (2001, October 26). *Women's Wear Daily,* p. 7.

Heavy lifting. (1998, April). *Women's Wear Daily Special Report.*

Henkel, J. (1999, November–December). Sugar substitutes: Americans opt for sweetness and lite. U.S. Food and Drug Administration: *FDA Consumer Magazine.*

Isreltre, J. (2001). Suncare year to year. Efficient Consumer Response Management Company, Inc. http://www.ecrm-epps.com? expose? V4__1/Suncare__Year.htm.

La Ferla, R. (2001, July 15). Fashionistas, ecofriendly and all-natural. *New York Times,* Section 8, p. 1.

Makeup sales: It's back to basics. (2001, October). *Women's Wear Daily,* BeautyBiz, p.60.

Male grooming. (2001). www.auroracolors. plc.uk/archive.html.

Mayer, T. (2001). Plastic surgery statistics. http://plasticsurgery.about.com/library/ weekly/aa121800a.htm.

Mayfield, E. (1999, January). A consumer's guide to fats. U.S. Food and Drug Administration: *FDA Consumer Magazine.*

The media and eating disorders. (2001). Rader Programs. http://www.nutrition.org. uk/Facts/nutandhealth/malnutrition.html.

Mokoto, M. (1989). Eating is a solitary pastime. *Japan Quarterly, 36,* 207–210.

Morrison, S. (2001, December 5). *Cosmeceuticals drive healthy grown rates.* Chemical Week Associates.

Nailcare. (2001–2002). Aubrey Organics, Inc. http://www.tipsofallsorts.com/nail.html.

Nestle, M., and Jacobson, M. (2000, February/ January). Halting the obesity epidemic: A public health policy approach. *Public Health Reports,* pp. 115, 12–24.

Non-surgical treatments for baldness/hair loss. (2001). All about hair. Folica.com. http://www.health.library.com/hairloss/tr eatment.htm.

Physical activity and health. (1996). U.S. Department of Health and Human Services. Washington, DC: U.S. Government Printing Office.

Platt, L. (1999, November 14). They bad. *New York Times Magazine,* pp. 114–117.

Position of the American Dietetics Association: Use of nutritive and non-nutritive sweeteners. (1998). *Journal of American Dietetics Association,* 581–587.

The real skinny. (2002, February 11). *People,* p. 88.

Robins, S. H. (1991). *Biological perspectives of human pigmentation.* Cambridge, England: Cambridge University Press.

Safire, W. (1993, January 17). On language: Smearing it on, rubbing it in. *New York Times,* Section 6, p. 14.

Saint Louis, C. (1999, November 14). What were they thinking? *New York Times Magazine,* p. 82

Sanz, C. (1997, September 29). Happy as they are. *People,* pp. 116–122.

Schimelpfening, N. (2001). *Troubled teens: Fact sheets for parents.* Part 3: Eating disorders. About depression. http://depression.about.com/library.

Shiro, A. M. (1993, January 16). New products under the sun. *New York Times,* Section B, p.7.

Sizer, F, and Whitney, E. (2000). *Nutrition: Concepts and Controversies (8th ed.)* Belmont, CA: Wadsworth.

Smith, J. (2001). Sun exposure: Precautions and protection. *Ohio State University Extension Fact Sheet.* Columbus, OH: The Ohio State University.

Spindler, A. M. (1996, June 9). Its a face-lifted, tummy tucked, jungle out there. *New York Times,* Section 3, p. 1.

Steele, T. W. (1996, August 25). Boomers hit a bump: Wrinkles. *New York Times,* Section 1, p. 49.

Strauss, G. (1998, May 15). Weider, 75, keeps $400 million empire growing. *USA Today,* pp. B1, 2.

Study: Data on women's weight takes pounding. (1995, September 24). *Los Angeles Times,* pp: A1, 28.

Sudy, Michelle. (1991). *Personal Trainer Manual, 1,* 27.

Sugar intake hit all-time high in 1999. (2000, May 18). Washington, DC: Center for Science in the Public Interest.

Sun. (1998). New York: Clinique Laboratories, Inc.

Sunscreens, tanning products, and sun safety. (2000, June 27). *Office of Cosmetics and Colors Fact Sheet.* Washington, DC: U.S. Food and Drug Administration Center of Food Safety and Applied Nutrition.

Surgical treatments for baldness/hair loss. (2001). All about hair. Folica.com. http://www.health.library.com/hairloss/treatment.htm.

Tedeschi, B. (2001, April 30). What do diet services have in common with financial data? *New York Times,* Section C, p 8.

Theissman, J. (2000) July-25). Boomers still on top of their game. www.beautycare.com/articles/MensCare.html.

Torres, N. (2001). You can give a man makeup, but how will he choose the right purse to carry it in. Entrepreneur Media, Inc.

Tresniowski, A., and Nelson, M. (2001, October 8). For the love of Anna. *People,* pp. 114–120.

Turkington, C.A., and Dover, J.S. (1996). *Skin deep.* New York: Facts on File, Inc.

Visscher, M. (2000, May 18). *Skin care.* Cincinnati: University of Cincinnati.

Visscher, M. (2001). *Anatomy of the skin.* Baltimore, MD: University of Maryland Medicine. http://www.umm.edu/skincancer/anatomy.htm.

Wallop, H. (2001, June 22). International feature: Creaming off the fat—with more of the US and UK. *Investors Chronicle,* p. 82.

Wal-Mart to sell cosmetics line. (2001, June 14). *New York Times,* Section C, p. 5.

Why beta is better. (1997, August). *Good Housekeeping,* 35.

Wilkinson, D. (2001, June 24). Banish wrinkles in an hour! *New York Times,* Section 15, p. 10.

Design Elements and Principles Applied to Clothing Selection

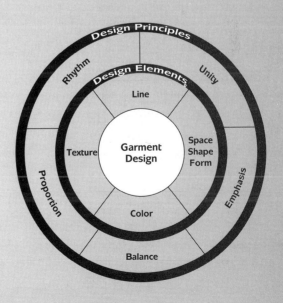

Space, Shape, Form, and Line

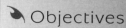 Objectives

- Define the elements of design and explain their interrelationships.

- Discuss the functions of the various types of lines.

- Apply the elements of space, shape, and line to facial shapes, hairstyles, and necklines.

Elements of design are the space, shape, form, line, color, and texture that are used to create a design.

The elements of design—space, shape, form, line, color (Chapter 7), and texture (Chapter 8)—are tools used by designers to create visual effects in apparel. The designer as artist uses the elements of design as ingredients to create a portrait in fabric. The design must be attractive, comfortable, and look good on the human body. Designers are considered successful if they produce apparel that enables the wearer to create the desired image.

When selecting clothing, most shoppers try the garments on. Generally, items are accepted or rejected quickly. This first appraisal of the garment on the body is very often a subconscious mental computerization of the elements of design—space, shape, form, and line, along with color and texture. These elements are all responsible for determining how the garment looks on the body.

Because of the integral relationship of space, shape, form, and line, the discussion of any one of these elements involves the others. Understanding the role of space, shape, and form and developing the skill to analyze line direction helps one learn to predict the effect or impact of each design. Because these design elements

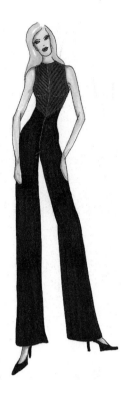

Figure 6.1 *Space, shape, form, and line are important considerations in clothing selection. (Courtesy of Kit Sui)*

combine with color and texture to produce all designs, they are important in all areas of creativity.

When applied to clothing selection, the importance of space, shape, form, and line cannot be underestimated. The three dimensional form of the body within the garment creates the contours, which give the garment shape. The shape of the garment may be body concealing or body revealing, depending on the design details of the garment, but the illusion of the shape of the garment is always dependent on the form of the body within the garment. The space of the garment is the background area. The division of space with construction details, decorations, texture, color, and printed fabric design is critical to the style of the garment. **Lines** are used to define the form and the shape of the garment and to divide the space within the shape of the garment. Lines lead the eye in a definite direction (Figure 6.1).

In order to understand the design elements and their interrelationships in apparel, the discussion will begin with a definition of each (Figure 6.2). Then the characteristics of space, shape, form, and line will be applied to facial shapes, hairstyles, and necklines.

Space

Space is the empty area, the "blank" that designers use shape, line, color, texture, and pattern to subdivide.

Space	Background area found within a shape; space is enclosed by line.
Shape	Silhouette or contour of an object; shape encloses space; shape is defined by line.
Form	Three-dimensional object that can be viewed from different directions; a figure; form is enclosed by a surface; form is a three-dimensional shape.
Line	Indicates length and width directions; encloses space; defines and creates shapes; implies direction.
Color	Quality of an object or substance with respect to light reflected by it.
Texture	Surface appearance and feel.

Figure 6.2 Elements of design.

Space is the background. It allows shapes to be highlighted. It provides visual relief for the eye as it moves from shape to shape. In apparel design, space would be the fashion fabric to which shape, form, line, and color can be added to create a garment.

Divisions created in space are an important part of design. If the space is too crowded, the eye is distracted or fatigued. The human eye needs uncluttered space for visual relief.

Davis (1996) explained the importance of space to design:

- Importance is given to the object by the surrounding space. Space serves to identify, isolate, define and distinguish it. For example, a piece of jewelry is accented by the space of the shirt that serves as its background.
- Space gives stability to a relationship by locating and fixating an object.
- Space provides the distance which determines how the other art elements relate.
- Space provides rest and relief to the eye from the stimulation of a pattern—a "visual pause." (p. 65)

Shape

Shape is the silhouette or contour of an object. It encloses two-dimensional space.

flat

Shape refers to enclosed space or the outside dimensions or contour of an object—the silhouette. When the silhouette of the body is observed, the shape of the body is seen. Shape cannot exist without space and line. Space provides the canvas on which to place shapes. Line defines the exterior limits of the shape.

Shapes help designers project a mood. An **angular shape** (Figure 6.3) such as a rectangular shape with the combination of vertical and horizontal lines and strong right angles seems strong and stable. An angular shape like the diagonal edges found

Figure 6.3 *This garment is designed by using vertical and diagonal lines to create angular shapes. (Courtesy Jennifer Forbes)*

in triangles, pentagons, and octagons seem less stable but more dynamic. A **curved shape** (Figure 6.4) has some point of roundness similar to the shape of the body and seems softer.

Shape: The Silhouette in Clothing

Silhouettes are outlines of ensembles (Figures 6.5 and 6.6). Silhouettes are made up of the line of the garment, the form of the body wearing the garment, and the construction features that produce the desired visual effect. Figures 6.7 and 6.8 show several clothing silhouettes that designers use repeatedly.

Fashion silhouettes cycle through popularity just as colors do. People generally have a variety of silhouettes (shapes) concurrently in their wardrobes. Womenswear silhouettes change rapidly, while menswear silhouettes tend to evolve more slowly. The silhouette may conform to a body shape or may be exaggerated for emphasis. The changes in silhouettes are accomplished through garment design features such as padding in the shoulder area, excess fabric in the back hip area, or figure-shaping boning in the torso area.

Figure 6.4 *Curved shapes are used repeatedly in this design to create a shape with roundness that conforms to the body. (Courtesy Jean Claude Limited)*

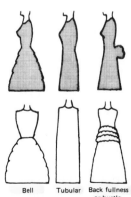

Bell Tubular Back fullness or bustle

Figure 6.5 Throughout history there have been three basic silhouettes: the bell, the tubular, and the back fullness, or bustle. They recur, but not in predictable cycles. The bell and tubular silhouettes, because they follow the contour of the body, are more predominant in fashion.

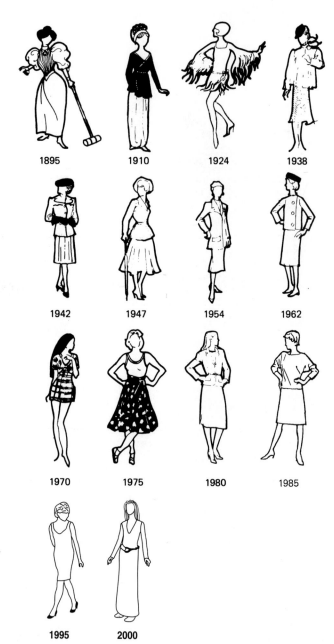

Figure 6.6 Styles of the past century illustrate the repeated use of the three basic silhouette shapes. Fashions change gradually in one direction until the extreme has been achieved, then fashion takes a new emphasis. This is illustrated by both silhouettes and hem lengths of the past century.

Form

Form is a three-dimensional object that can be viewed from different directions.

The hollow form has an interior referred to as *volume,* whereas a solid form is referred to as *mass.* The human body is an example of form. The body can be viewed from different directions (front, back, or either side), thus revealing the form.

Silhouette	Characteristics
Wedge	• The traditional menswear silhouette, most often seen in men's suits in which the shoulder area is padded to emphasize the drop between a man's shoulder and waist measurement. • A traditional silhouette for women's suits and jackets. • Camouflages figure irregularity by visually increasing shoulder width. • Visually heightens the wearer.
Natural	• Garments are constructed without padding or inner construction and follow the body's natural contours; (e.g., body-hugging jeans and a snug T-shirt). • Athletic and swimwear for men and women typically have a natural silhouette. • The silhouette changes least.
Full volume	• Conceals the body behind the large size of the garment. • Most commonly found in outerwear such as ski jackets. • When the full-volume jacket is worn with a slim-fitting leg, it takes on the appearance of a wedge.
Soft	• Most typical silhouette in men's casualwear. • Camouflages the body because of the fuller cut. Pants fronts will be wider and softened with pleats; skirts will be fuller. • Hides the natural contours of the body.
Rectangle	• No waist suppression; same width at shoulder, waist, and hemline. • Boxy. • Examples: man's sack coat, women's coat dress.
Bell	• Fitted top; full skirt. • Example: Dior's New Look; ballerina costume.
Hourglass	• Feminine silhouette emphasizing the bust and hips by highlighting a small waist. • Adding length to the skirt enhances this look.

Figure 6.7 Characteristics of garment silhouettes.

Structural clothing is generally hollow, having an interior column that conforms to the exterior dimensions of the body. A design sketched on paper shows the shape of the front or back of a garment, depending on the view the designer has chosen to illustrate. The shape of the various two-dimensional flat pattern pieces of a garment, when sewn together, must relate to the three-dimensional body the garment covers. When the garment is constructed it will have a form because all sides will be completed.

The malleability of both shape and form allow for an infinite number of designs that can relate to each other as well as to the body. Geometric, floral, and abstract shapes appear in the flat pattern design of a fabric. The construction of that fabric into a garment creates a form that is designed to relate to the contour of the body it will surround.

a.

b.

c.

d.

e.

f.

g.

Figure 6.8 *These photos illustrate the seven silhouettes most often used by designers: (a) bell (Courtesy IMP Originals); (b) natural (Courtesy Jennifer Forbes); (c) rectangle (Courtesy AXIS); (d) soft (Courtesy Jean Claude Limited); (e) hourglass (Courtesy Jean Claude Limited); (f) full volume (Courtesy Quiksilver); and (g) wedge. (Courtesy Peter Shen)*

Figure 6.9 *Lines can be used to create illusions. The empire waist (horizontal lines) of this garment gives the illusion of very long legs. (Courtesy Nicole Miller)*

Line

> **Line** establishes the boundaries of a form and breaks the space into interesting relationships.

Lines create visual impressions, and can be used in a garment to make the wearer look taller, shorter, heavier, or thinner (Figure 6.9 on p. 193). Lines, and the optical effect that they create, can make hips look small or large, shoulders look broad or narrow, and waists look thick or thin. The effects that lines produce are related to other factors, such as:

- The shape of the body wearing the design.
- The color of the fabric.
- The degree of contrast that enables the lines to be noticed.
- The comparison of adjacent shapes or spaces formed by lines.
- The fabric drape, hand, weave, print, and texture.
- The effect that the viewer has been preconditioned to expect.

Line serves several functions. It encloses space; defines and creates shape; leads the eye; indicates direction, length, and width; establishes a point of emphasis; and creates mood and illusion.

Types of Lines

There are only two kinds of lines—**straight lines** and **curved lines.** Straight lines can take four directions: vertical, horizontal, diagonal, or zigzag (Figure 6.10). A curved line may be extreme, approaching a full circle (Figure 6.11), or it may be very gentle or subtle, almost straight.

Figure 6.10 *Study the lines in this picture carefully. How many kinds of lines can you find? How many different effects of line are represented? (Courtesy Kit Sui)*

Figure 6.11 *A curved line can approximate a full circle like the hat in this photo.*

Figure 6.12 *The use of straight lines in clothing design is affected by the fabrics selected. When soft fabric is used, the straight lines drape on the body curves, creating a rounded effect. When stiff fabrics are used, straight lines are maintained. (Courtesy Nicole Miller)*

Straight Lines

Straight lines are in opposition to the natural curve of the body. They are rigid or crisp. The use of straight lines in clothing design is very often softened by the texture of the fabrics selected. For example, when a soft fabric such as a matte jersey is used, the straight lines drape on the body curves; stiff fabrics such as organdy or taffeta maintain the straight line because they stand away from the body (Figure 6.12). Figure 6.13 illustrates how straight lines in clothing may be achieved.

Each direction of a straight line (vertical, horizontal, diagonal, or zigzag) creates an optical effect or illusion that must be judged on the individual to identify the effect of a particular garment design. It is important to note that visual illusions are not experienced by all people to the same degree, and some people may not perceive them at all. Perception of illusion varies among individuals because of experienced association, imagination, attitude, cultural differences, and eyesight.

Fabric design	• Weaves/prints • Stripes • Plaids
Structual lines	• Pleats • Tucks • Gathers • Creases
Trims	• Rows of buttons • Braids • Laces • Embroidery

Figure 6.13
Examples of straight lines.

Conditioning plays an important part in perception. Illusions are errors of the visual sense, the intellect, or judgment. Lines, forms, shapes, spaces, colors, and texture may form an illusion that will distract the eye or make accurate judging impossible. Illusion can be used to produce certain effects, but the effect may not be recognized in the same manner by everyone.

Vertical lines. Vertical lines generally add height or length to the body and make it appear more narrow. They lead the eye up and down and detract from the width of the body (Figure 6.14). This is the favored line direction for those who wish to appear taller and more slender. Examples of vertical lines are found in Figure 6.15.

When a vertical line is emphasized in garment design, the eye of the observer measures the length of that area. Noticeable vertical lines that divide skirt/pant and bodice/shirt areas can reduce the apparent visual width of these spaces. To illustrate, a plain skirt, undivided by visible vertical seaming, usually appears broader than a skirt with one or more vertical seams in the front and back sections (Figure 6.16). The angle and spacing of two or more visible vertical seams in the same garment will vary the effect of slimness and length.

Vertical lines that are repeated in quantity (such as in a striped-print pattern) can add width. The visual effect of the vertical line depends on the spacing and the background color contrast (Figure 6.17).

Closely spaced, parallel vertical lines may lead the eye in an upward direction, but as the space between the lines is increased, the eye may begin to measure width. This widening effect may also occur if there is variation in the distance between the two lines. As noted previously, to judge the effect of vertical lines, it is best to study the garment on the body. Double-breasted garments add width because of the space between the vertical lines, in addition to the bulk of the double layers of fabric (Figure 6.18).

Figure 6.14 *The vertical line movement of the garment design is reinforced in this photo by the center front button placket (vertical line) jacket.* (Courtesy Axis Clothing Corporation)

Vertical	Horizontal	Diagonal	Zigzag
• Fabric design with vertical movement • Construction lines • Long, narrow neckties • Pointed collars • Cigarette-leg pants • Vertical trims • Buttons • Vertical slash pockets • Darts • Single column of color • Knife pleats • Vests • Sleeveless garments • Dress shirts	• Fabric fullness • Horizontal fabric designs • Wide-brimmed hats • Necklines: bateau, turtle, square • Pocket flaps • Patch pockets • Double-breasted garments • Bare midriff • Contrasting/wide • Shoulder bags • Strap shoes • Contrasting socks/hosiery • Bow ties	• Suit/jacket lapel • Raglan sleeves • Halter tops • Rep ties • A-line skirt • Flared pants	• Fabric design • Criss-cross straps on shoes, tops, or dresses

Figure 6.15 Examples of use of line in clothing design.

Figure 6.16 The same skirt silhouettes with different space divisions create varying effects on the body.

Figure 6.17 *Noticeable vertical lines such as this jacket button closure divide the areas and reduce the apparent visual width of these spaces. (Courtesy St. John)*

Horizontal Lines. Horizontal lines generally add width or breadth and shorten the body. They can attract attention to a part of the body, which will balance another part or create an illusion. Often men's sportswear will feature knit shirts with horizontal stripes, which give the illusion of a broad chest. Horizontal lines are used often in casual clothing because these lines are associated with repose (Figure 6.19).

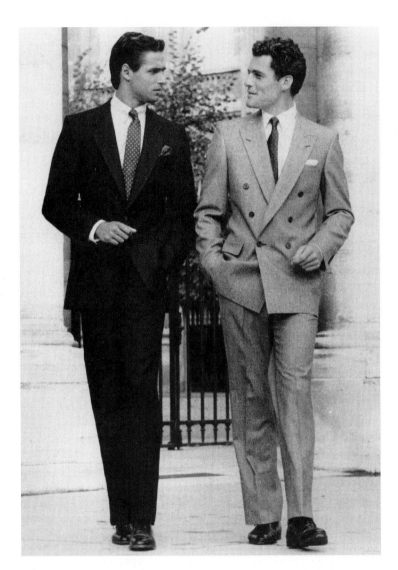

Figure 6.18 *Double-and single-breasted garments create different effects on the body in both men's and women's wear. (Courtesy Hartmarx Corporation)*

Horizontal lines usually carry the eye across the body (Figure 6.20). When a horizontal line is emphasized in a garment, the eye of the beholder measures the width of that area. For example:

- Widths of waists are measured by belts.
- Widths of hips are measured by jacket or sweater hemlines.
- Widths of legs may be measured at the level of the pant hem.

Figure problems can be corrected by horizontal lines. Narrow shoulders can be made wider with a shoulder yoke. A large hipline may look more proportional if a horizontal line is used in the top of the garment. Apparent widths of bust/chest may be increased if the hemline of the sleeve ends at the fullest part of the bust/chest.

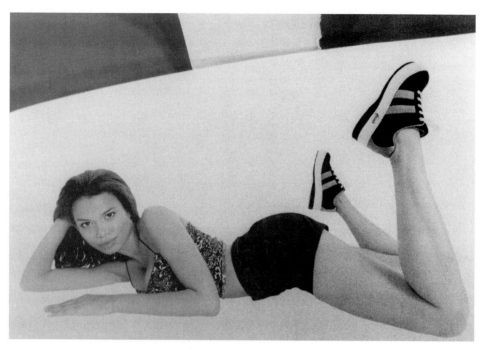

Figure 6.19 *How many examples of horizontal lines are in this outfit? (Courtesy Skechers)*

Figure 6.20 *Ankle-strap shoes create horizontal lines that measure the width of the leg and shorten the length of the leg. This is especially true when the shoe color is a strong value contrast to the stocking color. (Courtesy IMP Originals)*

Just as repeated vertical lines may sometimes add width, some horizontal line spacing can produce the illusion of length. This is because horizontal lines spaced closely together can create an illusion that leads the eye of the observer upward.

Plaids must be studied from a distance to determine which line direction will be emphasized. The wider horizontal lines add width to the wearer. Larger horizontal lines also add width and make the shoulder appear wider.

Diagonal lines. Diagonal lines are slimming because they direct the eye over body curves at an angle, thereby having a softening effect. They can create either symmetrical (which the eye sees as the norm) or asymmetrical effects.

The use of diagonal lines in clothing design is often very pleasing. Men's suits use the diagonal at the lapel to reinforce the wedge body shape.

Diagonal lines assume the characteristics of the vertical or horizontal line as the degree of slant approaches the extreme. The diagonal line approaching a horizontal is found in a wide, bouffant skirt. The very subtle slant of the A-line skirt or flared pants approaches the vertical line (Figure 6.21).

Zigzag lines. A zigzag is a series of connected diagonal lines. A zigzag forces the eye to shift direction abruptly and repeatedly in an erratic and jerky movement. This type of line is found most often in fabric design. Because of the eye activity caused

Figure 6.21 *Study these two photographs and determine the differences in the illusion created by the design of the diagonal lines. (Courtesy Nicole Miller)*

Figure 6.22 *Zigzag lines can be used to create interest in an otherwise simple garment. (Courtesy Kit Sui)*

by zigzag lines, they tend to increase the apparent mass or size of the area covered by them (Figure 6.22).

A visual summary of the illusions created by straight line combinations is found in Figure 6.23.

Curved Lines

Curved lines generally follow the contour of the body (Figure 6.24). When the curved line becomes exaggerated toward a full circle, it becomes very active and may easily be overdone. A restrained curve is graceful, flowing, and gentle. Just as straight lines can conform to the body contour through fabric textures, so do curved lines—with the effect of being extremely curvy (Figure 6.25).

For example, if a ruffle is added to a garment, the eye moves quickly over the smooth parts of the garment and tends to rest on the ruffle. Placing a ruffle at the

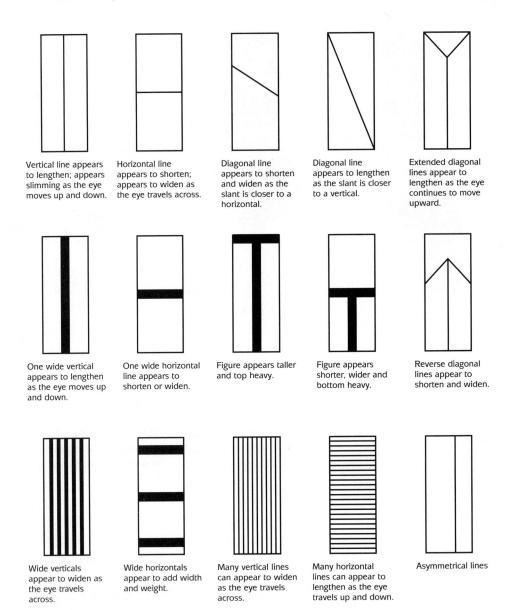

Vertical line appears to lengthen; appears slimming as the eye moves up and down.

Horizontal line appears to shorten; appears to widen as the eye travels across.

Diagonal line appears to shorten and widen as the slant is closer to a horizontal.

Diagonal line appears to lengthen as the slant is closer to a vertical.

Extended diagonal lines appear to lengthen as the eye continues to move upward.

One wide vertical appears to lengthen as the eye moves up and down.

One wide horizontal line appears to shorten or widen.

Figure appears taller and top heavy.

Figure appears shorter, wider and bottom heavy.

Reverse diagonal lines appear to shorten and widen.

Wide verticals appear to widen as the eye travels across.

Wide horizontals appear to add width and weight.

Many vertical lines can appear to widen as the eye travels across.

Many horizontal lines can appear to lengthen as the eye travels up and down.

Asymmetrical lines

Figure 6.23 This chart shows the optical illusions created by various combinations of straight lines. (*Reproduced by permission.* Wardrobe Strategies for Women: Communication in Business and Industry *by J. Rasband. Albany, NY: Delmar Publishers,*© *1996, p. 65*)

wrist, therefore, will attract attention there. Adding fullness to any part of a garment attracts attention (Figure 6.26).

Curved lines can add weight to a thin person or even an angular person. For examples of curved line see Figure 6.27 (Activity 6.1).

Figure 6.24 *Curves attract attention and soften an area. (Courtesy Kit Sui)*

Figure 6.25 *The effect of curved lines is emphasized if the body conformation is extremely curvy. (Courtesy Kit Sui)*

Figure 6.26 *An exaggerated curved line is the full skirt, which has long been the symbol of femininity because it looks both fragile and romantic. It holds the eye longer than the smooth parts of the garment—the eye tends to rest on the gathers and directs attention there. (Courtesy Jean Claude Limited)*

• Fabric design	• Yokes
• Necklines	• Hairstyles
• Collars	• Lapels
• Sleeves/pockets	• Hems
• Pocket flaps	• Trims
• Hats	• Scallops

Figure 6.27 Examples of curved lines.

ACTIVITY 6.1 Lines

Select a picture of a garment illustrated on a full-length body.

- Using a ruler and a red pen, draw over all the vertical lines in the garment design to make them more obvious.
- Change ink color and repeat for the horizontal lines, diagonal lines, and curved lines.
- Determine the effect on the body of the various lines.

Repetition/reinforcement	• A very tall, slender body is emphasized when the garment design features vertical lines that lead the eye of the observer up or down the body. • A square jawline is emphasized with a square neckline. • A full hip-thigh area is emphasized by repetition when the pant leg width is the same as the horizontal width created by the hip-thigh area.
Extreme contrast/counterbalance	• A short, heavy body is emphasized when the garment's fabric design features broad vertical lines that are spaced to lead the eye across the body. • A round face shape is emphasized by a square neckline or tie motif. • A small, tightly belted waistline may emphasize a large hipline.

Figure 6.28 Rules of line.

Emphasis of Line

In using line concepts, it is important to understand how they are affected by the principle of emphasis. Lines are emphasized by both repetition or **reinforcing** and extreme contrast or **countering** (Figure 6.28). When applied to clothing selection, for example, internal lines in a garment are emphasized by trim or piping (reinforcement) in a contrasting color (countering) (Figure 6.29).

A dominant line in a garment commands the most visual attention.

A subordinant line attracts a lesser amount of visual attention than the dominant line it complements.

When developing a garment, designers use either one dominant line or a group of similar lines. However, to break the monotony and add interest, contrasting or

Figure 6.29 *The garment lines are made more noticeable by construction details such as trim in a contrasting color. (Courtesy Lara Strang)*

subordinate lines are used to a lesser degree to complement the dominant line theme (Rasband, 1996).

Clarity of Line

Decorative lines are construction details such as a welt or top stitching.

The outline or silhouette of a garment and the body within it are more evident when there is contrast with the background. Not all internal structural lines are noticeable in a garment design because of a lack of contrast to emphasize them. Some garments do not show a definite line direction. The internal lines may not be noticeable in garments made of printed fabrics, especially dark prints or those with a great deal of color contrast. In some garment construction, dark or napped fabrics may conceal structural lines. Internal lines usually become less noticeable as the viewer gets farther away.

Garment lines are made more noticeable by construction details or decorative lines (Figure 6.30) such as panels of contrasting color, fabric, texture, or welt (Activity 6.2).

Application of Design Elements Space, Shape, Form, and Line

This section applies the design elements just discussed to facial shapes, hairstyles, and necklines.

Facial Shapes

The oval-shaped face was once called the "perfect face" because of the photographic effect experienced in black and white photography. Because it presented the most pleasing planes, the oval face was the easiest to light and photograph. Studio makeup artists therefore developed ways of making all faces appear oval. Because most filmwork is now in color, there has been a tremendous change in makeup products and techniques used in this industry.

Today's fashion industry has discarded one "perfect" facial shape concept and embraced men and women with diverse facial shapes to promote products. Fashion

Figure 6.30 *Garment lines are more noticeable when there is contrast. (Courtesy Kit Sui)*

 ACTIVITY 6.2 Examples of Design Lines

Leaf through a variety of fashion magazines and note the line combinations used by different designs.

- Are any more prominent this season than others?
- What visual impact do the various combinations have on the body?

magazines show a variety of interesting faces, each reflecting its own type of beauty. Fred Feucht, President of Fred Feucht Design Group, studied the popularity of various facial shapes among consumers and found the most preferred shape for men was the diamond and for women, the heart.

Facial shapes are difficult to determine exactly. Reference books often define faces by eight geometric shapes (Figure 6.31). In doing so, the silhouette (shape) of the face is examined with particular attention to the division of space: the proportion of the forehead, cheek width, and jawline (Activity 6.3). Also of interest are the lines formed by the facial features.

However, nature is often not this exacting. Because the face is composed of so many planes and shapes, it is often easier to describe a face than to label it with a

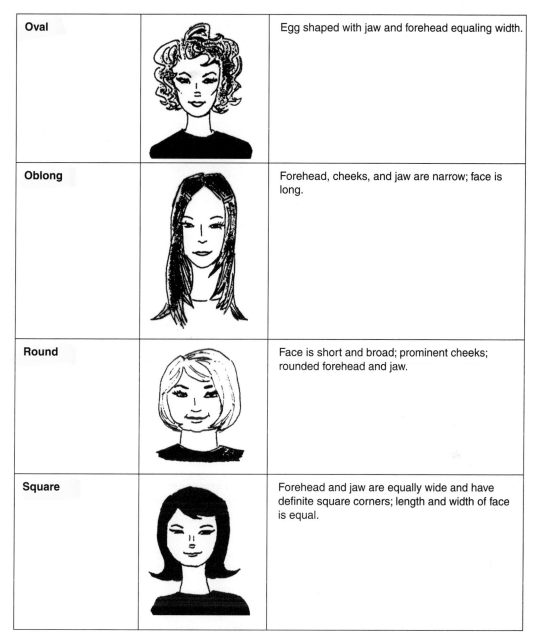

Oval		Egg shaped with jaw and forehead equaling width.
Oblong		Forehead, cheeks, and jaw are narrow; face is long.
Round		Face is short and broad; prominent cheeks; rounded forehead and jaw.
Square		Forehead and jaw are equally wide and have definite square corners; length and width of face is equal.

Figure 6.31 Description of facial shapes.

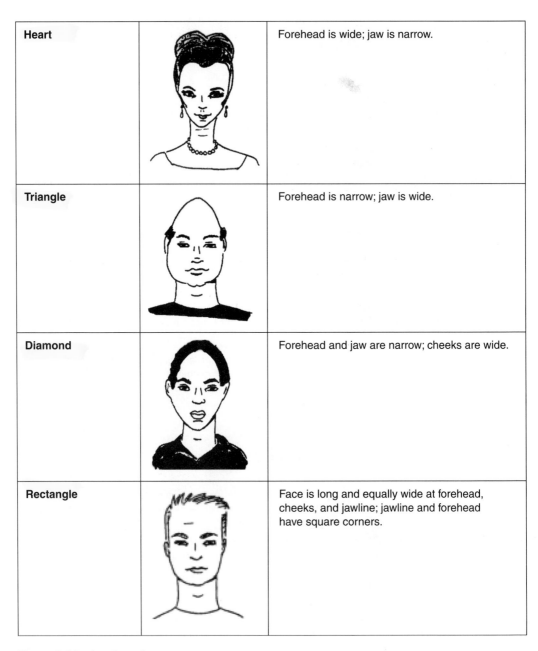

Heart		Forehead is wide; jaw is narrow.
Triangle		Forehead is narrow; jaw is wide.
Diamond		Forehead and jaw are narrow; cheeks are wide.
Rectangle		Face is long and equally wide at forehead, cheeks, and jawline; jawline and forehead have square corners.

Figure 6.31 (continued)

particular geometric shape. Some people do not have definite facial shape but may be a combination of several shapes.

Necklines

Necklines, including collars and lapels, are face-framing details of clothing. The shape of the neckline is determined by the lines of the garment design. A garment that repeats an individual's predominant facial lines in the neckline or is an extreme opposite of his or her facial lines will emphasize the face shape. Square faces or jawlines are emphasized by square necklines and by very round necklines such as the turtleneck. Round faces are emphasized by round necklines as well as by square necklines, and so on. The shape of the collar and lapels creates the same illusion.

A facial shape will be de-emphasized by using more subtle opposite lines. A diamond face will be complemented by a U-shaped neckline, which softens the angularity of the chin. A triangular face will be complemented by a short V-neckline, which will give length to the square jawline.

Necklines can also visually change the neck width and length by using lines to manipulate the neck space. For example, a long neck can be visually shortened by using a horizontal line high on the neckline to divide the space. A short neck can be made visually longer by wearing a V-neckline.

The neckline is often the most eye-arresting area of a garment. This effect can be created by either color or bare skin (Figure 6.32). Bright or contrasting colors used at the neckline area attract attention. To create the illusion of a more slender body, focus the observer's attention on the neckline interest, camouflaging the body.

Hairstyles

The lines of a hairstyle can be analyzed by considering the head, features, and body conformation. Repeating a facial line with a hairstyle line will emphasize that line; going to the extreme opposite of the line also emphasizes it. Therefore, to minimize a very round face, select a hairstyle that is neither completely round nor straight. To minimize a long face, avoid very straight lines and very round lines. To minimize a triangular face, avoid fullness at the widest and narrowest points of the face (Figure 6.33).

In selecting a hairstyle, the facial features and head conformation are important. The hair can be styled (use of line) to emphasize interesting facial features and minimize others. Line can be moved and space can be divided in a different way, which impacts the shape exposed. Generally, the hair length should end above or below a feature that is to be minimized, such as the jawline or cheekbone (Activity 6.4).

Severe hairstyles, those that are smoothly drawn back from the face, reveal each contour of the head (shape). In this type of hairstyle, imperfect features are emphasized because the hairstyle does not allow a softening effect. Center parts (vertical lines) also emphasize facial features as they give the observer a line with which to measure the formal balance of the face. With this part, the eye expects the right side

Figure 6.32 *The neckline is often the most eye-catching area of a garment. This effect can be created by either color or bare skin.* (*Courtesy Jennifer Forbes*)

To emphasize the eyes	Use bangs. Their strong horizontal line right above the eye attracts attention.
To emphasize the mouth	Emphasize with the strong vertical line of sideburns or a short hairstyle that ends on the face at mouth level.
To narrow a wide face	Cover some of the face space by combing the hair forward.
To widen a narrow face	Brush hair back and expose the entire face space.
To lengthen a short neck	Select a short of upswept hairstyle that exposes the entire neck length rather than having the neck space divided by hairline.
To shorten a long neck	A hairstyle that ends an inch or two below the jawline creates a horizontal line that shortens the neck by breaking up the space.
To make a small head appear larger	Fluff out the hair to enlarge the space-shape.
To make a large head appear smaller	A controlled hairstyle makes the space-shape smaller.

Figure 6.33 Hairstyles that emphasize and camouflage.

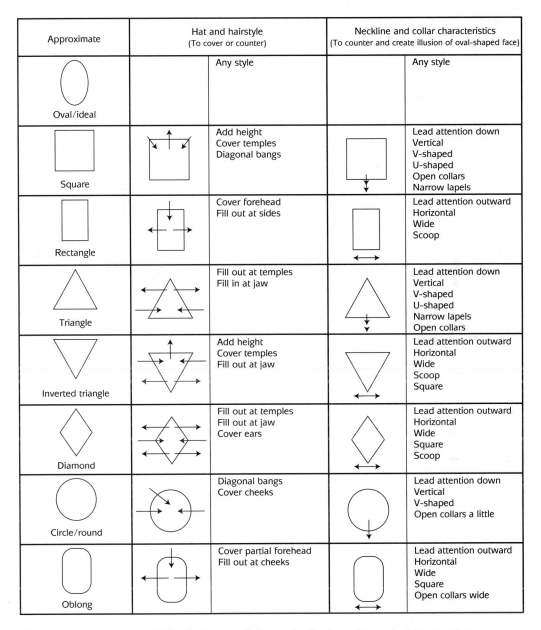

Approximate	Hat and hairstyle (To cover or counter)		Neckline and collar characteristics (To counter and create illusion of oval-shaped face)	
Oval/ideal		Any style		Any style
Square		Add height Cover temples Diagonal bangs		Lead attention down Vertical V-shaped U-shaped Open collars Narrow lapels
Rectangle		Cover forehead Fill out at sides		Lead attention outward Horizontal Wide Scoop
Triangle		Fill out at temples Fill in at jaw		Lead attention down Vertical V-shaped U-shaped Narrow lapels Open collars
Inverted triangle		Add height Cover temples Fill out at jaw		Lead attention outward Horizontal Wide Scoop Square
Diamond		Fill out at temples Fill out at jaw Cover ears		Lead attention outward Horizontal Wide Square Scoop
Circle/round		Diagonal bangs Cover cheeks		Lead attention down Vertical V-shaped Open collars a little
Oblong		Cover partial forehead Fill out at cheeks		Lead attention outward Horizontal Wide Square Open collars wide

Figure 6.34 Recommended style lines and shapes for the face. (Reproduced by permission.
Wardrobe Strategies for Women: Communication in Business and Industry by J. Rasband Albany, NY: Delmar
Publishing, ©1996, p. 92)

of the face to perfectly match the left side, which is rare. Soft (curved line), infor-
mally balanced (diagonal line) hairstyles are much kinder to the wearer. Free-form,
soft, asymmetric hairstyles may be used to perfect the contour of the head. Their ir-
regular shapes disguise the imperfections of the facial features. Figure 6.34 summa-
rizes face shapes and appropriate hairstyle and neckline direction.

ACTIVITY 6.3 Facial Shapes

Select an individual to study. Take full face and face profile photos to aid in the analysis.

1. Examine the facial features both individually and in relation to the face and head.
2. With the hair brushed off the face, study the face both in profile and full face. (The subject should not smile because smiling distorts the facial silhouette.)
3. Answer the following:
 - *Facial shape:* Which of the eight geometric shapes best describes this face?
 - *Forehead profile:* Does it recede, stand straight, or bulge forward?
 - *Forehead width:* Is it wide or narrow?
 - *Hairline position on the forehead:* Is it high, low, or a widow's peak?
 - *Eyes:* Are they set deep or do they bulge out? Are they set wide or close together?
 - *Nose:* Is it long or short? Describe its shape and size.
 - *Mouth:* Does it droop or pout? Are the upper lips and lower lips evenly full? Is the mouth centered?
 - *Chinline:* Does it recede or jut forward?
4. Analyze the features in relationship to the entire face. Determine the predominant lines.
5. Study the subject's neck length and width in relation to his or her head and body. Does the neck appear thin or thick? Long or short?

ACTIVITY 6.4 Facial Shapes, Hairstyles, and Necklines

Using fashion magazines, find a male and female example of the eight facial shapes. Then select a hairstyle and two necklines that will complement each.

 Summary

The process of design uses the interrelated design elements of space, shape, form, and line. Line can be either straight or curved. A straight line will have a different effect on the body depending on whether it is vertical (lengthens), horizontal (widens), diagonal (distracts), or zigzag (gives energy). Using curved lines soften that area. An understanding of the impact of these design elements can be applied to clothing selection and personal adornment such as facial shapes, hairstyles, and necklines.

❧ Key Terms and Concepts

Angular shape
Countering
Curved line
Curved shape
Decorative line
Dominant line
Elements of design
Figure

Form
Line
Reinforcing
Shape
Space
Straight line
Subordinate line

❧ References

Davis, M. L. (1996). *Visual design in dress* (2nd ed.). Upper Saddle River, NJ: Prentice Hall.

Rasband, J. (1996). *Wardrobe strategies for women*. San Francisco: Delmar.

Color

Objectives

- Identify the differences and similarities in the Prang and Munsell color systems.
- Define and give examples of the dimensions of color.
- Define and illustrate various color harmonies.
- Explain the influences on color perception.
- Discuss fashion color prediction.
- Apply color theory to personal coloring and wardrobe selection guidelines.

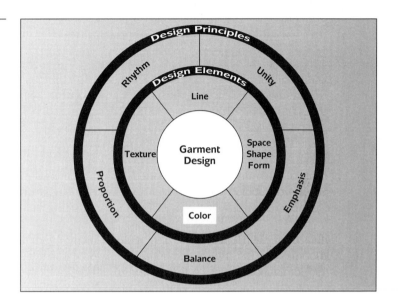

The diagram shows three concentric rings. The outer ring is labeled "Design Principles" with the words Rhythm, Unity, Emphasis, Balance, Proportion arranged around it. The middle ring is labeled "Design Elements" with Line, Space/Shape/Form, Color, Texture arranged around it. The center circle reads "Garment Design."

Color has been an important part of the human experience, and it is a vital part of our lives today. Try to imagine a world without color. Mentally attempt to remove color from the landscape, from exterior and interior design, from food, from clothes, and from people. If everything seen and known were suddenly to lose its color, patterns of living would be greatly altered. Most people would experience extreme mental depression. Color is that important.

The purpose of this chapter is to explore the use of color in its relationship to the selection of clothing and items of personal adornment.

What Is Color?

In 1666, Sir Isaac Newton conducted the first recorded experiments on light. By passing light through a prism that refracted or bent the light rays into a spectrum of colors, he illustrated that color is contained in light and that color does not exist in the absence of light. Light is a part of the electromagnetic field that is visible. In the non-visible area are x-ray, radar, radio waves, and others. Within the visible area, variations in wave lengths enable us to see different colors.

In his work, Newton counted seven hues in the spectrum: red, orange, yellow, green, blue, indigo, and violet. Newton's work is revealed visually through the rainbow. The

rainbow is a breakdown of light into hues that have the same fixed arrangement. This order always remains the same because each hue has a different wavelength (or rate of energy radiating from the sun). The longest wavelength is red, followed by orange, yellow, green, blue, indigo, and violet (the shortest wavelength). This predictable arrangement is seen again and again in the spray of a waterfall, a crystal chandelier, the sparkle of a diamond, even in a soap bubble.

Physiologists are discovering the exact process by which color is seen by the human eye and translated to the human brain. This is an extremely complicated process. The color reflected from an object is determined by the composition of the object. Light striking an object may be reflected, absorbed, or transmitted. Object transparency or opacity will determine the pattern of the reflected light. Colors not reflected are absorbed by the object and are not visible. For example, a green fabric is green because its dye absorbs all colored rays of light except green, which it reflects. If all light is absorbed by the surface, the surface appears black. If all light is reflected, it appears white.

Color Systems

Many systems are used to organize color. These color systems are based on the different interests of the people who work with color. The painter and the dyer are interested in the mixing of pigments or colorants. The physicist is interested in the aspects of light and measuring the wavelengths of the spectrum. The physiologist studies the eye–brain color effects and physiological responses. The psychologist examines the emotional responses to color.

The various systems have differences and similarities that are listed in Figure 7.1. The color systems frequently used are the Prang (sometimes referred to as Brewster) and the Munsell, which are explained next.

The Prang Color System

The **Prang Color System** is based on mixing red, blue, yellow, black, and white pigments.

Similarities	Differences
All are: • Based on a spectrum (a series of colors) arranged in a fixed order. • Have color wheels formed by twisting a band of color representing the spectrum into a circle.	Each has unique: • Primary/principle colors/hues. • Color terminology. • Color complements and notations.

Figure 7.1 Comparison of color systems.

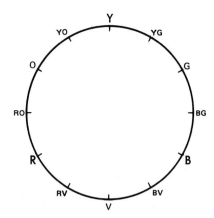

Figure 7.2 Prang Color System.

3 primary colors	Red, yellow, blue
3 secondary colors Red + yellow = Yellow + blue = Blue + red =	Orange, green, violet 　Orange 　Green 　Violet
6 tertiary colors	Red-orange, orange-yellow, yellow-green, green-blue, blue-violet, violet-red

Figure 7.3 Prang Color System characteristics.

In the Prang System, **primary colors** are red, blue, and yellow.

In the Prang System, **secondary colors** are violet, green, and orange.

In the Prang System, **tertiary colors** result when a primary color is mixed with a neighboring secondary color, such as yellow and green making yellow-green.

The Prang Color System (Color Figure 1) is the oldest, simplest theory and is most often used by students and artists for mixing paint colors (Figure 7.2). It is based on three primary colors placed equidistant on a color wheel. When two neighboring primary colors are combined, a secondary color visually halfway between the two is produced. The tertiary colors are formed when primary and neighboring secondary colors are combined (Figure 7.3).

5 principal colors	Red, yellow, green, blue, purple
5 intermediate colors	Yellow-red, yellow-green, green-blue, blue-purple, purple-red

Figure 7.4 Munsell Color System characteristics.

The Munsell Color System

The **Munsell Color System** uses five basic colors.

The Munsell Color System (Color Figure 2) is based on five basic colors that are placed equidistant around a color wheel. The basic colors are combined in equal amounts of the same visual intensity of two neighboring colors to produce the first intermediate colors. The second intermediate colors are formed by mixing the neighboring first intermediate colors (Figure 7.4). Then ten colors are subdivided into ten equal steps for each color, making a total of one hundred Munsell colors, designated by color number.

The Munsell Color System uses a three-dimensional irregular sphere having as its vertical axis the scale of values. The value scale has ten steps, from white at the north pole to black at the south pole. The horizontal axis carries the chroma or saturation. The saturation is greatest at the outer end and decreases to neutral at the center. In the Munsell system, each value and chroma change has a numerical notation, thus making it valuable in exact duplication of color. Equal numerical differences are equal visual differences (Figure 7.5).

Saturation is strength or intensity of a color.

Dimensions of Color

To discuss color, a knowledge of color terminology is necessary. Describing color is very difficult because each color has so many variations. Each person sees color in an individual manner related to the acuity of the eye and to past experiences with color.

In fashion, descriptive terms are often used to denote a particular color. These terms may be understood only by association. It must be remembered that fashion merchants sell color. "Watermelon pink" sells better than a "hue of red, medium value, and bright intensity." However, the person who has never seen a slice of watermelon would be unable to understand the color described by this fashion terminology.

The terms *hue, value,* and *chroma* are used to describe the three dimensions of color. The dimensions of color can be more effectively communicated using these terms.

Hue

Hue is the name of a color family such as red, blue, or green.

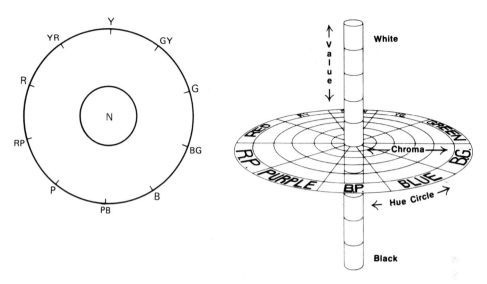

Figure 7.5 The dimensions of color—the color solid: every color has its own particular place in a three-dimensional solid. Think of our earth as the solid, rotating on its axis. The north pole is white, the south pole is black, and the axis is the gray scale. Then take a rainbow of the most intense colors, join the two ends to form a circle, and place these around the earth's equator. These are the hues. By adding white, black, or gray (black plus white) in varying amounts to any hue, you create the color family of that hue. A color containing equal visual amounts of pure color and white is located halfway between the equator and the north pole on a line drawn between the pure hue and white.

The term *hue* is often erroneously used interchangeably with the word *color.* Hue refers to only one dimension of color.

Warm and Cool Hues

Hue may be described as being warm or cool. **Warm hues** are those found in sun and fire; they are red, yellow, and orange. **Cool hues** are those found in water and sky; they are green, blue, and violet. Warm hues can have a cool cast; conversely, cool hues can reflect warmth. For example, red-purple will be cooler than red-yellow.

The warmth or coolness of a hue carries with it an illusion of visual weight. The warm hues—yellow, orange, and red—are known as advancing hues because they create an illusion of moving forward. Warm hues make objects, shapes, or areas appear larger, more important, and closer than other colors. Warm hues emphasize the body size and contours.

The cool hues of blue, blue-green, and violet are receding hues. Cool hues make objects, shapes, or areas appear smaller, less important, and farther away than other colors. Cool hues minimize the apparent body size and shape.

To illustrate this color phenomenon, picture two people of the exact dimensions dressed in exactly the same style garments except that one outfit is a warm red and the other is a cool blue. When viewed from a distance and in the same

Figure 7.6 To see all the colors in a hue family, slice the earth in half from the north to the south pole. You now see the entire gray scale, plus all the tints, tones, and shades of the two hues you cut through at the equator. Pure hue plus white makes tints. Pure hue plus black makes shades. Adding both white and black to a pure hue makes tones. Suppose one of the pure hues exposed is orange. A medium tint would be peach; a medium tone would be beige or buff; a medium shade would be brown. If the hue is red, a tint is pink, a tone is rose, and a shade is maroon. A group of colors selected exclusively from one hue family is known as monochromatic harmony.

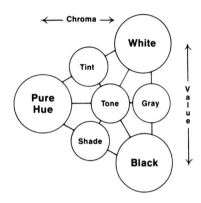

color environment, the person wearing the warm hue will appear to be closer and larger; the person wearing the cool hue will appear to be farther away and smaller.

Psychological Effects of Hues

Psychologists have studied the impact of color for decades. For example, in a factory, the temperature was maintained at 72° F and the walls were painted a cool blue-green. The employees complained of the cold. The temperature was maintained at the same level, but the walls were painted a warm coral. The employees stopped complaining about the temperature and reported they were quite comfortable (Faulkner and Ziegfield, 1969).

The psychological effects of warm and cool hues seem to be used effectively by the coaches of the Notre Dame football team. The locker rooms used for half-time breaks reportedly were painted to take advantage of the emotional impact of certain hues. The home-team room was painted a bright red, which kept team members agitated or even angered. The visiting-team room was painted a tranquil blue-green, which had a calming effect on the team members. The success of this application of color can be noted in the records set by Notre Dame football teams.

Value

Value describes the lightness or darkness of a color.

To change the value of a color, white or black must be added, which makes the color lighter or darker (Figure 7.6). As an example, when white is added to the hue red, a white-red or pink results. This new color is described as having a higher value; that is, it is lighter than the original hue. When white is added to a color, the result is called a tint of the original hue. When black is added to red, a black-red results. This new color is described as having a lower value; that is, it is darker than the original hue. Black added to a hue creates a shade of the original hue. There are limitless possibilities for degrees of color values (Figure 7.7).

Original hue	Add	Tint	Shade
Green	White	Lime	
Green	Black		Olive
Orange	White	Peach	
Orange	Black		Rust
Red	White	Pink	
Red	Black		Maroon

Figure 7.7 Tint and shade production.

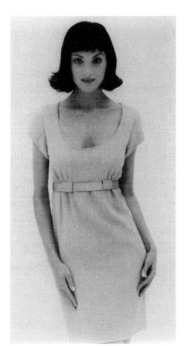

Figure 7.8 *The high value of this garment attracts attention to the wearer. (Courtesy Nicole Miller)*

Value Related to Body Size and Form

Applying value in clothing selection is most important. Exciting and dramatic effects and clever body camouflaging can be created by the use of value in clothing selection.

The extremes of value, very light or very dark, will usually emphasize the body appearance. Light or very high values reflect the light, which makes the object, shapes, or areas appear larger and stand out. Very dark or very low values will outline or silhouette the object, shapes, or areas and make the body contours stand out (Figure 7.8). The middle values will camouflage the body conformation. Middle val-

ues are not eye-arresting; instead of making the object, shapes, or areas important or well defined, they tend to blend them into the background.

The strength of the effect of hue value depends on the amount of contrast it has to the background against which it is viewed. As an illustration, consider a skier dressed in white ski wear with a snowy white background. There would be very little value contrast between the skier and the snow, so the skier would tend to blend into the background. However, if the skier were dressed in black or a value close to black, the skier would contrast sharply to the white background.

Most of the environment of life and work consists of middle values. Therefore, when wearing clothes with a middle value, the contrast is less obvious. White is the lightest value; black is the darkest value. White and black garments are generally strong contrasts to their background, especially during daylight hours. Because night lighting is low in value compared to daylight, darker-value clothing worn in the evening usually blends into the background. The effect of the value of the color against a background is important for those who do not wish to reveal their body conformation.

Value Contrast and Emphasis

The placement of value contrast is important because the eye of the observer will be attracted to this area of sharp contrast. The area where the value contrast is placed will be emphasized. Thus, to de-emphasize a part of the body, avoid placing value contrast there. As an example, imagine an outfit of dark pants and a pastel cardigan sweater. The length of the sweater will determine the line of value contrast. If the hemline of the sweater falls at the largest part of the hipline, this will be the point of emphasis. Value contrast at the hipline would be avoided if the pants and sweater were of the same color or of different, yet close in value, hues. Value contrasts that emphasize are found in many clothing designs.

White or very light-colored shoes are in direct contrast to dark, suntanned legs or dark hosiery; this value contrast emphasizes the size of the feet. This also happens when the light shoe is contrasted against the dark walking surfaces. Because of the advancing quality of light values, white, light or shiny hosiery also seem to increase the size of the leg and feet. Other contrasts that attract attention are contrasting belts, buttons, trims, or fabric colors (Figure 7.9).

Chroma or Intensity

Chroma describes the purity of a color.

Chroma is expressed as the strength or weakness, the brightness or dullness, or the degree of saturation of a color. *Chroma* and *intensity* are often interchangeable, but because *chroma* is the more accurate term, it appears more frequently in color literature.

High-chroma colors are pure, strong, brilliant, saturated colors. Low-chroma colors are muted, weak, grayed, and dull. On the color wheel each hue is usually shown at its fullest, purist chroma, which means the yellow seen on the color wheel is yellow at its greatest saturation, its greatest brightness, its most brilliant, its fullest intensity. The same is true for each hue on the wheel.

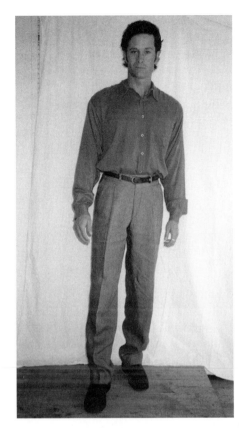 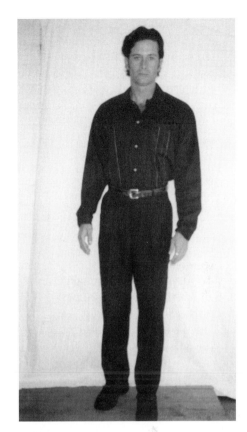

Figure 7.9 *Avoiding color breaks by keeping the various garments of an outfit in the same color family and close in value will make a figure seem taller. This same color technique will also camouflage body irregularities such as a wide waist or hipline.*

Interrelationship of Value and Chroma

When describing color technically, all three dimensions of hue, value, and chroma are required. A tint of a saturated, high-chroma red such as pink is light in value yet may be as high in chroma (intensity) as a shade of red that is darker in value such as true red. Many dark colors are both low in value and low in intensity. Maroon is a shade of red and is low in intensity. Browns are usually low-value and low-intensity yellow-red. Tans are actually high-value, low-intensity yellow-red. When both white and black (gray) are added to a hue, the result is a change in chroma, called a tone. For example, green plus white and black produces chartreuse; orange plus black and white produces buff, red plus white and black produces mauve.

Color Chroma and Clothing Selection

Color chroma is an effective tool for creating both camouflage and flair in the wardrobe. Clever use of chroma can extend the basic wardrobe by creating a wide range of accessory effects with the same basic clothes. Because of the eyeholding

power of chroma, often the accent will be remembered, but the background gar-ment will go unnoticed. This phenomenon is called the **Law of Color.** Small amounts of high-chroma color can be used to direct and hold the eye of the observer to any area of the body that is to be emphasized. Thus, the use of chroma is an im-portant technique in creating illusions with clothing.

Bright, strong, high-chroma colors are conspicuous and make the body appear larger. Dull, weak, low-chroma colors are less conspicuous and make the body ap-pear smaller.

The intensity of colors can be manipulated by placing them against various back-grounds. Colors appear more intense when placed against less colorful, gray, or black backgrounds. Thus, a red will appear redder, brighter, stronger, or more in-tense when placed against a dull color or a white, gray, or black background. In clothing selection, the higher the chroma of the color, the more attention it attracts. High-chroma colors will emphasize the body conformation.

Colors can be made to appear less intense by placing them next to their neigh-bors on the color wheel (analogous colors). Thus, red will appear less red, duller, weaker, or lower in chroma when placed next to an analogous color such as orange or magenta. This effect often can be observed in fabric designs.

Colors will appear more intense when they are placed next to or near their op-posites on the color wheel (complementary colors). Thus, red will appear redder when placed next to its complement, green.

People who tend to limit their dress to neutrals can use nature as a guide for ideas for color harmony. Nature uses a broad color palette, filling the whole world with exotic colors and harmonies that could lead us to experiment in the personal use of color. Consider the natural coloring of flowers, birds, and animals:

- Many blossoms are light and bright and usually contrast with dark foliage.
- A snow-capped mountain is set against a deep blue sky framed by evergreens.
- A field of wild flowers forming a mosaic of color provides an excellent ex-ample for combining hues, values, and intensities.
- Certain birds and animals wear protective middle-value coloring that blends in with their environment and hides them from their predators, while other birds and animals have bright colors to attract attention.

For a summary of the three dimensions of color—hue, value, and chroma—as they relate to clothing camouflage, see Figure 7.10.

Color Harmonies

Color harmonies are recipes used to achieve pleasing combinations of hues. Prefer-ence for a particular color harmony depends on social and cultural factors that are learned. Personal likes and dislikes cause a variety of responses to different color harmonies. No hard and fast rules should govern the use of color harmonies, but tra-ditionally organized patterns of color merit study, if only as a point of departure for personal improvisation. It must be kept in mind, however, that successful harmony depends on many factors, including the predominant color characteristics of the in-dividual, the size of the area in which the color is used, its location, and the selec-tion and combination of the value and chroma of the hue.

Problem	Hue	Value	Chroma
If you wish to increase body size choose	warm hues (reds, oranges, yellows)	light, high values, tints, strong value contrasts	pure, strong, brilliant, saturated, high-intensity colors
If you wish to decrease body size choose	cool hues (blues, blue-greens, blue-purples)	low, middle values, shades, weak or no value contrasts	weak, grayed, low-intensity colors

Figure 7.10 Summary of hue, value, chroma for clothing camouflage. (Note: Yellow-green to green is considered neutral.)

The traditional color harmonies are divided into related and contrasting groups. Related colors and related color harmonies are composed of groups of color having at least one hue in common. Yellow is related to orange and to green because it is common to the composition of these hues. Contrasting color harmonies have no hue in common. Thus, red, blue, and yellow are contrasting hues.

Related Color Harmonies

Related color harmonies have one hue in common.

Monochromatic Color Harmony

Monochromatic color harmony uses one hue.

Various tints, tones, and shades of one hue are used in monochromatic harmony; for instance, light pink, rose, maroon, and watermelon. If value and chroma gradations are too close together, the effect may be unpleasing because of ambiguity of colors, giving the impression of a mismatch. These schemes require noticeable differences to achieve the variations necessary to avoid a fatiguing and monotonous effect (Figure 7.11).

Analogous Color Harmony

Analogous color harmony uses colors that appear next to each other on the color wheel.

Colors such as yellow-orange, yellow, and yellow-green make up an analogous harmony (Figure 7.12). When one of the hues is allowed to predominate and when values and chromas are varied, striking effects can be achieved. This harmony creates movement and excitement because of the vibrating effect of adjacent hues. A variation of this harmony that produces a dramatic effect combines three analogous hues with an accent of the complement of the middle hue. Thus, yellow-orange, yellow,

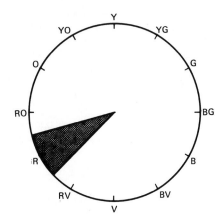

Figure 7.11 Monochromatic color harmony.

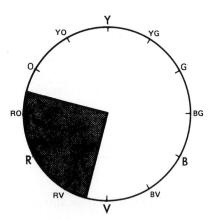

Figure 7.12 Analogous color harmony.

and yellow-green would be used with violet to produce an analogous scheme with a complement (mutual complement). Up to five neighboring hues on a sixteen- to eighteen-color wheel may be grouped for an analogous harmony.

Contrasting Color Harmonies

Contrasting color harmonies have no hue in common.

Complementary Color Harmony

Complementary color harmony results from using hues opposite each other in the color wheel.

Blue and orange, red and green, yellow-orange and blue-violet are examples of complementary harmonies. Simple complementary schemes of two hues can be extended by using tints, tones, or shades of the selected hues (Figure 7.13).

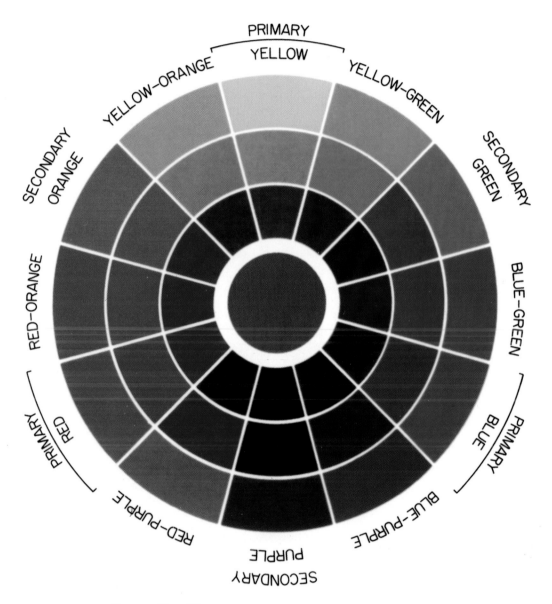

Color Figure 1 The Prang color wheel consists of three groups of colors, primary, secondary, and intermediate. The primary colors—yellow, red, and blue—when paired, make the three secondaries—orange, green, and purple. The primary colors, paired with secondaries, yield six intermediate colors. *(Reprinted by permission from Dorothy Stepat-DeVan et al.,* Introduction to Interior Design, *Macmillan Publishing Co., Inc., New York, 1980)*

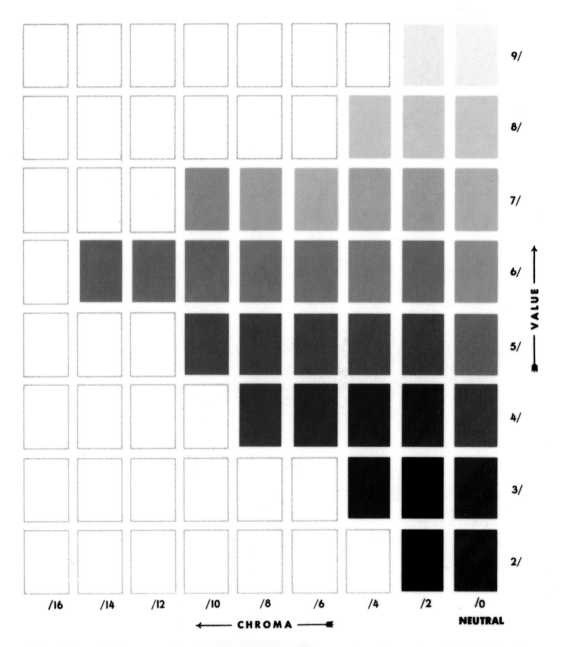

Color Figure 2 One page from the Munsell Color Co., Inc., color order system. Variations in value (brightness) and chroma (saturation) are shown for a single hue. *(Courtesy of the Munsell Color Co., Inc.)*

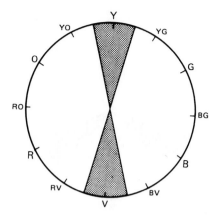

Figure 7.13 Complementary color harmony.

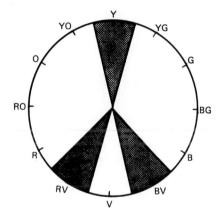

Figure 7.14 Split complement color harmony.

When complementary hues are used in their full strength (high chroma) and in equal quantities, they intensify each other and produce sharp contrasts. This causes a vibration that is often painful to the eye. Red will seem redder when placed next to its complement, green, than when red is used with yellow. Green appears greener next to red than when used next to yellow. This phenomenon is called **simultaneous contrast.** The effect of the vibrations caused by these complements can be lessened by using a smaller amount of intense color or by substituting a tone or shade of the desired hue.

Split Complement Color Harmony

Split complement color harmony occurs when a hue is used with the colors on either side of its complement.

An example of a split complement color scheme would be yellow joined with red-violet and blue-violet (Figure 7.14).

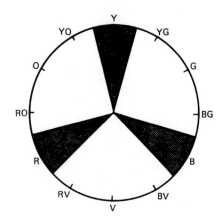

Figure 7.15 Triad color harmony.

Triad Color Harmony

A **triad color harmony** uses three hues placed equidistant on the color wheel.

Sample triad color schemes are yellow, red, and blue or orange, purple, and green (Figure 7.15). Activity 7.1 calls for examples of these various color harmonies.

Influences on Color Perception

Color under one set of conditions may appear very different under another set of conditions, as the following examples show.

Background

A color is never seen alone. It is always seen next to another color. For this reason, it will always relate to another color. Two colors placed next to each other interact. For example, a medium blue will appear lighter against a darker background, darker against a lighter background, clearer against a grayer background, grayer against a clearer background, redder against a green background, and greener against a red background.

Light Source

Color is affected by the light source under which it is viewed. The type of light will affect the depth of the color. Incandescent light, fluorescent lights, sunlight, and candlelight all have different effects on color. Sometimes this effect can be predicted and sometimes it cannot. The best way to test color is to view it under the light source with which it will be used most often.

Generally, bright sunlight changes the intensity of a color. As the intensity of daylight changes from morning to night, the degree of the color alteration also changes.

Artificial lights come in different color tones such as yellow, white, rose, and so on. Each of these lights has a different effect on color. The incandescent lightbulbs

ACTIVITY 7.1 Color Harmonies

Create a notebook with examples from fashion magazines illustrating the use of monochromatic, analogous, complementary, split complement, and triad harmony color schemes.

commonly used in the home give warm-hued light. Fluorescent lights are available in both warm and cool hues. Generally, a warm-hued light source intensifies red, yellow, and orange, whereas it grays cool colors such as blue and violet. A cool-hued light source usually intensifies green, blue, and violet and grays out red, yellow, and orange.

Distance

The distance from which a color is viewed can change its effect. Because of the amount of color used and the hue combination, proximity to the colors influences their appearance. In some allover designs of tweeds, tiny stripes, or checks, the mixture of colors blends together to form new combinations when viewed from a distance; the individual colors making up the design lose their original color identity. When this blending occurs, more accurate color matching of fabrics and accessories can be achieved by observing them from a distance rather than at close range.

Texture

Texture changes color. The same dyes used on different textures will produce a range of colors. Shiny fabrics such as satin reflect the light so that the colors become brighter or more intense. Dull textures, such as flannel, absorb the light and cause colors to become less intense. Shoes, stockings, garments, hats, and scarves are all made of materials of different textures; for this reason they can seldom be perfectly color matched. The textures involved reflect or absorb light differently, thus changing the value or chroma of the color.

Personal Reactions

Recent research has explored psychological reactions to color. Although there are still many questions to be answered in this area, it has been established that response to color is highly individual. Individuals react to color in a certain manner because of personal color preferences and the experiences and associations they have had with that color. Each man, woman, and child has a degree of color sensitivity. Some people are more color sensitive and react more violently to color than others. People may actually become physically ill, excited, soothed, or depressed by exposure to certain colors.

These intense emotional responses to color or why they vary so much with the individual are not completely understood. Attitudes toward color may be the result of

some childhood experience (either pleasant or unpleasant), lack of experience or association with color, or a psychological phenomenon. Each individual has certain colors and combinations of colors that are more pleasing to him or her than to others. The individual needs to experiment with color in relation to both his or her physical and psychological self and discover the most pleasing colors and color harmonies.

Fashion Color Prediction

Color is a part of the fashion mystique. Just as there are fashionable garments, accessories, hairstyles, and facial adornment, there are fashionable colors. A particular color may be high fashion one season and passé the next. Because color is one of the least expensive factors to change in clothing production, the garment industry frequently changes color before changing style.

Each fashion season presents a variety of "new" colors that differ from those of the past season. Fashion colors are rarely pure spectrum hues but variations of them. One of the ways new colors differ from old colors is in name. Fashion professionals rename colors when they select them for a new line of clothing, hoping these new colors will give a fresh image to their products in the eye of their consumer.

There are several groups worldwide whose purpose is to forecast what colors will be used in business and industry in the future. These include The Colour Group (Great Britain), Canadian Society for Color, The Color Science Association of Japan, and The Color Association of the United States.

The Color Association of the United States

The Color Association of the United States (CAUS), founded in 1915, is the oldest group of its kind in the United States. Working with an eighteen- to twenty-two-month lead time, it currently issues four forecast cards annually to over one thousand subscribers. Forecast cards for women's, men's, and children's apparel are issued twice a year. One forecast card for interiors is issued annually.

The CAUS colors are selected by three professional committees: one for womenswear and childrenswear, one for menswear, and one for interior colors. Each panel is made up of eleven members who contribute their time and expertise as an industry service. All work with color in some aspect of the American fashion, textile, and design industries. Members of the panels, all three of which meet separately for working sessions, come to the CAUS office with their ideas and their individual color selections. These are bantered about until each committee reaches a consensus. The association then authorizes and supervises the dyeing of the forecast shades and subsequently publishes the four separate forecast cards. Forecasts are printed and swatched to serve as working tools for stylists and designers (Totaro, 2002).

The strength of the CAUS forecasts has always rested with the color sensitivity of the members of its forecasting panels. The color sages note that the color climate is very nebulous. Current color authorities get cues from various influences, including the hues, values, and chroma/intensities that have been popular, political and societal situations, museum and art exhibits, and celebrities and public personalities.

From the thousands of color choices available, a limited palette is selected to be used for items to be sold at a particular time. Mass production of a limited range of

colors keeps costs down. Many fabricators build their range of colors around a group of steady-selling colors plus a limited group of fashion colors. This explains why it is often impossible to match a fashion color exactly the next year. Lower-priced items such as apparel follow color fashions quickly. Larger-ticket items such as home furnishings and cars have a slower color fashion change.

The Pantone Color System

The Pantone Color System also is used by many professionals in fashion and in other industries in which color accuracy is important. Pantone forecasts fifty-six color trends each year, which are then used by companies producing products such as clothing, home furnishings, automobiles, and paint. Marketing in a "fan," Pantone ColorTrends serves as a visual reference for designers. Among their many color services, they provide computerized color selection services on the Internet, a matching system that facilitates reproduction of color among companies, and scannable color to aid in designing web pages.

Personal Color Identification

Color Theory

Many factors come into play when a person selects the color of a product he or she plans to purchase, whether it's clothing, a car, home interiors, stationery, or a new pen set. People may select the color because it's fashionable, they personally like the color, it flatters and enhances their own coloring, it's accessible at the time, or maybe because it reminds them of something in the past. People are influenced by a variety of emotional, physical, and social reasons in color selections.

People may be intimidated by color for a number of reasons. Perhaps they have not been exposed to working with color and therefore their ability to see color is limited. They may believe that color is difficult to work with and that selecting and combining colors is beyond their talent. Many men, especially, are color blind; other people do not have a "color eye," are not visually inclined, or cannot remember color well.

The motivation behind developing a system to aid consumers in understanding color as it relates to their personal coloring came from a German art teacher named Johannes Itten. While instructing students on the principles of harmonious colors, he found a difference of opinion about the parameters for harmony. When the students were asked to display what harmony meant to them, he discovered that the students exhibited colors found in their own personal coloring. He concluded that to understand harmony, individuals must understand their own personal coloring (Itten, 1970). This initial observation created the color analysis trend.

One of the first to popularize personal color analysis was Carole Jackson. In 1980, Jackson wrote an industry-breaking fashion book titled *Color Me Beautiful,* which sold millions of copies and was on *The New York Times* best seller list for more than four years. She added *Color for Men* in 1985. (Her concepts were most recently updated by Spillane and Sherlock, 1995.) These books helped consumers analyze their personal coloring and suggested fashion colors that would be most enhancing. It was such a success that *Color Me Beautiful* gave birth to a household generic name: color analysis.

Autumn	Deep, warm, subtle colors: • The rusty reds, golds, and browns of the changing leaves • Fields of pumpkins and gourds of orange • Subtle yellows and olive greens • Drying dormant grass turning to tans and grayed greens
Winter	Deep, cool, vibrant colors: • Contrasting colors seen in the white snow-capped mountains against the contrasting black sky • Gray rainy days • Cranberry reds and pine greens during the holidays
Spring	Bright, warm, light colors: • Bright new flowers like crocuses, daffodils, tulips, and azaleas • The clear greens of newly sprouted grass and leaves; poppy reds
Summer	Light, blended, cool colors: • Dusty rose sunsets • Gray-blue skies • Watermelon reds • Ocean green waters

Figure 7.16 Seasonal colors. *(Personal interview with G. Totaro, national director of Color Me Beautiful. April 15, 2002)*

Color analysis is a process of looking at a person's eye color, skin tone, and hair color to determine what colors will flatter and enhance his or her natural coloring.

Color analysis has given men and women alike the confidence to shop for everything from small goods to major purchases and to know that their color selections will be successful.

The popularity of color analysis has spawned careers such as image consulting, color consulting, makeup enhancement, and training. Using a variety of systems, color consultants analyze an individual's personal color pattern, then relate it to a selected group of complementary colors. Often the client is given a pack of fabric swatches or paint chips to carry along to use as an aid in making future color decisions.

The foundational principle underlying personal color analysis is the effort to create personal color harmony. Harmony is visually displayed when something is pleasing to the eye. Harmony is easily demonstrated when viewing nature, especially during each season (Figure 7.16).

The hues, values, and chromas found in each season of nature can also be found in the natural color combinations of people. People look the most pleasing when their clothing is in harmony with the natural coloring of their eyes, skin, and hair (Totaro, 2002).

Color Theory Related to Personal Color Analysis

Every color in nature has hue, value, and chroma. The seasonal color analysis system divides colors by these characteristics and designates harmonious combinations according to the personal coloring of individual consumers.

	Warm (Spring/Autumn)	Cool (Winter/Summer)
Hair color	• Blonde: golden/ strawberry • Golden brown • Red • Copper • Auburn • Chestnut • Cream white	• Brown: charcoal/ black • Blonde: ash • Pearl gray • Silver • Black: blue/charcoal/jet • Salt and pepper • Snow white
Eye color	• Topaz • Yellow/green • Teal • Olive • Golden brown • Aqua • Hazel • Turquoise	• Blue • Blue/gray • Black • Black/brown • Gray • Slate • Violet
Skin tones	• Ivory • Porcelain • Peaches and cream • Golden beige • Golden brown	• Beige: cool, gray, rose • White/pink • Blue/black • Pink • Rose/brown

Figure 7.17 Hue related to personal coloring. *(Personal interview with G. Totaro, national director of Color Me Beautiful. April 15, 2002)*

Hue

The hue of a color is either warm or cool. Warm colors (orange, peach, lime green, teal blue, tomato red, brown) have a yellow undertone, and cool colors (pink, fuchsia, gray, cranberry red, deep pine green) have a blue undertone. The warm category may be referred to as "golden-based" and the cool colors as "blue-based" (Pooser, 1985).

People have either warm or cool hues or undertones. Those with a warm hue or undertone and skin and hair color similar to the descriptions in Figure 7.17 can be classified as Warm Autumns or Warm Springs. People with a cool hue or undertone similar to those described in Figure 7.17 are either Cool Winters or Cool Summers (Spillane and Sherlock, 1995).

Value

Value describes the lightness and darkness of a color. This is the easiest category to understand because the color white is light and black is dark, with many shades in between. Baby blue is light, whereas navy blue is dark. The light categories in the seasonal concept are Springs and Summers. The dark categories are the Winters and Autumns.

This is also the easiest category to understand when describing the terms to people. People with light eyes and light hair are predominantly light (Light Spring or

	Dark (Winter/Autumn)	Light (Spring/Summer)
Hair	Charcoal brown/black Chestnut Red Copper Salt and pepper Black Black/brown	White Silver Yellow/Gray Platinum Blonde: natural, golden, strawberry/ash
Eyes	Hazel/green Navy blue Teal Brown Black Red or black brown	Yellow/gray Gray Gray green Blue gray Blue green Topaz
Skin tone	Beige: rose or golden Golden brown Dark olive Blue/black Black/brown	White/pink Ivory Peaches and cream Pink Gray beige Light olive

Figure 7.18 Value related to personal coloring. *(Personal interview with G. Totaro, national director of Color Me Beautiful. April 15, 2002)*

Light Summer). People with dark eyes and dark hair are predominately dark (Dark Winter or Dark Autumn). Skin tone does not play a part in evaluating the light or dark categories (Totaro, 2002) (Figure 7.18).

Chroma

Chroma describes a color as either pure, bright, and clear or muted and dull. Bright, clear colors include primary and secondary colors—red, orange, yellow, green, blue, and purple. Pure, bright colors (those unmixed by gray, white, black, or brown) create contrast when used together. Grayed colors include gray-blue, mauve, grayed green, and salmon orange. Muted colors tend to lack contrast, creating a soft blended look. Figure 7.19 gives examples of personal coloring as it relates to chroma.

An individual whose coloring is clear will display a contrast of light and deep. People whose coloring is blended or muted lack contrast; their hair, skin, and eyes seem similar. Many times texture plays a part in a muted look as hair may be coarse, wavy, or curly; eye color may be hard to identify; and skin may have freckles, large pores, scarring, or a visibly opaque texture (Totaro, 2002).

Dominant Characteristics

The **dominant characteristics** of personal coloring—skin, hair, and eyes—determine an individual's "season."

	Pure, Clear (Winter/Spring)	**Muted (Summer/Autumn)**
Eyes	• Clear, bright, marble • Light • Dark • Jewel tone	• Medium eyes • Grayed • Nondescript • Multicolored
Hair	• Straight • Shiny hair • One solid color • Soft, fine	• Medium, neutral (lacking warmth or coolness) • Thick • Frosted • Multicolor • Textured (coarse, wiry, curly)
Skin	• Translucent • Glows or sparkle (reflects light) • Peaches and cream • One color • High contrast • Small pores • Smooth • Thin	• Medium skin tone • Thick • Opaque • Multicolored • Textured: large pores, freckles, scar tissue

Figure 7.19 Chroma applied to personal coloring. *(Personal interview with G. Totaro, national director of Color Me Beautiful. April 15, 2002)*

People can be viewed as having dominant characteristics found in hue, value, and chroma (Figure 7.20). A person may be predominantly warm, cool, light, dark, clear, or muted. The following defines the dominant characteristics:

- Warm: Warm hair, eyes, skin
- Cool: Cool hair, eyes, skin
- Light: Light eyes and hair
- Dark: Dark eyes and skin
- Clear: Shines; contrast and clarity of skin, hair, and eyes
- Muted: Medium, blended hair, eyes, skin; no contrast

If a person is not considered warm or cool, then his or her predominant characteristic is not from hue; it is from either value or chroma. If a person is not light or dark then his or her predominant characteristic is not from value but from hue or chroma. If a person is not clear or muted then his or her predominant characteristic is not from chroma but from hue or value (Activity 7.2).

Season	Hue	Value	Chroma
Autumn	Warm	Dark	Muted
Winter	Cool	Dark	Clear
Spring	Warm	Light	Clear
Summer	Cool	Light	Muted

Figure 7.20 Dominant characteristics of personal color. *(Personal interview with G. Totaro, national director of Color Me Beautiful. April 15, 2002)*

ACTIVITY 7.2 Predominant Color Categories

Look for pictures in magazines that represent the six dominant categories in color analysis. In a notebook, divide the pictures according to people who are (a) cool, (b) warm, (c) light, (d) dark, (e) clear, and (f) muted.

Figure 7.21 Seasonal color related to hue, chroma, and value. In analyzing personal coloring, ask three questions: Is my coloring warm or cool (warm = Autumn/Spring, cool = Summer/Winter)? Is my coloring light or deep (light = Summer/Spring, deep = Winter/Autumn)? Is my coloring clear or muted (clear = Winter/Spring, muted = Autumn/Summer)? The answers to these should help an individual pinpoint his or her color season. (Courtesy Gayla Totaro)

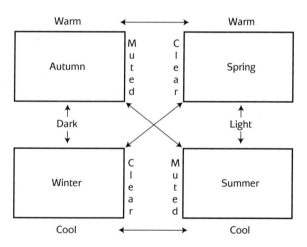

For a summary of hue, value, and chroma as applied to personal coloring, see Figure 7.21. To experiment with developing an eye for color differences, see Activity 7.3.

Specific Personal Color Considerations

Skin Color

In Chapter 5, the discussion of pigmentation of skin and hair noted that skin color was created by the pigment melanin and that undertones in skin coloring are the re-

ACTIVITY 7.3 Color Continuum

As a classroom activity, try to organize a "people continuum." Arrange class members in a single line across the room.

1. Group the students by their hue—from students with warmest coloring to those with lightest coloring.
2. Group students by value—from students with lightest coloring to students with darkest coloring.
3. Group students by chroma—from students with clearest coloring to students with most muted/blended coloring.

Determine the dominant characteristic of each student by noting in which group he or she was closest to an end (extreme).

sult of the presence of the orange pigment carotene or the reddish-blue cast of the blood's hemoglobin. Many skin tones can have a dominate cool or warm undertone.

With age, people not only lose the pigment in their hair as it grays, but they can also lose the pigment in their eyes and skin. But even as skin tans, ages, or weathers, it does not change its undertone.

Neutral skin tone. Some skin tones are not obviously cool or warm. In this case they are referred to as a neutral skin tone. In the color analysis concept discussed, a person with a neutral skin tone will more than likely fall under a predominant category other than cool or warm. Dark, light, clear, or muted will be more likely. Differentiating between skin tones takes a tremendous amount of observation to see the differences. Observers attempting color analysis can be misled if they do not understand that neutral skin tones exist.

Ruddy skin tone. One area of skin tone that is many times confused with a cool pinky beige skin tone is a condition called ruddiness. These are capillaries that have broken or are visible on the surface of the skin. Ruddiness is usually found in the warm skin tones. Many novice color consultants want to put this skin tone in the cool category, which only makes the uneven skin tone more pronounced.

Hair Color

Hair coloring generally complements skin coloring, although the enzymes or genes responsible for hair coloring are different from those responsible for skin and eye color. A person's natural hair color will always coordinate with his or her skin and eyes.

Color enhancement. People often wish to enhance their natural hair color or cover the gray. Caution must be taken to keep the hair color corresponding to natural personal coloring. Colors from an opposite hue will tend to make one look older by emphasizing facial wrinkles, shadows, and blemishes. Hues that have a chroma greater than that of the hair color will rob the hair of some of its color. Harmony can be lost if the hair color is incorrect.

Graying hair. Many times when the cool categories gray it will be an attractive snow white, pearl gray, silver, or salt and pepper color. Unfortunately some warm hair tones do not gray as attractively. Sometimes the hair will lose its vibrant golden highlights and look drab and mousy during the graying process. Once the person is completely gray, it can be an attractive creamy, warm, or neutral gray. When a person is graying, it softens his or her coloring and may change the predominate characteristics. Although the person may appear more neutral and light, it is rare that the overall undertone or season will change.

Eye Color

Eye color may darken or fade with age or be altered by disease or use of colored contact lenses, but it remains in the same color category from infancy on. Some specific examples of eye color based on dominant characteristics are:

- Clear: Bright blue, bright violet, and bright green eyes
- Muted: Soft or gray-blue eyes
- Warm: Yellow or gold in the middle; varying shades of green eyes; yellow-brown eyes
- Deep: Brown eyes; hazel eyes (they change from green to brown or blue to brown, but are always combined with brown)
- All categories have blue

Most eye colors, except brown and hazel, are intensified by a clothing hue that matches it in chroma. Brown eyes benefit most from contrasting shades of high intensity. Hazel eyes are like chameleons and reflect the color of their environment in direct relation to its brilliance.

As people age, they can lose pigment in their eyes as well as their hair (graying). This is most noticeable in certain brown eyes that appear to have a milky film around the iris.

Benefits of Color Analysis

The initial benefit of personal color analysis is to improve a person's appearance. The correct colors should make a person look healthier, younger, slimmer, more credible, and more successful and make them feel better about themselves (Activity 7.4). The secondary benefit applies to wardrobe planning and coordinating a wardrobe where there is more to wear with fewer things in the closet (Jackson, 1980).

ACTIVITY 7.4 Personal Color Analysis

Analyze your personal colors by using the hue, value, and chroma charts in this chapter.

The long-range benefit will be saving time, reduction in shopping effort, and saving money by purchasing garments that mix and match in the wardrobe. Color analysis can be used for every purchase where color must be considered: cosmetics, accessories, wardrobe, and exterior and interior design. For example, men and women can base their jewelry purchases on their personal coloring. Rose and white gold, silver or platinum are considered to be cool. Yellow gold, brass, and copper fall within the warm group (Jackson, 1980).

 ## Summary

Color is an important part of the human experience. Its three dimensions are hue, which describes the undertone (blue or yellow) of a color; value, which describes the lightness or darkness of a color; and chroma, which describes the purity or muted quality of a color. These dimensions have been used in various color systems such as Prang and Munsell, which aid in color selection and reproduction. These dimensions allow color to be used in innumerable combinations limited only by one's imagination. These same color dimensions can also be applied to the personal color patterns of consumers to facilitate harmonious clothing selection.

Key Terms and Concepts

Analogous color harmony
Chroma
Color analysis
Complementary color harmony
Contrasting color harmony
Cool hues
Dominant characteristic
Hue
Law of Color
Monochromatic color harmony
Munsell Color System

Prang Color System
Primary color
Related color harmony
Saturation
Secondary color
Simultaneous contrast
Split complement color harmony
Tertiary color
Triad color harmony
Value
Warm hues

 ## References

Faulkner, R., and Ziegfield, E. (1969). *Art today*. New York: Holt.

Itten, J. (1970). *The elements of color*. London: Von Nostrand Reinhold.

Jackson, C. (1980). *Color me beautiful*. New York: Ballantine Books.

Pooser, D. (1985). *Always in style with color me beautiful*. Washington, DC: Acropolis Books Ltd.

Spillane, M., and Sherlock, C. (1995). *Color me beautiful's looking your best*. Lanham, MD: Madison Books.

Totaro, G. (2002, April 15). National Director of Color Me Beautiful. Personal interview.

Chapter **8**

Texture

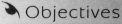 Objectives

- Explain texture as a sensory impression.
- Illustrate the influence of individual components of fabric on the formation of a texture.
- Present guidelines for making decisions about the selection of a single texture or a blend of two or more textures.

Texture is the element of design that describes surface appearance and feel.

Fabric, metal, leather, and straw—each has a distinctive texture. The descriptive words used to characterize textures are comparative: Both burlap and sailcloth are coarse textures, but their degree of coarseness differs. Textures are also compared to other textures with which they are combined and to the person wearing them. Some adjectives used to describe textures are *smooth, heavy, fine, crisp, glossy,* and *nubby* (Figure 8.1).

An understanding of the dynamics of texture helps individual consumers and fashion professionals make better decisions as they select apparel products and items of personal adornment. This chapter presents a discussion of texture as a sensory impression involving touch and sight. It focuses on how the individual components of fabric determine unique textures. It also presents guidelines for making decisions about the selection of a particular texture or a combination of textures in relation to the design of the product and the individuality of the consumer.

Texture as a Sensory Impression

Tactile qualities refer to coarseness, softness, or rigidity, as recognized by touch.

Texture	Description	Examples
Coarse	Loose, rough, or coarse	Burlap, sailcloth
Smooth	Free from obstruction	Batiste, voile
Crisp	Having the surface roughened into small folds or curling wrinkles	Linen, crepe
Nubby	Having small knobs or lumps	Tweed, shantung
Heavy	Having great weight in proportion to bulk	Quilted fabrics, tapestry cloth, specialty wool such as camel, boiled wool
Fine	Very thin in gauge or texture	Fine pina, fine cotton, organza
Clingy	To adhere	Tricot, plain jersey knit
Glossy	Having a surface luster or brightness	Smooth plastics, polished cotton
Shiny	Bright in appearance	Satin, vinyl
Dull	Lacking brilliance or luster	Cotton denim, medium-weight flannel

Figure 8.1 Categorizing textures.

Texture refers to the surface qualities of things. Visual perception is one of the systematic ways of relating to textures, as well as to all aspects of the physical environment. The visual aspect of texture is perceived by the eye because of the degree of light absorption and reflection on the surface of the material. Things can look hard or soft, rough or smooth, hot or cold. Such impressions are the result of a sensory impression understood by sight; at the same time, they involve contributions from other sense organs (Lee and Sato, 2001).

Texture is fully comprehended by touch, but it is not always necessary to feel an object to understand its tactile qualities. Lustrous textures are seen in satins and dull textures in fuzzy wools. Texture has the definite physical dimensions of weight, size, bulk, and shape. These physical dimensions are also visually perceived (Figure 8.2).

Hand refers to the tactile aspects of fabric.

The tactile aspects of fabric include the coarseness, softness, or rigidity as recognized by feel. Hand determines how some fabrics will respond to a given style. Some textures virtually speak to the designer as to how they should be used. Firm gabardine, linen, and worsted call for crisp tailoring; matte jerseys and chiffon are effective in

Figure 8.2 *Texture is a sensory impression understood by vision as well as touch. The texture of the fabric in each blouse can be readily understood visually.*

draped designs (Figures 8.3 and 8.4). Softly tailored garments need pliable fabrics such as crepe, shantung, or lightweight wool flannel.

Each fabric has textural characteristics that can be described by feeling, seeing, or feeling and seeing:

feel	soft-crisp, smooth-rough
see	shiny-dull, opaque-transparent
feel and see	thick-thin, clingy-rigid

Components That Determine Texture

Texture is determined by the arrangement of the component parts in fabric. These are the fiber, the yarn, the fabrication (e.g., weave or knit), and the finish that make up a fabric.

Fibers

Fibers are hairlike strands of materials, such as silk or wool.

Fibers are spun into yarns, which are used to construct fabrics of varying textures. Fibers of fine wool produce soft textures; flax fibers produce crisp linen fabric texture. Both of these are the result of inherent characteristics of the raw materials. The short, fuzzy fibers of cotton will produce fabrics that will absorb light and appear dull; the long, smooth filaments of reeled silk will make fabrics that reflect light, giving a shiny appearance.

Fiber	Yarn Structure	Weave, Knit, Film, etc.	Finish	Texture
Cotton	Simple, from short fibers	Plain weave	Mercerized	Absorbs light, dull
Merino wool	Novelty, with curls and coils	Plain weave	Napping	Soft
Silk	Smooth filaments	Satin weave	Routine	Reflects light, shiny
Flax	Simple, long staple fibers	Basket weave	Wrinkle resistant	Crisp

Figure 8.3 Unique fabric components that determine texture.

Yarns

Yarns are strands that are most often formed by twisting fibers together.

Whether the yarn is the result of twisting short fibers together or long filaments laid together with little or no twist, the result is a distinctive texture. This means that each method used to produce yarn, and there are many, results in the formation of a texture unlike any other. A yarn of a silk fiber given a low twist will produce a shiny textile, as found in satin; a highly twisted yarn of silk fiber will form a rough texture, such as crepe. Yarns of silk fibers organized by thick slubs form shantung, and those that are looped or coiled produce stretch fabrics. Yarns made of short fibers having a little twist can be brushed after being formed into fabric to produce a nap or fuzzy texture.

Fabrication

Fabric is a cohesive structure resulting from the arrangement of physical components (fibers, yarns) in relation to each other.

Fabric is formed by putting yarns together by some method, such as weaving, knitting, crocheting, felting, bonding, and braiding. Some fabrics, called film fabrics, which are often used for rainwear or to simulate leather, are formed by chemicals that are extruded in sheets instead of filaments. The way yarns are put together to form fabric determines the texture. A satin weave of loosely twisted yarns, woven so that the yarns float across many threads, produces visual effects that reflect light and give a shiny texture. The diagonal design formed in gabardine, denim, covert, and drill is the result of a twill weave. The pattern of knits is formed by the way the loops of yarn are formed. Knits absorb light and are dull textured unless a plastic or metallic yarn is used.

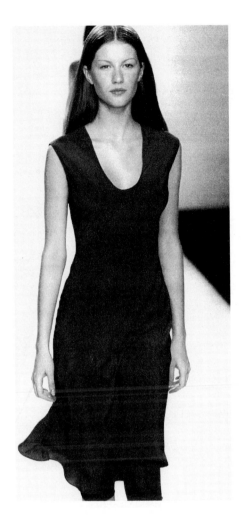

Figure 8.4 *Jersey and chiffon fabrics, having a soft and supple hand, work well in a loose, draped style. Firm fabrics call for crisp tailoring. (Courtesy Peter Shen)*

Finish

> A **finish** is the chemical or physical treatment of fabrics to enhance appearance or performance (Kadolph, 1998).

The finish given to fabric after it is constructed can impart or change texture as well as other qualities. The no-iron finish that makes a fabric smooth and wrinkle-free usually stiffens the texture and makes it less pliable than fabrics not given this finish. Crisp fabrics are produced by the addition of a sizing mixture that gives stiffness to the finish. Embossed fabrics, which are characterized by their three-dimensional designs, are

Figure 8.5 *Fine linen is combined with lace to create a delicate feminine image.* *(Courtesy Hamilton Adams Imports)*

formed by passing the fabric through rollers having embossed designs. Flocked fabrics have short fibers attached to the surface by adhesives.

The texture of fabrics is affected by the characteristics of the raw material used and by the production processes involved, from fiber to the final stage when the finish is applied (Figure 8.5). Texture determines how the fabric should be used. Garment designs that do not respect the fabric's texture characteristics cannot be satisfactory.

Fashions in Textures

Textures, as well as silhouettes and colors, enter and leave the fashion picture. For example, wrinkle-resistant cottons, a rather new innovation, are receiving consumer approval in the marketplace. One could also expect that the recent release of Dreamlinen or e-linen will be received with as much enthusiasm as were the wrinkle-resistant cottons. Manufacturers of Dreamlinen reported that the use of a very sophisticated technological finishing process resulted in an increase in elasticity of the fiber, thus reducing the tendency of the fabric to wrinkle ("Textiles Now," 2001). The style of the garment determines which textures will be used. Changes in fashion bring changes in texture.

Tailored garments are cut and sewn for a trim fit.

To **drape** is to arrange in loose folds.

Drapable means the ability to hang in flowing lines or loose folds.

Because texture and garment styling must be compatible, the fashion reappearance of textures as well as garment designs occurs periodically. Tailored styling trends require crisp, firmly woven fabrics to enhance the precise line. Body-clinging styles require textures that express this quality in soft and drapable fabrics. Fashion requires bulky, fuzzy textures at times and smooth, soft, or firm textures at other times. Designers often determine their styles by what the available fabric textures suggest. They manipulate the material to determine the hand and how it will react to draping, pleating, folding, or tucking. This technique helps them to decide how a garment should be designed. Many designers drape the fabric as they are creating a garment.

Some textures are classics; they remain popular year after year. These are usually textures that are not extremes; that is, they are neither very rough nor very smooth, very thick nor very thin. They belong in the middle textural range. Broadcloth, percale, lightweight flannel, and lightweight linen have all been fashionable for a long time. These textures are not particularly exciting, but their appeal is lasting because people do not tire of them as quickly as they do of the extreme textures. Because of their plain surfaces, these textures can support intricate structural design (Figure 8.6).

Figure 8.6 *Medium-weight herringbone shown in this jacket is an enduring texture. (Courtesy the Joseph & Feiss Company)*

Selection of Texture

When selecting textures, the individual's physical proportions, skin and hair textures, and personality must be considered. Texture selections that create combinations that provide contrast while, at the same time, carry out a predominant theme or idea seem to be the most pleasing. The result gives an impression of unity or a total look of textures and the other design elements.

Effect of Texture on Physical Proportion

Textures have the physical properties of weight, size, bulk, shape, light absorption, and reflection. Textures can produce illusions that change apparent body size. Textures can make one look heavier or thinner.

Since texture has the definite physical dimensions of weight, size, bulk, and shape, the use of certain textures on certain parts of the body should be well thought out. Some of the most interesting textures presented in the seasons of 2001 and 2002 challenged designers' creativity when considering their compatibility with various body styles. For example, leather was very strong, but all leathers are not the same when it comes to texture. A leather patchwork Bomber jacket by Pelle featured not only patchwork, but also patchwork in three different shades of blue. In addition, each patch was outlined with small, round metal discs ("Market Report," 2001). This texture would work for a tall, thin body, but it is definitely *not* for the person wanting to make the upper torso look smaller. Instead this person could choose a lightweight, soft, and smooth texture in a leather jacket.

Other interesting textures reappearing in the Spring 2002 season at the textile show in New York were in corduroy fabric and sparkle denim. The sparkle denim featured sparkle yarns of gold or aluminum (Maycumber, 2001). These textures will also require careful consideration on the designer's part because they can make the figure appear larger than the true size.

Lace, an especially feminine texture, was often seen in 2002. In fact, anything in lace or tulle or featuring ruffles was likely to catch the customer's eye. Dola and Gabbanna offered a lace trimfitted jacket. A silk top by Valentino featured lace inserts at the middle chest area and lace extensions on the long sleeves, while Emanuel Ungaro's printed silk blouse featured ruffles on each side of the center-front closure ("What Gives?" 2001). None of these textures would flatter the full-busted figure, but could flatter a small, less developed figure (Activity 8.1).

Fabrics may be grouped together by common characteristics such as softness, coarseness, or stiffness. Most fabrics possess a combination of characteristics that must be evaluated in regard to the effect they produce when incorporated into a garment design and placed on the body. For example, a fabric may be soft, bulky, and shiny. A consumer may want the softness but not the shine or bulk, as these two characteristics may not be becoming to a particular body type. In this situation it is better to find another soft fabric that is not bulky or shiny. Thoughtful selection of textures can help produce desirable physical illusions.

ACTIVITY 8.1 Fashionable Textures

Using fashion magazines such as *Vogue, GQ,* and *Elle,* find examples of textures promoted in current fashion for men, women, and those who appear "unisex."

Proportion of Textures

Proportion refers to the relationship of areas.

All fabrics have proportion or scale. The size relationship of the pattern formed by the texture determines the scale. Obvious proportion differences are seen by comparing the surface or the wale of corduroy in fine-, medium-, and wide-wale varieties. The small-scale pattern of some tweed fabrics is not so easily discernible as the large-scale tweed patterns with coarser yarns. Rep fabrics that have a thick filling yarn vary from fine, as in broadcloth, to heavy, as in bengaline. Nap length of wools determines their scale. The size of the yarn and the needles used in knitting produce the differences in the scale of textures in knits. When the scale formed by the pattern of texture is tiny, the pattern is lost when seen from a distance and the pattern of the fabric produces an overall effect. The textural effect of very large-scaled patterns such as wide-wale corduroy, Erin Isle knits, and wool fleece remains identifiable when viewed from a distance.

When selecting textures, consider their scale in relationship to the size of the person wearing them. A small-sized body wearing large-scale textures can get lost in the texture because of the extreme contrast between fabric surface and figure dimensions. Petiteness is emphasized by the large-scale texture. Very heavy people who wear large-scale textures will appear heavier owing to repetition of size (Activity 8.2).

Soft and Clingy Fabrics

Fabrics that are soft and drapable cling to the body, show every contour, and reveal any body irregularities. Unless additional treatment is given in the inner construction of garments made from these fabrics, their use should be limited to those people who wish to reveal their body.

Fashion fabric is the right side of the fabric, intended for public view; the outer fabric.

The fashion fabric quality of softness and the way it clings to the body can be changed by adding underlining or bonding. The degree of firmness of the underlining will

ACTIVITY 8.2　What Works and What Doesn't

Collect fabric swatches for a collage showing pleasing and unpleasing textural combinations for one of the consumer types as shown in Figure 5.6 on p. 139, which illustrates the three basic somatotypes.

Discuss the reasons for your selections with your classmates.

determine how stiff the outer fabric will be. The body contour can be camouflaged with these textures if they are underlined to lessen the clingy quality of the fashion fabric. (This should be done with care since stiff, supportive fabrics can spoil the effect of the fashion fabric.)

Stiff and Bulky Fabrics

Stiff textured fabrics stand away from the body and hide body irregularities. Excessively stiff fabrics appear to add bulk and weight to the body. Very stiff fabrics can be worn to advantage by persons who are average to tall in height with either average or thin bodies.

These textures should be avoided by persons with very small bodies who do not wish to appear dwarfed by the contrast. Overweight people will look heavier in these fabrics because they stand away from the body, creating the illusion of additional thickness. A moderate amount of stiffness in fabrics is desirable for the overweight figure because then the fabric does not cling to the body and reveal its exact contours.

Some textures add volume to the body by virtue of their weight and bulky nature. These fabrics, like those in the stiff classification, may by contrast be overpowering on the very slight, very thin, or petite body. The tall, slender person can use these textures more effectively.

Shiny and Dull Textures

Shiny textures reflect light and make the person wearing them appear larger. The fabric color is intensified by shine. Pile fabrics such as velvet, plush, velour, corduroy, and velveteen both reflect and absorb light. Shadows occur in these fabrics because of multiple reflections of light on the pile. Those who do not mind appearing larger can wear these textures effectively (Figure 8.7).

Dull fabrics, which absorb light, do not enlarge the body. These textures are suitable for all body types, provided they do not possess other qualities such as bulk, softness, and crispness that would contribute undesirable characteristics.

Middle-Group Textures

People who do not wish to call attention to their body irregularities will select textures that are not extreme—very thin or thick, very soft or stiff, or very shiny (Figure 8.8). Because textures found in the middle group may not be structurally

Figure 8.7 *Shiny textures reflect light and make a person wearing them appear larger. These include satins and glittery and wet-look textures. (Courtesy Edward Dalmacio)*

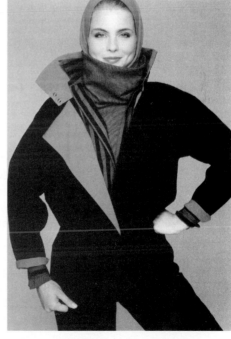

Figure 8.8 *Stiff and bulky fabrics stand away from the body. Excessively stiff fabrics appear to add bulk and weight to the body. (Left: Courtesy Edward Dalmacio. Right: Courtesy Jones of New York Sport)*

as interesting as the more extreme textures, other features such as color and line are often used to add interest to garments designed of such fabrics.

Texture Related to Skin and Hair

Skin and hair have texture. Both have degrees of fineness and coarseness that must be kept in mind when selecting fabrics, jewelry, and other textures to be worn next to the face. The extreme contrasts of coarse skin and hair textures with very fine fabrics can produce uncomplimentary effects in both skin and hair appearance. People with coarse or aging skin should select the middle range of textures, which are neither very fine nor very coarse. Fabrics such as piqué, crepe, jersey, medium knits, dull silk, linen, and lightweight wool are considered medium textures.

People with fine, smooth skin and hair can use fine textured fabrics such as voile, satin, sateen, organdy, polished cotton, batiste, dimity, China silk, finely woven silk, and smooth plastics. They can also wear the middle and rough textures effectively. If skin and hair differ in texture, careful analysis should be made to find textures most flattering to both.

Frames of glasses and jewelry worn next to the skin should be analyzed for textural qualities. Shiny metals and smooth stones are best used by individuals who have smooth and fine to medium-fine skin. In the medium range of textures in jewelry are coarse stones, Florentine-finish metals, and tortoiseshell.

Hair textures are not usually as important a consideration as skin textures. However, materials used for hats should complement hair textures. Smooth felt, shiny leather, satin, and finely woven straw will emphasize coarseness of hair textures. Most furs, velour, coarse leather, felt, and medium-textured straws fall into a medium-textured category, which can be worn by all.

Expressing Personality Through Texture Selection

The ability to select textures that reflect an individual's self-concept is achieved when there is an understanding of the character or idea projected by the textures (Figure 8.9). The distinctive individual qualities of some textures typify particular moods and feelings. A variety of fabrics must be examined carefully in order to be able to identify the character they project. For example, the feel of burlap differs from the feel of velvet.

Personal preferences undoubtedly play a large part in the selection of textures that the individual feels comfortable wearing. One should not overlook the possibility of using different and exciting textures to mirror personal qualities, enhance appearance, and give personal satisfaction. Texture is an element of design that can be effectively used to express individuality.

Harmony in Texture Combination

Harmony refers to a pleasing or congruent arrangement of parts.

Combinations of texture related to weight (thickness and thinness) and firmness (crispness and softness) do not present particular problems, but combinations related to the image, feeling, or personality of textures should be analyzed carefully.

Figure 8.9 *These four garment textures project differing personal qualities that complement each wearer. (Top left: Courtesy the Joseph & Feiss Company. Top right: Courtesy Hamilton Adams Imports. Bottom left: Courtesy Folkwear, Inc. Bottom right: Courtesy Priscilla of Boston)*

Figure 8.10 *Embroidery thread must be compatible in weight and texture with the ground fabric. Silk shantung cloth is enhanced by using embroidery floss having similar qualities. This Kashmir embroidery is enhanced by the use of gold threads to outline the motifs.*

Delicate lace and fine embroidery harmonize with fine, sheer fabrics (Figure 8.10). Coarse cotton lace and heavy crewel embroidery are too great a contrast for the same fine, sheer fabrics. Cotton lace combines well with percale, velveteen, and pique. Crewel embroidery has qualities in common with homespun, heavy knits, and monk's cloth. Sequins convey formality for evening wear and are better applied to silks, satins, taffeta, and laces rather than to straw purses, heavy knits, and medium-weight cottons. Heavy tweed pants and jersey tops have a similar character, whereas heavy tweed pants and smooth satin shirts do not.

Contrast in Texture Combination

Some fashion periods feature strong texture contrasts used together. Such combinations as glitter fabrics and denim for day wear, heavy boots with summer cottons, and sheer blouses with jeans produce change for the fashion moment. Contrasts are necessary to avoid sameness and monotony; however, a predominant texture idea should be evident so that unity is achieved.

When making decisions about textural combinations, stand away from them. Distance will diminish the effect the combinations present up close. They may blend together and appear too similar in texture, or they obviously may not belong together because they are too unrelated. Good design requires texture contrasts that are varied enough to be interesting.

Contrast of Textures with Accessories

The selection of accessories for an outfit provides an excellent way to use contrasting textures. An all-smooth or all-coarse or an all-dull or all-shiny textured ensemble would be unified, but it also might be monotonous and unrelieved. Variety in texture combination lends excitement, but thoughtful selection is required (Figures 8.11 and 8.12). A soft wool sportcoat with gabardine slacks accessorized

Figure 8.11 *Contrasts are necessary to avoid monotony. (Courtesy Axis Clothing Corp.)*

Figure 8.12 *Accessories provide an excellent way to use contrasting yet compatible textures. The result to be achieved is the design principle of unity with variety. (Courtesy Jennifer Forbes)*

263

with smooth leather suede shoes, a felt hat, and a silk scarf brings into the outfit a variety of compatible textures. A comfortable pair of faded blue jeans combined with a pastel-colored T-shirt is a compatible texture background for a leather belt.

For women, purses and shoes do not have to be of identical texture to be used together. It is more important that they express the same feeling.

Hosiery is available in a wide assortment of textures, from the traditional fine knit and mesh to coarse-ribbed or net. Coordinating these textures with the garment is essential. For both men and women, the heavier textured hosiery is best worn with medium-to-coarse fabrics, because it conveys the image of these materials. Heavily textured hosiery usually clashes with fine textures because of the extreme contrast. Women should note that the heavier textured hosiery make legs appear larger and call attention to them even more when stocking color contrasts with the skirt.

❧ Summary

Fabric texture is determined by each component used to produce the fabric. Textures vary a great deal and can have a significant impact on the image presented through the design. This chapter explains texture as a sensory impression. It illustrates the influence of individual components of fabric on the formation of a texture. It also presents guidelines for making decisions when selecting a single texture or a blend of two or more textures. Fashion professionals and consumers must consider the dynamics of fabric texture, the design of the apparel item or accessory, and the physical, psychological, and social characteristics of the individual in choosing fabric textures.

❧ Key Terms and Concepts

Drapable

Draped

Fabric

Fashion fabric

Fibers

Finish

Hand

Harmony

Proportion

Tactile qualities

Tailored

Texture

Yarns

❧ References

Kadolph, S. J. (1998). *Quality assurance for textiles and apparel*. New York: Fairchild.

Lee, W. and Sato, M. (2001). Visual perception of texture of textiles. *Color research and application, 26*(6), 469–477.

Market report: The leather channel. (2001). *NEXT: A supplement to DNR,* pp. 14–18.

Maycumber, S. G. (2001). Textile shows come to jittery New York. *DNR 31*(80), 20.

Textiles now: Innovations and developments. (2001). *International Textiles, 821,* 30–35.

What gives? (2001). *Women's Wear Daily, 182* (118), 6–7.

Principles of Design

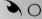 Objectives

- Explain the concept of design.
- Present a workable design vocabulary.
- Explain design principles.
- Present guidelines for making design decisions.
- Demonstrate the application of design principles in wearing apparel.

An understanding of design is important for both fashion professionals and individual consumers. The fashion professional uses an understanding of design to better develop products to meet the needs of a diverse population of consumers and incorporates this understanding into design work. Individual consumers also benefit from a knowledge of design elements and principles. Design evaluations are made when selecting most consumer products. Individuals evaluate the design of objects such as cars, appliances, houses, furniture, toys, and artwork, as well as wearing apparel. Many times evaluations of consumer products are done on a subconscious level when one thinks or says, "I really like this item, but I do not care for that one" or "This looks good on me, but that one does not." This chapter presents vocabulary that will allow the individual to express design opinions. It also presents guidelines for making design decisions.

Design is the arrangement of lines, form, shape, space, color, and textures into a coherent whole.

The elements of design—line, form, shape, space, color, and texture—are fundamental: fundamental because they are basic to every design. These design elements were covered in Chapters 6, 7, and 8 because the design elements have no practical meaning with reference to wearing apparel unless the discussion integrates the application of the organizing principles.

Structural and Applied Design in Clothing

Structural design is created by the construction detail form as the design is assembled.

Applied design, also called decorative design, is created after the form is complete and is the result of surface enrichment.

There are two general divisions of design, structural and applied. Structural design is inherent in all garments because construction details are used to assemble clothing: seams, collars, pockets, the color and texture of the fabric, and so on. Any detail that is an integral part of the garment is structural design. The structural detail may be either very elaborate (Figure 9.1) or very simple.

Figure 9.1 *Details that form an integral part of the garment are structural designs. These may be simple or elaborate. (Courtesy Richard Tyler)*

Figure 9.2 *Applied design used in limited areas produces an organized impression. The size of the applied design relates to the size of the area that it occupies. (Courtesy Ruby Duron)*

In clothing, structural design is most important because it is the fundamental component of the garment. Garments that rely on structural design for their interest and appeal are usually pleasing, and they are often expensive because of the detailing.

Applied design may be added to some garments (Figure 9.2). It consists of trims such as sequins, beading, embroidery, rickrack, and piping. It sometimes includes buttons without buttonholes and flaps without pockets.

Applied design is sometimes used as a less expensive method to achieve design interest. In mass production, applied design may be used to cover shoddy workmanship. Ready-to-wear items that do not have appropriate or effective applied design can often be enhanced by eliminating these details entirely or replacing them with more suitable trims. Existing garments in the wardrobe can be radically transformed by the use of applied design (Figures 9.3 and 9.4). Applied design can be evaluated by use of the examples of compatible textures in Figure 9.5. Activity 9.1 asks you to compare applied designs.

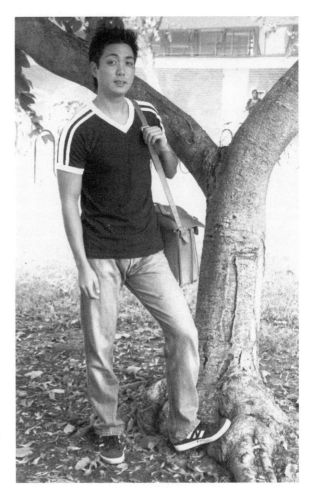

Figure 9.3 *Trims are most effective as applied designs when they are concentrated in one or two areas.*

Figure 9.4 *The size of the applied design is related to the area that it occupies as well as to the size of the individual.*

Fine embroidery	Finely woven fabric
Sequins	Shiny, fine textures
Rickrack	Medium-weight cottons
Embroidered tapes	Medium-weight cottons and wool
Raffia	Homespun cottons and linen
Crewel embroidery	Heavy woven and knitted fabrics

Figure 9.5 Examples of compatible textures.

Principles of Design

Principles of Design Defined

The arrangement of the elements of design into a completed coherent composition is the work of each designer. In order to create a pleasing design, material is arranged thoughtfully to create the desired look. The elements of design, as described in Chapters 6, 7, and 8 are form, shape, space, line, color, and texture. The principle of design (i.e., the unique arrangement of the elements) is based on some aesthetic system. The aesthetic system (ethno aesthetic) is the culture's understanding of and appreciation for art. It focuses on how designers imagine, create, and produce works of art and also on how people use and/or criticize the art. Since these value judgments are determined by and are expressions of a particular cultural aesthetic, they may not be transferable to all contexts.

One commonly used and accepted perspective on the study and application of art is referred to as the principles of design (or design principles): balance, proportion, emphasis, rhythm, and unity. These principles are intended to give coherence to the elements of design. Further, the principles are often used as a device to judge the validity of any art, including garment design.

Principles of Design Related to the Individual and Fashion

As mentioned earlier, this text examines a selected set of factors believed to influence individuality in clothing selection and personal appearance: physical influences, sociopsychological influences, and cultural influences. Although the individual items of dress can be evaluated by the design principles both on and off the body, the final analysis is not complete until all of the items are combined in a composite look on the individual. As stated by Eicher, Evenson, and Lutz (2000), "aesthetic evaluation is based upon the total effect of body plus the supplements and modifications imposed upon it" (p. 294).

ACTIVITY 9.1 Applied Design Comparisons

Collect pictures showing examples of appropriate and inappropriate applications of applied design. Find examples in womenswear, menswear, and childrenswear.

The principles of design can help when selecting apparel designs at the point of purchase or during customization of construction. These principles can also be helpful not only when selecting separate garments but also when coordinating several garments and accessories into a complete outfit.

The principles of design are flexible, as demonstrated by the diversity of styles in which they are seen. Designers may deliberately break a principle in order to express a fashion statement of the period, which is why fashion reflects the time in which it exists. An example of a broken design principle was demonstrated in the fashion of the early 1970s. During this time, a very popular "layered look" was achieved by combining garments. One garment might feature stripes, another plaids, another abstracts, another an unusual texture. These garments were worn together in a single outfit, although the combined fabric designs often lacked any unifying idea. In this period of political, social, and economic discord, current events were mirrored in fashion apparel.

Design principles can be used to create, discuss, and evaluate garment designs, on and off the body, providing there is an understanding of the terminology and a consensus as to the importance of the particular design principle. To establish this basis, a discussion of each of the design principles—balance, proportion, emphasis, rhythm, and unity—follows.

Balance

> **Balance** is an equal distribution of weight (actual or visual) from a central point or area.

Balance conveys a state of equilibrium. The purpose of balance is to create a satisfying relationship among all design parts. When the design elements of line, form, shape, space, color, and texture are in balance, a pleasing harmony is established. Forms of balance of shape and form include:

- Formal balance, also called symmetrical balance or bilateral symmetry
- Informal balance, also called asymmetrical or occult balance
- Radial balance

Formal balance. **Formal balance** occurs when identical objects are equidistant from a center (real or imaginary) and the objects appear to equalize each other. For-

mal balance can also be explained by saying that when measured from the center, one half of the design is the exact mirror image of the other half. An example of formal balance is found in the front or back view of the human body. Because of the shape of the human body, it is also an example of vertical, formal balance in most cases.

Many examples of formal balance may be found in clothing. In interior design, formal balance is said to have stability, dignity, and formality. In clothing design the feeling of dignity or formality created by formal balance is also influenced by color, texture, and cut. Formally balanced designs often give an impression of stability due to the equal or balanced placement of the parts that compose the design. In apparel, formal balance may emphasize body irregularities. This is because equal distribution of design parts from the center (real or imaginary) gives the eye of the observer benchmarks with which to judge or compare the body conformation. Formal balance often encourages comparisons of one side of the body with the other.

Using formal balance to create an outfit is easy and safe, but it may not be very exciting. This is the kind of balance found most often in ready-to-wear. When using formal balance in garments, it is a good idea to add interest and flair with unusual colors, textures, or accessories.

Informal Balance. **Informal balance** occurs when objects arranged on either side of a center (real or imaginary) are equal (in weight or mass), but not identical. Examples of informal balance (Figure 9.6) found in clothing include:

- The unbuttoned blazer jacket is styled so that two small pockets on one side of center are formally balanced by one large pocket on the other side. The buttons will also be informally balanced by the buttonholes.
- A side-closing Cossack-inspired shirt is often used as a uniform style. In this style of garment the mass on one side is informally balanced by the button closing on the other.

Informal balance is more a matter of visual impact than of exact physical weight distribution. For example, when the interior designer arranges a wall of pictures and art objects together, the grouping often will achieve informal balance visually, but it will not necessarily be an actual weight balance. This same concept is often applied in clothing designs. A jacket may appear balanced even though it has a self-fabric pocket on only one side of center; this is because the visual impact of the pocket is negligible. However, if a jacket had one large pocket on one side of strongly contrasting color or texture, the garment could not appear to be balanced.

Informal balance can be used to correct the appearance of body irregularities. This is because the eye of the observer is not given an exact duplicate with which to compare one side of the body to the other. If one side, or one part of the body, is not the same as the other (which is true of most individuals), informal balance in clothing designs may create illusions that will make the body appear symmetrical.

Informal balance gives the designer more freedom of expression than does formal balance. Informal balance is most difficult to use because of the many variations that are possible. When properly executed, informal balance is intriguing and dynamic because it has an element of surprise.

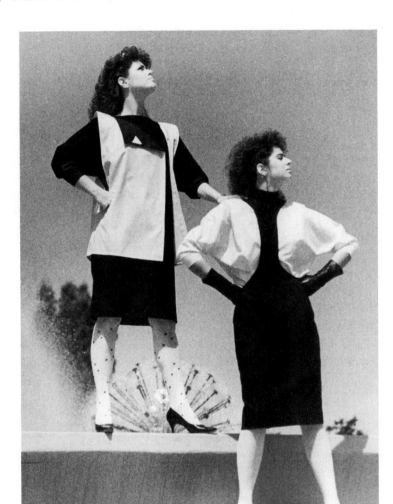

Figure 9.6 *Informal balance (left) occurs when elements on either side of the center are equal, but not identical. The garment on the right represents formal balance. Designer and model Cynthia Thompson (left) and Eleanor Dolgin (right).* *(Courtesy David Estep)*

Sometimes formal and informal balance are combined in a single garment (Figure 9.7). This could happen in a dress when the bodice is in formal balance and the skirt design is in informal balance. Such an arrangement often lacks harmony and relationship among the various parts. A design with this mix can appear pleasing when there is an interesting transition between the parts that unifies the two opposite effects.

Radial balance

Radial balance occurs when the major parts of the design radiate from a central point.

Radial balance uses a central point as the focal point. Pleats, seams, gathers, darts, or motifs radiate from the focal point, creating a sunburst effect (Figure 9.8).

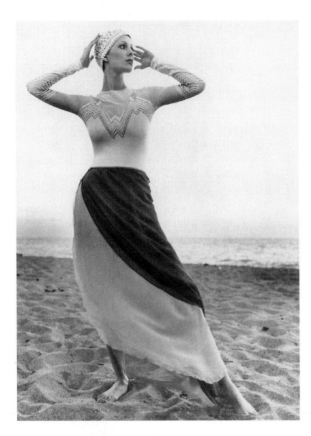

Figure 9.7 *Formal and informal designs may be combined in one garment. This arrangement is successful because the beaded design is repeated by the drape and hem lines of the skirt. (Courtesy J.P. Stevens, Inc.)*

Figure 9.8 *Here the design radiates from the base of the neck.*

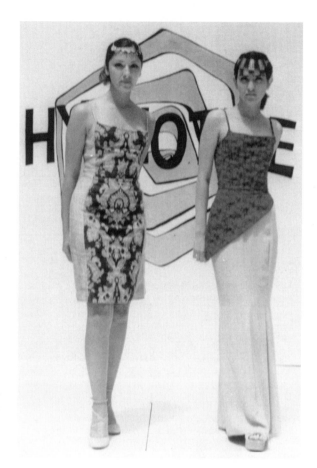

Figure 9.9 *Horizontal balance is achieved above and below the body landmarks where horizontal garment interest is located.*

Vertical and horizontal balance. Formal vertical balance is achieved in clothing designs when each detail of the garments and accessories on one side of an imaginary vertical line bisecting the body is a mirror image of the other side. Informal vertical balance is achieved in clothing designs when the details of the garments and accessories on one side of an imaginary vertical line bisecting the body differ from those on the other side yet appear to have the same visual weight.

Horizontal balance is achieved above and below the body landmarks (waist, hip, bust/chest; Figure 9.9). Because of the visual interest attracted to the area emphasized by the horizontal line, and because of the effect caused by this division, the fashion professional will need to consider horizontal balance as each outfit is produced or selected for various individuals. Horizontal balance on the human body can only be informal because of the anatomical differences between the upper and the lower sections of the body.

The horizontal division in clothing may not always result in horizontal balance. Some outfits are top-heavy; others are bottom-heavy. The classic man's business suit is an example of a top-heavy design. The width of the shoulders combined with the length of the jacket creates a bulk in the upper torso that is not balanced visually

Figure 9.10 Study the proportion of the five rectangles in this figure. Which looks the longest? the broadest? Which division of spaces would give the most slender illusion for a garment? the broadest? the shortest?

No. 1 represents the shape of a garment having no waistline, such as a shift.
No. 2 represents an empire line, with the high waistline under the bust.
No. 3 represents a natural waistline: a classic shirtdress, waist-length jacket, and skirt.
No. 4 represents a waistline dropped to hip level: jacket and pant of equal length.
No. 5 represents a long jacket with a short skirt: 3/4-length coat over skirt, long tunic.

with the length of the pants. An unadorned crop-top worn with full long pants of contrasting color is an example of a bottom-heavy outfit. The small top is not balanced visually with the mass of the pants.

The shape, width, length, color, and texture of each garment is produced or selected for its effects on various body types. The visual impression that the clothing is in balance both vertically and horizontally will give the outfit a look of stability and harmony.

Proportion

Proportion is the design principle concerned with the relation of the size of the parts to the whole and to each other.

Proportion includes the relationship of height, width, depth, and the surrounding space of each design. The differences in proportion make designs look different from one another. For example, study the proportions of the five rectangles in Figure 9.10.

Basic laws of proportion. Proportion is usually based on an ideal. In Chapter 3, the discussion acknowledged that each culture has its own ideals of what is beautiful. These ideals often pertain to proportion. A slender or a stout body, a tiny or prominent nose, layers of constricting clothing or near nudity, the tiny bound foot or the normal size foot all reveal the differences in preferred proportions. When something seems out of proportion, the observer will react.

Proportions idealized in Europe and North America are based on mathematical formulas established by the early Egyptians and later by the Greeks. Their well-known buildings such as the pyramids and the Parthenon and many of their sculptured figures were based on the proportions of 3:5:8 and 5:8:13. That means that the

Figure 9.11 Proportion of the Golden Mean represents a ratio of 3:5:8. The smaller space has the same relationship to the larger (3:5) as the larger space has to the whole (5:8). The relationship of the sweater length to the pant is in pleasing proportion. The sweater is related to the pant in a 3:5 proportion.

smaller space (3) has the same relationship to the larger space (5) as the larger space has to the whole (8). The same would be true of the 5:8:13 relationship. These proportions are sometimes referred to as the Golden Mean or the Golden Section. Actual measurements of the eye-satisfying pieces of ancient architecture and sculpture revealed these equations. However, once understood, the proportions of the Golden Mean are often achieved artistically or visually rather than by actual measurement.

Proportion applied to clothing design. The principle of proportion is important in clothing design and selection. The Golden Mean equations are used to produce garments that may be divided visually into 3:5, 5:8, and 8:13 horizontal sections. Although these divisions may not be precisely measurable, they are within certain limitations. This is because garment design is a creative expression and consumers can accept certain variations if they are pleasing (Figure 9.11).

For example, in the design of the *ao dai* worn by the Vietnamese, the tunic-type dress worn over the long loose pants gives the perception of a 5:8 proportion (Figure 9.12a). In the 1996 design by Richard Tyler, shown in Figure 9.12b, the top and skirt give the perception of a 3:5 relationship.

There are fashion periods when proportion may be inverted: that is, the largest division of the garment appears on the top section of the body. When the waistline of the garment or a jacket hemline is lowered, proportion is inverted. However, the proportions of such garments still will be visually pleasing if the space divisions are those established by the Golden Mean. Activity 9.2 illustrates various design principles.

There are also periods of fashion when garments are designed in "poor proportion." Examples are periods when miniskirts have been fashionable. These garments represent poor proportion because many of them could be visually divided into equal halves. However, when the miniskirted styles were judged on the body, the

Figure 9.12 *The Vietnamese* ao dai *(a) illustrates the 5:8 proportion. This contemporary design by Richard Tyler (b) is an example of a 3:5 proportion. (Right Photo courtesy Richard Tyler)*

principle of proportion was effective. The short garment was proportionally balanced by the length of the exposed leg and the use of colored stockings and flat shoes that complemented this fashionable 1960s style (Figure 9.13).

The proportion of fabric texture relates the dimension of the surface interest to the size of the wearer. Surface interest or texture refers to nap, pile, slubs, flocking, and other textile treatments that give dimension, including fur. The length, depth, bulk, or visual illusion created by the texture of a garment must be considered in relationship to the space the texture occupies in the garment design and to the body conformation of the wearer. Pleasing proportion is achieved when the texture of the fabric supports the garment design and is in keeping with the size of the person wearing the garment. Proportion of fabric design considers the dimensions of the individual motifs, their position in both fabric and garment, and the background spaces. The scale of the garment also must be in proportion with the size of the person wearing it.

The proportion of color involves using color in unequal amounts. When several colors are used together, one color should dominate. When garments of different colors are combined into one outfit, the line of color transition becomes a visual division that will impact the proportion of the entire outfit. In other words, garment lines are emphasized by color change and, therefore, are important proportion considerations.

Figure 9.13 *In the late 1960s miniskirted styles ignored the principle of proportion; however, when these styles are judged on the body, the length of the exposed leg and use of colored stockings and flat-heeled shoes makes a visually pleasing effect.* *(Courtesy Celanese Fibers Marketing Company)*

Proportion and body conformation should be considered carefully. As discussed in Chapter 5, body conformations vary widely. Each consumer and fashion professional will need to consider this fact in the design and selection of clothing for self and others. When a person wears clothing that is either too large in actual fit, in texture, or in fabric design or selects accessories that are too large, such as hats, purses, and jewelry, the size relationships are out of proportion. Sensitivity to the principle of proportion and careful evaluation of the size relationships of articles of dress to each other and to the body conformation will help guide design selection decisions.

Emphasis

Emphasis is dominance or a concentration of interest in one area of a design that prevails as the center of attention.

ACTIVITY 9.2 Application of Design Principles

Determine which of the design principles discussed in this chapter are shown in these dress designs.

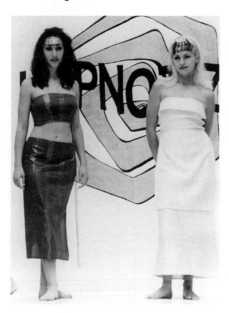
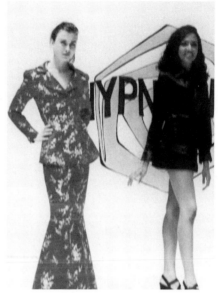

All areas of a design may be interesting, but not all areas should have equal strength of interest. This implies the use of subordination in some parts so that another area may be emphasized.

Emphasis should not be placed anywhere the individual wishes to minimize. Emphasis should be on the face or the personality area, the part of the person that is most unique and individualistic. Personality area emphasis may be achieved by color and texture contrasts, necklines, jewelry, scarves, neckties, hats, headwraps, or cosmetic application (Figure 9.14). Only one area must be the most important or dominant, and all other ornamentation is subordinate to it. Sometimes emphasis may be concentrated at the waistline, bust/chest, hip area, hands, legs, or feet. For example, hands are emphasized by long sleeves, cufflinks, bracelets, rings, and well-manicured nails. Legs and feet are made dominant by unusual hem lengths, design detail at the hem, textured or colored hosiery, and elaborate footwear. Color contrasts, texture, or cutwork in shoes is very eye-arresting and should be evaluated carefully.

Parts of the torso, such as the waist and hips, become areas of interest when garment lines or ornamentation fall at these areas. Emphasis is achieved by the use of color, line, texture, decoration, or trim or by an absence of fabric that reveals the skin.

Other methods used to obtain emphasis are repetition or concentration (Figure 9.15); unusual lines, shapes, or textures (Figure 9.16); decoration on a

Figure 9.14 *Emphasis can be achieved through texture contrasts such as the soft petals in the flower against the heavy plaid fabric. (Courtesy Jane Nicklas Photography)*

Figure 9.15 *Emphasis is achieved through pattern repetition.*

contrasting background (Figure 9.17); and contrast or opposition (Figure 9.18). Shape contrasts in designs are more strongly emphasized when their color (intensity, value, or hue) differs from the background. Yokes, collars, cuffs, and panel shapes will be more noticeable when their edges are outlined in a contrasting trim or when these sections use an intensity, value, or color contrast.

Figure 9.16 *Emphasis in this design is on the waist and is achieved by the diagonal lines in the fabric flowing from the same horizontal lines of the top.*

Figure 9.17 *Placing decoration on a plain, contrasting background makes the decoration dominant.*

Figure 9.18 *The draped collar is emphasized by contrasting edging. (Courtesy Traci Scherek for Traci Ltd., St. Paul, Minnesota)*

Texture contrasts provide a means of emphasis. The combination of textures creates excitement in an outfit. The use of all shiny, all dull, or all heavy textures in the same garment produces monotony; variations are more interesting.

Progression is a continuing change in size.

Emphasis can be achieved by progression in ruffles, contrasting bands, buttons, and other trims. Progression may also be achieved by intensity change from bright to dull, by value change from light to dark, or by the use of related color harmonies.

Rhythm

Rhythm is a pleasing sense of organized movement that gives continuity to a design.

Rhythm provides a transition from one unit to another and leads the eye in a fluid movement throughout the design. The pathway along which the eye is led may be actual or implied. Without rhythm, a design may appear spotty or disconnected. Rhythm in visual design resembles rhythm in music or audio design.

Individual garments and assembled outfits need rhythm to unify their composition. Rhythm is achieved in garment design by following lines, shapes, colors, and textures. Rhythm is also seen in the progression, gradation, or orderly sequence of gradually increasing or decreasing changes in sizes of elements or images (Figure 9.19).

Figure 9.19 *Rhythm results from gradation or an orderly sequence of gradually increasing sizes of the embroidered geometric motif. (Courtesy Folkwear, Inc.)*

Rhythm by radiation or organized movement may emanate from a central point of a garment (Figure 9.20).

Rhythm in an outfit is often more successful when it is sensed rather than too obvious. Rhythm does not always have to be in a regular series; it may be found in the feeling of echoing a line, shape, color, or texture occurring in the main theme of the look. Accessories can help to create rhythm by picking up lines, shapes, colors, or textures and repeating them with variations on the basic theme. Rhythm in clothing design is most interesting when it is not too predictable.

Fabric design with widely placed motifs may lack rhythm. These designs should be evaluated critically before they are cut and constructed into a garment. Often the garment design will interrupt this type of fabric design and produce strange effects.

Unity

Unity is the expression of a single concept or theme.

Unity in design, also called harmony, is achieved when the fundamental elements—line, form, shape, space, color, and texture—are used to express a single concept or theme. Unity is created when all parts of the design are related, consistent, and orderly. When a design has unity, its overall impression attracts and holds the attention of the observer.

Unity should not imply dullness. Unity is best when achieved with variety, which may be achieved by manipulating any or all of the fundamental elements composing the design. Care must be taken to make certain that the central idea of the design is em-

ACTIVITY 9.3 All in the Family

Assemble a collection of family photographs. Study the clothing of a particular family member. Try to select an interesting individual, such as grandmother, grandfather, or a chubby toddler.

Apply the principles of design to the clothing that this person selected or that was selected for them. Discuss your findings with your classmates.

Figure 9.20 *Rhythm is created by radiation, line from a central point, and gradation of color.* *(Courtesy Danskin, Inc.)*

phasized and that the variation of the theme supports the main theme. When unity of design is achieved, all parts of the design give a sense of belonging to the composition.

The term *total look* has been coined to describe unity in dress. A total look is achieved when each part of the design, including garments, accessories, jewelry, hairstyle, and facial adornment, expresses a single theme that is consistent with the age, time, and personality of the wearer and with the occasion (Figure 9.21). Activity 9.3 traces an individual's "look."

Figure 9.21 *Unity expresses a single concept or theme. Unity results when lines, shapes, colors, and textures express a single idea.*

❧ Summary

Each consumer and fashion professional becomes a designer creating an artistic composition when he or she creates a total look through the selection of garments, accessories, hairstyle, and facial adornment. This chapter covers the organizing principles of design. The flexibility of the organizing principles is emphasized and illustrated. Applying the principles to clothing designs to achieve a total look can be done without feeling confined, and in fact the knowledge gained should give the designer the confidence to experiment and express different personalities through dress.

❧ Key Terms and Concepts

Applied design
Balance
Design
Emphasis
Formal balance
Informal balance

Progression
Proportion
Radial balance
Rhythm
Structural design
Unity

❧ References

Eicher, J. B., Evenson, S. L., and Lutz, H. A. (2000). *The visible self: Global perspectives on dress, culture, and society.* New York: Fairchild.

Fabric Design

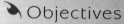 Objectives

- Explain how fabric design is created.
- Differentiate among the categories of design.
- Present guidelines for selecting fabric designs in relation to the garment design.
- Present guidelines for selecting fabric designs in relation to the body.

Fabric Design Components

Fabric design refers to the intended arrangement of materials on unfinished fabric to produce a certain result or effect.

An understanding of fabric design is important for both fashion professionals and individual consumers. The fashion professional uses an understanding of fabric design, its relationship to garment design, and its relationship to the human body to better develop products to meet the needs of consumers. Individual consumers also use an understanding of fabric design as they make selections from the marketplace. This chapter explains fabric design and differentiates among the categories of fabric design. It also presents guidelines for the selection of fabric designs in relationship to garment design and the human body.

Design in fabric is achieved by many different techniques. It may be created as the fabric is being made or it may be applied to the finished product.

Recently, computer-aided design (CAD) has revolutionized the process of creating fabric designs. Computer software creates representations of colors and patterns for the production fabric. Furthermore, additional variations (colors, size of motifs,

4 Families of Fabric Design

Ethnic	refers to any pattern or style associated with an ethnic group or having the "feel" of that ethnic group, such as paisley, mixed, or ethnic motifs, (e.g., Indian/Arabic/ Aztecs/ Peruvian) ("Starting Point," 2001).
Conversational	(sometimes called novelty prints) depicts some real creature or object, excluding flowers.
Geometric	(sometimes referred to as abstract) refers to a nonrepresentational motif, a shape that is not a picture of something out in the real world, flowing streams (Pathak, 1999), freely painted chevrons, wavy tonal lines (Tarses, 2001; "Textiles now," 2001), and digitally designed fabrics based on algorithms (Valhouli, 2001).
Floral	includes all the gatherings of the flower garden and the leaves of trees. (Dahlquist, 2001).

Figure 10.1 Families of fabric design patterns.

etc.) of the fabric can be created, printed directly on sample fabric or swatch cards, and finally stored in the computer for future use (Johnson and Moore, 1998).

Each season there is a clear movement forward with textile designers such as Gerber Colsman, an international textile design company. In 2001 they featured prints and solids as coordinating and complementing units ("Textiles now," 2001).

For the young and the "young at heart" 2002 witnessed Pop Art and graffiti inspired fabric designs ("Pop Art," 2002). The characteristics of the Italian Renaissance period influenced menswear. "The juxtaposition of sober suiting and embroidered decoration imparts an irresistible sense of style," wrote Morant (2002).

Selecting fabric with any kind of a design requires a careful appraisal of all the components that combine to form the finished product. These components include pattern or overall design, shape and arrangement of individual motifs, background areas, color and color combinations, texture and texture combinations, and end use of fabric.

Pattern and Motif

Fabric designers acknowledge four families of patterns in fabric design: conversational, ethnic, floral, and geometric (Figure 10.1). In addition, the families are subdivided into categories based on one or more of the following: motif, layout, color printing technique, and fabrication.

A **pattern** is an overall design.

A **motif** is an individual unit of a pattern.

Figure 10.2 *Sample geometric designs. (Center and right: Courtesy Edward Dalmacio)*

Fabric design is often created when motifs are repeated in a prescribed manner to create an overall pattern. Motifs are classified according to design style as geometric, realistic, stylized, and abstract.

Geometric Motifs

Geometric motifs include plaids, checks, stripes, and circles (Figure 10.2). Some geometric motifs are formed with yarns dyed before weaving; other geometric motifs are printed on woven cloth. Patterned fabrics made from yarns dyed prior to weaving ensure that the pattern will be "on grain." This means that the design formed by the colored yarns is in a horizontal (filling or weft) and vertical (warp) pattern, as these yarns form the grain of the fabric. When such fabrics are fashioned into garments, the pattern should be placed on the body so that the design looks straight and hangs evenly.

Plaids, checks, and stripes printed on a fabric after it is woven are often crooked; that is, the pattern does not align with the grain formed by the vertical and, more often, the horizontal threads. Printed fabrics often create problems in construction because the finished product will appear either crooked or mismatched on the body or will hang unevenly. It is important when purchasing fabric or garments of printed geometric designs to check that the pattern runs true with the horizontal grain and that the motifs are aligned (Figure 10.3). If they are not, the fabric or garment should be rejected because it will always be unsatisfactory.

Realistic Motifs

Realistic motifs duplicate nature or some man-made object.

Realistic motifs include florals that belong in the nursery and animals that abound in the forest. Motifs such as these do not show much imagination or creativity on the part of the fabric designer and are, therefore, less enduring than motifs that result

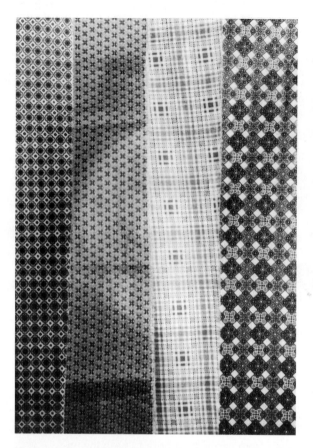

Figure 10.3 *These geometric motifs were not printed straight with the grain of the fabric. Note how the design does not align with the torn edge. (Courtesy Edward Dalmacio)*

Figure 10.4 *This Hawaiian print shirt uses realistic floral motifs that appear three dimensional. It is also a good example of an ethnic pattern.*

from an artist's interpretation (Figure 10.4). The realistic treatment of subjects is obvious, and frequently the obvious becomes monotonous.

Realistic designs often attempt a three-dimensional form in order to copy reality. Because of the perspective achieved, these designs do not respect the flatness of the fabric. Devices that are used to make a design appear three dimensional are shading, overlapping of objects, diminishing sizes, and texture. The designer attempts to use these techniques to make a motif and pattern appear to advance and not remain flat (Figure 10.5). Imitation of reality generally is not the effect one wishes to achieve in garment fabrics. Because these motifs are obviously reproductions of nature or man-made objects, they are not particularly suitable for apparel although they appear in fashion periodically.

Figure 10.5 *These three realistic designs do not respect the flatness of the fabric. Shading makes the designs appear three dimensional. (Courtesy Edward Dalmacio)*

Stylized Motifs

Stylized motifs are variations of natural forms.

Stylized floral or leaf motifs show imagination on the part of the artist who designed the fabric. Realistic floral forms are often used as inspiration, then creatively interpreted into infinite varieties of interesting shapes by textile designers. Stylized motifs are successful for fabric design because they are two dimensional and they relate to the flatness of the fabric (Figure 10.6).

Abstract Motifs

Abstract motifs are nonobjective and have no counterpart in nature or manmade objects.

Abstract motifs include splashes of color and shape. The effect produced by them is much like that found in paintings by Mondrian and Pollock. These motifs are most pleasing when used in fabric design (Figures 10.7 and 10.8).

Figure 10.6 *Stylized motifs are variations of natural forms that show imagination rather than imitation on the part of the designer. Floral forms were stylized for an overall design for the kimono in photo d.*

a.

b.

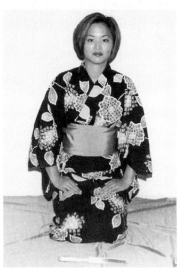

c.

d.

Warp prints and ikats belong in the classification of abstract motifs. The effect produced is a blur of soft, hazy colors, often in random groupings (Figure 10.9 on p. 296).

Combinations of Different Motifs in a Pattern

When different motifs are combined in a fabric, they should be related to each other in shape and size to achieve unity. This does not imply that they should be alike, for this would produce monotony. Some variation and some similarity produce interest. Totally unrelated shapes and sizes destroy harmony (Figure 10.10). When many different motifs are combined, there will be greater coherence to the total effect of the design if one shape or size dominates and the others are subordinated (Figure 10.11). Different motifs can be made cohesive by use of a predominant color (Figure 10.12).

Figure 10.7 *Examples of abstract motifs. (Courtesy Edward Dalmacio)*

Figure 10.8 *This overall abstract design has motifs of varying shape and size. (Courtesy WilliWear)*

Figure 10.9 *Ikats are often abstract designs. The effect results in blurred, hazy motifs.*

Figure 10.10 *Harmony is destroyed by the use of many unrelated motifs to form the pattern in fabric design. The realistic, geometric, and stylized motifs do not form a cohesive effect.*

Figure 10.11 *Several motifs are used in this fabric. One shape predominates while the others are subordinated; a single background color is used against the white motifs, giving a cohesive effect.*

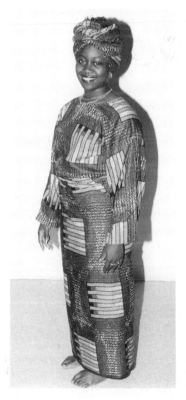

Figure 10.12 *Two different geometric motifs combine successfully through the use of shades and tints of color.*

Figure 10.13 *A photographic lace print is emphasized by value contrast. Each detail is clearly discernible.*

Motif shape is emphasized by value or chroma contrast with the background areas (Figure 10.13). If there is little value or chroma difference, the motif is not easily discernible. For example, bright pink polka dots on a pale yellow background will not appear as bold as black polka dots on a bright white background (Figure 10.14).

Pattern and Pattern Arrangement

Patterns may be considered formal—showing a regular, methodical repetition of the motif—or informal—having irregular placement of motifs.

When motifs are placed, the background area, sometimes called negative space, becomes as important in the design as the motifs themselves. The background areas should show thoughtful spacing of the motifs, whether the arrangement is formal or informal. If the background space is greater or smaller than the area occupied by the motif, the spacing will be more interesting than if it is equal to the motif. When the background area is greater than the motif, it gives it strength (Figure 10.15). However, too much background space generally makes the motif lose its importance. Not enough background space makes the motif appear crowded and prevents the single motif from dominating in the design (Figure 10.16). Equal divisions of the motifs and background areas lack variation and may be displeasing to look at, particularly when strong color contrasts are used.

Figure 10.14 *Motif shape is emphasized by value or chroma contrast from the background areas. Note the differences in the importance of the motif against backgrounds of varying contrast. (Courtesy Edward Dalmacio)*

Figure 10.15 *Sample of background area greater than the motif. (Courtesy Edward Dalmacio)*

Figure 10.16 *These two fabrics illustrate how too little background space makes the motif appear crowded. (Courtesy Edward Dalmacio)*

In order to avoid spottiness, the arrangement of the pattern should show some rhythmical movement from one motif to another. This should not be overdone so that the pattern fatigues the eye. For example, repeating checks or stripes of great value contrast are often difficult to look at or sew on due to the great amount of agitated line movement. Fabrics that have such movement can be tranquilized by combining them with a solid-color fabric.

Using Fabric Designs

Fabric Design in Garment Construction

Apparel constructed of a distinctly patterned fabric should reflect coordination of the fabric to garment cut and design. Gross distortions often result when little thought is given to the placement of the fabric design. Some of the most displeasing effects, perhaps because they are so obvious, occur in garments made from plaid fabrics. Unmatched seams and too many seams break the continuity of the plaid motif. The placement of darts, particularly in the bodice, often distorts the fabric design and forms unbecoming angles. Curved seams that do not repeat the angularity of the fabric, as in the princess line or raglan sleeves, make matching seams virtually impossible. These all result in distortions of the design (Figure 10.17).

Motifs whose shape, size, and spacing demand continuity must be matched both vertically and horizontally (Figure 10.18). Motifs should not appear in unbecoming places on the body. When widely spaced, realistic motifs are arranged informally, and placement on the body must be considered. Such motifs as roses with realistic

Figure 10.17 *Left: Note how the continuity of the plaid is distorted by the use of diagonal darts in the bodice in the top part. The bodice in the lower part utilizes horizontal darts that do not disrupt the geometric design as greatly. (Courtesy Edward Dalmacio) Right: In the example at the top the center skirt seam matches horizontally; however, no thought has been given to matching the plaids vertically. In the lower example, the skirt shows both vertical and horizontal matching. (Courtesy Edward Dalmacio)*

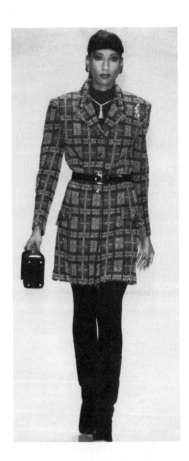

Figure 10.18 *Note the carefully matched plaids at seams, center front, and sleeves. (Courtesy St. John)*

thorns rising from the seat of the skirt are painful to see. Flowers blooming at the bustline or a large cabbage rose isolated over the abdomen call unnecessary attention to these areas of the body. Activity 10.1 may highlight these and other problems.

Geometric fabric patterns with angular lines, such as plaids, checks, and stripes, suggest designs with straight lines that are tailored and sophisticated. Dots and curvilinear patterns imply curved or transitional lines. One-way designs such as flowers with stems must be positioned carefully so that the motifs are placed in the same direction on all parts of the garment. Fabrics having surface interest and some knits must also be arranged during cutting so that all garment pieces are placed in the same direction. Failure to do so results in color change owing to the way that light strikes the fabric surface.

Either the pattern of the fabric or the structural lines of the garment should be allowed to dominate. If the garment lines are most important, they are best combined with a plain fabric. If the fabric design is most important, the lines of the garment should remain simple. If both have equal appeal, there will be a lack of emphasis and the total impression of the design composition will lose impact.

Figure 10.19 *Few fabric designs will work well on a range of individual body types. (Courtesy Jane Nicklas Photography)*

Effects of Fabric Design on the Body

The scale or size of the motif, its arrangement, and its colors are three factors that strongly influence the effect a fabric design has on the body. Ready-to-wear garments are best judged on the body; fabric sold by the yard can be draped over the body to suggest effects. Light source and viewing distance should also be considered when selecting fabric designs.

The scale of the pattern should be related to the size of the wearer. Very small overall patterns can be worn by almost anyone. Usually these patterns blend into a nondistinct design and do not increase or decrease apparent body size, providing they are of middle value and intensity (Figure 10.19). Generally, plain, undecorated fabric is body-revealing; a small overall pattern is body-concealing.

Small, distinct motifs, spaced so that the motif dominates the design, look best on the small or average-size body. Those who do not wish to call attention to a body that is tall and large or short and full should avoid this group because the extreme contrast of the body to the scale of the pattern will emphasize body size.

Fabrics that call attention to body proportion include those with bold designs, large-scale plaids, or big motifs with large amounts of background area. Men and women who have pleasing proportions and who are medium to tall are enhanced by larger-scale designs. A small body may seem smaller in large-scale designs because of the contrast in scale between body size and design. A person with a large, well-proportioned body wears the large-scale fabric designs best because he or she has the frame to exhibit the entire design.

Plaids come in small-, medium-, and large-scale units. The larger the scale of the unit, the wider the body will look. Small plaid units usually do not adversely affect the apparent size of the small or average-size body. Medium-scale plaids usually can be worn by all, but very large-scale plaids are best suited to the average or tall body.

ACTIVITY 10.1 People Watching

Study the effect of fabric design on garment construction. Take your camera to a location where people are coming and going. Find examples of garments illustrating how fabric design is supported and distorted by construction details. Ask the individual for permission to take a photograph, explaining that it will be used as a class assignment. Share your findings with your teacher and classmates. Remember, do not ask for or reveal the name of your subjects.

Figure 10.20 *Greater contrasts of color or value and intensity increase apparent body width. (Courtesy Edward Dalmacio)*

Large, full bodies and small bodies are best in medium-scale plaids with close value contrasts. The greater the contrasts of colors or values and intensity in the plaid, the greater is the apparent width of the body (Figure 10.20).

Circular motifs, such as polka dots, add width and fullness to the body. Border designs placed at the hemline, waistline, sleeve, or hipline also increase body width.

Motifs with a strong vertical movement usually add height to the body, and those showing horizontal movement usually add width. This is particularly true with great contrast in values, intensity, and colors and when motifs are arranged so that they appear isolated from each other.

Sharp color contrasts in prints will enlarge the visual appearance of the body. Using light values and bright intensities adds weight, whereas medium to darker values or dull intensities usually do not call attention to body size.

For those wishing to reveal body conformation, the solid-colored fabrics provide the least design distraction and are, therefore, the best for this purpose. On the other hand, for those who wish to conceal body contours, printed fabrics of low-value contrasts are recommended because they seem to break up the body boundaries and distract the eye.

Fortunately, fashion professionals, and to some extent consumers, can use computer imaging systems to develop the desired look. For the fashion professional, systems such as Gerber and Lectra are used to select the most appropriate fabric for a particular garment design or to select different colors for a range of garments (Johnson and Moore, 1998). For the consumer, technical improvements assist in fabric design selection. Software designed to complete a figure analysis has been available for several years. The Internet is starting to offer images and fabrics that designers can download for use in their designing. Could an enterprising consumer not do the same?

Use of Different Prints in One Outfit

Unifying two or more prints in one outfit requires careful analysis of the fabric designs. Some garments are designed for the use of coordinated fabrics. These fabrics go together because some factor unifies them to create a total effect. Figure 10.21 provides examples of techniques for combining different-patterned fabrics successfully.

Whichever technique is used in combining two different fabric patterns, one should be dominant in the design, and a unifying theme, such as color or motif, should unite the two fabrics (Figure 10.22). Including patterned fabrics in the wardrobe provides variety and interest.

Use the same predominant color in different prints.
Use fabrics with the same motif but with different background colors.
Use a patterned fabric that is greatly subordinated with a patterned fabric that has a more pronounced design.
Use ribbons, tapes, or solid color where the two fabrics are joined.

Figure 10.21 Techniques for combining different-patterned fabrics.

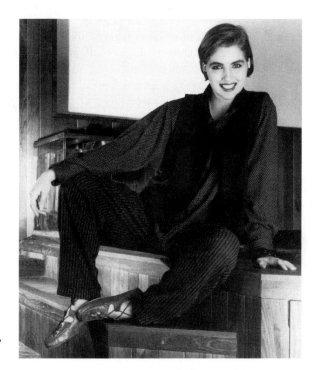

Figure 10.22 *A predominant color is used to unify the total effect in an outfit that combines different fabric designs. (Courtesy Cotton Incorporated)*

Influences on Fabric Design

Light Source

When choosing fabrics, the light source is very important because it affects the appearance of color. Daylight, fluorescent, and incandescent light may each produce different effects. When possible, the fabric should be studied in both natural and artificial light. Some stores have a variety of light sources for checking the effect.

Colors in two or more different fabrics that are to be combined may appear to match under one light source and not under another. This effect is known as *metamerism*. If possible, match the fabrics under the light conditions in which they will be worn. For example, fabrics selected for a wedding should be studied at the site of the wedding ceremony and reception. When the clothing will be worn under various lighting conditions, check the fabric under both daylight and incandescent light; if they match under both of these light sources, they will probably match under all conditions.

Distance

Distance also influences the appearance of a fabric design. Certain combinations of colors may take on different hues when viewed from various distances, and tiny patterns often will seem to blend into the background. Examples of this are fine checks, narrow stripes, and dainty floral patterns. For example, a red-and-white check can become pink when seen at a distance. Large motifs can appear spotty, blotchy, or without rhythm or unity when viewed from afar.

Summary

Selecting fabric with any kind of design requires careful attention to all of the components that combine to form the finished product. It also requires consideration of the physical characteristics of the future wearer and the conditions under which the fabric will be shown. This chapter explains the basic components of fabric design. It also presents guidelines for the selection of one or more fabric designs for an outfit while giving special attention to the matching of fabric design to garment design as well as fabric design to the physical characteristics of the consumer.

Key Terms and Concepts

Abstract motifs
Conversational motifs
Ethnic
Fabric design
Floral

Geometric
Motif
Pattern
Realistic motifs
Stylized motifs

References

Dahlquist, Z. (2001). Botanical art and textile design. *Surface design, 25*(2), 32–35.

Morant, D. (2002). Embroidery. *Traditional Home, 13*(1), 124.

Pathak, A. (1999). Indian textiles. *Arts of Asia, 29*(6), 81–95.

Pop art. (2002, January) *Seventeen Magazine,* 94–101.

Starting point: Textile fabrication design inspiration. (2001). *International Textiles,* 821, 53–62.

Tarses, B. (2001). Faux ikat. *Shuttle, Spindle and Dye-pot, 32*(3), 40–47.

Textiles now: Innovations and developments. (2001). *International Textiles,* 821, 30–35.

Valhouli, C. (2001) Fiber fusion. *ID Magazine, 48*(3), 58–63.

Part III

Consumer Clothing Selection Issues

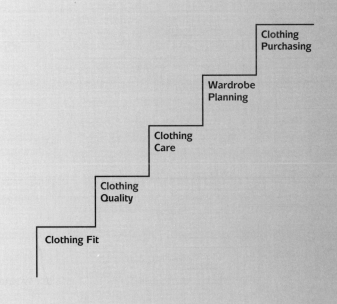

Clothing
Purchasing

Wardrobe
Planning

Clothing
Care

Clothing
Quality

Clothing Fit

Chapter **11**

Clothing Fit

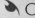

- Explain the use of fit models in manufacturing to establish ready-to-wear sizing.
- Define the sizing categories for men, women, and children.
- Identify general fit guidelines.
- Describe fit guidelines specific to jackets, women, and the older adult.

Consumer Clothing Selection Issues

- Clothing Purchasing
- Wardrobe Planning
- Clothing Care
- Clothing Quality
- Clothing Fit

Fit is the correspondence in form of a piece of clothing to the body's dimensions.

F it is one of the most important factors in customer satisfaction. Garments that fit properly look better and are more comfortable. They are able to meet the need for which they were purchased. It is important to look objectively at a garment and evaluate its fit. Improperly fitted clothing can never appear attractive or give the look of quality clothing.

Fit can be modified for theater and film costumes to create different images of the actors and actresses in the mind of the audience. Ill-fitting clothing can depict both comical and pathetic characters. In a comic role, oversized clothing is often used to illicit laughs, whereas the pathetic character may wear clothing that is either too tight or too loose to evoke pity.

Fit standards vary with fashion. The later part of the twentieth century featured clothing that was fashionably oversized in both childrenswear and adult clothing. Baggy jeans worn low on the hips so that undergarments were prominently featured was a common sight on high school campuses. Oversized sweaters and shirts worn over tights was a main look in women's casual wear. By contrast, the early twenty-first century saw a movement toward figure-revealing apparel that incorporated bias-cut fabrics, minimal ease, and lots of skin.

Adjustments to the fit of a garment enables individuals to create different images. Figure variations can be successfully camouflaged, creating the illusion of a perfect figure through fit. Proper clothing choices that enhance one's positive attributes depend on accurate fit.

To lay the foundation for understanding fit, this chapter begins with a discussion of sizing for men, women, and children. This is followed by a discussion of fit standards and guidelines. An increased understanding of sizing and fit will enable the consumer to make a better informed clothing purchase decision and aid the fashion professional in designing better fitting apparel for their consumers.

Sizing

Garment sizing is a tool to be used by customers to select properly fitted garments. Several things influence the way a garment is sized. One is the customer's body measurements, figure type, concept of comfort, aesthetic ideals, and personal fit preferences. Another influence is the garment manufacturer's interpretation of figure and fashion. Additional influences include the garment's styling, fabric, quality control during manufacturing, and price point (Jarnow and Dickerson, 2003).

The 1942 Voluntary Product Standards PS 42-70 formed the basis of the current voluntary sizing system. It does not reflect the multiple sizing needs of today's customers. The American Society of Testing Materials (ASTM) and other researchers are working to develop a sizing system that will accurately reflect the population's fit needs (Brown and Rice, 2001). Two techniques to help customers select the correct size include body scanning (see Case Study 11.1) and pictogram labels. Pictogram labels give garment circumference and height measurements that can be compared to the customer's measurements.

Customers can become frustrated when sizing varies from manufacturer to manufacturer and brand to brand. Apparel manufacturers' interpretations of sizing are based, in part, on satisfying a target market, their choice of fit models (discussed next), and customer lifestyles. Size variations can also be a result of production processes. For example, garment sizing can vary based on price point, with higher-priced garments tending to "run large" and lower-priced garments tending to "run small" (Brown and Rice, 2001, p. 146).

Fit Models

A **fit model** is a person of specific height, weight, and proportion on whom the manufacturer fits its clothes.

In the past, manufacturers fit their garments to a dress form similar to the one pictured in Figure 11.1. Today, hoping for a more realistic fit, manufacturers determine their apparel dimensions by fitting each garment to a fit model who suits their ideals (Workman and Lentz, 2000). Fit models are hired by manufacturers to try on each sample garment. While the garment is on the fit model's body, the garment designer

Figure 11.1 *Dress forms have long been used by clothing manufacturers to fit the garment. (Courtesy Jean Claude Limited)*

makes adjustments to it. These adjustments become corrections to the sample's pattern before the garment is mass manufactured. The proper fit of the sample garment is extremely important as this garment is fitted in just one size. The other garment sizes are based on this prototype.

Since every manufacturer uses a different fit model, it is easy to see why such a variety of fits are possible in a group of garments that are all labeled the same size.

Sizing Womenswear

Sizes are currently grouped by sex, age, and body type. Womenswear sizes are shown in Figure 11.2. Often manufacturers double ticket their sizes to fit two size categories. For example, a junior size 7 may be combined with a misses size 8 on the same label as 7/8.

Women's sweaters and blouses are sold according to the bust measurement (Figure 11.3):

- *Misses:* Small (32″–34″), medium (34″–36″), or large (36″–38″)
- *Women's:* Small (38″–40″), medium (40″–42″), large (42″–44″)

Size	Size Range	Height	Characteristics
Misses	Even sizes, 2–20	5'5"–5'7"	Adult women of average proportions
Petites	Even sizes, OP–14P	Under 5'4"	Mature figure with average proportions
Talls	Even sizes, 6T–18T	Over 5'7"	Mature figure with average proportions
Women's	Even sizes, 34W–52W or 1X (16–18), 2X (20–22), and 3X (24–26)	5'5" +	Full mature proportions with longer torso and sleeves
Plus sizes	Even sizes, 12–24	5'–5'6"	Middle to older adults, full figure
Juniors	Uneven sizes, 3–13	5'4" and under	Young women with slim, youthful proportions, a less developed figure, and a higher bustline and waistline than misses
Petite juniors	Uneven sizes, 3P–13P	5'4" and under	Youthful, slim proportions

Figure 11.2 Sizing for womenswear.

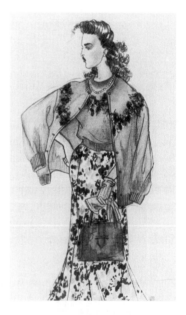

Figure 11.3 *Women's sweaters are sized small, medium, and large. These three general sizes fit the majority of women due to the extra design ease in sweaters and because they are knitted, which allows them to stretch to cover a variety of figure types.* (Courtesy Jean Claude Limited)

Skirts and slacks may be sized according to the waist measurement in sizes 22–44 or classified by sizes 3–15 for juniors or 4–14 for misses. These garments also come in proportioned lengths (i.e., the larger sizes are longer than the smaller sizes).

With the globalization of the apparel manufacturing industry, international sizes become significant. Gross, Stone, and Urquhart (2000, p. 206) provided readers with a comparison of sizes in the United States, Great Britain, and Europe.

- United States: 4, 6, 8, 10, 12, 14, 16, 18, 20
- Great Britain: 8, 10, 12, 14, 16, 18, 20, 22, 24
- Europe: 32, 34, 36, 38, 40, 42, 44, 46, 48

Catalog sizing tends to be cut fuller than ready-to-wear. Catalog companies have found that women are less likely to return a larger-fitting item, but they almost always return one that is too small (Quick, 2000).

One reason women prefer a fuller cut might be that, on the whole, women are getting larger (see Chapter 5). The Centers for Disease Control and Prevention report that at least half of the U.S. population is overweight, with 25 percent of the women and 20 percent of the men judged to be obese ("Nation Continues to Gain," 2001). Some manufacturers have responded by adjusting the size numbers downward—called vanity sizing (Brown and Rice, 2001). As a result of her research on measurements of prototype female bodies, Jane Workman concluded that a size 10 misses fit model in 1976 was a size 8 fit model in 1986 (Workman, 1991), and the bust and waist measurements of a 1997 size 8 fit model were significantly larger than those of the 1986 size 8 fit model (Workman and Lentz, 2000).

Until 1977, fashions were made solely for the average-sized customer, ignoring women who fell outside the norm. However, today, the average woman is 5 feet 4 inches and weighs 144 pounds (Felton, 2000). Twenty-eight percent of the women's apparel business is in plus sizes, which grew seven times faster than misses sizes from 1999 to 2001 ("Plus Size," 2001).

Realizing that the plus size is an important potential market, American designers (Ralph Lauren, Tommy Hilfiger, Ann Klein, Oscar de la Renta, Dana Buchman, and DKNY) have increased their 16–24 sizes 20 percent since 1999 (Betts, 2002). Available plus size lines include It Figures, NPD Fashion Walk, and Lisa Todd, Inc. ("Plus Size," 2001).

Sizing Menswear

Menswear sizing covers men's suits and sportcoats, dress shirts, and casual shirts and pants.

Suits and Sportcoats

Jackets—both suit jackets and sportcoats—are sized by chest measurements from 38 to 46, and jacket lengths are designated as short, regular, long, and extra long (Figure 11.4). Some retailers carry suits sized portly, which fits men of average height

Jacket Lengths	Height	Chest Measurements Stocked
Short	under 5'7"	36–44
Regular	5'8"–5'11"	36–50
Long	6'0"–6'3"	41–48
Extra long	6'4" +	42–50

Figure 11.4 Suits stocked by size category at Nordstrom's. (J. Addis, personal interview with Nordstrom's men's suit buyer, June 13, 1998)

Suit Cut	Characteristics
American (standard cut)	• For the average build • Focuses on comfort • Usually single breasted • Lower-cut armholes • Single center back vent • Hangs loosely from the shoulders, gently draping over the body with a 6″ drop
European	• For the slimmer build • Often double breasted • More padding in the shoulders • Higher-cut armholes • Either two back vents or none • Closely fit at the waist and body with a 7″–9″ drop
British	• Falls between the American and European cuts • Slightly padded shoulders • Conforms to the body more than American cut • Two back vents • 6″–7″ drop

Figure 11.5 Men's suit cuts and characteristics.

with larger-than-average builds. Men with slimmer-than-average builds require alterations. The pants accompanying men's suits are sized by the average drop.

Drop is the difference in the measurement between a man's chest and waist measurement.

There are three main categories of suits, which are characterized by their fit and design: American, European, and British (Figure 11.5). Men generally pick a suit that best complements their body shape.

Dress Slacks

Men's dress slacks are sized by waist and inseam measurements. Waists are typically sized from 32 to 40. Inseams are the measurement from the crotch to the hem of the pant. Rise is another important fit consideration. Retailers stock slacks with a regular rise of 6 inches from crotch to waist. Short and long rises are generally specially ordered. The legs of dress slacks are always left open (unhemmed) so that a man can have a precisely fitted pant length for his formal business occasions.

Rise is the length of the crotch to the waistband.

Figure 11.6 *Like dress shirts, men's sports shirts— designed as a rectangle—fit a wide range of body shapes. (Courtesy Axis Clothing Corporation)*

Dress Shirts

Several areas of sizing are important to dress shirts: neck, sleeve, and body fullness. Dress shirts are sized by neck circumference and sleeve length. Neck measurements are calculated at the base of the neck and are taken below the Adam's apple (not over it). Dress shirts are always long sleeved and are designed to be long enough for 1/4 to 1/2 inch of cuff to show beyond the hem of the suit or sportcoat jacket. Therefore, sleeve length is measured from the center back neck base across the shoulder and over the elbow joint to the wrist with the arm slightly bent. Ready-made dress shirts are also sized by the fullness in the shirt body. Regular-cut shirts have rectangular silhouettes when on the hanger and predominate in the inventories in this category. However, some men prefer a more tapered or European cut, which is less readily available but can be special ordered.

Casual Shirts and Slacks

Men's sportswear—casual shirts and slacks—are designed to fit the majority of men while limiting production to a few sizes (Figure 11.6). Producing a limited number

of sizes saves money by reducing production costs for the apparel manufacturer. Sport shirts are measured by the neck circumference and are sold in sizes that cover a range of neck measurements: small/S (14–14 1/2 neck), medium/M (15–15 1/2), large/L (16–16 1/2 neck), and extra large/XL (17–17 1/2 neck). This type of lettered sizing is also used for men's underwear and sweaters.

Men's casual slacks are sized by waist measurement and usually are produced and stocked in even sizes only. In terms of length, they are designed to fit what the manufacturer considers to be the average leg length—from 29 to 34—for each particular waist size. Casual pants typically come cuffed, although some are open lengths, which can be hemmed to suit the leg length of the buyer.

Custom Sizing

Made-to-measure technology is available to consumers today and is comparable to ready-to-wear garments in cost (Oliver, Bickle, and Shim, 1993). Levi Strauss, in its Lexington Avenue store in New York City, can custom make a pair of jeans for about $15 over the retail price with a two-week turnaround. Levi's then uses the sizing information obtained from this select clientele to compile and keep current a demographic data bank of the size needs of customers worldwide who demand custom-made garments (Rifkin, 1995) (Case Study 11.1).

Made-to-measure business suits have always been an option for men. Costing at least 10 percent more than ready-made suits, top-of-the-line manufacturers reported in the late 1990s that their business had increased by 25 to 30 percent (Gellers, 1998).

Children's Sizing

The sizing standards for children's clothing is presented in Figure 11.7.

Fit

To determine whether an article of clothing fits, it must be tried on and observed from all angles in front of a triple, full-length mirror while wearing the same underclothing and shoe heel height that will be worn with the garment (Activity 11.1). This is very important because shoe style and underclothing can change the fit and hang considerably

Size Category	Characteristics
Infants	3–24 months fits infants up to 18 months old
Toddlers	2T–4T fits toddlers 18–36 months old
Girls	2–6X fits 3–6 years old 7–14 fits girls 7–11 years old
Boys	3–7; fit corresponds with age 8–20 fits boys 7–17 years old

Figure 11.7 Sizing of childrenswear. *(Note: Lettered sizing [S, M, L, XL] is also used in childrenswear.)*

ACTIVITY 11.1 Fit Consistency

Check the consistency of fit. Try on garments labeled the same numerical size to observe differences.

CASE STUDY 11.1

Body Scanning

In 2000, Lands' End completed a fourteen-city cross-country tour designed to scan the bodies of volunteers (Quick, 2000). Their goal was to "create virtual models with customers' exact body dimensions so they can 'try on' clothes in cyberspace and see how they fit" (p. B1). As a major catalog and Internet retailer, Lands' End wanted to overcome one of the primary disadvantages of distance retail: seeing how garments look on and fit your body.

Body scanning consists of obtaining a computerized image of your physique while wearing a body suit. While being scanned, a person must stand very still in a predetermined pose while a computer scanner measures 200,000 data points on the body. In addition, the person being scanned needs to provide his or her height, weight, skin tone, hair color, and facial shape.

- Would you be interested in having your body scanned?
- Would you have any reservations about using computer technology to determine your size?
- Would you be willing to buy garments that look good on you in cyberspace?

———

(R. Quick. 2000, October 18. Getting the right fit—Hips and all. Wall Street Journal, pp. B1, 4)

in both men's and women's garments. Undergarments that effectively support the body improve the fit of the outer garment (Felton, 2000; Gross, Stone, and Urquhart, 2001).

General Fit Guidelines

Many guidelines are standard for both menswear and womenswear. There are several standards of fit that can be applied to garments in general: wrinkles, grain, and ease.

Wrinkles

When individuals try on a garment in their size, it should be inspected for fit. Most fitting rooms in retail stores have three-way mirrors that allow a customer to see both front and back views simultaneously (Figure 11.8). The main indicator of improper fit is a wrinkle (Figure 11.9). Clothing should fit over the body without wrinkles. Sometimes wrinkles are caused by a person's posture, but more likely they are caused by a garment being too tight or too loose or the wrong shape for the individual's body build. Wrinkles caused by improper fit cannot be ironed out; rather, they are signals

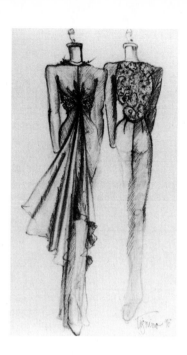

Figure 11.8 *Garments should be checked for fit from the front and the back before purchasing. (Courtesy Jean Claude Limited)*

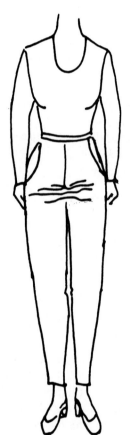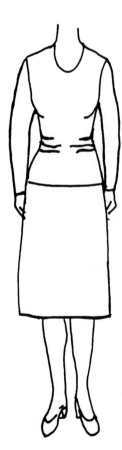

Figure 11.9 These garments illustrate two examples of horizontal wrinkles in garments. The left garment's wrinkles are caused by the garment being too tight; there is not enough fabric in the thigh area. The right one is caused by the garment being too long for this body's torso length.

Types of Wrinkles	Cause	Solution
Horizontal Under tension Loose folds	Garment too small Garment too long	Let out at vertical seam. Take in at horizontal seam.
Vertical Under tension Loose folds	Garment too short Garment too wide	Let out at horizontal seam. Take in at vertical seam.
Diagonal Under tension	Tip of wrinkle points to area that is too small or needs more fullness	Check to see if darts can be adjusted to increase fullness or let out at nearest seam.

Figure 11.10 Wrinkles: Causes and solutions. *(P. Brown and J. Rice. 2001.* Ready-to-Wear Apparel Analysis. *Upper Saddle River, NJ: Prentice-Hall)*

to the wearer that the garment needs to be altered in some way. Figure 11.10 discusses the various types of wrinkles, their causes, and the result or solution.

Grain

> **Grain** consists of lengthwise and crosswise yarns in a woven fabric that are at right angles to each other.

A properly fitting garment starts with fabric that is cut and sewn so that the lengthwise yarns run down the center front and back, while the crosswise yarns go around the body. This is referred to as being on grain. (The exception to this standard is a garment that is cut on the fabric bias or diagonal.) Garments should envelop the body without wrinkles and balance evenly around the body. Horizontal grain is parallel to the floor at the chest and hips. Lengthwise grain is perpendicular to the floor at the center and the side seams. Garments that are cut on grain will hang evenly, without skew.

Ease

> **Ease** is the difference between the actual dimensions of a person and the size of a garment.

There are two types of ease: wearing ease and design ease. Even though the body is emphasized in a very fitted garment, there should be enough wearing ease. A minimum amount of wearing ease is 2 to 4 extra inches in the chest and hips and 1 to 1 1/2 extra inches in the waist.

> **Wearing ease** is room to move in a garment.

> **Design ease** refers to the ease that is added to the garment by the designer to produce the desired visual effect (Brown and Rice, 2001).

Figure 11.11 *Men's shirts have a generous amount of design ease. (Courtesy Axis Clothing Corporation)*

When full design ease is added, creating an oversized garment, the body is de-emphasized. Very fitted or body-emphasizing garments often have smaller dimensions than those garments with comfortable wearing ease.

Design ease impacts body types in different ways (Figure 11.11). In general, tight-fitting garments will reveal body irregularities by emphasizing their contours. Conversely, body irregularities can be camouflaged by the use of adequate ease and nonclinging textures. For example, a very thin person will look thinner wearing a very loose-fitting garment because of the extreme contrast. A thin person wearing a moderately close-fitting garment generally does not effect a thin look because there is no extreme contrast. A heavy person in a somewhat loose fit looks less heavy because of the lack of contrast between the silhouette created by the garment and that of the body. The fit for jeans provides an example of various fit options (Figure 11.12). Research has shown that consumers prefer a sizing system that uses pictures—a pictogram (Figure 11.13)—and contains at least three body dimensions for their initial size selection.

Fit for Jackets

Suit jackets and blazers for both men and women have similar guidelines (Figures 11.14 and 11.18). In general, suit jackets should comfortably fit over shirts and blouses; sportcoats and blazers should fit comfortably over sweaters without pulling. A woman's jacket or business suit should comfortably fit under a 1-inch longer coat.

Category	Fit
Traditional/regular	Classic, cut to contour body. Straight-leg version is 16″ wide at ankles.
Relaxed/easy	Adds 1/2″ more ease in hip, thigh, leg, and knee. Tapers to 15″ at ankle.
Loose/baggy/wide leg	As much as 4″ extra at hips and thigh.
Lower legs: • Straight • Flair • Boot cut	 Pant leg has same width all the way down. 1″ extra beginning below knee. Wider at ankle to accommodate boots.

Figure 11.12 Jeanswear fit categories and standards. *(P. Garfinkle and B. Chichester. 1997. Maximum Style. Emmaus, PA: Rodale Press)*

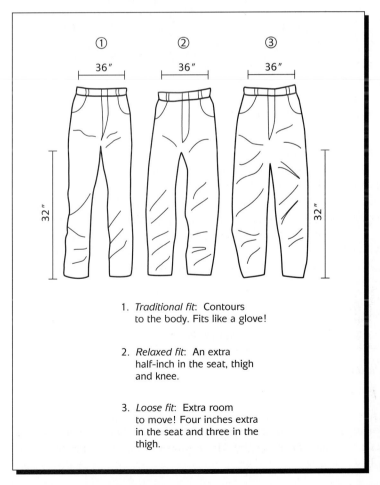

1. *Traditional fit*: Contours to the body. Fits like a glove!

2. *Relaxed fit*: An extra half-inch in the seat, thigh and knee.

3. *Loose fit*: Extra room to move! Four inches extra in the seat and three in the thigh.

Figure 11.13
This pictogram illustrates three fits for jeans: traditional, relaxed, and loose.

Design Area	Fit Guidelines
Collars	• Allow ½″ exposure of shirt collar at center back. • Should lie flat. • Should hug the neck at the collar. • Undercollar and neck seam should not show.
Lapels	• Should lie flat without undercollar or seam showing. • Should lie flat against the chest.
Shoulders	• Pads should be balanced. • Shoulder seams should appear straight and smooth. • Shoulder seam should coincide with the body to create natural look.
Armholes	• Should not bind and gap; should feel comfortable. • Suit jacket armhole seamlines can extend from ½″ to 1½″ past the shoulder joint.
Upper back/chest	• Should be flat and smooth. • Garment needs enough width for arm movement without undue strain at the back armhole seam.
Sleeves	• Should fit smoothly, hang free of folds, and fit into the armhole with at least 1½″ of ease. • Wrist-length sleeves should reach or cover the prominent wrist bone. • Long-sleeved shirt sleeve cuff should extend ¼″ to ½″ below the business suit jacket sleeve.
Pleats and vents	• Should stay closed and hang straight down when the wearer is standing upright and the jacket is buttoned.
Linings	• Wrinkles should not shadow or leave imprints on the outside of the garment. • Should have ½″ fold at the bottom of the hem and a pleat along the center back for movement.
Pocket and pocket flaps	• Should lie smoothly against the body when standing, unless designed to stand away.
Jacket length	• Bottom of the jacket should be even with the thumb in traditional styles. • Jacket should cover the trouser seat.

Figure 11.14 Fit for men's jackets.

Fit for Men

Fitting standards for men's slacks are covered in Figure 11.15. Fitting standards for men's dress shirts are summarized in Figure 11.16. Men's fitting checkpoints are illustrated in Figure 11.17.

Design Area	Fit Guidelines
Crotch	• Should fit smoothly in crotch. • Should have 1½″ ease in the crotch length measurement.
Length	• Bottom of pant should meet the top of the shoe in front with a slight break. • Bottom of pant should meet the back of the shoe where the heel and sole meet. • Pant hem can be canted (slanted backward slightly).
Waist	• Should typically fall at the natural waistline (umbilicus). • Should have smooth closure at waistline. • Should have 1–1½″ ease.
Hip	• Should be wrinkle free. • Should have adequate ease to move freely. • Pockets should not gap. • Should be free of excess fabric.

Figure 11.15 Fit for men's slacks/trousers/pants.

Design Area	Fit Guidelines
Collar	• ½″ shows about the jacket collar. • Curves smoothly around the back of the neck without spreading or gapping. • Comfortable when buttoned (one finger can be inserted in the collar without causing stress to the neck).
Shirt sleeve	• Bottom of cuff should reach the prominent wrist bone when the arm is bent slightly. • Should extend ½″ below the business suit jacket sleeve.
Shirt armholes	• Should be wide enough for freedom of movement. • Should be deep enough to prevent binding.
Shoulder line	• Should lie smooth and straight from neck to sleeve. • Should conform as close to the natural armline as possible.
Shirt body	• Adequate fabric for ease and comfort. • Length should be about 6″ below the waist.

Figure 11.16 Fit for men's dress shirts.

Fit for Women

A few specific fit areas apply only to women. For example, the fullness in the bust area is provided by the use of darts, gathers, or curved seams. Large body curves require more fullness and darts that are deep at the base; small body curves need darts that are proportionally smaller at the base. This dart principle applies to any curved

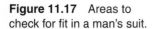
Figure 11.17 Areas to check for fit in a man's suit.

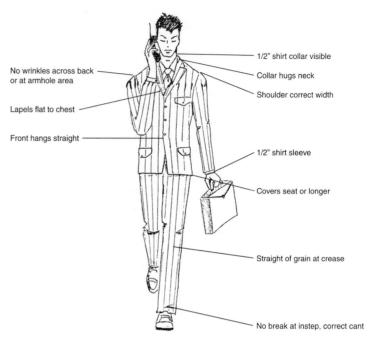

No wrinkles across back or at armhole area

Lapels flat to chest

Front hangs straight

1/2" shirt collar visible

Collar hugs neck

Shoulder correct width

1/2" shirt sleeve

Covers seat or longer

Straight of grain at crease

No break at instep, correct cant

area of the body, such as the hip and shoulder. Bust darts must be properly placed and point to the area of greatest fullness, not extend beyond the area of the greatest curve, and end within 1 1/2 to 2 inches of the bust point. Waistline darts directed to the bust usually end about 1/2 inch below the bust point, and long diagonal French darts that begin at the hip side seam end just short of the bust point. Princess styling or curved seams provide fullness for the bust. Women's fitting standards are summarized in Figure 11.18. Fitting checkpoints for women are illustrated in Figure 11.19.

Fit for Older Adults

The fastest growing segment of the population is older adults. They account for one in eight persons residing in the United States. Older adults have the health and discretionary income to enjoy an active lifestyle. The challenge is to find stylish, acceptable garments that meet their needs and that fit.

When shopping for garments, older adults are looking for a fit that accommodates their shorter stature, thicker waist, protruding abdomen, flattened buttocks, and forward tilt of their head and shoulders (Campbell and Horne, 2001). Some seniors experience reduced mobility and loss of small-muscle strength. The garment sizes that most closely meet their fit needs are misses petite 14–18, misses 12–18, and plus sizes 14–20. Consult Figures 11.20 and 11.21 for specific fit requirements for older men and women.

Garment Area or Detail	Fitting Guides
Basic Lines Necklines	Should fit flat around the base of the neck unless designed otherwise, without cutting into the neck, wrinkling, or gapping. Wide or lowered necklines should lie flat and snug on the chest.
Collars	Should fit comfortably around the neck. When buttoned, one finger should fit easily into the neckline. 1/2″ of a shirt collar should show above a suit collar at center back.
Shoulder seams	Should lie flat on top of the shoulder, bisect the neck and shoulder, and end at the joint unless design lines dictate otherwise. Shoulder pads should appear natural, well placed, and not too small or too large.
Upper back	Should fit smoothly with no bubbles, wrinkles, or bulges with enough ease to make movement comfortable.
Armholes	Should not bind, gap, or cut into the arm, but allow easy movement. Unless design lines dictate otherwise, the lowest point should be 1–2″ below the armpit.
Armhole seams	Should cross the shoulder at the joint and follow the back arm crease unless design dictates otherwise. Jacket armhole seams may extend 1/2–1″ and coat seams 1–1 1/2″ beyond the shoulder joint.
Sleeves	Should lie smooth around the arm with 1 1/2″ ease. One finger should fit easily under short sleeves, and elbows should have plenty of room to move in long sleeves. Elbow darts or fullness should be over elbow. Long sleeves should end at the wrist bone when the arm is bent at the elbow and be no longer than the bend of the wrist when the arm is hanging straight. Short sleeves should add to the pleasing proportions of the bodice. Set-in sleeve caps should have no puckers or wrinkles, and the fullness should be even between front and back.
Waists and waistbands	Should fit comfortably when standing, yet have 1–1 1/2″ ease for sitting. Two fingers should slip easily inside the waistband.
Seams Center front and back seams	Should be perpendicular to the floor and be centered on the body. They should not curve or pull to the side.
Side seams	Should appear perpendicular to the waist and to the floor with no pulling or curving.
Lengthwise grain	Should follow front and back seams unless the skirt is cut on the bias. Should hang down the center of the sleeve above the elbow and down the crease of slacks.
Crosswise grain	Should parallel the floor at the hem, hip, upper arm, upper back, and chest.

continues

Figure 11.18 Fitting standards for women. *(Reproduced by permission:* Wardrobe Strategies for Women *by J. Rasband. Albany, NY: Delmar Publishing, 1996)*

Garment Area or Detail	Fitting Guides
Design Features Lapels	Should lie flat and be symmetrical. Should not gap open.
Darts	Should point toward and end 1–1 1/2″ from the fullest part of the curve being fitted. Should taper and end smoothly.
Pockets	Should lie flat without pulling or gapping open.
Closures	Should be straight and smooth without pulling, curving, or gapping. Front button closures should have one button at the fullest part of the bust.
Gathers	Should be even and tiny with no bunching or grouping. Gathers should fall evenly.
Pleats, slits, tucks, and vents	Should hang flat, closed, and straight against the body, opening only for movement. Should not pull open.
Linings	Should be cut on grain, not show, lie smooth, yet allow for ease of movement.
Clothing Articles Jackets	Should have room to fit easily over shirts and sweaters and to button without strain.
Coats	Should be roomy enough to fit over suits and jackets. Hems should fall about 1″ longer than skirts.
Skirts	Should have 2″ ease around the hips, should hang straight from the waist rather than cup around stomach, buttocks, or thighs. Skirt hems should be in proportion to the figure without crossing the widest part of the calf.
Pants and trousers	Should hang smoothly from the waist with ample room for the abdomen, thighs, and buttocks and with correct length for crotch. If wrinkles appear in pants when standing straight, check fit. Hems should brush the top of shoes in front, tapering to the top of heels in back unless designed otherwise.

Figure 11.18 *(continued)*

Fit for Children

Children are typically most interested in comfort and the ability to move in their clothing. Figure 11.22 gives a summary of a few points to consider when evaluating children's fit. Activity 11.2 also discusses fit for any age.

Collar fits neckline snugly for style

Adequate sleeve width

No wrinkles below waist back

Adequate seat room

Shoulder length correct for body & style

Horizontal grain parallel to floor

Darts point to, not over bust

Pocket openings do not spread

Waist at normal waistline

Horizontal grain parallel to floor

Side and center front seams parallel to floor

Figure 11.19
Checkpoints for women's fit.

Problem Area	Solutions
Lower and larger bustline	Breasts can be supported by a well-fitting bra and de-emphasized with gathers or fullness.
Prominent abdomen	Abdomen can be supported with wide elastic or a girdle.
Shoulders rounded in back	Garments should be cut with more width across shoulder blades, length down center back, and less fabric across front between armholes. Dropped/kimono sleeves allow for movement.
Petite and older	Need shorter sleeves, narrower pant legs, and shorter jacket lengths.
Tall older women	Need longer crotch lengths to compensate for a protruding abdomen, plus wide pant legs.

Figure 11.20 Fit for older women.

Problem Area	Solutions
Larger abdomen	Pants with a longer rise to accommodate a larger abdomen.
Larger waist	Pants with adjustable or elastic waistbands. Men often forgo belts in favor of suspenders or Sansabelt-type waistbands.
Larger hips	Often requires a larger size or an alteration.

Figure 11.21 Fit for older men.

Children's Sizes	Fit Requirements
Infants	• Easy access necklines to compensate for a large head relative to the body. • Room is needed for movement and diapers.
Toddlers	• Allow for growth and movement
Little boys and girls	• Compensate for rapid growth in height and limbs, more muscular bodies, and broader shoulders. • Neck openings in woven fabric should be at least 22″ or the size of a child's head. • Fitted waistline openings should extend 4″ past fitted area. • Dresses, jumpers, and shirts need 2″ of ease around chest. • Sleeves with banded cuffs around biceps need 1/2″ of ease. • Long sleeve cuffs need 1 1/2″ of ease to allow for hand entry. • Waistband needs 3/4″ ease. • Tightening or relaxing waistband elastic can aid fit.

Figure 11.22 Specifics of fit for children.

ACTIVITY 11.2 Improper Fit Evaluation

Bring to class garments that do not fit correctly. Analyze the fit problems. Decide what alterations could recycle the garments and which alterations would be impossible to make.

❧ Summary

In order to make an informed clothing purchase decision, consumers need to understand sizing and fit. Sizing is often the result of how the prototype of a garment fits a manufacturer's fit model. A wide variety of sizes are available for average consumers to experiment with as they determine their ideal fit. Many are labeled with fit illustrations to aid the consumer in prepurchase decisions. Guidelines regarding fit are normative for clothing in general; however, manufacturers take into account the special fit requirements of special groups.

❧ Key Terms and Concepts

Design ease
Drop
Ease
Fit

Fit model
Grain
Rise
Wearing ease

❧ References

Betts, K. (2002, March 31). The tyranny of skinny, fashion's insider secret. *New York Times,* Section 9, pp. 1, 8.

Brown, P., and Rice, J. (2001). *Ready-to-wear apparel analysis* (3rd ed.). Upper Saddle River, NJ: Prentice Hall.

Campbell, L. D., and Horne, L. (2001). Trousers developed from the ASTM D5586 and the Canada standard sizing for women's apparel. *Clothing and Textiles Research Journal, 19*(4), 185–193.

Felton, L. (2000). *Does this make me look fat?* New York: Villard.

Gellers, S. (1998, July 8). Made-to-measure: Raising the stakes for better clothing. *Daily News Record,* p. 9.

Gross, K. J., Stone, J., and Urquhart, J. (2000). *Simple chic women's wardrobe.* New York: Alfred A. Knopf.

Jarnow, J., and Dickerson, K. (2003). *Inside the fashion business* (2nd ed.). Upper Saddle River, NJ: Prentice Hall.

Nation continues to gain. (2001, January 19). *Science,* p. 429.

Oliver B., Bickle, M., and Shim, S. (1993). Profile of male made-to-measure customer. *Clothing and Textiles Research Journal, 1*(2), 59–62.

Plus Size [Advertising supplement]. (2001, November 19). *Women's Wear Daily,* pp. 1–8.

Quick, R. (2000, October 18). Getting the right fit—hips and all. *Wall Street Journal,* pp. B1, 4.

Rasband, J. (1996). *Wardrobe strategies for women.* Provo, UT: Conselle Institute of Image Management.

Rifkin, G. (1995, October 6). Levi Strauss buys custom-fit software concern. *New York Times,* p. D2.

Workman, J. E. (1991). Body measurement specifications for fit models as a factor in clothing size variation. *Clothing and Textiles Research Journal, 10*(1), 31–36.

Workman, J. E., and Lentz, E. S. (2000). Measurement specifications for manufacturers' prototype bodies. *Clothing and Textiles Research Journal, 18*(4), 251–259.

Clothing Quality

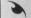 Objectives

- Define quality.
- Explain how the characteristics of each component part affect the quality of the product.
- Identify specific details in garments that influence quality.
- Discuss the relationship between price and quality.

Consumer Clothing Selection Issues

Clothing
Purchasing

Wardrobe
Planning

Clothing
Care

Clothing
Quality

Clothing Fit

The clothing consumption process and consumers' quality evaluations of purchased wearing apparel begin at the time of purchase, continue into the use and care phase, and end at the point of discard. The quality evaluation process cannot end until the consumption process ends.

It is important for the fashion professional to have reliable information regarding factors influencing apparel quality in order to make decisions about the components and characteristics to include in the specifications for the manufacturer or to assess the sample in the showroom. It is also important for the consumer to have reliable information about the quality of apparel in order to obtain maximum value for the amount of money spent. This chapter defines quality and explains how the quality of the product is influenced by the unique characteristics of each of its component parts. It discusses the relationship between price and quality and describes selected articles of clothing, analyzes the content of the garment, and identifies specific details of the garment that influence its quality.

Perspectives on Apparel Quality

Quality refers to conformance to a certain set of standards.

Researchers (Abraham-Murali and Littrell, 1995; Hines and O'Neal, 1995) have identified at least two different perspectives in the study of quality in wearing apparel. The first is described as quality from the industry's perspective, and the second is quality from a consumer's perspective. Obviously, however, these perspectives are each a part of a larger whole—the desire to provide or experience satisfaction from the purchase.

Quality from the Industry's Perspective

Quality of wearing apparel from the industry's perspective focuses on physical properties that can be measured objectively (Brown and Rice, 1998). Quality is a multidimensional construct that includes a set of product attributes, each having the potential to influence the quality evaluation. Further, the industry assumes that consumers can differentiate between low- and high-quality garments based on the evaluations of physical attributes of the garment (Hines and O'Neal, 1995; Fowler and Clodfelter, 2001).

Quality from a Consumer's Perspective

The **cost sheet** conveys the cost in dollars to produce the garment, from materials sourcing to packaging.

Quality evaluations from a consumer's perspective tend to focus on the extent to which the wearing apparel provides the service characteristics that the individual consumer desires (Abraham-Murali and Littrell, 1995), or the extent to which the wearing apparel meets the expectations of the consumer (O'Neal, 1992–1993).

Personal values do influence purchasing decisions. For example, consumers who value economy may examine wearing apparel carefully at the point of purchase to make sure that they are getting the best value for their dollar. Consumers who place high value on beauty may evaluate the attractiveness of the garment on the human form. Each individual must consider how his or her personal values influence his or her evaluations of the quality of wearing apparel. (Refer to the discussion in Chapters 3 and 4 for values clarification.)

According to Gellers (2001), garment luxury and performance have become industry standards at every price point. With the return to the wearing of suits—whether double-breasted; three-button; single-breasted; the high two-buttoned silhouette; or the return to strong shoulders and the use of fabrics with stripes, tweeds, moleskin, and corduroy—manufacturers were challenged to meet consumers' expectations of quality.

The fashion professional communicates the specific characteristics desired in a garment to the manufacturer through a cost sheet (Figure 12.1). The cost sheet, along with the specifications sheet, details specifically how a particular garment must be constructed to meet company standards.

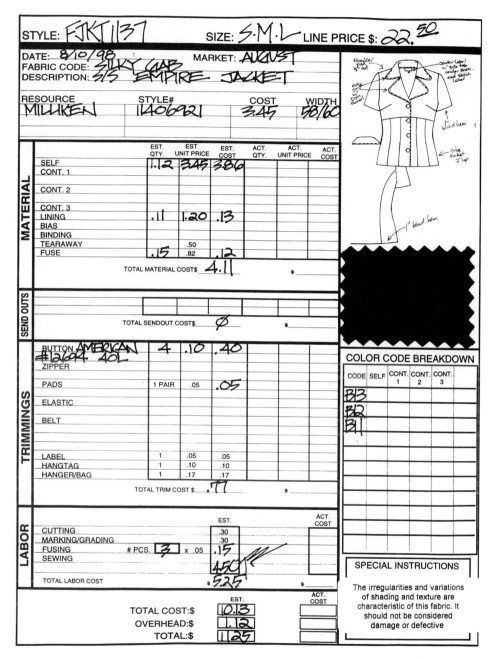

Figure 12.1 Fashion professionals communicate their expectations to the manufacturer on a cost sheet. *(Courtesy Heart & Soul)*

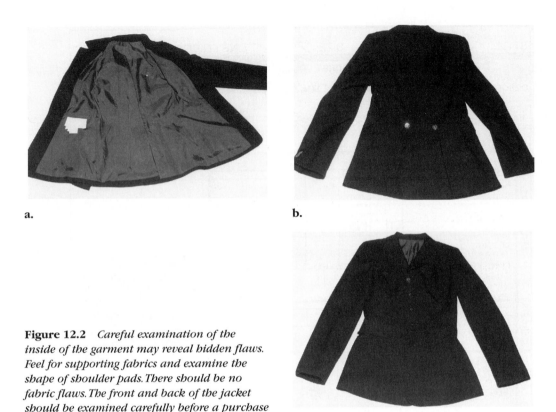

a.

b.

c.

Figure 12.2 *Careful examination of the inside of the garment may reveal hidden flaws. Feel for supporting fabrics and examine the shape of shoulder pads. There should be no fabric flaws. The front and back of the jacket should be examined carefully before a purchase is made.*

According to Cotton Incorporated's *Lifestyle Monitor* as quoted in "A Matter of Quality," 2001, "more men than women believe that better quality garments are made with natural fibers—in fact, an astonishing 64.4% of male consumers believe this is true" (p. 3). In addition, research also shows that "although expectations of quality and the ability to distinguish various quality characteristics vary, the more educated and sophisticated consumer generally has more specific expectations of quality" (Fowler and Clodfelter, 2001, p. 58).

Some retailers also recognized the importance of having an assortment of apparel made from fabrics of natural fibers and were promoting this to consumers through additional attention in preprinted advertisement, store displays, hangtags, and packaging ("A Matter of Quality," 2001).

The consumer should carefully examine and evaluate every important characteristic available at the point of sale. This evaluation should include the inside as well as the outside of the garment (Figure 12.2). It also requires an evaluation of the garment on the body, under appropriate lighting conditions.

Recognizing Quality in Wearing Apparel

The quality of a garment is determined by the characteristics of each of its components. Every element, from the fiber used to construct the fabric to the last finishing detail, will influence the final appearance of the garment. To the discerning eye, quality is evident in the external appearance of a garment; it is also evident in the details that are not seen from the outside, such as interfacings, linings, and construction techniques. These elements affect not only how the garment looks but also how it will retain its shape and how it will wear.

Fabric Components

Natural fibers are found in nature in the fibrous state.

Manufactured or synthetic fibers are developed in a laboratory.

The construction of a fabric will determine its wearing qualities. Fabric is made from yarns, which are made from fibers. A variety of natural and manufactured fibers are currently used in producing fabric yarns.

Fibers

Each type of fiber has qualities that give particular characteristics to the fabrics constructed from them. Each fiber has positive and negative characteristics; at this time there is no one "perfect fiber." Major qualities of fibers are shown in Figure 12.3.

Fiber blends result when two or more types of fibers are used in the fabric (e.g., cotton and polyester).

Two or more fibers are sometimes used in a fabric in order to take advantage of the outstanding characteristics of each. Cotton and polyester have been used together for years. The correct percentage of each fiber is combined to make a fabric that possesses the best characteristics of cotton and polyester. A 60 percent polyester/40 percent cotton blend produces a fabric that, among other desirable characteristics, needs very little ironing.

Wools are blended with nylon to create a strong fabric. The blend also produces a fabric that looks good in tailored garments, such as a blazer. In addition, the resulting fabric wrinkles little and thus travels well.

The fiber content label, required by law to be attached to each garment, must indicate the percentage of each major fiber present in the fabric. The chief characteristics of the fabric are those of the predominant fibers. Understanding the textile information given on the garment's label can help the consumer and fashion professional know what to expect in garment performance and care before an order is placed or a purchase is made.

Fiber Name	Positive Characteristics	Negative Characteristics
Cotton	Comfort, easy care, good durability, softness, moisture absorbency, air permeability, pliability, easy to launder, may be dry cleaned.	Requires ironing, unless a wrinkled appearance is intended.
Flax (linen)	Strong and cool, comfortable, easily laundered or dry cleaned, may be very smooth or very rough.	Wrinkles easily if a special finish is not applied.
Silk	Strong, flexible, durable, warm, absorbs moisture, soft, drapable, luxurious appearance. Some are hand washable.	Pressing requires expert techniques. Somewhat expensive to buy and maintain.
Wool	May range from very thick and stiff to very sheer, warm, comfortable, stretches and recovers, absorbent, flexible, resistant to wrinkling, tailors very well, look and feel good, can be made washable.	Tendency to shrink if not handled properly; dry cleaning is generally required.
Rayon	Varies in weight from very heavy to very sheer, varies in hand from very soft and limp to very firm and stiff, easily pressed, absorbent, comfortable, soft.	Requires special handling if laundered; dry cleaning usually preferred; may stretch when wet and shrink when dry.
Lyocell (Tencel)	Close to cotton in its characteristics; may be made washable or dry cleanable; soft, smooth hand.	May shrink during laundering if a special finish is not applied.

Figure 12.3 Positive and negative characteristics of fibers.

Some of the new modifications of manufactured fibers have been in the areas of fiber size, such as micro fibers, and in imparting a variety of surface characteristics, such as texture or crimp. These modifications, as well as others, have produced fabrics that have very high strength and low weight (Figure 12.4); have the ability to keep the body dry and warm or cool; and, in ready-to-wear, have exceptional drape and soft, lightweight sophistication.

Yarns

Most fibers are twisted together to make yarns. Yarns may be made of short fibers or long fibers. High quality yarns are made from long fibers. The twist placed into the yarn may be low; this, in general, results in a fabric that reflects light, such as satin. Low-twist yarns are generally weak compared to high-twist yarns, and high-twist yarns create the strongest fabrics. However, extremely highly twisted yarns are weak; these are used for crepe and novelty yarns. Crepe yarns are especially appreciated for their aesthetically pleasing appearance.

Fiber Name	Positive Characteristics	Negative Characteristics
Acetate	Bright appearance and good luster, lightweight.	Low strength, weaker wet than dry, poor elastic recovery, poor wrinkle recovery, may experience relaxation shrinkage, exposure to high temperatures may cause shrinkage, not cool to wear, builds up static electricity, softens with the application of heat.
Triacetate	Bright appearance and good luster, resilient, good wrinkle recovery, good resistance to stretching and shrinking, lightweight.	Low strength, weaker wet than dry, not cool to wear, builds up static electricity, softens with the application of heat.
Nylon	Light in weight, very strong, good abrasion resistance, drapable, good elasticity, wrinkle resistant, maintains its shape, dries quickly after laundering, an easy-care fiber.	Needs very low cleaning and pressing temperatures, has an affinity for oil-borne stains.
Polyester	Medium in weight, good elasticity, excellent wrinkle recovery, relatively strong, good wicking ability, easy care; new micro denier fibers have many exceptionally good properties.	Nonabsorbent, needs very low cleaning and pressing temperatures if not heat set.

Figure 12.3 Positive and negative characteristics of fibers. *(continued)*

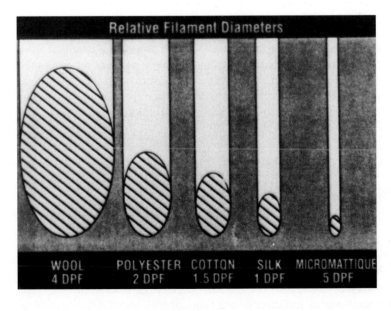

Figure 12.4 Dupont's micro denier fiber, micromattique, gives fabrics exceptional drape and a good hand. Compare the denier of micromattique to regular polyester. Dupont has recently produced a micro denier fiber of .3DPF.
(Courtesy Dupont)

Figure 12.5 *The fibers, yarns, and fabrics used in these "dressup" clothes would not be expected to perform as those used in work clothing. (Courtesy IMP Originals)*

Fabrics or Textiles

Yarns are made into fabrics by many different processes. Knitting and weaving are the most common methods used; however, other methods may be used as well, such as felting and bonding.

There are many different types of weaves. Some are strong, such as a twill weave, and some are weak, such as a loose basket weave. Knitting joins loops of one continuous yarn. Some knitted fabrics stretch and recover very well, whereas others stretch but recover poorly. The size and strength of the yarns also contribute to fabric strength.

The characteristics of the completed fabric are determined by the fiber characteristics, the yarn characteristics, and the type of fabric construction. These characteristics, in turn, determine the end use of the textile (Figure 12.5). A fabric woven from low-twist yarns composed of short woolen fibers will be soft and weak, but it can be molded by heat and moisture into a tailored garment. A textile knitted of a fine, continuous nylon filament would be smooth, lightweight, clinging, and wrinkle-free, yet it could melt under high ironing temperatures.

Fashion Fabric

The fashion fabric must have "eye appeal" to attract the attention of the buyer, and it must be attractive on the body. The wearing qualities depend on the fiber used, the yarn, and the fabric construction.

Studies have shown that consumers consistently identify the fiber content of fabric as the most important quality indicator of wearing apparel. Industry professionals

(Brown and Rice, 1998) noted that "of all the components used to produce ready-to-wear, fabric makes the greatest contribution to the cost and quality of the garment" (p. 157). The fabric provides the foundation for a high quality garment; "therefore, the evaluation of fabric is integral to assessing apparel quality" (Brown and Rice, 1998, p. 157).

Luca Trabaldo, the fifth generation of his family to work in the Trabaldo Tonga firm, announced that in addition to the use of wool the company also developed a selection of fabrics with new qualities based around cotton, among them a wind- and shower-proof, bonded reversible fabric ("New Collections," 2001).

In summary, good quality indicators for fabric include having a pleasing hand, being free of flaws, and the fabrication, whether woven or knitted, holding together when cut on grain. The fabric must complement the design of the garment. Poor quality indicators for fabric may include flimsy, scratchy, or brittle hand; very loose fabrication; and the addition of too much sizing or fillers that will be removed during the first cleaning.

The quality of the fashion fabric also depends on the dyes or the dyeing methods used to add color. Some dyeing techniques cause colors to fade when the fabric is exposed to the sun or the atmosphere, cleaned, or worn. The labels on garments should give information regarding colorfastness, but the manufacturer is not required to provide this information. The consumer or fashion professional can check for color fastness by rubbing a white piece of cloth over the fabric in question to see if any color rubs off. However, this method will only test colorfastness when the fabric is dry. The color also may rub off when the fabric is wet.

Finishes are added to fabrics in the final steps of production. A variety of finishes are used for specific purposes, and they often affect fabric performance. For example, a finish used to prevent wrinkling may make ironing difficult if wrinkles are set by heat in the dryer. Soil release finishes sometimes stiffen the fabric so that a familiar textile takes on new characteristics. Durable-press finishes may create some abrasion and spot removal problems. Durable press fabrics are easy to care for but do not wear as they would without the finish.

Supportive Fabrics

Supportive fabrics are located on the inside of the garment to lend shape and support to the garment.

Fabrics used on the inside of a garment fulfill one of several purposes (Figure 12.6): interfacing, underlining, and lining. **Interfacings** are supportive and build shape and design into small areas of the garment. **Underlinings** are supportive and add stability and durability to the fashion fabric. **Linings** are decorative and enclose construction details. The fabrics used for each are a significant factor in the quality of the garment.

Supportive fabrics should be fastened securely and finished appropriately for the design of the garment. They should not wrinkle or distort the fashion fabric. These supporting fabrics may determine how long a garment will maintain its shape and fit and how long it will wear.

Figure 12.6 *Interfacing helps to maintain a garment's shape during wear. The lining also helps to maintain the garment's shape as well as makes for an attractive inside finish since it conceals all seams and supporting fabrics.*

Construction Details

Construction is the method used to assemble the garment.

Texture direction is an arrangement of yarns such that the pile slants in one direction, giving an up-and-down pattern.

Bias cut is a line diagonal to the grain of a fabric.

Richardson (1999) noted that "high quality material lasts longer, feels better, and looks cooler. The finer details of manufacturing—perfect seams, silk linings, anything sewn by hand—mean that a garment will fit better, maintain its shape, and possibly outlive you" (p. 88).

As discussed in Chapter 10, some fashion fabrics have a design or texture direction. This must be taken into consideration in the construction of a garment or the beauty of both fabric and design will be distorted. Fabrics such as twills, plaids, large checks, stripes, or distinctive motifs must be cut and sewn together so that the design is not distorted. The fabric design must be matched in the construction of the garment (see Figure 10.18 on p. 302). This includes center front and center back,

side seams, and sleeve and bodice joinings. Bias-cut seams should match at their joining. Plaids and stripes must match both horizontally and vertically to maintain the continuity of the design. Motifs, such as flowers, intended to be whole must not be quartered or halved. Matching is costly and may be difficult to find in low-priced garments.

If the design is in the texture, such as a twill weave, the garment must be constructed so that the diagonal line flows in one direction or chevrons (formed when pattern forms a V at the seams). In some fabrics—velvet, velveteen, corduroy, some satins, and some knits—a change in color depth will be obvious unless all pattern pieces are placed the same direction and follow the grain.

Stitch Length

Sewing machine stitch length should be appropriate to the fabric. Generally, small stitches indicate high quality, but some fabrics, such as synthetics and permanent-press, require longer stitch length in order to avoid seam-puckering. Thread color should match the fashion fabric unless it is used as a decorative touch. Transparent thread is a sign of low-quality construction. Thread ends should be secured so that they will not pull out. Seam pucker results from poor sewing techniques, and pressing cannot correct this problem. Check for pucker on lengthwise seams of fabrics of synthetic fibers, blends, and permanent-press garments.

Seam Allowance

Many ready-to-wear garments have narrow overlocked seams, which are satisfactory (Figure 12.7). An adequate seam width in most woven fabrics is about 1/2 inch so that it can withstand or tolerate stress of wear without pulling or fraying out. The seam should be pressed open smoothly unless design detail indicates otherwise. Seams should not show signs of puckering or pulling. Only fabrics that tend to ravel need a seam finish to prevent this. Seam finishes include pinking, edge stitching, and overlocking cut edges. Cut edges may be completely hidden by bound, French, flat-felled, or Hong Kong-finished seams.

Garments made of knitted fabrics may have a 1/2-inch to 5/8-inch seam width if seams lie flat. Some knits have a very small seam allowance since the knit tends to roll and produce a bulky seam. Knits that do not ravel do not need a seam finish.

Hems

Unless hems are a design feature, they should not be visible from the right side of the garment (see Figure 12.7). Hem width depends on the fabric and the garment style. The hem finish should be appropriate for the fashion fabric and stitched so that a ridge does not show on the right side of the garment. Some fabrics such as felt and faux leathers do not need turned-under hems.

Sleeves

Sleeves should be set in smoothly without sign of puckering, unless that is a design detail (Figure 12.8). There should be comfortable ease in the fit of a sleeve so that it does not draw or pull when on the body. The grain line for a set-in sleeve should be parallel and perpendicular to the floor across the center upper arm.

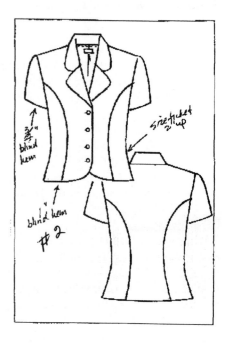

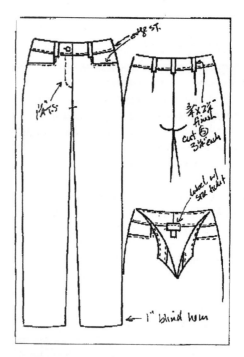

Figure 12.7 Fashion professionals communicate specific types of stitches required to meet the company's standards. Here, three-thread overlock is specified. A closer look at the sheet reveals a request for other details as well. *(Courtesy Peter Shen)*

Figure 12.8 *The focus here is on the smoothness in which the sleeve has been set into the armscye. There is not a sign of gathers or wrinkles. (Courtesy Axis Clothing Corporation)*

Collar

The collar must be placed symmetrically, unless indicated otherwise by the design. The under collar should not be visible from the right side. The collar should have well-defined edges and a good shape.

Ease

The amount of ease or fullness in a garment often indicates quality. The overall fit of the garment should leave adequate and comfortable room for movement. A garment should never bind or constrict the body. Adequate ease should also be found in the fullness of gathers, pleats, and tucks (Figure 12.9).

Finishing Details

Buttons

All fasteners should be properly placed and securely attached. Quality in a garment is indicated by the choice of fasteners, such as buttons. Buttons should be in harmony with the texture, color, and design of the garment.

Buttonholes

Buttonholes must be properly placed and correctly sized to accommodate the buttons. Bound buttonholes, finished with fabric rather than overcasting thread, are a

Figure 12.9 *Adequate ease should be found in clothing for every member of the family. (Courtesy Jane Nicklas Photography)*

sign of quality in women's clothes, but not all fabrics are suitable for them. Machine buttonholes should have close stitches, and the thread ends should be secured to prevent raveling.

Zippers

A zipper should zip easily and should be well covered by the fashion fabric. It should be installed so that it stays closed. In some high-quality garments the zipper is "hand-picked" (sewn with small backstitch stitches to make it nearly invisible).

Decoration

Decoration and trim should be in keeping with the quality of the garment. The placement and quantity of the applied design should add to the beauty of the garment. Check all applied design to see that it is appropriately placed and securely attached.

Linings

Coats and jackets should have a firmly attached lining that is caught at the shoulder seams in order to prevent it from pulling and showing below the hemline (Figure 12.10). A pleat of about 3/4 inch at the center back should release extra fullness for movement.

Pressing

Pressing is extremely important to the appearance of the garment. Each detail of the garment should be pressed into position. There should be no overpressing effects

Figure 12.10 *This full lining fits the fashion fabric well and is secured at the shoulders. A pleat of about 3/4 inch at the center back of the lining releases extra fullness.*

on the right side of the garment, such as hem and dart impressions, pocket imprints, or a shine on the fashion fabric. The garment should be smooth, well shaped, and ready to wear (Figure 12.11).

Relationship of Price to Quality

The price paid for a garment is often equated with the quality the buyer expects to receive. High-priced garments are expected to be high-quality garments, but this is not always true. Although the price tag may be an indication of overall quality, several factors influence the pricing of garments.

Fabric

A garment may be expensive because the fabric is costly. High-quality Merino wool fabric, finely woven silk fabrics, and linen are more expensive than most cottons, synthetics, and blends. Garments made from expensive fibers will cost more at the outset.

Design

The exclusiveness of the design will influence the price. If only a few garments of one design are cut, this will be reflected in a higher price. The design of the garment will affect its price. Garments composed of many pieces and odd-shaped pieces require special handling, thus adding to the labor cost. Fabric designs that require matching of plaids or stripes require more labor and thus are more expensive.

Figure 12.11 *Skillfull pressing techniques will result in a smooth, well-shaped garment waiting to be worn. (Courtesy Axis Clothing Corporation)*

Handwork

The amount of handwork involved also affects the cost. Linings stitched in by hand, fabric-covered buttons, zippers inserted by hand, and hand hemming all result in high labor costs.

Richardson (1999) identified several extrinsic and intrinsic variables that should be considered when determining the quality of apparel. These include the fact that (1) "most major designers and department stores stand behind the quality of their garments . . . , (2) certain countries are associated with a tradition of quality—Scotland for wool and cashmere, for instance, and Italy for leather . . . , (3) well made clothes should not ripple or gather in odd places, such as across the shoulders, down the back seam of a jacket, or in the seat of the pants" (p. 92). He concluded with the observations that careful attention must be given to construction details and choices of fabrics for linings; neat, flat seams free of loose threads; and buttons made of high-quality natural materials.

Activity 12.1 highlights quality factors found by comparison shopping. Case Study 12.1 explains how to read a price tag.

Compare similar garments in three different price ranges. For example: slacks/dresses at $50, $130, and $250 or a suit at $80, $150, and $250.

Write a report on your comparison-shopping experience. Include the following information:

- *Hangtag or label information:* Price, brand-name/manufacturer, designer, fiber content, care instructions.
- *Store names, addresses, and locations:* Store image, type of merchandising, type of store service.
- *Garment presentation:* Display appeal or impact, coordination of accessories.
- *Garment construction:* Fashion fabric, supportive fabrics, linings, number of pieces in design, matching of pieces, widths/seam finishes, handwork, quality, finishing, details and trims, manufacturing shortcuts, pressing.

Summarize findings and recommend the garment believed to be the best value.

CASE STUDY 12.1

How to Read a Price Tag

Grass and Stone (2000) asked, "What is the difference between a $300 and a $3,000 garment—for example, a suit?"

They answered:

It is the fabric:

- Cheap suit . . . cheap fabric.
- "It has not been chosen for its drapability, hand, strength, or softness . . . may not have a good memory (i.e., the ability of the fabric to hold its shape after multiple wearings)."
- Expensive suit . . . the best fabric.

It is the manufacturing:

- "Cheap suit, . . . a mass market . . . Machine-made." Shows signs of poor-quality control.
- "Expensive suit . . . produced in very limited numbers . . . made—very possibly by hand . . ." Shows signs of good quality control.

It is the detailing:

- Cheap suit . . . weak detailing. "May not fit as well as the expensive one."

It is the private label:

- "Poor quality private label . . . on sale at huge markdowns . . . at unpredictable times of the year."
- "Good quality label . . . the look and feel of designer merchandise . . . displayed on racks near designer merchandise."
- "Good quality private label rarely goes on sale during the season."
- "Poor quality private label . . . one style in twelve different colors."
- "Poor quality private label . . . heavily advertised."

(Grass, K. J., and Stone, J. (2000). Women's Wardrobe. *New York: Alfred A. Knopf, p. 205)*

Summary

The quality of a garment is determined by the characteristics of each of its parts, from design to finishing details. Each component has the potential to improve or lower the quality of the garment. This chapter defines quality and explains how the quality of the product is influenced by the unique characteristics of each of its component parts. It describes selected articles of clothing, analyzes the content of the garment, and identifies specific details of the garment that influence its quality. It also discusses the relationship between price and quality. Fashion professionals and consumers must have reliable information regarding factors that influence quality in wearing apparel in order to make wise decisions.

Key Terms and Concepts

Bias cut
Construction
Cost sheet
Fiber blends
Interfacings
Linings

Manufactured or synthetic fibers
Natural fibers
Quality
Supportive fabrics
Texture direction
Underlinings

References

Abraham-Murali, L., and Littrell, M. A. (1995). Consumers' perceptions of apparel quality over time: An exploratory study. *Clothing and Textiles Research Journal, 13*(3), 149–158.

Brown, P., and Rice, J. (1998). *Ready-to-wear apparel analysis.* Upper Saddle River, NJ: Merrill/Prentice Hall.

Fowler, D., and Clodfelter, R. (2001). A comparison of apparel quality: Outlet stores versus department stores. *Journal of Fashion Marketing and Management, 5*(2), 120–132.

Gellers, S. (2001). Stripe it rich. *Daily News Record, 31*(87), 6.

Grass, K. J., and Stone, J. (2000). *Women's Wardrobe.* New York: Alfred A. Knopf.

Hines, J. D., and O'Neal, G. S. (1995). Underlying determinants of clothing quality: The consumers' perspective. *Clothing and Textiles Research Journal, 13*(4), 227–233.

O'Neal, G. S. (1992–1993) A conceptual model of consumers perceptions of apparel quality. *Themis: Journal of Theory in Home Economics 2*(1), 1–25.

A matter of quality: Men equate natural fibers with better apparel. (2001). *Daily News Record, 31*(88), 3.

New collections s/s. (2000). *International Textiles,* 813, 41–44.

Richardson, D. C. (1999). What's it worth to you? *Men's Health, 44*(8), 88–90.

Clothing Care

 Objectives

- Explain routine clothing maintenance as a strategy for prolonging a garment's serviceability.
- Apply storage principles and processes to clothing maintenance.
- Explain permanent care labeling.
- Describe the selection of laundry products and procedures for the clothing care process.

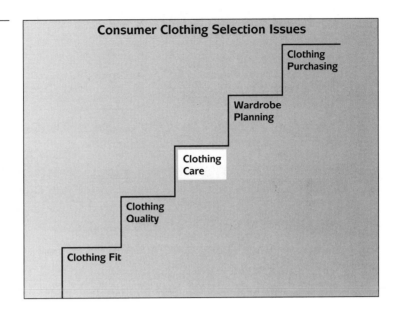

Consumer Clothing Selection Issues

- Clothing Purchasing
- Wardrobe Planning
- Clothing Care
- Clothing Quality
- Clothing Fit

Garment maintenance is an important part of being well dressed and, therefore, a major factor in the clothing decision-making process. Fashion professionals and apparel manufacturers are intimately involved in care as one aspect of customer satisfaction (Kadolph, 1998). Issues addressed by apparel manufacturers and fashion professionals include how a product responds to care such as soil and stain removal and shrinkage; how effective laundry products are at returning garments to a just-purchased condition such as color retention and abrasion resistance; how the recommended care process affects design features such as pockets, collars, pleats, creases, and seams; and how the recommended care process affects interfacings and underlinings. Manufacturers and retail textile companies that have testing laboratories include Eddie Bauer, Esprit, J.C. Penney, Lands' End, Mervyns, and Sears Roebuck.

When a garment is selected to meet the wearer's psychological, sociological, cultural, and physical needs, it is subjected to a variety of stressors:

- Environmental pollutants such as acid rain
- Dirt and pollen
- Moisture such as perspiration and rain
- Wrinkling
- Stains from contact with food or perfume

- Light and sunlight
- Stretching from movement
- Abrasion

Wearing can be hazardous to a garment's health. Though some aspects of one's day are beyond control, efforts to protect and care for a garment can reduce maintenance costs and prolong serviceability.

This chapter discusses the maintenance, storage, and cleaning of clothing and accessories. Regardless of the cost of the garment, these factors give clothes a significantly improved appearance.

Routine Maintenance

After wearing a garment, inspect it for stains, soil, and damage such as rips, missing buttons, broken zippers, or unstitched hems. Brush, air, and press garments as needed to prepare them for the next wearing. Wool garments need to "rest" at least twenty-four hours between wearings to allow the fibers to return to their original dimensions. Leather shoes and garments made from stretch yarns also need a rest period between wearings. Some spots/stains can be treated with a spot remover right after wearing to prolong the period between cleanings.

Clothing Storage

Storage gives garments a time to rest and prolongs the life of the product. Components of storage include facilities and equipment and the storage process.

Storage Facilities and Equipment

The goal of organized storage is to focus on what to wear, not what to find. Figure 13.1 shows before and after closet organization. In well-organized closets garments are not crowded; they hang straight. Hanging space is organized to accommodate the length and bulk of the garments. There is flat and hanging storage, as well as accessory storage. Designating separate storage for current and off-season items as well as regular and special wardrobe items reduces pressure on the storage area. Selecting items for flat storage such as knits that could stretch out of shape can further increase closet space. Designating space for accessories can reduce selection time.

Good hangers are an important part of good storage. Thick, padded hangers provide support in the shoulder and sleeve cap area that wire hangers cannot equal. Skirts and pants can be fastened to wire hangers with pins or placed on specialized pant/skirt hangers. Sometimes it is advantageous to place tissue inside garments to further support the garment shape.

The purpose of storage is to provide a safe environment for clothes and accessories when not in use. Storage should provide protection from

- Dust and dirt
- Insects
- Fungus and bacteria
- Dye transfer
- Moisture

Figure 13.1 *"Getting your closet done" has become a popular innovation in home remodeling. A relatively small space can be organized to provide adequate hanging and flat storage space. (Courtesy California Closet Company)*

- Raw wood
- Light

Closet doors should be left ajar for good air circulation. Moth repellent products may be necessary in some climates as well as a closet light in areas with high humidity.

Plastic garment bags are harmful to the product because of the acid from the bags, the dust attracted by the static, and moisture entrapment. Placing garments next to raw wood exposes them to the acids of the wood, which will lead to staining.

The Storage Process

After wearing and routine care, garments should be prepared for and placed on hangers or put on shelves or in drawers. Air clothes as necessary to remove odors. Empty pockets and remove accessories. Decide if the garment needs cleaning. Place the garment in storage with like items and parts of an ensemble together. Garments that have just been cleaned should be removed from plastic bags and placed on supportive hangers. Check footwear for scuffs, damage, and run-down heels.

In some climates, summer and winter wardrobes are stored in the off-season. The Soap and Detergent Association ("Life after Storage," 2001, "Simple Steps," 2001) recommends four steps for successful seasonal storage. First, check to make sure the garments to be stored are clean and free of stains. Second, complete any repairs prior to storage. Third, do not iron items to be stored. Last, store garments in a cool, dark, dry, and well-ventilated area. When removing garments from seasonal storage, check for insect damage, stains, and odors. Air garments, press, and enjoy wearing seasonal favorites.

Caring for Clothing

Clothing care refers to the techniques used to clean garments to restore their just-purchased look.

Successful garment care depends on:

- Fibers, fabrication, dyes, and finishes that make up the garment's fabric.
- Chemical structure of the products used to clean garments and their interaction with the fabric's fibers, dyes, and finishes.
- Temperature of the water or air and the amount of agitation used to clean the garment.
- Quality of garment construction.

Permanent Care Labeling

A ruling by the Federal Trade Commission, first made effective in 1972, requires all wearing apparel and bolts of fabric sold by the yard to carry permanently affixed labels giving instructions for care. Items that are exempt from the ruling are household textiles, retail items costing less than $3.00, footwear, head gear, hand coverings, and items not used to cover and protect the body such as belts, neckties, handkerchiefs, and suspenders. Items that would be marred by the label as well as one-time use garments are also excluded.

Manufacturers are required to provide full care instructions about regular care or to provide warnings if a garment cannot be cleaned without harm. The care label must be permanently attached to the finished garment where it can be seen or easily found. The labels must remain legible for the life of the garment. Care information for piece goods must be at the end of the roll or bolt of fabric. If the label is not easy to see, additional information must appear on the packaging or hangtag fastened to the product.

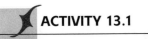

ACTIVITY 13.1 Care Labels

Create a care label for a garment that requires the following:
- Machine wash, normal
- Do not bleach
- Tumble dry, permanent press
- Steam iron medium

The care label ruling was revised in 1980. The revision was ordered to restore consumer confidence in garment care labels by providing information known to be reliable on care labels. At least one safe method for cleaning is to be given, even though other methods may be satisfactory. The ruling was amended in 1983 to increase the consistency, completeness, and accuracy of information. A glossary of terms was developed to ensure clarity. The care instructions must include whether the garment should be washed or dry cleaned, and only the process listed on the label is checked for safe use.

On July 1, 1997, a conditional exemption to the Care Labeling Rule allowed the option of care symbols to be used instead of words on apparel care labels (Pullen, 1997). The purpose of this voluntary care-symbol option was to harmonize with care labels in Canada and Mexico. Care labels with symbols are easy to learn and provide clear and accurate instructions on how to care for a product. These universally understood symbols are important in global trade. Care labels with symbols are smaller and have a more generic use, saving manufacturers and retailers on production, storage, and printing costs.

The care label symbol system is based on six basic symbols that are used to give care instructions (Soap and Detergent Association, 2001) (Figure 13.2). In addition to the symbols, lines and dots give consumers exact settings within each symbol category. The more dots used, the higher the heat. The more lines that are present, the gentler the movement. An X overlayed on a symbol is a warning not to use this process (Activity 13.1).

Types of Garment Care

There are three ways to clean garments: dry cleaning, professional wet cleaning, and laundering (washing).

Dry Cleaning

> In **dry cleaning,** petroleum solvents such as perchloroethylene (PERC) and synthetic solvents such as tricholortriflouroethane are used for soil and stain removal.

In dry cleaning, garments are sorted, cleaned, spotted, and finished by professionally trained garment care specialists. When care labels indicate dry cleaning as the

Figure 13.2 Care symbols provide clear and accurate instructions on how to care for a product. *(Courtesy The Soap and Detergent Association)*

⟩ ACTIVITY 13.2 **Understanding Professional Cleaning Processes**

Work with a partner. Select a dry cleaning business and a wet cleaning business in your community. One partner interviews the owner or manager and tours the dry cleaning facility. The other partner does the same for the wet cleaning business. Compare and contrast the two businesses. Share the results with class members.

appropriate care procedure, look for a dry cleaner with the IFI or International Fiber-care Institute symbol in the window or at the front counter. This national organization of professional dry cleaners uses voluntary standards to ensure consistent and quality garment care among its members.

Professional Wet Cleaning

Wet cleaning uses one or more water-based techniques to wash clothes that have traditionally been dry cleaned.

Wet cleaning involves both advanced computer-controlled machinery and certain hand-cleaning techniques. Professional wet cleaning uses specially developed washing and drying machines that can precisely control the characteristics of the washing and drying cycles, including heat, moisture, and agitation, according to the needs of various types of fabrics. Wet cleaning machines are controlled by microprocessors that can store dozens of programs for specific fabrics and garments. The machine work may be supplemented by manual wet cleaning techniques, which involve a variety of cleaning methods selected for the type of garment being cleaned. These techniques include steam cleaning, spotting, immersion and gentle hand washing, scrubbing, and tumble drying.

In a study in which duplicates of the same garment were professionally dry cleaned and professionally wet cleaned, high-quality garments performed well regardless of the professional cleaning system used. Color migration and color loss occurred in fabrics made of natural fibers in both cleaning systems. Dimensional change was noted with certain garments regardless of the cleaning system used. Garments with hand and resiliency changes tended to develop a better hand and resiliency. Clinging dry cleaning solvent odor was noted most in professionally dry cleaned garments, whereas most garments cleaned with the professional wet cleaning system were judged to have a clean smell (Jackson and Stanley, 1997) (Activity 13.2).

Laundering

Laundering is the process of hand or machine washing and drying apparel items to remove soil and stains as well as to restore items to their first-purchased appearance.

Laundering can take place in the home, in a laundromat, or at a professional laundry facility. Water is the solvent used with a variety of laundry products. Because this process is so common, the rest of this chapter is devoted to laundry techniques and products.

Laundry Products

The detergent aisle of any grocery store displays an overwhelming array of laundry products. It is important to match the laundry product to the garment's cleaning needs and fabric characteristics. Laundry products fall into the following categories: soaps and detergents, bleaches, water softeners and conditioners, pretreatments, fabric softeners, and starches and fabric finishes.

Soaps and Detergents

> **Soaps** are natural cleaning agents composed of fats, oils, and alkali along with compounds used to increase sudsing, soften hard water, and improve cleaning.

Soaps are rarely used in home laundry today because of their reaction to hard water. When the components of soap combine with the lime and magnesium salts found in hard water, a curd or scum is formed. This curd is almost insoluble, and it clings to fibers and fabrics, resulting in stiff, grayed clothes.

> **Detergents** are synthetic cleansing agents.

Two types of detergent dominate the laundry product market: built or heavy duty and unbuilt or mild. Built detergents contain alkali to boost cleaning power. They are used with sturdy fabrics with medium to heavy soil. Unbuilt detergents have a much lower or no alkali content and are used with delicate fabrics such as silk and wool.

Generally, detergents contain the following:

- Surfactants to lift dirt from clothes
- A builder to soften water and disperse soil
- Fabric whiteners to make fabrics appear whiter or brighter
- A suds control agent to raise or lower the level of foam generated by a detergent formulation
- A processing aid to improve manufacture and powder properties (e.g., pourability)
- A corrosion inhibitor to protect interior washer parts from corrosion
- An antiredeposition agent to prevent dirt from going back into the fabric
- Perfume to cover the chemical odor of the base product and to leave a pleasant residual odor on laundry (Collier and Tortora, 2001; Kadolph and Langford, 2002)

Some detergents also contain oxygen bleach, enzymes, and fabric softeners. These products are also available separately.

Bleaches

Bleaches are used to whiten fabrics, remove color from stains, and, combined with hot water, disinfect (Collier and Tortora, 2001; Kadolph and Langford, 2002).

Bleaches do not clean. Bleaches can remove color. There are two types of bleach used in home laundry, chlorine and oxygen.

Chlorine Bleach

Chlorine bleaches are strong bleaches that oxidize stains, whiten, and disinfect when used with hot water. They also remove color.

Chlorine bleaches can be used for **white** and **colorfast** cotton, linen, polyester, acrylic, triacetate, nylon, rayon, and permanent press. They cannot be used on silk, wool, mohair, spandex, colors not fast to bleach, and certain flame-retardant finishes. They should be added to the wash water about five minutes into the wash cycle because they inactivate optical brighteners. Chlorine bleach is best used with detergent, which acts as a buffer to protect fabrics. A general formula for chlorine bleach is one part bleach to four parts water. Fabrics that have been yellowed by chlorine bleaches may be restored by soaking the fabric in a solution of two tablespoons of sodium sulfite or hyposulfite (available at a photographic supply shop) and 1/2 cup (4 ounces) of white vinegar per gallon of hot water.

Oxygen Bleach

Oxygen bleaches whiten fabrics.

Oxygen bleaches are safe for all washable fabrics including cotton, silk, wool, durable press, rayon, and spandex as well as resin-treated and colored fabrics. They are not as effective for soil and stain removal or restoring whiteness as chlorine bleach. It is important to use them at each laundering for the optimal effect.

Water Softeners and Conditioners

Hard water contains dissolved minerals that interfere with the cleaning capability of laundry products.

Hard water creates problems in the laundry, and the minerals present in the water can prevent soaps and detergents from cleaning effectively. Some homeowners install a water softening system that reduces the minerals that interfere with laundry products. Water softeners are a way to control the effect of minerals in hard water. Precipitating water softeners such as borax combine with minerals to remove them from the water. Nonprecipitating water softeners such as Calgon tie up minerals and allow detergents to clean effectively.

Pretreatment Products

> **Pretreatment products** consist of petroleum-based solvents that facilitate the removal of soils and stains.

Pretreatment products are most effective on synthetic fabrics, garments with durable press finishes, and greasy stains. Enzymes are used to remove protein-based stains. It is important not to use them with protein-based fibers such as wool and silk, as they will cause the fabrics to decompose.

Fabric Softeners

> **Fabric softeners** use a lubricant to make fibers feel softer.

Fabric softeners make clothes fluffy, minimize wrinkling, and eliminate the static electricity that causes clothes to cling. These products are used either in the wash water, the rinse water, or as a dryer product. Fabric softeners for the washer tend to be liquids that need to be diluted prior to adding to the wash or rinse water. Fabric softeners for the dryer are imbedded in nonwoven fabrics or sponges. The heat of the dryer releases the softening ingredients. Dryer sheets can be used in the last rinse of the wash cycle if a dryer is not used.

Some fabric softeners create a buildup on fibers, causing reduced absorbency. This can be a problem for products intended to absorb moisture such as towels. To remove the excess fabric softener, put the product through a wash cycle using a non-precipitating water softener such as Calgon, and continue washing the product until the water is clear.

Starches and Fabric Finishes

> **Starches and fabric finishes** are temporary sizings that restore body and stiffness to limp fabrics.

Starches and fabric finishes also tend to help fabrics shed soil because the dirt slides off the smooth finish. Stains tend to attach to the starch, making them easier to remove. They are available as liquids and sprays (Activity 13.3).

Laundry Procedures

There are several steps to achieve satisfactory results when laundering clothes.

Garment Preparation

Clothes that are to be laundered need some attention prior to entering the care process. Remove all items from the pockets and take off pins, detachable trims, and unwashable buttons and belts. Inspect the garment for and complete needed repairs. Zip up zippers and turn dark clothing inside out to prevent lint from collecting on the right side of the garment. Make sure all parts of an ensemble are laundered together.

Category	Description
Dark colors	Separate dark-colored clothing to keep them free of lint and to prevent any color transfer to light-colored garments.
White and light-colored synthetics	Color pickup from other garments is avoided if these garments are handled separately.
Fabrics to be bleached	White and light-colored synthetics and cottons to be bleached during washing are put together.
Colored clothes	Brilliant colors should be washed separately to avoid color transference. These may require cold or warm water.
Terry and velvet-cut towels	Dark, intense colors will be dulled by lint from other colors. They should be washed separately.
Knits and delicate garments	These require gentle handling.
Durable-press	Durable-press pieces can be washed in the regular manner if an automatic dryer is to be used. If these garments are line dried, wrinkles may not be removed.

Figure 13.3 Garment sorting.

Sorting

Like items should be laundered together. Sorting items by color, fiber, fabrication, size of the item, lint production, colorfastness, and amount of soil can improve the results significantly (Figure 13.3).

Pretreating

Spots, stains, and excessively soiled garments may need treatment before washing. Synthetic fibers and many easy-care finishes tend to retain oil-borne stains. Washing in cold water reduces the effectiveness of many laundry products. Pretreatment products and concentrated liquid detergent can be used approximately fifteen minutes prior to washing. Read and follow label instructions, including information about fiber content, nature of the soil, and testing for colorfastness. Figure 13.4 offers stain removal suggestions.

Heavily soiled apparel items may require presoaking. This can be done in the washing machine on a presoak cycle or by using the rinse cycle. Presoaking is most effective when warm or hot water is used.

Water Temperature

The fiber, construction of the garment, fabric dyes, finishes, and the amount and type of soil will influence the water temperature needed to clean clothes. The best guide

This chart applies only to washable items. It does not apply to garments which should be dry-cleaned. Some stains are not easily seen when the fabric is wet. Air dry the articles to be certain the stain has been removed. Machine drying might make the stain more difficult to remove. Prewash products may be more convenient to use in treating stains than the process of rubbing detergent into the dampened stain.

	Bleachable Fabrics: White and colorfast cotton, linen, polyester, acrylic, triacetate, nylon, rayon, permanent press.	Non-Bleachable Fabrics: Wool, Silk, Spandex, non-colorfast items, some flame-retardant finishes (check labels).
Stain	**Removal Procedure**	**Removal Procedure**
Alcoholic Beverages	Sponge stain promptly with cold water or soak in cold water for 30 minutes or longer. Rub detergent into any remaining stain while still wet. Launder in hot water using chlorine bleach.	Sponge stain promptly with cold water or soak in cold water for 30 minutes or longer. Sponge with vinegar. Rinse. If stain remains, rub detergent into stain. Rinse. Launder.
Blood	Soak in cold water 30 minutes or longer. Rub detergent into any remaining stain. Rinse. If stain persists, put a few drops of ammonia on the stain and repeat detergent treatment. Rinse. If stain still persists, launder in hot water using chlorine bleach.	Same method, but if colorfastness is questionable, use hydrogen peroxide instead of ammonia. Launder in warm water. Omit chlorine bleach.
Candle Wax	Rub with ice cube and carefully scrape off excess wax with a dull knife. Place between several layers of facial tissue or paper towels and press with a warm iron. To remove remaining stain, sponge with safe cleaning fluid. If colored stain remains, launder in hot water using chlorine bleach. Launder again if necessary.	Same method. Launder in warm water. Omit chlorine bleach.
Catsup	Scrape off excess with a dull knife. Soak in cold water 30 minutes. Rub detergent into stain while still wet and launder in hot water using chlorine bleach.	Same method. Launder in warm water. Omit chlorine bleach.
Chewing Gum, Adhesive Tape	Rub stained area with ice. Remove excess gummy matter carefully with a dull knife. Sponge with a safe cleaning fluid. Rinse and launder.	Same method.

Figure 13.4 Sample stain removal guide. *(Courtesy Maytag)*

	Bleachable Fabrics: White and colorfast cotton, linen, polyester, acrylic, triacetate, nylon, rayon, permanent press.	**Non-Bleachable Fabrics:** Wool, Silk, Spandex, non-colorfast items, some flame-retardant finishes (check labels).
Stain	**Removal Procedure**	**Removal Procedure**
Chocolate and Cocoa	Soak in cold water. Rub detergent into stain while still wet, then rinse thoroughly. Dry. If a greasy stain remains, sponge with a safe cleaning fluid. Rinse. Launder in hot water using chlorine bleach. If stain remains, repeat treatment with cleaning fluid.	Same method. Launder in warm water. Omit chlorine bleach.
Coffee, Tea	Soak in cold water. Rub detergent into stain while still wet. Rinse and dry. If grease stain remains from cream, sponge with safe cleaning fluid. Launder in hot water using chlorine bleach.	Same method. Launder in warm water. Omit chlorine bleach.
Cosmetics (Eye shadow, lipstick, liquid make-up, mascara, powder, rouge)	Rub detergent into dampened stain until outline of stain is gone, then rinse well. Launder in hot water using chlorine bleach.	Same method. Launder in warm water. Omit chlorine bleach.
Crayon	Rub soap (Instant Fels, Ivory Snow, Lux Flakes) into dampened stain, working until outline of stain is removed. Launder in hot water using chlorine bleach. Repeat process if necessary. For stains throughout load of clothes, wash items in hot water using laundry *soap* and 1 cup baking soda. If colored stain remains, launder with a detergent and chlorine bleach.	Same method. Launder in warm water using plenty of detergent. Omit chlorine bleach. If colored stain remains, soak in an enzyme presoak or an oxygen bleach using hottest water safe for fabric; then launder.
Deodorants and Antiperspirants	Rub detergent into dampened stain. Launder in hot water using chlorine bleach. Antiperspirants that contain such substances as aluminum chloride are acidic and may change the color of some dyes. Color may or may not be restored by sponging with ammonia. Rinse thoroughly.	Rub detergent into dampened stain. Launder in warm water. Antiperspirants that contain such substances as aluminum chloride are acidic and may change the color of some dyes. Color may or may not be restored by sponging with ammonia. (If ammonia treatment is required, dilute with an equal amount of water for use on wool, mohair, or silk.) Rinse thoroughly.

Figure 13.4 Sample stain removal guide. *(continued)*

	Bleachable Fabrics: White and colorfast cotton, linen, polyester, acrylic, triacetate, nylon, rayon, permanent press.	Non-Bleachable Fabrics: Wool, Silk, Spandex, non-colorfast items, some flame-retardant finishes (check labels).
Stain	**Removal Procedure**	**Removal Procedure**
Fingernail Polish	Sponge white cotton fabric with nail polish remover; other fabrics with amyl acetate (banana oil). Launder. Repeat if necessary.	Same method.
Fruit Juices	Soak in cold water. Launder in hot water using chlorine bleach.	Soak in cold water. If stain remains, rub detergent into stain while still wet. Launder in warm water.
Grass	Rub detergent into dampened stain. Launder in hot water using chlorine bleach. If stain remains, sponge with alcohol. Rinse thoroughly.	Same method. Launder in warm water. Omit chlorine bleach. If colorfastness is questionable or fabric is acetate, dilute alcohol with two parts water.
Grease and Oil (Car grease, butter, shortening, oily medicines such as oily vitamins)	Rub detergent into dampened stain. Launder in hot water using chlorine bleach and plenty of detergent. If stain persists, sponge thoroughly with safe cleaning fluid. Rinse.	Rub detergent into dampened stain. Launder in warm water using plenty of detergent. If stain persists, sponge thoroughly with safe cleaning fluid. Rinse.
Ink (Ballpoint)	Sponge stain with rubbing alcohol, or spray with hair spray until wet looking. Rub detergent into stained area. Launder. Repeat if necessary.	Same method.
Ink from Felt Tip Pen	Rub household cleaner such as 409 or Mr. Clean into stain. Rinse. Repeat as many times as necessary to remove stain. Launder. Some may be impossible to remove.	Same method.
Mayonnaise, Salad Dressing	Rub detergent into dampened stain. Rinse and dry. If greasy stain remains, sponge with safe cleaning fluid. Rinse. Launder in hot water with chlorine bleach.	Same method. Launder in warm water. Omit chlorine bleach.
Mildew	Rub detergent into dampened stain. Launder in hot water using chlorine bleach. If stain remains, sponge with hydrogen peroxide. Rinse and launder.	Same method. Launder in warm water. Omit chlorine bleach.

Figure 13.4 Sample stain removal guide. *(continued)*

	Bleachable Fabrics: White and colorfast cotton, linen, polyester, acrylic, triacetate, nylon, rayon, permanent press.	Non-Bleachable Fabrics: Wool, Silk, Spandex, non-colorfast items, some flame-retardant finishes (check labels).
Stain	**Removal Procedure**	**Removal Procedure**
Milk, Cream, Ice Cream	Soak in cold water. Launder in hot water using chlorine bleach. If grease stain remains, sponge with safe cleaning fluid. Rinse.	Soak in cold water. Rub detergent into stain. Launder. If grease stain remains, sponge with safe cleaning fluid. Rinse.
Mustard	Rub detergent into dampened stain. Rinse. Soak in hot detergent water for several hours. If stain remains, launder in hot water using chlorine bleach.	Same method. Launder in warm water. Omit chlorine bleach.
Perfume Perspiration	Same as alcoholic beverages. Rub detergent into dampened stain. Launder in hot water using chlorine bleach. If fabric has discolored, try to restore it by treating fresh stains with ammonia or old stains with vinegar. Rinse. Launder.	Same as alcoholic beverages. Same method. Launder in warm water. Omit chlorine bleach.
Ring Around the Collar	Apply liquid laundry detergent or a paste of granular detergent and water on the stain. Let it set for 30 minutes. A prewash product especially designed for this purpose may be used. Follow manufacturer's directions. Launder.	Same method.
Rust	Launder in hot water with detergent and RoVer2 Rust Remover. Follow manufacturer's instructions. RoVer is available from authorized Maytag dealers and parts distributors; specify Part No. 57961.	Same method. If colorfastness is questionable, test a concealed area first.
Soft Drinks	Sponge stain immediately with cold water. Launder in hot water with chlorine bleach. Some drink stains are invisible after they dry, but turn yellow with aging or heating. This yellow stain may be impossible to remove.	Same method. Launder in warm water. Omit chlorine bleach.

Figure 13.4 Sample stain removal guide. *(continued)*

ACTIVITY 13.3 Home Laundry Products

Make a list of the laundry products that you own. What is the primary purpose of each product? Review the care labels in your closet. Do the garment needs and the laundry products match?

Temperature	When to Use
Hot water: 140°F (60°C)	Use for white cottons, white linens, and heavily soiled clothing.
Warm water: 100–110°F (37.78–43.33°C)	Use for colored cottons, delicates, and spandex. Durable-press, synthetics, and blends that will be dried in the dryer can use this temperature.
Cold water: from the tap	Use for durable-press, synthetics, and blends if not dried in a dryer. Washable woolens and knits use with gentle action. Use for bright or sensitive colors that have a tendency to fade.

Figure 13.5 General guidelines for washing temperature.

to water temperature is the garment care label. See Figure 13.5 for general guidelines for water temperature.

Loading and Cycle Selection

Consult the garment care labels for the most effective cycle. Place the items to be washed in the laundry tub loosely. They should not be folded. Fill the laundry tub to the top of the agitator. For some items such as terry robes it is best to select a second rinse to make sure all detergent has been removed.

Drying

Drying can be accomplished with or without a dryer. Refer to the garment care label for the best way to dry just-washed items. When deciding how to dry an item, consider color, fiber, finish, colorfastness, and garment construction. If using a dryer, use dryer settings that correspond to the recommendations on the care label. Line, hanging, or flat drying are energy efficient and can reduce shrinkage. If the items are stiff, use the air setting on the dryer to restore some softness.

Ironing and Pressing

Ironing requires a gliding motion with a heated iron that removes wrinkles from fabrics.

Equipment	Description
Ironing board	A well-padded, balanced board with a tight-fitting, lint-free cover is necessary to obtain a good finish on fabrics.
Iron	A steam iron is the best choice, especially one with a spray. Sole plates (the heated surface of the iron) with a nonstick finish are convenient.
Sleeve board or roll	A long, narrow cylinder used to press sleeves and other small shaped areas to eliminate crease lines.
Press cloth	A piece of cotton fabric such as medium-weight cotton muslin or cotton drill that is used on the surface of the right side of the fabric to prevent singes when ironing a garment.
Pressing mitt	A hot-pad type mitt used to press rounded and shaped areas that are difficult to reach.
Strips of heavy wrapping paper	Grocery sack paper cut lengthwise about 2″ from the crease can be placed under seams to prevent a seam impressing from showing.

Figure 13.6 Pressing and ironing equipment.

Pressing uses a lifting motion that shapes fabrics.

Personal standards and fashion influence the amount of smoothness expected of one's appearance. The fiber and finishes as well as the washing and drying procedures used will indicate the amount of ironing and pressing required. Use the garment care label to determine the temperature of the iron. Ironing on the wrong side of gabardine, rayon, acetate, and silk fabrics can help prevent a shine from developing on the outside surface of the fabric. Wool should not be pressed dry as it makes the fibers brittle. Pile fabrics such as corduroy and velvet should be pressed into a terry towel to prevent the pile from being flattened. Figure 13.6 describes types of ironing and pressing equipment.

Care Products that Extend the Wear Time of Garments

Some garment care products are designed to extend the time garments can be worn before dry cleaning or washing. They can release wrinkles, neutralize odors, and/or remove light stains. There are three types of products: wrinkle removers, fabric refreshers, and in-dryer care kits. When using garment care products, read and follow the instructions that are printed on the container. Coordinate the product instructions with the garment care label information.

Wrinkle removers relax fibers and release wrinkles without ironing.

Wrinkle removers were developed to smooth fabrics without an iron (Soap and Detergent Association, 2001). These spray-on products can be used on washable and

dry cleanable garments that do not water spot. Clothes that have been in a dryer, closet, drawer, or suitcase can be sprayed, tugged, and smoothed for a wrinkle-free appearance.

Fabric refreshers neutralize odors in hard-to-clean fabrics.

Fabric refreshers are aimed at odor control (Soap and Detergent Association, 2001). Refreshers can remove odors from fabrics by spraying the fabric surface or by adding the refresher to the wash cycle.

In-dryer care kits freshen garments, get rid of wrinkles, and remove light stains. These care kits do not replace garment cleaning; they just increase the number of wearings between cleanings. They can be used with garments that are dry clean only, hand washable, or made with special details such as beads or sequins. Some kits should not be used with leather, suede, or fur. It is important to check for colorfastness prior to use. Touch-up ironing may be needed.

❧ Summary

This chapter focuses on clothing care. Routine maintenance and garment storage are important strategies in prolonging the life of a garment. Understanding care labels facilitates cleaning decisions and helps consumers to maintain the new look of apparel items. It is important to coordinate fabric characteristics and garment construction with laundry products and processes for successful care experiences. Figure 13.7 gives a summary of care procedures by fiber content.

❧ Key Terms and Concepts

Bleaches
Chlorine bleach
Clothing care
Colorfast fabric
Detergents
Dry cleaning
Fabric refreshers
Fabric softeners
Hard water
In-dryer care kits

Ironing
Laundering
Oxygen bleach
Pressing
Pretreatment products
Soaps
Starches and fabric finishes
Wet cleaning
White fabric
Wrinkle removers

❧ References

Collier, B. J., and Tortora, P. G. (2001). *Understanding textiles* (6th ed.). Upper Saddle River, NJ: Prentice Hall.

Jackson, H. O., and Stanley, M. S. (1997). Professional cleaning systems' effects on apparel product performance. In N. Owens (ed.) *Proceedings for the International Textile and Apparel Association, 38*. Monument, CO: International Textile and Apparel Association.

Natural Fibers

Cotton
- Preshrink before sewing fabric.
- Machine wash in hot water with soap or on delicate cycle of machine. Fabric softener may be used during final rinse.
- Chlorine bleach may generally be used on whites; on colored clothes only if specially formulated.
- If labeled "do not bleach," never use chlorine bleach.
- Machine dry at regular or hot setting.
- Remove permanent press items from dryer as soon as cycle is completed and fold or hang immediately.
- Press or iron with moderately hot iron.
- Press while damp.
- Press dark garments on wrong side.
- Dry clean if colors run.

Linen
- Machine wash in warm water with mild suds.
- Do not twist or wring.
- Smooth and let dry on nonrust hangers.
- Avoid repeated pressing of sharp creases to prevent fibers from breaking.
- Press while damp, on wrong side, with hot iron.
- Protect stored linens from mildew.
- May be dry cleaned to improve shape retention.

Ramie
- Machine wash in warm water with mild suds.
- Do not twist or wring.
- Smooth and let dry on nonrust hangers.
- Avoid repeated pressing of sharp creases to prevent fibers from breaking.
- Press while damp, on wrong side, with hot iron.

Silk
- Usually silk must be dry cleaned.
- If labeled "hand washable," use only a mild soap and warm water.
- Do not use chlorine bleach or strong soaps and detergent.
- Do not wring or twist.
- Smooth and let dry on a nonrust hanger.
- Press while damp, on wrong side, with warm, not hot, dry iron.
- Protect from prolonged exposure to sunlight.
- Protect from moths and carpet beetles.

Wool
- Preshrink fabrics before sewing.
- Wool is usually dry cleaned.
- If washed, use hand or delicate machine cycle, cold water, mild soap or special wool soap, such as Woolite.
- Do not rub, wring, or twist.
- Avoid chlorine bleach and strong soaps or detergents.
- Smooth out and dry on flat towel.
- Press with steam on moderate heat setting, on wrong side of fabric and with press cloth.
- Protect against moths and carpet beetles.
- Air wool garments frequently. Let stand twenty-four hours between wearings.
- Wool may be hung near a steamy tub or shower to remove wrinkles.
- "Washable" woolens are good for children's wear, but tailored-style adult clothing tends to lose its shape when washed.

Figure 13.7 Natural and man-made fibers care. *(Reproduced by permission,* Wardrobe Strategies for Women *by J. Rasband. Albany, NY: Delmar Publishing, copyright 1996)*

Man-Made Fibers

Acetate
- Generally acetate should be dry cleaned. If labeled "washable," use the following guidelines:
 - Do not soak colored fabrics or they may fade.
 - Wash in mild suds and lukewarm water.
 - Do not wring or twist.
 - Smooth or shake out garment and let dry on a nonrust hanger.
 - Press while damp on wrong side with the lowest setting. Use a press cloth for work done on the right side.
 - Nail polish and perfumes containing acetone will dissolve fabric.

Acrylic
- Remove oil spots and stains before washing.
- Wash delicate items by hand in warm water with soap. Rinse thoroughly in warm water.
- Gently squeeze out water; do not wring or twist.
- Smooth or shake garment and let dry on nonrust hanger. Knit garments should be dried flat on towel.
- When machine washing, use warm water and add a fabric softener during the final rinse cycle once in every four to five washings to reduce static buildup.
- Machine dry at low temperature setting. Remove garments from dryer immediately to prevent heat-set wrinkles.
- If ironing is required, use a moderately warm iron, never hot.

Anidex
- Machine wash similar to Spandex.
- Tumble dry on warm heat or cool.

Modacrylic
- Dry cleaning or fur cleaning process is best for deep pile garments.
- If washable, machine wash in warm water and add a fabric softener during the final rinse cycle once every four or five washings to reduce static buildup.
- If machine dried, use low setting and remove articles immediately after end of cycle.
- If ironing is required, use lowest setting. Never use a hot iron or fabric will melt.

Nylon
- Wash delicate items by hand in warm water with soap or detergent.
- Rinse thoroughly in warm water and use a fabric softener in the rinse water.
- Gently squeeze out water, do not wring or twist.
- Smooth or shake out garment and let dry on nonrust hangers. Sweaters and knit items should be dried flat.
- Most items made from nylon can be machine washed. Use warm water and add fabric softener to the final rinse cycle once every four to five washings to reduce static buildup.
- Bleachable with chlorine bleach, but test for color fastness first.
- Machine dry at low temperature setting and remove articles from dryer as soon as cycle is completed to avoid heat-set wrinkles.
- If ironing is required, use a moderately warm iron. Never use a hot iron or fabric will melt.
- May use a commercial color remover on grayed or yellowed nylon fabric.
- Is a "scavenger" for color. It takes on the color from darker clothes during washing and storing. Separate nylon items in washing and in storage bags or containers.

Polyester
- Remove spots before washing with undiluted liquid detergent or spray-stain remover.
- Wash delicate items by hand in warm water with soap or detergent.
- Rinse thoroughly in warm water.
- Use a fabric softener in the rinse cycle to reduce static buildup.
- Gently squeeze out water and smooth or shake out garment and let dry on a nonrust hanger.

Figure 13.7 Natural and man-made fibers care. *(continued)*

Polyester
- Most items made from polyester can be machine washed in warm water and soap, with fabric softener used in the rinse cycle.
- Machine dry at a low temperature setting and remove items when drying cycle is completed to prevent heat-set wrinkles.
- If ironing is desired, use a moderately warm iron. Never use a hot iron or fabric will melt.

Rayon
- Most rayon fabrics wash well with gentle agitation, but some types of fabric and garment construction make dry cleaning advisable.
- For washable items, use mild suds in lukewarm water.
- Do not soak colored fabrics or fading may occur.
- Bleach may generally be used, however, some rayon fabrics are sensitive. Test first.
- Gently squeeze suds through fabric and rinse in lukewarm water.
- Do not twist or wring fabric.
- Smooth or shake out article and dry on nonrust hanger.
- Press the article while damp, on the wrong side and with an iron moderately warm. Use a press cloth when pressing on the right side.

Spandex
- Hand or machine wash on delicate cycle in lukewarm water.
- Do not use chlorine bleach on any fabric containing Spandex unless directed otherwise. Use an oxygen or sodium perborate type bleach.
- Rinse thoroughly.
- Drip dry. If machine dried, use low temperature setting.
- If ironing is required, use light, quick strokes, on low temperature setting.

Triacetate
- Pleated garments are best hand washed. Most other garments containing 100 percent Triacetate can be machine washed and dried.
- Jersey knits need no ironing. Touch up woven garments with steam iron.
- Nail polish and perfumes containing acetone will dissolve Triacetate.

Figure 13.7 Natural and man-made fibers care. *(continued)*

Kadolph, S. J. (1998). *Quality assurance for textiles and apparel.* New York: Fairchild.

Kadolph, S. J., and Langford, A. L. (2002). *Textiles* (9th ed.). Upper Saddle River, NJ: Prentice Hall.

Life after Storage: Reviving your winter wardrobe. (2001, November/December) *Cleanliness facts,* p. 2. Washington, DC: Soap and Detergent Association.

Pullen, J. A. (1997). Decoding the ASTM care symbol system. *Textile chemists and colorists, 29*(12), 28–32.

Rasband, J. (1996). *Wardrobe strategies for women.* Albany, NY: Delmar.

Simple steps for summer storage. (2001, September/October). *Cleanliness facts,* p. 3. Washington, DC: Soap and Detergent Association.

Soap and Detergent Association. (2001). Fabric care for today's hectic lifestyle. Retrieved February 27, 2002, at http://www.cleaning101.com.

14

Wardrobe Planning

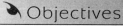

Objectives

- Show the importance of planning prior to clothing selection.
- Discuss the relationship between resources and clothing budget.
- Establish general principles for wardrobe planning and clothing and accessory purchases.
- Delineate principles of appropriate dress for various occasions.

Consumer Clothing Selection Issues

Clothing
Purchasing

Wardrobe
Planning

Clothing
Care

Clothing
Quality

Clothing Fit

Wardrobe is a collection of clothes and accessories.

Thus far in this text, the influences on consumer clothing selection and the elements and principles of clothing design, including the impact on individual consumers, has been covered. Actual clothing selection issues are now addressed. In other words, keeping the foundational steps in mind, what is the process by which a consumer makes clothing choices?

Wardrobe items are typically accumulated over time. In examining the garments in a selected consumer's wardrobe, one would find:

- Clothes worn frequently
- Special-occasion clothes
- Clothes rarely worn

Few consumers have a workable, coordinated wardrobe that completely suits their lifestyle. Most consumers continue to add to and subtract from their personal clothing collection with little forethought or planning. A planned wardrobe can work very much like a planned budget. Assets can be built on, and liabilities can be eliminated. By careful wardrobe analysis, consumers can organize and coordinate groups of clothing to serve a variety of needs and occasions.

Several consumer trends have emerged in the past few decades that have further established the need to put thought into a wardrobe:

- A dramatic increase in the percentage of women working outside the home requires that their clothing budget now be apportioned between career and more casual apparel.
- The discriminating consumer's desire for "value" in clothing purchases encourages comparison of the value differences between individual clothing items (Much, 1998).
- The casual trend in many companies regarding career dress motivates consumers to add appropriate sportswear to their wardrobes.
- A decrease in time to shop and pleasure taken in shopping necessitates forethought to make the most of each clothing purchase excursion.

The fashion industry works to keep abreast of these trends and has made changes to accommodate consumers. Retailers have:

- Added departments featuring professional wear such as Dana Buckman to accommodate career women.
- Stepped up the quality of the private label programs (Much, 1998)—Macy's INC, for example—and offered many price levels of apparel to accommodate each budget requirement.
- Jumped on the casual business trend by promoting career-appropriate casual coordinates for men and women, such as The Gap.
- Hired personal shoppers to cut consumers' shopping time such as Saks Fifth Avenue's 5th Avenue Club.

Manufacturers also have made efforts to meet changing consumer trends:

- Many traditional menswear manufacturers have introduced new lines of professional womenswear, such as Brooks Brothers.
- Manufacturers of designer clothing—Anne Klein, Donna Karan—have urged designers to create less expensive diffusion lines like Anne Klein II and DKNY.
- Manufacturers of sportswear have produced casual professional clothing and promoted it to companies nationwide such as Dockers by Levi's.
- Manufacturers have sought to decrease shopping time by putting apparel "catalogs" on the Internet such as L.L. Bean and Lands' End.

Despite their efforts to provide a variety of apparel choices, manufacturers and retailers know that wardrobe planning and choices are still an individual endeavor, for each consumer is the best judge of his or her own clothing needs. Consumers in the twenty-first century have a broadened base of apparel appropriate for personal and careerwear, allowing them much more freedom of expression in apparel choices.

Much of the foundational information for consumers in planning personal wardrobes or for fashion professionals in planning apparel inventories suitable to their customer was discussed in Part I of this text. For a summary of this material, see Figure 14.1.

Sociopsychological	Cultural	Physical	Target Market	Fashion Industry
Image Roles Personality Self-concept Values Attitude Interests Individuality	Geographic location Ethnicity Sexual orientation	Nutritional status Body proportion Head proportion Muscle/fat percentage Height/weight distribution Skin Hair Nails	Lifestyle Consumer groups Lifestage Age Income Education Work status	Fashion promotion Fashion trends Designers' offerings Fashion leaders

Figure 14.1 Influences on clothing selection.

Wardrobe Planning

This chapter offers some areas to consider regarding wardrobe planning that will enable consumers to be appropriately dressed for various occasions at an affordable budget. These include lifestyle analysis, existing wardrobe analysis, resource evaluation, basic and extra wardrobe component identification, and purchase planning.

Lifestyle Analysis

Any wardrobe plan must begin with thoughtful evaluation of the consumer's lifestyle (Figure 14.2). Lifestyle is a major variable in decision making and was discussed in Chapter 4 of this text. In this chapter, individual consumer lifestyles will be evaluated as a means of wardrobe planning.

The lifestyle chart (Activity 14.1) will help individuals understand the various patterns of everyday living. Completing the chart with a focus on an individual's current activities can help determine current wardrobe needs. The amount of time spent in various activities gives a graphic idea of the percentage of the wardrobe to devote to the kinds of clothing required by these activities. (A change in lifestyle necessitates clothing changes.)

Existing Wardrobe Analysis

An analysis of consumers' existing wardrobes helps one to understand consumers' clothing preferences. To understand a particular consumer's clothing preferences, use the criteria in Figure 14.3 to evaluate the garments that an individual most often wears. After this analysis, one can begin to identify one's own fashion personality.

Fashion personality categorizes the basic style patterns into which an individual would most likely fit.

Figure 14.2 *A wardrobe plan fits a particular lifestyle and pattern of activities. A surfer would have different requirements from a rock climber, for instance. (Courtesy Quicksilver)*

Lifestyle Match	Design	Fit	Care Required	Quality
Dominant lifestyle activities Anticipated future lifestyle activities	Predominant lines Style Color Texture Classic or trendy design	Fit based on current body conformation Physical comfort Psychological comfort	Shape stability Pressing ease Affinity to soils Cleaning method required Maintenance expense	Original price Length of ownership Fiber content Fabrication Design Construction

Figure 14.3 Bases of evaluating clothing owned.

To determine a consumer's fashion personality, answer the questions in Activity 14.2. The characteristics of the clothing the person most often wears can now be used to place the consumer into one of the five main fashion personality categories: (1) dramatic, which is high fashion and extreme; (2) sporty or natural, which emphasizes casual, comfortable clothing; (3) classic, which leans toward tailored, simple, understated lines; (4) romantic, which is feminine, often relying on soft or floral textured fabrics; and (5) eclectic, which is characterized by creative, unusual combinations of textures, colors, and styles of clothing. For a complete description, use Figure 14.4. Most consumers will identify a dominant fashion personality (Figure 14.5) that describes the majority of their apparel choices and a subordinate fashion personality

ACTIVITY 14.1 Lifestyle Chart

1. List the activities in the time chart below of a selected consumer using the following code:

 A = Athletics (sports, exercise)
 B = Executive office work
 C = Casual office work
 F = Formal/semiformal events
 S = Social events
 T = Travel
 O = Other (Specify: _)

2. Analyze the percentage of time spent on each *type* of activity.
3. Plan clothing appropriate for each activity.
4. Apportion the consumer's clothing budget based on 1–3.

	Mon.	Tues.	Wed.	Thurs.	Fri.	Sat.	Sun.
5 A.M.							
6							
7							
8							
9							
10							
11							
Noon							
1 P.M.							
2							
3							
4							
5							
6							
7							
8							
9							
10							
11							

that describes the remainder of their clothing choices. Individuals usually find that when they wear clothing outside of their fashion personality, they feel psychologically uncomfortable.

Evaluating the characteristics of frequently worn clothing yields insightful information about clothing preferences. For example, as a result of completing the exercises, the various characteristics that make garments pleasing, practical, and appropriate for this particular consumer and the variety of clothing needed for this consumer's lifestyle should be clearer.

Fashion Personality	Fabric	Colors	Patterns	Accessories	Clothing Goal
Classic	Natural fibers	Neutral	Solids, small motifs	Pearls, simple gold cufflinks	Investment dressing, understated
Sporty/ natural	Ease of wear: cotton, lycra, blends	Primary, neutrals	Geometric	Minimal, sports watch	Comfort, informal, casual
Dramatic	Unusual, extreme	Black, white, strong chroma	Abstract, trendy	Bold, unusual tie patterns	Attract attention, high fashion
Romantic	Touchable angora, cashmere	Pastels	Floral, tweeds	Ribbons, scarves, pocket squares	Soft appearance
Eclectic	Unmatched combinations	Unusual	Odd	Variety from several eras	Individuality

Figure 14.4 Fashion personalities.

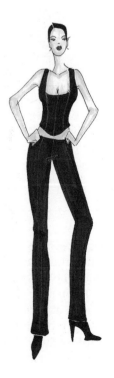

Figure 14.5 *Using the fashion personalities described in Figure 14.4, what would be the fashion personality of this woman? (Courtesy Kit Sui)*

ACTIVITY 14.2 Fashion Personality Identification

Answer the following questions to begin to identify an individual's fashion personality:

- Is the consumer a fashion leader or a fashion follower? Fashion leader: Does the consumer enjoy wearing trendy clothes or classics? Fashion follower: Is the consumer a conservative dresser who likes to use clothing to blend in with the crowd or is he or she part of a subculture that uses clothing to shock the establishment?
- What colors predominate the consumer's wardrobe; e.g., pastels, neutrals, unusual combinations, strong chroma?
- What fabrics predominate in the consumer's wardrobe; e.g., natural, manufactured, blends?
- What patterns predominate the wardrobe; e.g., solids, abstracts, geometric, florals?
- What accessories does the consumer favor; e.g., pearls for women, simple gold watch for men?

By using the information on pages 378–379, criteria can be developed on which to base the selection of new garments. The goal is to have a wardrobe containing clothing that is actually worn. Typically, any item that has not been worn for one year may be eliminated. Garments that require hanging and that are worn only occasionally may be moved into a secondary storage space, if possible. Garment repair or updating occurs before replacing clothing into a closet. Clothing and accessories may be grouped by color and usage, which facilitates clothing coordination.

Resource Evaluation

Wardrobe planning entails exploring all available resources. The first question that most often comes to mind is what proportion of a consumer's income can be allotted to clothing purchases and upkeep. A recent study shows that the average American family of four spends $3,868 on clothing, with a third more spent on women's clothing than on men's (Carini, 2001).

Women's apparel accounted for 52 percent of all apparel sales in 2000, while men's accounted for 31 percent ("Industry Environment," 2000).

Wardrobe costs also include the price of upkeep. The methods used for garment cleaning often affect the clothing budget and need to be planned. Whether to buy a real suede jacket, which requires leather-cleaning techniques at about seven times the cost of regular professional dry cleaning, or a washable pseudo-leather garment is more than a fashion decision. Economical, washable fabrics can replace the dry-clean-only textiles in wardrobes of consumers with limited clothing dollars. Light-colored clothing with dry-clean-only labels will require more expensive upkeep than darker clothing.

Many consumers overlook the simple economics of quality versus quantity. Garments that need frequent replacement do not contribute to wardrobe building. High-quality clothing of fine workmanship and materials is often overlooked from the

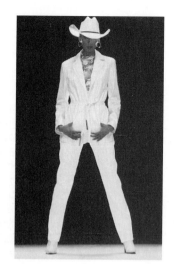

Figure 14.6 *Wardrobe basics are classic in style and design, in low value colors and nonextreme textures. This outfit would be classified as basic for a conservative executive career-type wardrobe. (Courtesy St. John)*

standpoint of dollar savings. However, a good-quality major clothing item in a classic style can be worn for many years and, therefore, is less expensive in the long run than two or three garments of lesser quality that will need to be replaced during the same number of years.

> The **cost per wearing formula** (cost of garment/number of wearings) helps determine the true value of an item of clothing.

Consumers can determine the value of a garment by applying the cost per wearing formula. Consider the example given in Case Study 14.1. A contrasting example is found by applying the formula to tuxedos and evening gowns.

Family clothing budgets must be extended to cover the needs of each family member. Major purchases are usually staggered so that expensive items of clothing do not have to be purchased all at the same time, which is especially important for consumers living on a limited budget. Both families and individuals benefit from planning for clothing expenditures in advance.

Basic and Extra Wardrobe Component Identification

> **Basics** form the framework of the collected wardrobe. These garments are worn most often, every day, season after season.

The next aspect of wardrobe planning is putting all the preliminary analyses, budgeting, and planning into action. When making clothing purchase decisions, not only is the original price important but also how the garment coordinates with various other clothing in a consumer's existing wardrobe. An existing wardrobe contains items on which to build. If these garments are of a style that enables them to be worn for most of one's activities, they may become the basics of the wardrobe (Figure 14.6). When

CASE STUDY 14.1

 Determining Garment Value

Jonathan is graduating from college and entering the workforce as an executive trainee for Macy's department store. He needs a wool blazer for work. He is examining two choices. Since both are classic in design and made of a year-round-weight wool, he will wear either blazer once a week for fifty weeks, which would equal fifty wearings per year. However, one blazer is considerably more expensive, using a higher-quality fabric, lining, inner construction, and buttons and, thus, can be worn longer. His two choices are:

- **Blazer A:** costs $200 and can be worn for two years
- **Blazer B:** costs $400 and can be worn for eight years

Which blazer would be the best value for Jonathan to purchase?

> *Cost per wearing = Cost of garment/Number of wearings*

- **Blazer A:** $200 / 2 (years) × 50 (wearings per year) = $200/100 = $2 per wearing
- **Blazer B:** $400 / 8 (years) × 50 (wearings per year) = $400/400 = $1 per wearing

In this example, Blazer B would be the best value. Even though it costs twice as much initially, it can be worn four times as long for half the money each wearing. The blazer thus costs less in the long run.

surveyed by Lifestyle Monitor, 81 percent of women reported that they usually purchase wardrobe staples rather than the latest trends ("The Great White Shirt," 2001).

Extras are additional wardrobe pieces selected to coordinate with basic pieces.

Wardrobe extras add flair and a fashion signature to the basics (Figure 14.7). These items—a classic silk scarf or tie, an unusual belt, or a fleeting fad item—may be worn for many years or worn once and then discarded. Figure 14.8 outlines the characteristics of wardrobe basics and extras.

Ideally, basics and extras may be interchanged to create a variety of looks. Factors determining whether garments coordinate include style, color, texture, trim, and quality. For example, men or women might select a basic navy blue blazer to wear with chinos or jeans. Some interest for men could be gained by adding a polo shirt in a bright color. Women might add a belt in a fashion color.

The **cost per outfit formula** (total cost of all pieces/number of possible combinations) shows the value of clothing coordination.

The formula of cost per outfit presupposes choices that easily coordinate with one another and result in a variety of combinations (Case Study 14.2). Mixing clothes is not about having a lot of clothes, but it is about being resourceful, allowing us to

Figure 14.7 *Wardrobe extras such as the floral man's tie or the woman's scarf add flair to a wardrobe. Feldon (2000) recommends beginning a wardrobe with quality basics built around a single dark, neutral color to which unusual pieces may be added later. (Right photo courtesy St. John)*

create and maximize our investment. For example, Jay Friedman, group president of Hartmarx's HMX sportswear division, calls the sportcoat "the completer" of a business casual wardrobe. He recommends a wardrobe of "seven easy pieces" of which the sportcoat is the anchor. The six additional pieces are two pairs of trousers, a dress shirt, a woven sport shirt, a cashmere V-neck sweater, and a polo knot (Figure 14.9) (Dodd, 2000).

Judith Rasband recommends clothing clusters that center around a small group of coordinated clothing, usually five to ten pieces plus coordinating accessories (Dodd, 2000).

Purchase Planning

Another step in wardrobe planning is to evaluate the existing wardrobe to decide what major purchases will be required (Figure 14.10). Remember, each wardrobe

Clothing Characteristics	Basics	Extras
Style/Design	• Simple, classic. • Structural surface enrichment.	• Special, unique, interesting, exciting. • Applied surface enrichment.
Color	• Solid or neutral low-value colors such as beige, brown, gray, white, black, or navy. • Darker fashion colors such as hunter green and eggplant. • Classic middle-value colors such as red, blue, green. • All basics should be in the same color undertone.	• Accents varying in value or intensity. • Same undertone as fundamentals.
Texture	• Middle texture; no extremes of roughness or smoothness. • Background textures that are not memorable.	• Scaled to the wearer's size. • May be unique, unusual.
Trims	• Surface enrichment that is not memorable. • Subtle self-trims.	• Scaled to the wearer's size. • May be contrasting, unusual.
Quality	• When purchasing a traditional wardrobe, the highest quality one can afford is generally a wise investment. • When purchasing more casual clothing, high-quality garments might be less important.	• Wide range based on personal preference.

Figure 14.8 Characteristics of basics and extras.

CASE STUDY 14.2

 Valuing Wardrobe Coordination

Chris is planning career clothing purchases and wants to use his money wisely. He has selected the following items:

Two pairs of pants @ $100 each	= $200.00
Five shirts @ $25 each	= 125.00
One blazer @ $250	= 250.00
Total cost	= $575.00
Pants/shirt/jacket combinations	= ten

To determine the wisdom of his choices, use the cost per outfit formula:

> Cost per outfit = Total cost of all pieces / Number of possible combinations

In this example, cost per outfit = $575/10 or $57.50 per outfit. Thus, this interchangeable dressing results in a wise use of resources.

- Save money by purchasing well-constructed basics.
- Coordinate clothes gradually. Cluster clothes in your closet according to the occasion they are worn for, e.g., athletics, work, entertaining, dating.
- Rely on neutral colors, dulled or muted tones of every hue.
- Add accent colors to your wardrobe for interest.
- Rely on all-season fabrics that you can wear all year long such as light- to medium-weight woven wools and cottons and knits.
- Wear tailored clothes when you need to appear more authoritative.

Figure 14.9 Advice for shopping wisely. *(Rasband, J. 2000, July 12. America's going down the tube in a T-shirt. Daily News Record, p. 6)*

a.

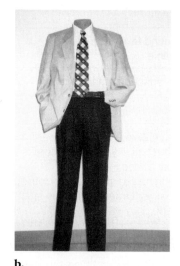

b.

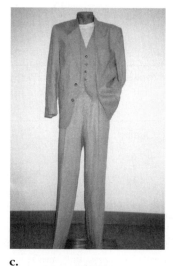

c.

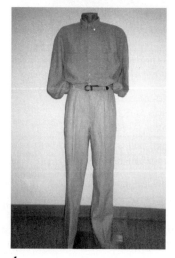

d.

e.

Figure 14.10 *Clothing should be planned so that it can be worn in a variety of ways. Factors that determine whether garments go together include style, color, texture, and quality. (Courtesy Peter Shen)*

Jacket	Pant/Skirt	Blouse/Shirt	Accessories
Navy blazer	Gray pant	White shirt	Black shoes, black belt
Gray blazer		Navy striped shirt	Black shoes, black belt
Camel blazer	Brown pant	Red polo	
Black blazer	Gray pant	Black T-shirt	

Figure 14.11 Wardrobe inventory. What items are needed to make this wardrobe more wearable?

must be suited to the individual consumer and to the unique requirements of his or her lifestyle. (For wise clothing investment suggestions, see Figure 14.9.)

To determine clothing needs, consider making a chart. For example, for an individual whose career requires a traditional business wardrobe, the chart would list the individual's jackets followed by the appropriate slacks or skirt, blouse or shirt, and accessories that would complete the outfit. After charting the clothing owned, items that are needed will be revealed. These items then become priorities in terms of future purchasing. For example, Figure 14.11 shows that a pair of pants is needed to complete the outfit when choosing to wear the gray blazer and navy striped shirt, and casual shoes are needed when wearing the more casual red polo or black T-shirt.

Consumers who follow a very simple lifestyle may require only a few garments. For example, the "ideal" college wardrobe may consist of a collection of T-shirts, jeans, sweatshirts, and shorts. As the student approaches graduation, plans for a career wardrobe must be made and budgeted for.

Older, retired adults may find their wardrobe needs scaled back from their career days. Both men and women may find that casual, comfortably fitting slacks and shirts carry them through much of their week. Yet, their lifestyle may have changed to include additional travel, so a collection of clothing appropriate to these activities and destinations is needed.

Likewise, consumers who wear a uniform for the majority of the day find many of their clothing choices are made by others. The wardrobe strategies of these consumers— children who wear school uniforms or adults whose jobs require uniforms such as pilots or police officers—are more centered on clothing for their leisure time.

Strategic wardrobe planning is ongoing, with wardrobe needs evaluated on a biannual basis. As lifestyles change so do clothing needs. Once a pattern has been established, basics can be combined with extras to create clothing combinations to meet the needs for individuals and families. A planned wardrobe allows for wide variation to meet the special lifestyle needs of a particular consumer and his or her individuality. Consider apparel selection for the three consumers in Activity 14.3.

Dress for Selected Occasions

The following section discusses dress for five occasions: job interviews, careers, leisure, special occasions, and travel.

Dress for Job Interviews

For interviewing, the traditional business suit is generally a safe choice for both men and women. The best guideline remains constant: Individuals should dress as though they already had the job. Paul Capelli, vice president of public relations at CNBC, has developed his own rule for selecting the appropriate attire for a job interview: Find out the company dress code and notch it up a step. Career counselors typically advise interviewees to err on the side of formality since interviewers need to know that the candidate takes the job seriously (Silverman, 2001). If you are interviewing for a leadership position, Jenny Crowe-Innes, CEO of Crowe-Innes Associates, says, "Leadership has an image to it and being fashionable goes with being a leader," (Wilson, 2001b).

Even though the trend in dress for many businesses has become more casual, a prospective employee generally should still dress in traditional professional apparel for interviewing. Typically this would be a conservative business suit if it is a corporate office, or trousers or layered separates for an informal office (Smith, 2001). Today's job candidates can find interview dress strategies on the Internet at such sites as Vault.com (Silverman, 2001).

For a person applying for a job in fields such as fashion, interior design, promotion, or entertainment, the dress requirements are often very different from other, more conservative environments. Clothing choices may be used to reveal not only the prospective employee's creativity but also an awareness of what is currently fashionable.

The most important thing to establish in an interview is credibility. The interviewee needs to help the prospective employer understand that he or she is knowledgeable and serious about accepting the responsibilities of the job. Clothing selection can help establish this credibility. For example, a youthful-looking medical doctor may use clothing to appear older and instill confidence in her patients, who may be much older.

Dress for Careers

Whatever the job—a part-time summer job, an entry-level position, a management position, or company president—work clothes are important (Figure 14.12). The

ACTIVITY 14.3 Wardrobe Analysis

Plan a wardrobe for each of the following three consumers.

Consumer 1: 65-year-old retired African American female; height = 5′ 3; widowed; exceeds recommended weight for her height; exercises little; activities limited to housework, shopping, time with friends, and volunteer work as a docent at a local museum.

Consumer 2: 20-year-old Caucasian male college student with a steady girlfriend; height = 5′9″; weight normal for his height; participates in moderate exercise on weekends; works part-time as a waiter.

Consumer 3: 40-year-old Asian married female politician; height = 5′ 6; maintains low body weight; exercise consists of walking treadmill sporadically; mother to a 5-year-old son; regularly travels between Los Angeles and Washington, D.C.

A woman's appearance on the job affects whether or not	Agree	
	Men	Women
• she's taken seriously.	68%	84%
• she'll be offered a promotion or a raise.	60%	68%
• she'll be asked to represent the company at outside meetings	79%	89%
• she's given new challenges and opportunities	62%	72%

Figure 14.12 Appearance and success. *(Advice for women job seekers. 2001, May. CTFA. http://.casualpower/innews56htm)*

Figure 14.13 *This student has chosen to break with traditional formal wear and wear athletic shoes with his tuxedo. What can be implied about power and appropriateness through this choice?*

company's dress code is usually the primary guide to dressing after landing a job. For many years, the business world believed people at the top of the corporate ladder should dress to show their hard-earned power. They held a stereotypical impression of appropriate apparel choices that lent power to the wearer.

Most professionals describe the traditional man's business suit complete with shirt and tie, and the female version of the business suit as "power clothes," appropriate for professional meetings. However, this same business suit is only a power garment when it is appropriate to the occasion. It would be an inappropriate choice to wear to a job where no one in authority dresses in business suits. Power dressing is achieved only when the outfits worn are accepted by the people in control of the situation and considered by them to be appropriate for the wearer and the occasion (Figure 14.13).

In today's world, the standards of appropriateness in business dress have undergone dramatic changes, yielding more options. Today's business clothing can be divided into four major categories: traditional business, business casual, everyday casual, and uniforms. In addition, some professionals allow dress that is so unique

and nonprescriptive that it defies the more conformative categories and can best be called innovative.

Traditional Business Dress

Traditional business dress consists of more classic business wear, including suits for men and women, dress shirt and traditional ties for men, and classic blouses and accessories for women.

Traditional companies that fit into the ultraconservative classification, including most law and brokerage firms and some banks and corporations, want employees to dress conservatively. Most of these companies are endeavoring to extend a corporate image that says, "Trust us."

According to Stephen S. Roach, economist for Morgan Stanley, 75 percent of America's 12.3 million jobs added between 1994 and 2000 were white-collar occupations (Koretz, 2001). Many of these workers are required to dress formally in a manner that will inspire confidence and will not attract attention. Quiet or dark colors such as navy, gray, brown, and beige work well. Accessories work best when keeping the quality conservative image in mind also.

For men, the dress rules are specific: Traditional business dress consists of matched business suits with a dress shirt and tie and understated accessories in the best quality one can afford. For women, a well-tailored business suit and a silk blouse of good quality is the basic uniform (Figure 14.14). Women can sometimes vary this look with dresses or a pants suit. For women, the rules still include no plunging necklines or loud colors and no see-through, clingy, or glittery fabrics (Feldon, 2000).

After a decade of companies dressing more casually, businesses are dressing up again. The trend toward the return of the business suit seems to be fueled by the decline of the dot.coms and the economic recession, which makes jobs more competitive. Thus, dressing up more tends to give the wearer an edge (Knox, 2001).

Business Casual Dress

Business casual dress follows rules that are more relaxed than traditional rules.

Business casual dress began as a notion called "casual Fridays." This trend has resulted in a new classification of apparel in stores called "Friday wear," "easy Friday," or the "third wardrobe."

According to a 1999 study done by the Society for Human Resources Management, between 1992 and 1999, the number of businesses allowing casual attire at the office increased from 24 to 95 percent. In 1992, 75 percent of the companies maintained a one-day-per-week casual wear allowance, but by 2001 more than 50 percent of companies permitted casual wear every day. Despite these figures, some experts contend there has been some decline in business-casual office dress. The survey was repeated in 2001 and found that companies were saying that casual is not appropriate attire when meeting clients. They found that the one-day-per-week casual wear trend seemed to peak in 1998 at 97 percent and decreased to 86 percent by 2001 (White, 2001). In addition, while one of the arguments for casual office

Figure 14.14 *Traditional business dress consists of tailored conservative suits. (Left photo courtesy Joe Totaro; right photo courtesy St. John)*

dress was that productivity would improve, new studies indicate the opposite—that dressing up improves worker productivity (Gellers, 2001).

Companies opting for casual business wear include IBM, once an icon of traditional professional dress; many motion picture production companies; and the big automobile makers.

Appropriate apparel for positions in these firms is a casual variation of the conservative look. A wide range of garments is acceptable in these places of business, so it is important to take cues from current employees. The popular uniform for business casual is khakis, golf shirts, and loafers (Figure 14.15). This look is being nudged aside for a slightly more polished look of well-cut trousers, button-down shirts, or tailored clothing, both worn with polished leather footwear. Employees report that they want to have an edge in a tighter job market, and clothing is one way to accomplish this goal (Wilson, 2001) (Figure 14.16).

Everyday Casual

Everyday casual wear is very casual apparel, including jeans, sweats, shorts, and T-shirts.

Companies that promote everyday casual wear are extremely casual companies. Employees may wear jeans, warm-up suits, shorts, collarless shirts, T-shirts, and

Figure 14.15 *Examples of casual business dress include blazers, buttoned shirts without ties, and khakis for men. (Courtesy Joe Totaro)*

sweaters (Figure 14.17). Jackets and ties are not required. Athletic footwear is allowed in most of these companies, but beachwear is prohibited. Most design and manufacturing companies would fall into this category. Also, fashion professionals who work in areas such as visual display dress casually every day.

Uniforms

A uniform is an identifying outfit worn by members of a group. In this discussion, a group could be employees of hotels, restaurants, airlines, and hospitals and members of the military, who are required to wear a uniform. Uniforms typically are selected to project a very specific corporate image. Companies such as the airlines disapprove of any personalization of their uniform. The basic purpose of a company

a.

b.

c.

Figure 14.16 *Some human resource managers argue that employees take the idea of casual dress too far. Would the clothes in these photos be acceptable in the workplace? (Photos (a) and (b) courtesy Bryan Wisely; photo (c) courtesy Skechers)*

Figure 14.17 *Everyday casual dress for business includes jeans, T-shirts, shorts, and casual shoes. (Courtesy Joe Totaro)*

uniform is to project a degree of conformity, common purpose, and professionalism (Figure 14.18).

In the early 1990s, school uniforms became one of several strategies used by U.S. public schools to improve the school environment. Many communities chose school uniforms, along with other strategies such as a focus on basic skills, conflict resolution, peer mediation, parent involvement, and increased hall patrols, to address safety, behavior problems, attitudes toward school and learning, and school spirit issues. Some parents supported the use of school uniforms; others expressed concern about the level of conformity school uniforms represented.

Figure 14.18 *Companies that require uniforms hope to create a consistent image of their employees.* *(Courtesy Doug Williams)*

School uniform wardrobes tend to include dark (black, blue, green, or red) pants, shorts, skirts, and jumpers; light (white or pastel) shirts with collars that must be tucked in; dark shoes or athletic shoes; and coordinating dark sweaters, sweatshirts, and jackets. Some items may have school names or logos. Dress codes remain in place in schools with uniform policies.

Innovative Dress

On the opposite end of the scale from traditional business dress are the companies in which dress is often the utmost expression of individuality. Businesses where anything goes have long been characteristic of creative fields such as the entertainment industry, including the music, television, film, and theater industries. Many public relations firms, some advertising agencies, interior design firms, fashion magazines, and boutiques are

Figure 14.19 *Innovative dress uses unusual fabrications in unique combinations.* *(Courtesy Deborah Call)*

among the businesses that also could be classified in this group. These organizations want their employees to project unique, creative, attention-grabbing images. For employees in these firms anything may go—wild, funky, punk, or bizarre (Figure 14.19).

For examples of apparel appropriate for each of the five professional dress categories, see Figure 14.20.

Dress for Leisure

Personal appearance should continue to project intended messages when dressing to reflect a personal lifestyle or engage in leisure activities. The clothing selected for leisure may have great variety, just as lifestyles have, yet is appropriate for the situation, time, place, activity, and the age and body conformation of the wearer (Figure 14.21).

Dress for Special Occasions

Social invitations present opportunities to dress for special occasions. What to wear can present a dilemma if the occasion is unfamiliar. Often the safest choice is to underdress. That is, dress conservatively in dark clothes that will not call undue attention. If the occasion is business related, business-type dress may be the best choice. If it is a black-tie occasion, the dress rules are well defined: a tuxedo with a black tie for men and a short or long gown for women (Figure 14.22).

Dress for Travel

A travel wardrobe typically reflects the wearer's lifestyle since when people travel they continue to do things that are a part of their normal lifestyle. If planning a trip to an unfamiliar place, it may be necessary to become familiar with such things as the weather, expected activities, and dress customs. For example, in the United

Category	Men's Examples	Women's Examples
Traditional business	Solid or small-patterned, dark-colored suits; white or pinstriped shirts	Solid dark-colored or neutral suits; white or other solid-colored blouses
Business casual	Navy sport coat; gray or khaki slacks or chinos; denim, white shirt, or colored polo shirt; T-shirts under blazers	Black blazer, gray or tan skirt; khaki pants or dark blue jeans; solid or patterned blouse, T-shirts, sweaters, knitted tops
Everyday casual	Jeans, warm-up suits, shorts, collarless shirts, sweaters, tennis shoes	Jeans, warm-ups; vests; casual dresses, shorts, sandals
Uniforms	Left to the discretion of the company	Left to the discretion of the company
Innovative	Unlimited choices: wild, funky, punk, bizarre	Unlimited choices, unusual combinations: trendy or retro, fashion colors

Figure 14.20 Professional dress examples.

States, travelers are generally seen in T-shirts, shorts, and tennis shoes virtually everywhere, but in some other countries, travelers would be restricted from entering various tourist sights if dressed so casually.

Certain garments and fabrics withstand travel better than others. A simple prepurchase test is to crush the fabric quickly in one's hand and release it. If wrinkles appear in this brief time, this fabric would not pack well. Knits usually travel very well and will shed wrinkles easily. Good travel fabrics include wool, permanent press blends, and many polyesters. Fibers/fabrics that are "easy care" or will not show soil make the best travel clothing. The travel wardrobe can be built around one or two basic colors for maximum interchangeability and travel ease (Figure 14.23). Similarly, versatile accessories that can be worn repeatedly complete the travel wardrobe.

Accessories

Accessories are "articles worn or carried to complete a fashion look."

A final consideration in wardrobe planning is attention to accessories. Accessories are the details that give a wardrobe selection distinction. They can make two identical suits look totally different, lead the eye of the observer to a point of emphasis, or add contrast in line, shape, color, or texture. They can inexpensively change the look of an outfit. For example, a male may purchase a new shirt and tie for last year's suit and the suit seems new again. Or a woman may purchase a new scarf or piece of jewelry to accent last year's blazer.

Figure 14.21 *The clothing selected for personal life varies with lifestyle. (Courtesy Jean Claude Limited)*

Because styles and popularity of accessories change so rapidly, it is impossible in a textbook to be specific about what might be currently fashionable. It is better for consumers to understand the underlying principles so that no matter what is fashionable, accessory choices will be complementary (Figure 14.24).

Accessory design incorporates the elements and principles of design discussed in earlier chapters. Application of these principles to each fashion variation is the key to selecting accessories. Thus, each accessory should be selected so that its line, form, shape, space, color, and texture harmonize with and complete the total look.

Hats

Hats go through fashion cycles just as other accessories do (Figure 14.25). Within the majority population in the United States, men's formal hats disappeared from fashion in the 1960s during the Kennedy presidency and women's shortly thereafter. There was some revival in hats instigated to a large extent by public figures such as

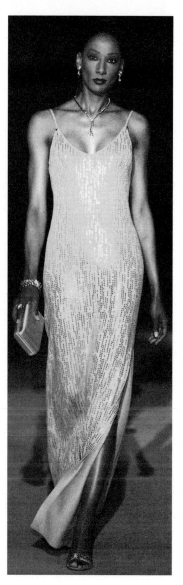

Figure 14.22 *A formal invitation is an opportunity to dress in glamorous formal wear. (Left photo courtesy Caumont Cherchez Ltd., Allan Curtis; right photo courtesy St. John)*

Suggestions for Women	Suggestions for Men
Black suit with skirt and pants	Navy sports jacket
Jeans	Gray slacks
White T-shirt	Khakis
Casual shirt	White T-shirt
Dressy white top	Two colored polos
Medium-size black handbag	White dress shirt and tie
Tote bag for extras	Casual shirt
Black casual shoes	Black dress shoes
Black heels	Casual shoes

Figure 14.23 A sample three- to five-day travel wardrobe.

Professional category	Guidelines	Suggestions for Men	Suggestions for Women
Shoes	Color choice: • Darker than pant/skirt • Neutrals • Match socks	Formal: Tied wingtips or oxford types Casual: loafer, deck shoe	Formal: • Medium heels • Closed toes Casual: Flats
Hosiery	No contrasting colors. (More contrast is more casual.) Socks should cover calf when pant leg raises.	Formal: • Color: Dark; match shoe/trouser; solids/small patterns • Thin Casual: • Thick • Color: Brighter patterns; may contrast	Color: • Match skin tones • Matching clothing and shoes visually elongates leg • Contrasting colors shorten leg • Light clothes need light shoes and hosiery Formal: Sheen Casual: Opaque such as tights
Belts	Color: • Contrasting highlights waist • Match clothes, visually increase height • Darker than clothes Leather/skin	Color: • Shade darker than pant • Select one black and one brown to blend with shoes May elect suspenders	Tailored, slim Color: Blend with clothing
Scarves/ties	Draw attention to face Fabric: formal—silk; casual—cotton	Formal: Foulard, rep, pindot, solid Casual: Knit, club, paisley, large dot, conversational, floral	Color: • Contrasting color brightens, emphasizes • Matching color softens, more sophisticated
Briefcases, wallets, handbags	High quality: • Leather • Nylon Color: • Dark • Blend with wardrobe	Wallet should fit flat inside jacket pocket	Proportioned to body Simple: • Clutch • Shoulder
Jewelry	Fine or bridge Simple, classic	Minimal	Small to medium classics

Figure 14.24 Traditional professional accessory selection guidelines.

Figure 14.25 *Hats go through fashion cycles. The size, shape, and details should follow the current trends of other garments. (Courtesy Jennifer Forbes)*

Princess Diana who wore hats in the late 1980s and 1990s. Drew Hindes, fashion di-rector for *MR* magazine, reported that today young men are wearing hats in a big way because they want to look different ("Hat Life News", 2001).

However, the majority of the hats purchased in the United States are functional such as ski caps or casual hats, which are predominately baseball caps or those worn for sun protection. Worn by both males and females of all ages beginning with in-fants, baseball caps first became a contemporary fashion statement in the early 1980s when rap groups started wearing them and sports teams began to license their team logos. Largely as a result of this trend, the U.S. hat industry generates $3 billion worth of sales annually (Garfinkel and Chichester, 1997).

Jewelry

Fine jewelry uses precious stones and metals and is the most expensive of the jewelry classifications.

Jewelry Catagories	Fine	Bridge	Costume
Stones	Precious/genuine: • Diamonds • Sapphires • Rubies	Semiprecious: • Amethysts • Agates • Opals Cubic Zirconium Man-made	• Glass • Plastic • Paste
Mounting	Precious metals: • Gold • Sterling silver • Platinum	• Sterling silver • Gold plate • Copper	• Wood • Metal • String • Rope • Ribbon

Figure 14.26 Characteristics of jewelry types.

Jewelry has three broad classifications: fine, bridge, and costume (Figure 14.26). Fine jewelry is made from natural, or genuine, stones—diamonds, pearls, sapphires, and rubies. These stones are very expensive because of their rarity and the skill required to cut them to achieve maximum beauty. Real stones are mounted in precious metals—gold, silver, or platinum. Cultured pearls result from the same processing as natural pearls.

Bridge jewelry uses semi-precious stones and is moderately priced.

Bridge jewelry resulted from the demand from consumers who wanted a special piece of jewelry at a more affordable price. Bridge jewelry is often one of a kind but made of sterling silver and semiprecious stones—amethysts, agates, opals, turquoises, and corals—or cubic zirconium (CZ), making it less expensive than fine jewelry. Scientists have developed man-made stones that closely resemble such natural stones as diamonds, rubies, and sapphires. These stones are used in bridge jewelry to simulate fine jewelry.

Designers often design bridge jewelry to coordinate with a garment line. For example, St. John Knits began a line of jewelry as a result of customers' requests for the earrings models wore in St. John fashion shows. The earrings were actually buttons the company produced for its garments, but St. John seized the opportunity to branch out and created a profitable accessory business (Figure 14.27).

Costume jewelry is the least expensive and most casual jewelry.

Costume jewelry may be made of wood, metal, paste, plastic, glass, or feathers. It often is short-lived because it appeals to a mass market and is usually inexpensive. Other pieces of costume jewelry, such as handcrafted or ethnic items, enjoy long-term appeal.

Figure 14.27 *Jewelry should add distinction to clothing. St. John has achieved this by creating jewelry that coordinates with their garments. (Courtesy St. John)*

In selecting business jewelry, often "less is more." Men's business jewelry is usually limited to a simple ring and a nonsports watch. A women's traditional business jewelry collection may include small to medium-sized earrings in classic hoops and flat or ball shapes, a simple necklace such as a chain, and a watch.

For more casual occasions, costume jewelry is the norm. Men might add necklaces, earrings, and sports watches; women might add multiple earrings, bracelets, necklaces, multiple rings, and contrasting belts.

Eyewear

Eyewear has become big business. Sales of eyewear reached $17.4 billion in 2000 with sunglasses equaling 25 percent of this total ("Optical Industry Growth," 2001). Styles, colors, and detailing of frames change with fashions.

Although fashion sometimes dictates otherwise, the size of the frame typically should be related to the size of the wearer's face and complement the wearer's features (Activity 14.4). The shape of the frame should complement the lines of the face. For example, selecting a rounded frame would soften the angularity of an angular face but would emphasize the roundness of a round face.

Richard Morgenthal of Morgenthal Frederics Eyewear (Gastl, 2001) gives this advice for selecting flattering eyewear:

- *Noses:* Glasses with a low bridge will reduce the length of a nose while a high bridge lengthens a nose.
- *Eyebrows* should always show above the frames.
- *Hairstyle:* Those with short hairstyles can wear a heavier frame.
- *Coloring:* The frame should not drain your face of color. Contrast your skin tone with your frames, e.g., light skin with dark frames. Reinforcing a skin

ACTIVITY 14.4 Facial Shape and Eyeglass Frames

Directions: First, determine your face shape. Select a photograph of yourself with your hair pulled back to reveal the silhouette of your face. Draw a dot in the center, on the lowest part of your chin, on each side of your jaw, at the widest point of each cheek, and in the center and at each corner of your forehead. Connect the dots. Which geometric figure is your face shape?

Match your face shape to the chart below to determine the most flattering glasses frame for you.

Round	**Angular frames, wide frames, or cat eyes.**
Square	**Rounded shapes that are more horizontal than vertical.**
Oval	**Any shape.**
Oblong	**Choose a shape that's more wide than long.**
Triangle	**Top-heavy styles like aviators or those with a half-rim on top.**
Heart	**Butterfly shapes or those wider at the bottom.**

(Adapted from Gaste, M. 2001, November. Eye openers. In Style, *pp. 203–210)*

tone also works, such as warm skin tones and a warm frame color. Select the same colors that are flattering in clothing.

For prescriptive glasses, tinted lenses are not the best choice because the shading seems to create a barrier between the wearer and others. Clear or very pale tinted lenses are the basic recommendation in this case.

Shoes

U.S. consumers purchase one billion pairs of shoes per year totaling $35 billion in annual sales. Men purchase between two and four pairs, and women purchase between six and eight pairs annually.

In general, women's formal business shoes have medium heels of not more than 2 1/2 inches in height. A selection of business shoes in noncontrasting colors—usually neutrals such as black, brown, or cream—create a unified look and do not draw attention to the feet. Shoes that match the wearer's leg color and hosiery color create the illusion of height. Although often popular, heavy shoes make thin legs look thinner and heavy legs heavier.

Businessmen's shoes work best in colors darker than the suit they are worn with, which makes brown or black shoes a good choice for most suits. Brown is more stylishly flexible and has long been the top choice among European men (Flusser, 1996). The classic men's tie shoe is the wingtip or oxford. The loafer, once thought to be

too casual for business wear, is now accepted in both formal and informal situations (Garfinkel and Chichester, 1997).

Hosiery

The most versatile stocking for business women is one that matches their natural skin tone. Echoing the color of an outfit elongates the body (Feldon, 2000). Light clothing calls for light-colored hosiery and shoes. Even though light hosiery and dark shoes might be striking and fashionable, the contrasting combination draws attention to the legs and creates a visual break, whereas matching hosiery and shoes lengthen the leg. Hosiery with a sheen is considered dressier than opaque hosiery, such as tights, which are usually reserved for casual wear.

Businessmen may choose to match their hosiery to their shoe color or their trousers. The more contrast between the socks and trousers, the more casual the look (Flusser, 1996). Darker hosiery is considered dressier. A length long enough to cover the calf when pant legs are raised is the most professional. The thinner the sock, the dressier; thicker socks are considered casual. Patterned socks are often quite popular for men. Casual in feel, patterns include argyle, birdseye, plaids, stripes, and conversationals.

Handbags, Briefcases, and Wallets

Handbags, briefcases, and wallets are highly visible parts of the business wardrobe; therefore, quality is important. High-quality leather that will last for several years, in a color that blends with the wearer's wardrobe, is preferred by many.

The selection of a wallet is important for businessmen. By carrying only the absolute minimum number of credit cards, the wallet will fit flatly in the jacket's inside pocket. A simple purse, in proportion to the wearer's body and equipped with only the necessities, serves businesswomen well.

Briefcases are either structured over a stiff frame or are less formal, unstructured bags. Although leather has long been the most professional choice for briefcases, many of today's fashionable briefcases are made of nylon and good-quality elastic such as those by Fendi and less expensive knockoffs.

Belts

Belts highlight the waist. Waistlines are emphasized by a contrasting colored belt or a very wide belt, thus making a small waist appear smaller and a large waist appear larger. Leather is preferred for business-wear belts. Contrasting colored belts also can decrease height, whereas similarly colored belts maintain an illusion of height. Thus businessmen and women find that belts in a darker tone or shade of the clothing's color generally work better with most professional clothing.

Tailored and slim belts work best for women's business wear. Unusual or exotic selections can be saved for casual wear.

Men's formal business belts feature a simple buckle and no logos. A man will likely need both a brown and black belt; a black belt requires a black shoe, and a brown belt requires a shoe in the brown family.

Men may choose instead to eliminate the belt and to wear suspenders or braces that button to the front and back of trousers and are adjustable. Braces hold trousers in place while being cooler, less constricting, and fashionable (Feldon, 2000).

Scarves/Ties

Scarves and ties focus attention toward the face. High-quality scarves and ties are made of silk so that they add light to the face. Other tie or scarf fabrications such as cotton work for casual wear.

Scarves can serve several functions. Businesswomen can brighten a suit or dress by selecting a scarf in a contrasting color. A large wool scarf can be draped over the shoulders of a jacket and there also are numerous ways to tie a rectangular or oblong scarf at the neck of a suit or dress. For casual wear, scarves may serve as a belt.

Men's ties have long been their most important fashion accessory. Ninety-five million ties are sold annually with total sales equaling $1.56 billion. "The choice of a tie says something about the wearer's personality, whether real or imagined. They are the easiest means of expressing individuality," says Abbott Combes (1999, p. 52). For example, ties can reveal what sports the man supports, an example of his sense of humor, and even his favorite restaurant or city. Ties are easily changed and a good way to update a suit or sportcoat. Although subject to current fashion trends, several tie patterns dominate the market (Figure 14.28):

1. Conversational: Fashion forward, depicting city skylines, cartoon characters, familiar products, and so forth.
2. Rep/regimental: Stripes in strong, pure colors.
3. Club: Any repeated representational pattern such as tennis rackets or birds.
4. Paisley: Curved teardrops.
5. Dot/plaid: Formal small dots; casual large dots and plaids.
6. Floral: Flowers, usually in muted colors.
7. Plaid.
8. Solid: One color, which, if chosen to blend with the suit, will provide an understated look; if chosen to contrast with the suit, will create a focal point.
9. Knitted: Solid color, usually sporty and informal in feel.

For men, selecting a shirt and tie to team with a suit is always a challenge. The classic accents for men's ties are the primary colors—red, blue, and yellow; however, other fashion colors that blend will be suitable also. When selecting a suit-tie-shirt combination, two of the three may be patterned but rarely three. A solid tie is often the perfect choice for a boldly patterned shirt, and an intricately patterned tie will liven up a solid shirt.

Although this section concentrated on business accessories, casual accessories are big sellers for all ages. Because of the freedom allowed in casual wear, consumers can use accessories to express their individuality. For example, younger consumers—children through teens—are becoming big purchasers of accessories. Retailers such as Wet Seal and Rampage have developed a profitable business marketing various

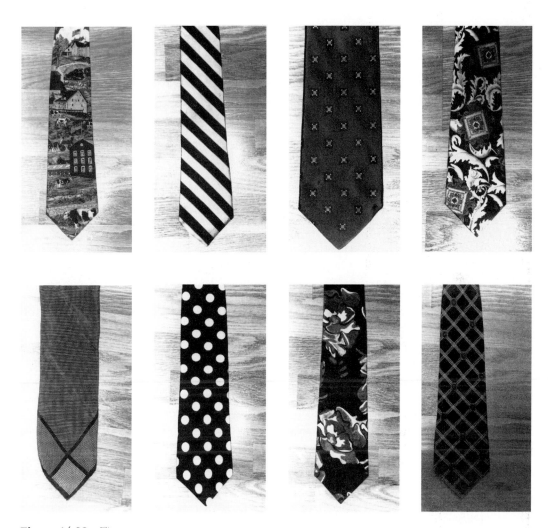

Figure 14.28 *Tie patterns.*

accessories—hair ornaments, jewelry, belts, socks, purses, sunglasses, and hats—to young girls and teens. Retailers such as Pacific Sunwear have added similar accessories—jewelry, caps, belts, wallets, and sandals—aimed at the teenage male market. Bob Sayre, young men's and accessories general merchandise manager for Pacific Sunwear, reports that accessories account for 17 percent of the company's business, and the percentage is rising. As a result, the company hired a buyer to handle accessories only (Young, 2001).

All wardrobe elements discussed in this chapter are considered in the wardrobe plan in Activity 14.5.

ACTIVITY 14.5 Wardrobe Plan

Analyze a selected consumer's wardrobe as described in this chapter:
- Summarize the individual's current wardrobe strategy.
- Divide the existing clothing found in this wardrobe into basics and extras. What have you learned that will guide this consumer in future purchases?
- Plan for additions to these two groups, including possible color choices.
- Estimate the costs for the additions.
- Formulate a two-year clothing budget and plan in order to accommodate the needed additions. Examine the consumer's resources and explain how the costs will be met.

🦅 Summary

This chapter shows the importance of planning prior to clothing purchases. Wardrobe planning is based on analyses of a consumer's lifestyle, existing wardrobe, and resources. These analyses are followed by an identification of wardrobe basic and extra pieces and the establishment of a purchase plan. It includes dress for selected occasions: interviews, careers, leisure, special occasion, and travel. The chapter concludes by discussing guidelines for business accessory selection.

🦅 Key Terms and Concepts

Accessory
Basics
Bridge jewelry
Business casual dress
Cost per outfit formula
Cost per wearing formula
Costume jewelry

Everyday casual wear
Extras
Fashion personality
Fine jewelry
Traditional business dress
Wardrobe

🦅 References

Carini, M. C. (2001, Oct. 11). Industry Profile, www.netadvantage.

Combs, A. (1999, November 14). Secrets and ties. *The New York Times Magazine,* p. 52.

Dodd, A. (2000, July 12). Casual dressing is not so easy. *Daily News Record,* p. 6.

Feldon, L. (2000). *Does this make me look fat?* NY: Villard.

Flusser, A. (1996). *Style and the man.* New York: Harper Collins.

Garfinkel, P., and Chichester, B. (1997). *Maximum style.* Emmaus, PA: Rodale Press.

Gastl, M. (2001, November). Eye openers. *In Style,* pp. 203–210.

Gellers, S. (2001, April 25). Suits are returning, claim consumer newspapers. *Daily News Record,* p. 2.

The great white shirt. (2001, October 18). *Women's Wear Daily,* p.2.

Hat life news, (2001, October 21). http://www.hatlife.com/pages/news.htm.

Industry environment. (2000, August 18). Los Angeles: Los Angeles County Economic Development Corporation.

Knox, N. (2001, March 25). Wall Streeters return to dressing for success. *USA Today,* p. 1.

Koretz, G. (2001, April 23). A white-collar job squeeze. *Business Week* online. http://www.businessweek.com.

Much, M. (1998, April 17). Helping retailers manage their private labels. *Investor's Daily.*

Optical industry growth. (2001, October 21). http://www.visionsite.org/profes/page1-html.

Silverman, R. (2001, April 17). Why are you so dressed up? Do you have a job interview? *Wall Street Journal,* p. B1.

Smith, J. (2001, October 15). Dress to impress. www.handbag.com.

White, R. (2001, August 26). Clashing dress styles. www.latimes.com.

Wilson, C. (2001a, October 1). Business not-so-casual. *Daily News Record,* p. 22.

Wilson, C. (2001b, October 1). Dressing for success: An update, *Daily News Record,* p. 22.

Young, K. (2001, September 17). PacSun prepares women's growth. *Women's Wear Daily,* p. 14.

| Chapter | 15 |

Clothing Purchasing

 Objectives

- Explain the importance of consumer predisposition in the apparel purchasing process.
- Characterize the major store and nonstore retail formats.
- Discuss some of the important consumer issues that affect clothing purchase decisions, such as:
 1. Retail price
 2. Merchandising/store atmosphere
 3. Services
 4. Ease of purchase
 5. Advertising

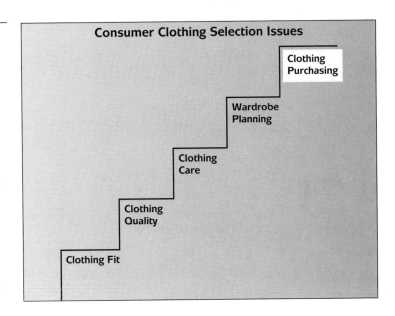

Consumer Clothing Selection Issues

Clothing Purchasing

Wardrobe Planning

Clothing Care

Clothing Quality

Clothing Fit

In an urban society, the selection of consumer goods is an important task. The prior chapters of this text have laid the foundation for clothing purchase decisions. This chapter describes the major retail formats and answers some of the questions that influence customers' purchasing decisions. Although the primary concern of this text is clothing selection, much of the information given in this chapter can be applied to purchase decisions for other items as well.

There are a variety of both store and nonstore retailers employing many techniques to influence the customer toward making a sales transaction. The packaging of products, the displaying of merchandise, the pricing of items, the store's image and advertising methods, and the floor plan are all thoughtfully designed to attract customers and sell goods.

When the time comes to buy apparel, consumers evaluate the various retail options. Consumers are interested in not only the store's merchandise offerings but also issues such as retail price, merchandising, services, and ease of purchasing. In retailing, the customer is always in the lead position in a relationship with a merchant, exercising the prerogative to select or reject what the merchant is selling.

In short, retail purchasing is dependent on retailers using their knowledge of potential customers to provide merchandise and services that convert customers into loyal buyers. This chapter discusses three areas that influence the decision to

purchase: (1) the predisposition of consumers, (2) the unique characteristics of various retailers, and (3) consumer issues that have an impact on the clothing purchase decision.

Consumer Predisposition

One theory in marketing management contends that business is like warfare: to win, a plan is needed. To win a war, a battle plan starts with knowing the enemy. In retail, to win profits, the plan starts with knowing the store's customers and what makes them buy (Schneiderman, 1996b). Figure 15.1 gives one example of profiling department store customers.

Consumers today are less interested in shopping, preferring instead to spend their time on leisure activities. Forty-four percent of consumers say they shop only to replace items; only 3 percent say that shopping is a favorite leisure activity (Taylor, 2001).

Women	
Classification	**Characteristics**
Fashion statements	Affluent, educated; income averages $73,400; high index of planned purchases; like being on cutting edge of fashion
Wanna-buys	Same attitudes as Fashion statements but less money ($40,600); impulse buyers
Family values	Children at home; 50% have college degrees; 90% are professionals; planning to buy kid's clothing, appliances, sporting goods
Down to basics	60% have children, household income of $32,600; only 3% have college degrees; careful spenders; little credit; sale driven; buy little except for kids
Matriarchs	Older women living in retired households; most conservative; planning fewer purchases
Men	
Patricians	25% are married; most money ($57,500); targets are men's clothing, electronics, sporting goods
Practicals	Income averages $39,500; single; pay with cash; more likely to shop in discount stores; targets are men's clothing, electronics, sporting goods
Patriarchs	Lowest educational level; lowest household income; oldest; buy for replacement but purchase top-of-the-line

Figure 15.1 Characteristics of female and male department store shoppers by category. *(Adapted from Management Horizons, A Division of Price Waterhouse LLP, Retail Intelligence System ® Consumer Focus Report—The MH Six Shopper Typologies, July 1987.)*

Question	Men	Women
Time per shopping visit	37% spend less than 1 hour	25% spend less than 1 hour 36% spend 1–2 hours 27% spend 2–3 hours
Compare several stores before making a purchase	No, 60% of purchases planned ahead for item and store	Yes (61%)
Love shopping	No, shop on as needed basis only (60%)	Yes (60%)
Like apparel grouped by wearing occasion	Yes	Yes
Take time to shop	No, 83% shop only to replace	63%

Figure 15.2 Comparison of men's and women's shopping attitudes. *(More time-pressed men opting for convenience of specialty stores. 2001, April 27.* Daily News Record, *p. 2; Living in the fast lane. 2001, June 27.* Women's Wear Daily, *p. 2; Reeling 'em in: Store displays can be the lure for hard-to-catch men. 2001, April.* Daily News Record, *p. 2)*

Men	Women
• In-stock merchandise (98%) • Merchandise reliability (97%) • Ease of shopping (96%) • Convenient location (94%) • Good return policy (91%)	• Good return policy (86%) • Flattering styles (70.2%) • Sale prices (70%) • Low everyday prices (67.3%) • Ease of shopping (66.6%)

Figure 15.3 Store selection criteria. *(Men column information from D. Silverman, 1998, July 6. Consumers are becoming more shopworn.* Daily News Record, *pp. 12–13; Women column from I. P. Schneiderman, 1996, January 29. 'Less' is heard more often in survey of apparel shopping habit.* Daily News Record, *pp. 24–25)*

The average consumer makes thirty-eight mall trips per year and shops seventy-seven minutes per trip. They spend an average of $66.70 per trip (Silverman, 1998). When consumers make a decision to shop, the type of store they prefer is based on personal attitudes and values. See Figure 15.2 for a comparison of men's and women's shopping attitudes. Consumers have definite ideas about what they prefer in a store (Figure 15.3). If a customer tries a store and finds it unsatisfactory, 77 percent leave and only 32 percent of those who leave ever return (Silverman, 1998). The top reasons consumers give for not purchasing are:

- Unappealing styles (84 percent)
- High prices (69 percent)
- Incorrect fit (60 percent)
- Long lines (61 percent)

Since today's consumers are more time pressured, they are more purposeful when they shop. Few consumers come to a mall these days to browse; they have a definite purchase in mind. Retailers are anxious to provide that product. However, retailers have a very short amount of time in which to do this. Gary LaVasser, president of TSL Visual Group, says the average amount of time a store has to attract the attention of a consumer is six seconds—after which the consumer moves on to another store (McElwain, 1990).

Retailers also know the importance of keeping the customer in the store as long as possible because the majority of purchases (80 percent) are made impulsively (McElwain, 1990). Thus, stores seek ways to take advantage of impulse buyers by placing eye-catching displays in prominent areas near store entrances, elevators, escalators, and cash registers.

Retail Formats

A **retail format** is the classification of both store and nonstore retailers.

Consumers can choose to purchase merchandise from a variety of types of stores. Ninety-seven percent of retail sales are from bricks and mortar stores ("Retail Industry Overview," 2001). (See Figure 15.4 for a comparison of where men and women shop for clothing.)

Retail Stores

Store image is created by a combination of many aspects of the business operation, which form the appearance, the atmosphere, and the mood of an establishment.

One of the means of attracting consumers' attention is through store image. Retailers create an image that is an important factor in attracting specific clientele into a particular store. There are many different kinds of store images: high-fashion, trendy,

Figure 15.4 Retail formats most commonly used for men's and women's clothing purchases. *(More time-pressed men opting for convenience of specialty stores. 2001, April 27.* Daily News Record, *p. 2.; Living in the fast lane. 2001, June 27.* Women's Wear Daily, *p. 2)*

Retail Format	Men	Women
Department stores	21%	26%
Chain stores	24%	25%
Specialty stores	24%	20%
Mass merchants	18%	17%
Factory outlets	4%	2%
Catalogs	4%	3%
Off-price	2%	3%

- Location, including its exact placement in the community, surrounding environs, neighboring businesses, and both vehicular and pedestrian traffic patterns.
- The physical appearance of the business building: architecture, colors, style of fixtures, and decor including merchandise displays and window design.
- Atmosphere such as music or other sounds.
- Store personnel characteristics such as their general appearance, clothing, attitude, manners, competence, and willingness to provide service.
- The methods of advertising, including shopping bags.
- Community involvement of the store.
- The kinds and quality of merchandise sold by the establishment.

Figure 15.5 Factors influencing store image.

conservative, casual, family-oriented, and career-oriented. The factors influencing store image are listed in Figure 15.5. The main retail formats convey distinct store images.

Department Stores

Department stores merchandise both hard and soft goods in various departments all under one roof and cater to customers on every social and economic level.

Large national department store chains, such as Dillard's and Federated Department Stores, typically feature basic, traditional styles at affordable prices. These chains operate stores nationwide under a variety of names. For example, the Dayton Hudson Corporation owns Marshall Field's in Chicago, Dayton's of Minneapolis, and Hudson's of Detroit.

Today's retail landscape reflects the consolidations at the end of the twentieth century in which regional chains were taken over by larger players. This resulted in U.S. department stores being reduced to six major retail ownership groups: J. C. Penney, Sears, May Company, Dillards, Target, and Federated. Virtually all fashion retail chains are part of a large corporation or a division of a large corporation or holding group (Frings, 2002).

Centralized buying is merchandise buying being controlled from one central location.

Large department store organizations consolidate their stores' inventory needs and are then able to purchase merchandise in greater quantities, thus enabling them to obtain goods at lower prices than the smaller stores. This is called *centralized buying*. Yet, customers complain of cookie-cutter assortments not tailored to their locale. This has resulted in dissatisfied customers and an erosion of the customer base. Arthur Anderson's study showed that 64 percent of women found department store

Specialty stores	35.2%
Discounters	18.8%
Department stores	16.4%
Major chains	13.8%
Mail order	6.5%
Off-pricers	6.3%
Outlets	2.8%

Figure 15.6 Fashion market share percentage by retail store classification. *(Frings, G. 2002.* Fashion: From Concept to Consumer, *7th ed. Upper Saddle River, NJ: Prentice Hall)*

Figure 15.7 *Specialty stores can be focused like Ann Taylor, which sells bridge priced apparel to career women. Other specialty shops are departmentalized like Barney's, which sells various product categories—menswear, womenswear, childrenswear, cosmetics, home furnishings, and gifts.*

shopping to be "drudgery," citing the intimidating size and maze-like layout as reasons for this negative feeling. As a result, department stores' market share is 16.4 percent as compared to mass merchants (commonly defined as discounters, off-pricers, and outlets), whose share is 27.9 percent (Frings, 2002). (See Figure 15.6 for market share by retail store classification.)

Specialty Stores

A **specialty store** carries a limited selection of its specialty items while creating a distinctive lifestyle image.

Very often specialty stores specialize in only one category of merchandise such as Kathy Jean's shoes or in related items such as Structure, which sells only menswear, or The Limited, which sells only womenswear (Figure 15.7). Some large specialty store formats like Nordstrom or high-end specialty stores like Neiman Marcus seem similar in size and layout to a department store but specialize in a variety of soft goods. Due to this more focused selection, customers can shorten their shopping time.

So WHAT'S on your MIND?

1 What do you think about Structure Associates?

- ◯ Really helpful
- ◯ Not bad
- ◯ Rubbed me the wrong way
- ◯ Nowhere to be found

2 Did you have any of these problems while shopping for Structure pants? *(check all that apply)*

- ◯ Couldn't find my size
- ◯ Didn't have the style I liked
- ◯ Couldn't find the color I wanted
- ◯ Fit wasn't right for me

3 Overall, how do you like the pants at Structure? *(check all that apply)*

- ◯ Great quality
- ◯ Quality could be better
- ◯ I like the style
- ◯ Not my style
- ◯ Colors and fabrics are right
- ◯ Colors and fabrics are not for me

4 What do you think about the prices of Structure pants?

- ◯ The prices are really low
- ◯ The prices reflect the style and quality
- ◯ A little high
- ◯ Need to find a second job to afford Structure

5 Which type of pants do you primarily buy?

- ◯ Denim
- ◯ Khakis
- ◯ Dress Pants

6 Overall, how did you like shopping at Structure?

- ◯ Great, I'll come back
- ◯ A little disappointed, but I'll give it another try
- ◯ You'll be lucky if you ever see me again

7 How often do you shop at Structure?

- ◯ More than I'd bother counting
- ◯ A few times a year
- ◯ Only once in a while
- ◯ This was my first time

8 Anything else on your mind?

NAME

ADDRESS

CITY STATE ZIP

TELEPHONE () BIRTHDAY / /

Please drop this postage-paid card in the mail, or give it to any Structure associate.

STRUCTURE
SUPERIOR QUALITY | CLOTHING

Figure 15.8 Companies are showing increased interest in keeping abreast of consumer preferences. Some use brochures like this one to perpetually survey their customers. *(Courtesy Structure, division of Limited Inc.)*

Specialty stores build their reputation on their merchandise selection and personal services. Very often the sales associates are well trained and have much information about the merchandise. In upper-end specialty stores, salespersons may keep cards on customers' preferences, listing colors, sizes, and styles and enabling the store to serve customers more personally when new merchandise arrives. If the specialty store carries several categories of merchandise, the knowledgeable salesperson can help the customer coordinate an outfit or plan a wardrobe to cover career and special occasions. Nine West expresses the idea of fully meeting its customers' needs with its slogan: "Everything she needs" (Fallon, 1998).

Specialty stores are continually looking for ways to improve their service (Figure 15.8). When Saks Fifth Avenue computerized an aspect of its customer service, it created a new image-rich database that allows the creation and maintenance

of a detailed customer profile. Designed for the custom-fit business, the computer records specific customer measurements, style preferences, career and social clothing needs, digital photographs of the customers, and each item purchased. The Saks staff can produce a printout giving examples of wardrobe coordination ideas. The technology also allows orders to be placed by electronic transmission (Hye, 1998).

> A **boutique** is a small specialty shop that features a strong fashion image.

A subcategory of the specialty store is the boutique. The success of this type of retailer results from customers' rejection of the redundant merchandise offerings of department stores and their desire for more individuality in dress. A boutique's inventory does not rely on mass-produced ready-to-wear but instead features limited numbers of unique garments and accessories, ranging in price from a few dollars to $1,000 or more. Boutiques may feature merchandise from a well-known company or a less expensive line from a couturier (Figure 15.9).

Franchise Stores

> **Franchising** is when a manufacturer sells the right to retail its merchandise.

Franchising has long been a popular business format for travel agencies, auto dealerships, real estate companies, and fast-food services. This type of business is now becoming more popular with fashion retailing. Shops such as Benetton, Esprit, Laura Ashley, Ralph Lauren's Polo Shops, and Yves St. Laurent's Rive Gauche are examples of franchise shops. The **franchiser** offers a well-established name, expert business guidance, and brand-name merchandise. The **franchisee** invests in the parent company and subsequently pays a percentage of all sales to the franchiser.

Off-Price Stores

> **Off-price stores** sell brand-name and designer apparel at prices 20 to 60 percent lower than the same items sold by department stores.

Off-price stores are a fast-growing segment of the retail industry. The stores feature few amenities and limited services. Off-pricers such as Marshalls, T. J. Maxx, Loehmans, Burlington Coat Factory, and Ross are usually situated in strip centers rather than in large shopping centers.

The merchandise carried by off-pricers is obtained from a variety of sources. Excess production, closeouts, and canceled orders of clothing are purchased directly from factories, from buying services that specialize in the fashion business, or from jobbers who take merchandise that manufacturers or department stores cannot sell. Merchandise is typically an odd assortment of sizes and colors.

Discount Stores

> **Discount stores** sell large volumes of merchandise at low prices with little customer service.

Figure 15.9 *Boutiques are often used to showcase high-end companies like Escada or European couturiers' ready-to-wear like Versace and Lacroix.*

Discounters have been gaining in their percentage of the apparel business each year since the early 1990s. This format is popular with the majority of the population, 70 percent of whom say that price is a key consideration in apparel purchasing (Schneiderman, 1996a).

Discount stores, such as Wal-Mart (Seckler, 1998a), Kmart, and Target operate on a low-price, high-volume, rapid turnover principle with few customer services. Most discount stores are self-service, although there are sales personnel available for limited assistance.

Outlets

Outlet stores sell overstocks or other excess inventory from name brand designers.

Outlet malls have sprung up nationwide. They may be located on the fringe of garment districts or in low-rent areas. Clothing obtained by outlet stores comes from:

- Manufacturers' closeouts, discontinued lines, unsold merchandise, past season merchandise, stock liquidation, returns of orders, seconds, and irregulars.
- Salesmen's samples.
- Retail stores' unsold merchandise, past season merchandise, and discontinued lines.

Because of the popularity of outlets, manufacturers and retailers often have less merchandise than needed to provide adequate inventory for these stores. Therefore, many retailers and manufacturers produce special lines of merchandise to be sold exclusively in their outlets. Even though a garment's label may say Barney's or Anne Klein, the garments may be made specifically for outlet inventory rather than retail store inventory. These garments may not be as high a quality as these same labels sold at retail.

Membership Stores

A **membership store** is a combination department store/discount store. Memberships are sold to and restricted to a particular group of people, who then have the privilege of shopping in the store.

Membership stores, such as Sam's and Costco, work on a limited selection, large-volume, rapid-turnover, reduced-price policy. They generally offer minimal services and a limited number of basic apparel choices.

Previously Owned Clothing Stores

Resale and thrift shops, flea markets, swap meets, and garage sales have become a way of life. In the mid-1990s, the retro-1970s trend made these stores especially popular. Wearing used clothing was popular among high school and college students. For several years, vintage clothing has been viewed as "totally hip with teens and women in their twenties," reports *Women's Wear Daily* ("She's Gotta Have It," 1998).

Consignment shops are resale stores offering "gently worn" designer apparel at bargain prices.

The most important arm of the used clothing retail category is the upscale consignment shop. The number of women who shop in consignment stores is increasing in every age group. For example, more than half of women aged twenty-four to thirty-five shopped in a consignment store in 1997 ("She's Gotta Have It," 1998).

The traditional thrift shop often handles worn and/or out-of-date clothing that has been donated. Some thrift shops are run by organizations such as the Junior League, Salvation Army, or Heart Association to raise money for charitable causes. At times almost-new, high-quality clothing worn by the wealthy who update their wardrobes frequently can be obtained at nominal prices. Designer garments can generally be purchased for between 25 and 35 percent of their original price. For example, Clotheshorse Anonymous in Dallas sold an $1,100 Armani jacket for $300, while Out of Our Closet in New York sold a $2,000 Gucci suit for $500 ("She's Gotta Have It," 1998).

Shopping Centers

Shopping centers combine store types to appeal to various target markets. Some appeal to the high-income, high-fashion market; others appeal to the mass market or lower-income market. Most shopping centers today include an element of entertainment; many are attached to hotels or businesses. Activity 15.1 outlines a way to compare shopping centers.

Nonstore Retailing

Nonstore retailing includes catalogs, infomercials, online computer shopping, and television shopping channels.

Nonstore retailing represents around 6 percent of all retail apparel sales (Russell and Lane, 2002). Through these formats customers can take shopping tours by simply touching a button. The nonstore formats discussed here are catalogs and the Internet.

Catalogs

The largest sales volume of all nonstore retail formats selling apparel comes from catalogs. The Direct Marketing Association reports there are 15 billion catalogs distributed in the United States each year (Russell and Lane, 2002), with the average household receiving 1.7 per week (Seckler, 2000). Catalogs are big business with sales of $95 million in 2000 (Swanson and Everett, 2000). However, many retail analysts have begun to question the inroads that Internet shopping will have on catalog shopping. Currently 19 percent of consumers report that they are spending less through catalogs as a result of web shopping (Russell and Lane, 2002).

To maintain their customer base, mail-order companies have evolved; catalogs have become more focused. The Neiman Marcus catalog, for example, features

ACTIVITY 15.1 Shopping Center Comparison

Visit several shopping centers. Determine the differences and similarities in what they offer the consumer using the following criteria:

- Types of shops that predominate
- Degree of fashion represented
- Services offered
- Number and diversity of shops and services
- Greatest attraction for shoppers
- Greatest disadvantage for shoppers
- Cleanliness and attractiveness
- Entertainment opportunities
- Public transportation access and parking facilities
- Other observations

Compare your findings among shopping centers.

high-priced specialty items and one-of-a-kind gifts. For example, the Neiman Marcus Christmas catalog is known for featuring an extravagant, exclusive gift each Christmas season. In 2001 the catalog offered customers their very own Neiman Marcus Limited Edition 430 Helicopter from Bell, which sold for $6,700,000. Among the descriptors used to promote the gift were the signature NM logo painted on the side as well as embossed into the deluxe sculptured carpeting (Neiman Marcus Christmas Book, 2001).

Some retailers have fine tuned their catalogs and created a more unique product. Sears, once the giant of the catalog industry, abandoned its big book in favor of smaller, more closely targeted catalogs (Russell and Lane, 2002). Some mail-order companies specialize in hard-to-find items such as wide or narrow shoes, 100 percent natural fiber clothes, or clothing for people with special needs.

The catalog customer profile is a 40-year-old female who has a family and a household income of $40,000 (Swanson and Everett, 2000). In an effort to capture more of the younger market, Abercrombie & Fitch produces the A & F Quarterly, which they call a "magalog" because it is a combination magazine and catalog. Selling for $6 on newsstands and costing $12 for an annual subscription, it is aimed at college students, 18 to 22 years old (Gampier, 2001).

An additional nonstore format is **home shopping.** The combined purchases of merchandise via television home shopping networks produced $3 billion in sales in 2000 ("Retail Industry Overview," 2001). Companies such as catalogs and home shopping networks that target consumers where they live and seek to elicit a direct response from them have formed their own trade association that supports their efforts:

The Direct Marketing Association
1120 Avenue of the Americas
New York, NY 10036
212-768-7277
www.the-dma.org

Most are women.	62%
Purchasers under 35.	40%
Purchasers under 45.	70%
Among clothing purchasers most prefer off-line purchasing.	70% +
Tend to be catalog customers who are used to buying from remote locations.	
Say a known brand is more likely to spur a purchase.	40%
Also purchase at bricks and mortar stores whose websites they purchase from.	78%
Also purchase through catalogs.	76%
Traditional store shoppers who research purchases online.	73%

Figure 15.10 Characteristics of online apparel purchasers. *(Seckler, V. 2001, October 10. Web study cites 'Super Shopper'. Women's Wear Daily, p. 15.; Seckler, V. 2000, July 12. Survey says web apparel buys doubled. Women's Wear Daily, p. 2)*

Internet

Currently 1.7% of retail sales are produced from **websites** (Seckler, 2001a), and the figures continue to increase. (See Figure 15.19 on p. 434 for a listing of some unique fashion websites.) Predictions are that **online sales** will be 3–5 percent of total retail sales by 2004 (Seckler, 2001b).

In the first quarter of 2001 online apparel sales surged 108 percent over the previous year to total $1.3 billion. This figure moved apparel sales into the second-best-selling category of merchandise online (Seckler, 2001d).

Among regular Internet users (see Figure 15.10 for a profile of Internet shoppers), 60 percent said they shop for apparel online, with 41 percent reporting that they shop for apparel on the web a minimum of once per month and 56 percent having made at least one apparel purchase online (Seckler, 2001b). Internet consultant Mary Whitfield commented that "As people get more comfortable buying commodities online, they're branching out into 'higher risk' categories like apparel" (Seckler, 2001b, p. 2). A 2000 Price Waterhouse survey of Internet users found that 16 percent had purchased clothing on the web during the previous month—a twofold increase over the 8 percent of the previous year.

Further, the survey reported that Internet shoppers typically "shop around" at various sites; however 80 percent of online clothing shoppers and 77 percent of online clothing purchasers say they are primarily drawn to sites that have been mounted by familiar bricks and mortar stores. The survey also reported that Internet retailers continue to have difficulty convincing consumers that e-tailing is easier and preferable to a trip to the mall. Some of the reasons consumers identify for not purchasing on the web are listed in Figure 15.11.

In an effort to increase clothing purchases via the web, companies have begun to study their customers and have defined them into distinct basic types of online shoppers (see Figure 15.12). They have also surveyed consumers asking them to

Reason	Percentage
Inability to try item on	81%
Inability to feel material	45%
Difficulty in returning products	41%
Concerns regarding confidentiality	32%
More expensive than at stores	25%
Difficulty to browse Internet	14%

Figure 15.11 Reasons consumers give for not purchasing apparel via the web. *(Seckler, V. 2001, July 12. Survey says web apparel buys double.* Women's Wear Daily, *pp. 2, 16)*

Internet Shopper Type	Description	Need
"New to the net"	Still trying to grasp the concept of e-commerce. Use web for research. May begin purchasing online with small, safe purchases.	Guide, simple process, pictures, nonthreatening way to learn.
Bargain	Use comparison shopping tools a lot. No brand loyalty; lowest price wins the sale.	Convince shopper that he or she is getting lowest price.
Serious	Know exactly what they want. Purchase only that item. Know criteria looking for and will match it to what's given on the website.	Product information. Quick insights into other shoppers' experiences.
Enthusiastic	See shopping as recreation. Frequent purchasers. Most adventurous shopper.	Make shopping fun, engage them in the website.
Power	Shop out of necessity. Sophisticated strategies; don't waste time shopping.	Excellent navigational tools; lots of information about products.

Figure 15.12 Online shopper types. *(Cuthbert, M. 2000. The six basic types of E-shoppers. Available: http://www.ecommercetimes.com/perl/story)*

ACTIVITY 15.2 Shopping the Internet

Surf the Internet. Log on to find three fashion retailer's web sites and answer the following questions for each site:

- How is the website designed?
- Who is the target market?
- What are the features of the site? Is it interactive? Can you purchase merchandise off the site? Explain the ease and safety of the process.
- Describe the merchandise selection.
- Would you buy from this site?
- Compare the three sites. Explain the strengths and weaknesses of each.

identify what would make them purchase more clothing via the web. Consumers had three responses: free shipping (50 percent); lower prices than stores (40 percent); and nothing (33 percent) (Seckler, 2001b). In addition, companies are continually creating new ideas to attract consumers. For example:

- Some retailers are using online reminders such as flashing bars, pop-up boxes, or e-mail to alert customers to buy gifts and replace apparel (Seckler, 1998b).
- Internet companies are wooing females by uploading couture fashions onto the web only a few hours after they appear on the European runways. Women are urged to log onto FirstView (http://www.firstview.com) for the latest fashions ("Runway Robbery," 1998).
- Companies are appealing to consumers by comparing the prices of a product at retail to its web price. For example, Chanel No. 5's 3.4-ounce Eau de Cologne splash sells for $57 with free delivery when purchased from www.perfumemart.com, compared to $60 plus tax when purchased at Saks Fifth Avenue (Krantz, 1998, p. 37).

One successful Internet company is Lands' End, long known for its catalog business. In the late 1990s Lands' End added an Internet site to target younger customers and more females. Lands' End says now its website draws an equal number of men and women, adding that the women are primarily looking for bargains. They feel their online demographic skews toward a younger population because of the entertainment factor of using the net. Currently, Lands' End spends $10 million per year to promote its website (Russell and Lane, 2002). The company sent out 269 million catalogs in 2001, which resulted in sales of $814 million; Internet sales totaled ($218 million (Lands' End, 2001). Activity 15.2 addresses Internet shopping.

Consumer Issues in the Purchasing Decision

Retail strategy is the thought process behind the way a company does business—the decisions and policies a retailer establishes in hopes of motivating consumers to spend in their stores some of the $182.3 billion spent on fashion in 2000 (Carini, 2001).

ACTIVITY 15.3 Value Comparison

Compare similar garments in three different price ranges, for example: slacks/dresses at $50, $130, and $250 or a suit at $80, $150, and $250.

Write a report on your comparison shopping experience. Include the following information:

- *Hangtag or label information:* price, brand name/manufacturer, designer, fiber content, care instructions
- *Store names, addresses, and locations:* store image, type of merchandising, type of store, type of service
- *Garment presentation:* display appeal or impact, coordination of accessories
- *Garment construction:* fashion fabric, supportive fabrics, linings, number of pieces in design, matching of pieces, widths/seam finishes, handwork, quality, finishing, details and trims, manufacturing shortcuts, pressing

Summarize your findings and recommend the garment you believe to be the best value.

In the late 1990s, consumers were value-driven, searching for the lowest prices before purchasing apparel. (Activity 15.3 shows how to compare the value of clothing purchases.) Beginning in 2001, consumers began to define value as more than just price. Today's retail consumers define value as a combination of price, effective merchandising/pleasant shopping atmosphere, services, and ease of purchase ("Living in the Fast Lane," 2001).

Retail Price

Three issues regarding retail pricing will be discussed in this section: the cost and subsequent markup of merchandise, the pricing of various merchandise labels, and the frequency of sales.

Cost and Markup

Markup is the amount of money the store adds to the wholesale cost it pays for an item.

Manufacturers' price garments that they sell to retailers based on the production costs of the garment plus a profit. Typically a retailer's markup is arrived at by doubling this wholesale price to cover the store's cost of doing business and to ensure a profit (Activity 15.4).

Labels: Branded, Private, Designer

National brands are sold nationwide to various stores. These goods will have a fairly consistent price in all the stores that carry them.

ACTIVITY 15.4 Store Pricing Policies

Shop four stores in the same neighborhood for one identical item (identical in style, quality, and preferably brand and model number). The item can be apparel, cosmetics, or grooming equipment, such as an electric shaver or a hair dryer. Then shop three department stores at three different shopping centers for that same item.
Note:

- Names of the stores
- Exact locations
- Brand(s) compared
- Manufacturers' names
- Price charged at each store

Summarize your findings.

The retail price of merchandise is based on the cost of that merchandise to the retailer. Stores' inventories are chosen from among national branded merchandise (Levi's, Hanes), designer label goods (Calvin Klein, Donna Karan), and private label merchandise (Norsport, Classique), which are produced exclusively for Nordstrom. Costs for each of these types of products are determined in different ways.

National brands are sold nationwide to various stores. These goods will have a consistent price in all the stores that carry them. Many consumers feel loyal to national brands and habitually compare the price of their favorite brand at various stores. Sixty-nine percent of consumers are so brand loyal that a study done by Market Facts, Inc., reported that they would spend more on a nationally branded item than a private label one (Rossiter, 1995).

Private label items are produced exclusively for one store.

A private label item has no exact competition since it is produced exclusively for one store. This allows the store to set the price with no possible consumer comparison.

Designer label items carry a recognized designer's name and logo.

Licensed products are produced by a manufacturer who pays a royalty to use a designer's name.

Designer label items are often more expensive than nationally branded and private label items. Besides the obvious reasons—superior fabrics, trims, and workmanship—consumers pay for the designer's name on the product. Many designers' goods are licensed. In licensing, manufacturers pay a licensing fee to the designer for the privilege of using the designer's label in their merchandise. This fee is calculated into the

Selling Terms	Definition
Sale	10–20% price reduction from the original retail price.
Irregulars	Merchandise with a small defect sold at a lower price. Usually merchandised together and clearly marked as "irregular," such as irregular towels or bed linens during a white sale.
Seconds	Items with a noticeable flaw, generally sold in manufacturers' outlets. Marked as seconds.
As is	Damaged; store will assume no responsibility for repairs.
Wholesale	Manufacturer's price; typically not available to consumers.
Comparable value	Merchandise is similar but not identical to store's merchandise at same or higher price.
Manufacturer's suggested retail price/list price	Price established by manufacturers.
Selling at cost	Items sold at no (loss leader) or little (leader) profit. Used to attract customers with hopes they will also purchase regular-price merchandise.

Figure 15.13 Terms used in sales.

wholesale price of the item, which adds a minimum of 5 percent to the garment's cost to the retailer. This extra cost is passed on to the customer by a higher markup of the item.

Frequency of Sales

The big end-of-season clearances, frequent sales, and markdowns have become a way of life for many stores. Certain stores offer sale prices on merchandise so frequently that customers have been trained to rarely pay retail prices. With the proliferation of sales, customers can get confused by the various sale terminology (Figure 15.13) and the multitude of sale types (Figure 15.14).

Merchandising/Atmosphere

A shop within a shop merchandises all of a popular designer's or manufacturer's products together in a specialy department of a large store.

Merchandising inventory means arranging it in a way that facilitates merchandise location, coordination, and payment. A popular way for department and large specialty stores to merchandise a popular designer's or manufacturer's products is to create a specialty department, often called a "shop within a shop." Driven by one manufacturer's or designer's lifestyle concept, the total product offerings the store carries from that resource are housed together ("One-Stop Shops," 1998).

Type of Sale	Definition
Clearance	End-of-the-season sale to rid the store of seasonal apparel odds and ends.
Liquidation	Held as a result of a store quitting business and needing to sell entire stock.
Preseason	Merchandise prices reduced for a short period of time before the regular selling season begins.
Promotional sales	Used to promote sales of items. These sales have become habitual in some stores.
24-hour/one-day sales	Prices reduced for a short time period.
Special purchase	Merchandise purchased at less than store's normal retail prices especially for a sale.
Warehouse sale	Often sold from a manufacturer's warehouse.
Closeout	Divesting a particular type of inventory.

Figure 15.14 Types of sales.

This concept is now favored by Liz Claiborne, Donna Karan, Calvin Klein, Tommy Hilfiger, and others. A store's privilege of purchasing from many of these resources is now dependent on the store offering the manufacturer this exclusive space. The "shop within a shop" facilitates shopping especially for the brand loyal customer.

Service

> **Personal shoppers** suggest clothing, accessory, and gift choices for customers; keep files on customer preferences and sizes; and inform them of new merchandise arrivals and sales.

At one time stores offered the customer a large staff of well-trained, knowledgeable sales help. Unfortunately, this service is seldom available today. Owing to money-saving cutbacks, well-trained and knowledgeable sales help is rare, particularly in stores catering to customers in the moderate- and lower-income groups.

To counter the lack of service, many stores—particularly large department and specialty stores—retain a staff whose main responsibilities are to assist individual and corporate customers with purchases—at no charge. Dan Samson, head of the personal shopping department at Barney's, summarizes his job as polishing a man's image (Gellers, 2001). Personal shoppers make clothing, accessory, and gift choices for customers; keep files on them; and follow up to inform them of new merchandise arrivals and sales. For a description of the services of a personal shopper at an upper-end specialty store, see Figure 15.15. Time poverty due to dual careers has made the use of professional consultants increasingly popular. (Some consultants work independently of stores, providing the same basic services but for a fee.)

Level of Service	Benefits
Executive	• Aimed at executive men, women, and families • Direct phone line • Reminder cards for special occasions • Coordinate "back to school" and "off to camp" children's wardrobes • Separate billing for home and office accounts • Same-day delivery • Folio catalog • Advance notice of special events • Taxi and private car services
Marquise	• Aimed at individuals with many responsibilities • Professional consultation • Priority alterations • Invitations to fashion shows and special events • Pick up for Revillon fur storage • Private car service
International	• Multi-lingual service by phone • Escorted store tours with consultant • Shipping
Passport (NY only)	• Shop unescorted • Customer selects merchandise from any department; selections are sent to 5th Avenue Club and paid for in one transaction
Studio	• Designed for entertainment industry • Assistance to costume designers and stylists
Premium	• Designed for travelers • Service available at exclusive hotels through concierge
5th Avenue Club for Men	• Wardrobe planning • Made-to-measure clothing • Alterations • Fittings at office • Special billing • Same-day delivery • Corporate gift service

Figure 15.15 Services offered by Saks 5th Avenue Club. *(Saksfirst. 2002. New York: Saks Fifth Avenue)*

To ensure professionalism, consultants, personal shoppers, and image consultants have formed trade associations, one of which is the Association of Image Consultants International (see Figure 15.16 for a complete address), which has branches in most major cities around the globe including Tokyo, Prague, Manchuria, and Botswana (AICI, 2001). Their goal is to help members (100,000 in the United States alone) to build their businesses and improve their fashion knowledge, and develop their leadership skills (AICI, 2001).

The Association of Image Consultants International
2695 Villa Creek Dr., Ste 260
Dallas, TX 75234
e-mail: info@aici.org
web: http://www.aici.org

Figure 15.16 Address for The Association of Image Consultants International.

In addition, department stores also have begun to cooperate with manufacturers in instituting "Selling Specialist" programs. Selling specialists are trained to be experts in a single manufacturer's merchandise and sales techniques. A customer makes an appointment and gets undivided attention in choosing clothing and accessories ("Living in the Fast Lane," 2001). These specialists sell merchandise from one manufacturer. For example, the Liz Claiborne selling specialists sells only Liz Claiborne products.

Ease of Purchase

> **Proprietary credit** is offered by the store, most often as a private label card in the store's name.

One of the means of ensuring ease of purchase is offering credit. After watching third party credit (Visa, MasterCard) erode their percentage of apparel credit sales, stores have increased their efforts to increase customer loyalty by offering **proprietary credit** cards. To encourage increased usage of these cards, customers are offered various rewards based on charged purchases. Specialty stores, such as Casual Corner and Episode, offer a credit card that features 10 percent off the first purchases, advanced announcements of sales, a toll-free number, and no annual fee. These incentives are the most basic ones offered with store credit cards.

Macy's credit card has levels of benefits: Preferred, Premier, President's, and President's club Visa. For each level, the awards and benefits increase.

CASE STUDY 15.1

 The True Cost of Credit

In most states, revolving or budget accounts are charged 1 to 1.5 percent per month on the unpaid balance. This amounts to 12 to 18 percent over a twelve-month period and can add considerable cost to an item. Work the following problem.

Chris is purchasing a $240 blazer. He can pay $20 per month on his bill. If Store A charges 1.5 percent per month and Store B charges 1 percent per month,

- How much would he pay to each store?
- How many months will it take him to pay his bill to each store?

Figure 15.17
Purposes of fashion
advertising. *(M.S.
Bohlinger. 1993.
Merchandise Buying.
Boston: Allyn & Bacon,
p. 451)*

- To attract customers to the store.
- To convert customers to buyers.
- To build good will for the store.
- To introduce new products, fashions, and services.
- To stimulate and create demand for products and services.
- To build a favorable store image.
- To show new applications of a product.
- To develop a list of potential customers.
- To assist sales persons through preselling.
- To increase mail and telephone orders.
- To maintain store name, trademark, or product before the public.
- To keep customers satisfied with previous purchases.

Offering even more benefits is Saks Fifth Avenue's card, Saksfirst, which earns the user points based on each store purchase. After earning two thousand points, the customer receives a First Reward Bonus certificate to be used for future shopping. In addition, customers receive free local delivery, priority notification of sales, opportunities to participate in "double point" events such as their birthdays, catalogs, coat check, and delayed payment opportunities (Saksfirst, 2002). ·

Despite the rewards offered by stores for using their credit, the privilege of using the card costs consumers money. Case Study 15.1 gives an example of the true cost of credit.

The methods a retailer uses to create value for customers affects the store's image in the eyes of those customers. As a result they are either more or less motivated to purchase apparel from that particular store. However, even a store that is heavily committed to value must ensure that its message is heard. The most common method of communicating with consumers is through the use of advertising.

Advertising

Today the average American consumer is exposed to approximately five thousand advertisements each day. One of the reasons companies spend so heavily on advertising is to keep their products continually on the minds of their customers. Research shows that consumers must be exposed three times to an advertisement for it to be effective (Russell and Lane, 2002).

The primary purpose of advertising is to sell goods and services. It does this by frequent and regular communication with customers, making them aware of products and services and creating a desire to have them. Advertising also attempts to convince the consumer that one brand is more desirable than others (Figure 15.17).

The media that carry advertising include print (newspapers, magazines), broadcast (radio, television), direct-mail advertising, position advertising, and point-of-sale displays. Newspaper (38 percent) and television (18 percent) account for 56 percent of the $2.65 billion of U.S. advertising dollars spent annually (Russell and Lane, 2002). Some of the apparel companies that are the biggest spenders are Nike at $211 million, L'Oreal at $160 million, and Levi's at $100 million (Swanson and Everett, 2000).

ACTIVITY 15.5 Advertising Analysis

Clip several kinds of clothing and accessory advertisements from magazines and newspapers. Analyze advertising for informative content vs. emotional appeal.

- Underline in red all copy based on emotional and nonrational appeals. Underline in black all copy that is informative.
- Note the needs and values the appeals are directed toward, such as emotional security, health, convenience, comfort, status, power, prestige, or financial gain.
- Summarize the types of appeals used most frequently.
- Determine the relationship, if any, that a certain type of appeal might have to a particular age group.

The benefits of advertising to customers are not always positive. The vast majority of advertisements are designed to sell a product by emotional persuasion. This includes emotion-charged advertising that is directed to the hidden fears of the consumer or advertising that promises to satisfy the concealed hopes of the consumer. Numerous advertisements are directed toward the human desires for:

- Emotional security: youthfulness, glamour, belonging, sex appeal, prestige, or status.
- Convenience and comfort: ease of care, upkeep, or use.
- Safety and health: safe products that promote well-being and longevity.
- Financial gain: wise buy, bargain, economical, shrewd investment, snob appeal (Activity 15.5.)

For example, the purchase of licensed apparel from the various professional U.S. teams offer a promise of athletic success; athletic shoes promise quickness and agility; hair products offer increased attention from the opposite sex.

It is revealing to compare the style of advertising for various price ranges of clothing. In advertisements for high-priced designer clothes often only the designer or brand name appears and sometimes the name of one retailer. No detailed descriptive copy accompanies the photograph. The concept for this type of promotion is that the avant-garde or established designer customer does not need selling or persuading to wear innovative styles; such a customer needs only to be notified that new garments are available.

Fashion advertising in newspapers and magazines for medium-priced clothing features clear photographs. The accompanying copy contains extensive descriptions written to persuade the customers that they will appear fashionable in these styles, or that they will achieve the lifestyle they desire by wearing this apparel.

Low-priced clothes usually sell themselves. Advertising is limited, and television is the preferred medium. Retail outlets selling clothes in this price range are often known by their customers, who are concerned with price and functionality. Low-priced clothes can be fashionable and are usually in the styles that have been proven.

Consumers can determine the credibility of information presented in advertisements by recognizing the underlying purposes of an advertising campaign. Advertising has both advantages and disadvantages that the consumer should consider (Figure 15.18) before making a purchase decision.

Visit some of the fashion websites listed in Fig 15.19 and determine how effective they are in advertising.

Advantages	Disadvantages
• Making people aware of new products and services and of the stores in which they can be purchased. • Enabling people to make comparisons between products without leaving their homes. • Moving goods and services, which in turn provide employment in all phases of manufacturing, distribution, promotion, and selling.	• Influencing some people to overextend their budgets and misuse credit. • Encouraging obsolescence by making consumers dissatisfied with what they own (planned obsolescence) long before signs of garment wear appear. • Exaggerating claims, misrepresenting, and promoting dangerous products by some advertisements (allergy-causing cosmetics, drugs with harmful side effects, and ineffective sun protection products).

Figure 15.18 Advantages and disadvantages of advertising.

Fashion Websites	
alexblake.com	Hosiery, product reviews, glossary
alight.com	Trends for size 14+
bagenvy.com	Bags for all occasions—night to gym
bibisworld.com	Resale boutique for clothes, shoes, bags
builtbywendy.com	Cutting-edge designs
chelsea-girl.com	Soho vintage clothing outlet
designerexposure.com	Celebrities' second-hand clothing
diamond.com	Diamonds
fabric8.com	Clothes, bags, music, accessories from San Francisco underground
herroom.com	Lingerie, accessories

Figure 15.19 Websites. *(Foxman, Ariel. 2001, November. Surfin' U.S.A. In Style, pp. 307–314)*

ice.com	Discounted jewelry
incagirl.com	Exotic bags, belts, beachwear
ibdtogo.com	Little black dresses
leftgear.com	Fashions from 40 LA designers plus sale rack
meandrojewelry.com	Jewelry
moosejaw.com	Gear for outdoor sports
patchnyc.com	Retro crocheted caps, charm jewelry, etc.
paulfrankisyourfriend.com	Clothes, jewelry
pilgrimdesigns.com	Trendy fabric purses; choose strap length
ravinstyle.com	Designs for three personality types: feminine, city, and new age-y
shanghaitang.com	Silk creations from China
stacianewyork.com	Feminine yet modern looks
stylechop.com	Trendy designer clothing on sale in limited quantities
tibichick.com	Fun prints
timbuk2.com	Design your own: messenger bag, laptop sleeve, cell-phone holster
tinatang.com	Sterling/semiprecious stones jewelry
2funkychicks.com	Customizable Ts, camisoles, thongs
underwoo.com	Trendy things made from recycled denim, cashmere, leather, etc.
windowshoppinginparis.com	Parisian accessories shops
zappos.com	Women's, men's, kid's affordable shoes
Beauty Websites	
apothia.com	Beauty products from Fred Segal's boutiques
auntvisgarden.com	High-end, all natural beauty products with spiritual bent
ezface.com	Submit digital photo of your face and use site's Virtual Mirror to experiment with colors of season

Figure 15.19 *(Continued)*

fresh.com	Great-smelling bath products
glodirect.com	Hair-care, skin-care, makeup
gloss.com	Umbrella site run by Estee Lauder
latherup.com	All natural bath and beauty products
mariobadescue.com	From NY skin care clinic of stars
smallflower.com	Head to toe needs
threecustom.com	High-end cosmetics custom-blended to a fabric or hair color
whosthefairest.com	Quirky, off-beat hair, face, and body products
Gift Websites	
areyougame.com	Board games, puzzles
bookfinder.com	Locates first-edition rare books
cspostgeneralstore.com	All-American gifts
dish-shop.com	Sleek, sculptured tabletop and barware
endicottfive.com	Retro-feel gift wrap
esappa.com	Unique, handmade jewelry, housewares, bath products
flight001.com	Luggage, travel accessories
fredflare.com	Paper goods
goldviolin.com	Items for seniors
mossonline.com	NY items
papivore.com	Stationery
robinseggblue.com	French country accents for home and office
send.com	Send anything, anywhere
unicahome.com	Snob appeal products
vivre.com	Style, interior, men's luxury goods
windowbox.com	Windowboxes, terrace garden accessories

Figure 15.19 *(Continued)*

❧ References

AICI image: Past, present, future. (2001). http://www.aici.org/general-info.html.

Carini, M. (2001, July 26). Retailing: Specialty. http://www.netadvantage.standardpoor.com.

Cuthbert, M. (2000, September 29). The six basic types of E-shoppers. http://www.ecommercetimes.com/perl/story.

Fallon, J. (1998, April 20). Nine West launches lifestyle shop. *Women's Wear Daily,* p. 10.

Foxman, Ariel. (2001, November). Surfin' U.S.A. *Instyle,* pp. 307–314.

Frings, G. (2002). *Fashion from concept to consumer* (7th ed.). Upper Saddle River, NJ: Prentice Hall.

Gampier, M. (2001, November 16). Manager of Abercrombie & Fitch, the Shops at Mission Viejo, Mission Viejo, CA. Interview.

Gellers, S. (2001, April 27). The personal shopper. *Daily News Record,* p. 18.

Hye, J. (1998). It's women's traditional clothes and data. *Women's Wear Daily,* p. 16.

Krantz, M. (1998, July 20). Click till you drop. *Time,* pp. 34–41.

Lands' End, Inc. Reports third quarter fiscal 2002 results. (2001). http://www.landsend.com.

Living in the fast lane. (2001, June 27). *Women's Wear Daily,* p. 2.

McElwain, J. (1990). More than window dressing. *California Apparel News.*

More time-pressed men opting for convenience of specialty stores. (2001, April 27). *Daily News Record,* p. 2.

Neiman Marcus Christmas Book 2001. (2001, December). Dallas, TX: Neiman Marcus.

One stop shops. (1998, July 2). *Women's Wear Daily,* p. 2.

Reeling 'em in: Store displays can be the lure for hard-to-catch men. (2001, April). *Daily News Record,* p. 2.

Retail industry overview. (2001, October 4). http://www.wetfeet.com/asn/industry profiles.

Rossiter, D. (1995, November). *DNR infotracs.* New York: Fairchild.

Runway robbery. (1996, March 18). *Time,* p. 34.

Russell, J., and Lane, R. (2002). *Kleppner's advertising procedure* (15th ed.). Upper Saddle River, NJ: Prentice Hall.

Saksfirst. (2002). Saks Fifth Avenue brochure. New York: Saks Fifth Avenue.

Schneiderman, I. P. (1996a, January 29). 'Less' is heard more often in survey of apparel shopping habit. *Daily News Record,* pp. 24–25.

Schneiderman, I. P. (1996b, February 21). Understanding today's male shopper. *Why Men Buy 2: DNR's National Survey of Consumer Attitudes Towards Buying Men's Wear,* p. 2.

Seckler, V. (1998a, June 15). IMRA study: Hunt for new profits. *Women's Wear Daily,* p. 18.

Seckler, V. (1998b, June 24). On-line reminders: What's in store? *Women's Wear Daily,* p. 13.

Seckler, V. (2000, April 23). QVC invests in the knot. *Women's Wear Daily,* p. 8.

Seckler, V. (2001a, May 9). Survival of the fittest online. *Women's Wear Daily,* pp. 2, 8.

Seckler, V. (2001b, July 12). Survey says web apparel buys doubled. *Women's Wear Daily,* pp. 2, 16.

Seckler, V. (2001c, October 10). Web study cites "super customer." *Women's Wear Daily,* p. 15.

Seckler, V. (2001d, October 17). Strong Sept. for fashion on the web. *Women's Wear Daily,* pp. 1, 7.

She's gotta have it. (1998, May 7). *Women's Wear Daily,* p. 2.

Silverman, D. (1998, July 6). Consumers are becoming more shopworn. *Daily News Record,* pp. 12–13.

Swanson, K., and Everett, J. (2000). *Promotion in the merchandising environment.* New York: Fairchild.

Taylor, H. (2001). Reading remains the nation's favorite leisure time activity. Harris Poll Library. http://www.harrisinterative.com/harris_poll.

Index